Seeing
America

Seeing America

WOMEN PHOTOGRAPHERS
BETWEEN THE WARS

Melissa A. McEuen

THE UNIVERSITY PRESS OF KENTUCKY

Publication of this volume was made possible in part
by a grant from the National Endowment for the Humanities.

Scholarly publisher for the Commonwealth,
serving Bellarmine College, Berea College, Centre
College of Kentucky, Eastern Kentucky University,
The Filson Club Historical Society, Georgetown College,
Kentucky Historical Society, Kentucky State University,
Morehead State University, Murray State University,
Northern Kentucky University, Transylvania University,
University of Kentucky, University of Louisville,
and Western Kentucky University.
All rights reserved.

Editorial and Sales Offices: The University Press of Kentucky
663 South Limestone Street, Lexington, Kentucky 40508-4008

04 03 02 01 00 5 4 3 2 1

Library of Congress Cataloging-in-Publication Data

McEuen, Melissa A., 1961-
 Seeing America : women photographers between the wars / Melissa A.
McEuen.
 p. cm.
 Includes bibliographical references and index.
 ISBN 0-8131-2132-9 (cloth : alk. paper)
 1. Women photographers—United States—Biography. 2. Documentary
photography—United States—History—20th century. 3. Photography—
United States—History—20th century. I. Title.
TR139.M395 1999
770'.92'273—dc21
 [B] 99-17219

Manufactured in the United States of America

For Family,

the McEuens
and
the Stantons

Contents

Acknowledgments

THE PLASTIC CAMERA MY PARENTS GAVE ME on my eighth birthday had only two features, a shutter button and a neck strap. That such a simple box could create a world of images amazed me. For several years, I proudly displayed my black and white pictures as squares of captured time, shots of ordinary people going about their daily lives in my small western Kentucky hometown. Many years later I began probing the meanings of photographs, inspired by my graduate school mentor, Burl Noggle. He directed an early paper I wrote on "realities" in pictures taken in the 1920s. From there I expanded my arguments about visual images, first in a master's thesis and then in a doctoral dissertation, all the while sustained by Burl's patience and encouragement.

My dissertation lies at the core of this book, and I want to acknowledge the financial support I received to complete both projects. The T. Harry Williams Fellowship in History at Louisiana State University allowed me a year's leave, the valuable time necessary for sustained research. A generous faculty research grant from Georgetown College made it possible for me to spend a summer in Washington, D.C., and a Jones Faculty Development Grant from Transylvania University funded another research trip in 1997.

I received kind assistance from many cooperative and patient archivists, curators, and staff members at the Archives of American Art; the Art Department of Berea College; Special Collections at Berea College; the Bancroft Library of the University of California, Berkeley; the J. Paul Getty Museum; the University of Kentucky Art Museum; the University of Louisville Photographic Archives; the National Archives; the New York Historical Society; the Southern Historical Collection at the University of North Carolina, Chapel Hill; Special Collections at the University of Oregon; and the South Carolina Historical Society. Especially

helpful were Lisa Carter, at the University of Kentucky Special Collections; Therese Thau Heyman, at the Oakland Museum; and Amy Doherty, at George Arents Research Library, Syracuse University. My unending gratitude goes to Beverly Brannan, Curator in the Prints and Photographs Division at the Library of Congress. Over the years we have discussed ideas, read each other's manuscripts, and shared numerous stories about women who chose photography as a profession. Beverly's enthusiasm and wide-ranging knowledge in the field are blessings.

The comments offered by colleagues and members of the audience at several meetings, including those of the American Studies Association; the American Historical Association, Pacific Coast Branch; the Louisiana Historical Association; and the 1997 Doris Ulmann Symposium at the Gibbes Museum of Art, helped me to shape my positions on several issues. Fellow participants at the 1995 National Endowment for the Humanities Institute, "The Thirties in Interdisciplinary Perspective," directed by John and Joy Kasson at the University of North Carolina, prodded me with thought-provoking questions that strengthened the book. I extend special thanks to Robert Snyder for his insights on my work and for taking a chance on a young scholar by inviting me to contribute to a special issue of *History of Photography* that he edited. Those who have read all or parts of the manuscript and whose invaluable comments have enhanced it beyond measure include Jessica Andrews, Peter Barr, Robert Becker, Beverly Brannan, James Curtis, Gaines Foster, the late Sally Hunter Graham, Philip W. Jacobs, Wendy Kozol, Heather Lyons, Richard Megraw, Mary Murphy, Daniel Pope, Janice Rutherford, Charles Thompson, and Alan Trachtenberg. An anonymous reader for the University Press of Kentucky offered excellent suggestions. In the Social Science Division Office at Transylvania University, Linda Denniston helped me tremendously and usually on short notice.

Those familiar with liberal arts colleges devoted to undergraduate education know that time for research and writing is precious; there are no teaching assistants or graders, and teaching loads are heavy. So I remain awed by the example of my former Georgetown College colleague, Steven May, who has gracefully balanced his roles as an award-winning teacher, a faculty leader, and a prolific scholar for thirty years. His sound advice and hearty

encouragement were extremely important when I was starting out in the academic world.

Loving friends have been with me at the times I needed them most—I am lucky to be able to share secrets and an occasional breakfast, lunch, or afternoon tea with Sharon Brown, Barbara Burch, Regina Francies, and Mary Jane Smith. As always, the warm embrace of my parents, Bruce and Peggy McEuen, and my brothers, Kevin McEuen and Kelly Brown McEuen, has been constant and life-sustaining. The family that I married into about the time I began writing this book also have given me their unconditional support. No one has lived with this project more than my husband, Ed Stanton. As a scholar, he knows the rigors of academia and so has carefully protected my solitude. As a companion and lover, he keenly understands what the most essential things in life are and has passionately safeguarded our time to enjoy them together. He not only made this book possible but allowed its creator to thrive in the sweetest Eden imaginable.

Introduction

WHEN *LIFE* PHOTOGRAPHER MARGARET BOURKE-WHITE drafted an essay for *Popular Photography* magazine in the fall of 1939, she reminded readers and fellow photographers, "It is the thoughts that live in your head that count even more than the subjects in front of your lens."[1] Her judgment alerted every creator of visual images and every subsequent observer of those pictures to the vital reality that understanding the substance of a photograph requires understanding the person behind the camera. The whole range of ideas, prejudices, and desires that a photographer harbors is as significant as what he or she chooses to frame.

This book examines the lives and work of five American women who distinguished themselves as professional photographers in the years between the world wars. They are tied together by their passion for viewing people and places in the United States and, more importantly, by a common desire for their visual images to make a difference, serve a purpose, or influence what Americans thought about themselves or other people or distant locales or new ideas. As a result of these motivations, all five photographers ultimately embraced the most popular vehicle for socially conscious expression in the 1930s—documentary. Each woman then molded the genre to advance her own agenda, at the same time reshaping the visual form itself, even creating ameliorative possibilities for it. By freely allowing personal prejudices to permeate their gazes on the world, Doris Ulmann, Dorothea Lange, Marion Post, Margaret Bourke-White, and Berenice Abbott revealed the malleable nature of documentary photography. This examination of their lives and their pictures attempts to illuminate the primary impulses that drove photographers to use their cameras to send highly charged political and social messages in an age when most people believed that pictures did not lie but rather substantiated what was questionable or clarified what was imperceptible.[2]

The following study focuses on women photographers. Why women exclusively? After having set out to delve into New Deal politics and the photography it inspired in the thirties, I soon reached the same conclusions as Chicago gallery owner Edwynn Houk, who in 1988 planned a photography exhibit that would display a solid cross-section of twenties and thirties pictures. Nearly all of the final selections for the show, he realized, were photographs taken by women. Houk found the results intriguing and concluded, "Without attempting to focus on women artists, the Gallery nevertheless came to represent the works of many women by offering the best and most significant images produced in photography during the twenties and thirties." Similarly, a substantial number of the most penetrating visual studies I viewed in the early stages of my research were created by women. Their photographs seemed endless. Yet the scholarly literature on them was scant compared to that based on their male contemporaries. Perhaps worse, women were poorly represented or omitted completely from the best-known photography anthologies. Given their marginalization in the scholarship on photography, I grew even more curious about the photographers themselves. Why did they take up camera work initially? What led them to become professional photographers? What obstacles did they face or what freedoms did they enjoy because they were women in the profession? What were they trying to accomplish? How did they feel about the use of their photographs by employers or gallery owners or others? What political or cultural connections did they make with their visual imagery, or did they care at all about these matters? The most important questions, in my opinion, probed the inextricable relationship between the photographers' lives, the conceptual frameworks they built around their subjects, and the final images they produced. After pursuing the answers to these questions, I saw that they revealed the rich texture of American culture and a web of ideologies that circulated in the first half of the twentieth century. So what had begun as a project narrowly defined as political history became women's history and then developed into a larger examination of American history and culture. What kept appearing in my imagination was the superb title that editors Linda Kerber, Alice Kessler-Harris, and Kathryn Kish Sklar gave to a 1995 essay collection dedicated to Gerda Lerner—*U.S.*

History as Women's History. It seemed an appropriate description for my own discoveries regarding the development of documentary photography through the lens of its female practitioners. The composite analysis finally showed, as their essay collection did, "a vision of U.S. history as women's history quite as much as it is men's history."[3]

Analyzing photographs and evaluating aesthetic philosophies proved to be complementary to the demands of a feminist theoretical framework, which encouraged deep probing into the photographers' backgrounds, including what they thought their work did for them on a personal level. Historically, the photography profession provided an attractive alternative to the constrictive boundaries of nineteenth-century domestic existence, which still affected many women in the first decades of the twentieth century. In 1902 Myra Albert Wiggins stated, "Nothing has revealed human nature, given me a chance to travel, [and] given me valued acquaintances and friends as much as photography." And for women who desired a sense of independence, the vocation allowed "an individual working alone . . . [to] achieve something." As a low-ranking profession in the nineteenth century, photography was considered an acceptable pursuit for members of politically marginalized groups, particularly women. Those who engaged in taking pictures did not threaten powerful elements in the hegemonic structure, because photography was not steeped in tradition, as were the fields of law, medicine, and academia. Successful careers in photography did not depend upon attendance at august institutions, where women were rarely if ever admitted. But as early as 1872, the Cooper Union offered photography courses to women in New York City, hoping to prepare them for employment as assistants in the rapidly developing field. Pictures taken by American women were exhibited at the 1876 U.S. Centennial Exhibition in Philadelphia and accounted for a significant part of the Paris Exhibition in 1900. As camera equipment became less bulky and more inexpensive in the early twentieth century, an individual wanting to experiment with photography needed little capital. Many women were able to borrow cameras from friends or relatives or use the equipment owned by the studios where they retouched negatives, made prints, or posed models for well-established photographers.[4]

Photography opened doors for women, perhaps at no time more widely than in the years between the world wars. Exhibit curator Paul Katz noted that this generation of female photographers "wanted careers—public lives that would be more like a marriage with the world. Photography offered that possibility. In their quest they were aided by the vast increase in photographically illustrated publications and the creation, as a result, of new fields such as photojournalism and advertising photography. The needs of editors tended to override sexual prejudices, and the relatively low status of the profession as an art form made it easier for women to enter." Katz contends that "the sheer number of women who found a vocation in photography proclaims a social revolution . . . as emblematic of the age as the feats of Amelia Earhart and Gertrude Ederle."[5] Finding a vocation in photography did not necessarily guarantee a comfortable life, though. In the present study, only one of the five women, Doris Ulmann, never had to worry about money. Personal wealth sustained her career and her expensive habits. In contrast, Dorothea Lange saw her immediate family members, including her young children, scatter in different directions when the Depression began; Berenice Abbott took on a variety of odd jobs to support her career; Margaret Bourke-White had outstanding accounts at nearly every major department store in New York City during the 1930s; and Marion Post once admitted having said "yes" to any man who asked her out so that she could have at least one good free meal that day.[6] Despite their sporadic economic hardships, female photographers in the twenties and thirties received recognition as equals of, even superiors to, their male colleagues and competitors.

If there were so many women working in photography during this period, then why single out these five—Berenice Abbott, Margaret Bourke-White, Dorothea Lange, Marion Post, and Doris Ulmann? What makes them so compelling? Chiefly, all were prolific photographers who turned to documentary expression in the interwar years. Here the term *documentary* is defined broadly, not as a distinctive and recognizable style that focuses on specific subjects (especially since 1930s documentary was expressed in various styles using all kinds of subjects), but instead as a touchstone measuring two elements: first, the photographer's role as both recorder and participant in the cultural dramas in which she

engaged, and second, the extent of her desire to have her images used for larger social or political purposes. For this reason photographers such as Laura Gilpin and Imogen Cunningham, whose reputations were made primarily as art photographers during the 1920s and 1930s, are not included here. And although Tina Modotti has been labeled a documentarian, her oeuvre is largely Mexican, which puts her photography outside the geographical parameters of this study, namely the United States. Beyond my desire to focus on photographers who considered themselves documentarians of some sort and who completed all or most of their work in the United States, I wanted to show the tremendous range of documentary styles exhibited by women photographers, which in turn would foster a discussion about their contributions in shaping the genre and its role in public life. To accomplish this, I chose five individuals who carried out extensive "fieldwork" in the discipline by traveling to unfamiliar surroundings or uncharted territory in order to survey American life. Each produced perceptive views on the astounding variety of occupations, values, and leisure activities in the nation between the world wars, and in the process they made considerable contributions to historical photography. Finally, each cultivated a distinctive style woven from the skeins of her aesthetic sensibilities, her personal politics, and the pressing social and cultural forces of her time.

Together, the five women produced a corps of visual images that covers an impressively broad spectrum in tastes, methods, and perspectives, all of which fit comfortably under the large umbrella of documentary photography. That these women worked during such a critical time in the nation's history simply augments their professional achievements. When their pictures are viewed collectively and examined across time, patterns emerge that show the development of documentary as a medium of expression. The life of socially conscious visual expression in the 1920s and 1930s may be plotted along the paths taken by Ulmann, Lange, Post, Bourke-White, and Abbott. Beginning with Ulmann's studio-in-the-field approach in the mid-1920s, documentary then experienced modifications by Lange, who fashioned slightly more informal portraits than Ulmann did while on the road. Post turned the medium into a forum for radical political views, exposing racism and class stratification in the United States through her angles on social situa-

tions and her telling backdrops. Bourke-White attempted to infuse documentary with the high-style modernism of innovative advertising photography. But not until Abbott systematically utilized a different kind of modernist aesthetic in her large-scale project "Changing New York" did documentary and modernism coexist harmoniously on photographic paper. Despite the apparent incongruity of a marriage between documentary and modernism, Abbott managed to combine the two forces almost seamlessly.[7] Her calculated juxtapositions of old monuments with new architectural creations showed layers of the past stacked up next to the present and the foreseeable future, an array of generations realized in two-dimensional form.

Beyond their diverse stylistic preferences, these five photographers posited certain nationalist ideals by pursuing subjects that they believed would highlight American cultural strength and in turn promote greater social awareness or change. In each woman's prescriptive works, themes emerge that connect present circumstances with eventual consequences. Ulmann perceived American ingenuity and continuity overwhelmingly in rural Appalachian craftspeople, whereas Abbott found characteristic "Americanness" in urban growth and renewal. Bourke-White pictured sophisticated machine technology as the nation's greatest hope for a promising future, while Lange illuminated the steadfastness and survivalist spirit of its ordinary people as the country's most reliable resources. Post idealized the notion of collective cooperation as a means of alleviating the most deeply rooted social problems in the United States. Over a twenty-year span, the five women analyzed here articulated in pictures the principal cultural forces that manipulated American thought and action in the critical years between the world wars.

More than anything else, this is a study of visual images as the tangible results of personal motivations and historical forces. I began my research on this project by following James Borchert's prescription for evaluating visual evidence, a charge to "cast as wide a net as possible." He maintains that scholars may more easily determine "bias" if they look at a substantial number of pictures. The virtue of quantity also provides clues as to what surrounding evidence a photographer may have purposefully left out. To that

end, photographic series of subjects, including whole jobs and complete assignments rather than isolated images, form the visual evidence base of this study. Consequently, the historian's task involves interpreting the visual thinking of the photographer. Thomas Schlereth suggests that historians of visual imagery attempt to "get inside the mind of the photographer." To accomplish this rather difficult task, I examine the ways each photographer prepared for fieldwork, dealt with local officials, approached her subjects, described her perceptions of various jobs, and handled her superiors, such as supervisors and editors. In the process of contextualizing each woman's life, I attempt to show that a photographer born in the 1880s was more greatly swayed by her training in the 1910s than by the stock market crash, and that another, who was a teenager in the 1920s, viewed Americans differently than her institutional colleague who had been an established portraitist in that same decade. The more familiar historical markers, such as the 1929 stock market crash and presidential election years, appeared to me to be artificial guidelines, since social and cultural changes in the United States did not necessarily parallel economic and political shifts. It took time for some photographers to recognize the enormity of the Great Depression and its effects on the nation; only after witnessing hunger and despair firsthand did they seek out "the people" as their principal subject. And although picturing the "common" man and woman is often interpreted as a requisite function of documentary expression in the 1930s, there were American photographers like Doris Ulmann experimenting with these subjects in the 1920s and even earlier. Historian David Peeler has written that "one of the more enduring American myths is that social art of the thirties, with all its intensity and commentary, was completely divorced from a frivolous and self-indulgent twenties culture."[8] The fluidity of artistic, ideological, and cultural trends in the interwar years led me to construct a narrative organized to enhance the historical contexts in which these photographers worked. For that reason, I have chosen a biographical approach for ordering my analyses. Although such a schema does present the possibility of thematic discontinuity, its advantages outweigh the conceivable impediments.

In his provocative study of American modernism and its purveyors in the South, Daniel Singal defended his use of a bio-

graphical framework by noting that "[a] sociologist may be trained
in the most advanced social science theory, or a novelist may be
steeped in the literature of his times, but in each case the beliefs
and perspectives actually absorbed and utilized will depend on the
constellation of formative experiences the person has undergone."
Likewise, a photographer's vision emerges from the mélange of
past experiences, present emotions, careful calculations, and tech-
nological processes that come together at the moment in time and
space when a scene is framed through the lens and recorded on a
glass plate or a strip of film. Since images cannot be separated
from their creators' intentions, they are treated as such in this text.
Photo scholar Allan Sekula has pointed out that "every photo-
graphic image is a sign, above all, of someone's investment in the
sending of a message." Such messages cannot be fully understood
if the photographer is cast on the periphery by researchers. The
most significant recent scholarship on American photography has
shown the primacy of examining the sources of images, their cre-
ators, in order to understand more clearly the messages being sent.
I have built upon the exceptional work of Alan Trachtenberg, whose
book *Reading American Photographs: Images as History, Mathew
Brady to Walker Evans* displays a method for examining photo-
graphs as cultural texts while keeping the photographer's responses
and motivations near the center of the analysis. James Curtis
provides yet another revisionist model in *Mind's Eye, Mind's Truth:
FSA Photography Reconsidered,* a work based on primary mean-
ings of photographs, with the creator's intentions and biases al-
ways at the forefront. Halla Beloff wrote in *Camera Culture* that
"the camera and the film link a photograph concretely with a
machine, and yet we understand that a human intelligence, and
sensitivity, and a human need have made us that picture."[9] In the
1920s and 1930s, those human intelligences, sensitivities, and needs
manifested themselves powerfully through the vehicle of documen-
tary photography. The fruits of the documentary visions cultivated
by Doris Ulmann, Dorothea Lange, Marion Post, Margaret Bourke-
White, and Berenice Abbott are rich representations of the intri-
cate workings of American culture in the years between the wars.

Documentarian with Props

Doris Ulmann's Vision of an Ideal America

One picture . . . cannot express an individual.
—Doris Ulmann

A FEW WEEKS BEFORE HER DEATH at age fifty-two, Doris Ulmann wrote, "Personally, I think there is always more value in doing one thing thoroughly and as well as possible than in spreading over a large area and getting just a little of many things."[1] The specific reference was to her current photography project, but the statement also clearly defined the approach she had taken in her twenty years behind the camera. Spending hours with each subject, posing and reposing, Ulmann ultimately created a composite image of the person or object on which she focused. Her method of painstakingly observing each portrait sitter remained the hallmark of her in-depth studies. Beginning as a photographer who posed wealthy, educated, and privileged individuals in New York City, she later broadened her focus to create images of rural Americans. She chose ethnically distinctive enclaves that interested her and carefully studied individuals within those groups. Combining an interest in human psychology, a nostalgia for an idealized American past, and the finest available training in photography,

Ulmann produced some of the most penetrating character studies of Americans in the 1920s and 1930s.

That she realized her portraits could serve a social purpose places her squarely within the documentary tradition of American photography. She reached this conclusion well past the midpoint of her career, embarking upon new and extensive projects despite debilitating physical frailties. Although her style and her equipment remained virtually unchanged for twenty years, Ulmann's camera eye shifted significantly three times: in 1919, when the hint of publishing success ensured her status as a professional photographer; in the mid-1920s, after her marriage legally ended, her mentor died, and she suffered a crippling fall; and in 1933, when she began a comprehensive survey of southern Appalachian handicrafts to illustrate a colleague's written text on the subject. At each juncture Ulmann embraced subjects that she felt deserved the attention of the public and, most of all, required a photographer's interpretative eye (her own) to grasp and hold that attention. The faces and scenes she rendered reflect her desire to create photographic records that not only would illuminate personalities and lifestyles but also would expose ideal worlds—worlds created by the good intentions and active imaginations of Ulmann and her upper-middle-class counterparts. Their interests led them to grapple with the myriad changes wrought by a modern, industrialized, and increasingly urbanized nation.

Ulmann's family background and educational pursuits set the stage for the work she found most satisfying as a professional photographer. She was born in 1882 into a wealthy Jewish family, her father having immigrated to the United States from Bavaria in the 1860s. Supported by a successful textile manufacturing business, the Ulmann family lived in New York City's heart, Manhattan. The urban environment provided the cosmopolitan influences that shaped Ulmann's initial aesthetic tastes and values. She cultivated many interests that she would continue to enjoy for the rest of her life, from literature to theater to modern dance. Her New York public school education was supplemented by excursions abroad with her father, Bernhard Ulmann. In 1900 she enrolled in teacher training at the Ethical Culture School, an institution founded by Felix Adler, who was an optimistic reformer driven by humanistic impulses and a great need to sponsor and help the burgeoning

working classes. His progressive institution functioned according to the Ethical Culture Society's motto, "Deed not creed," thus setting it apart from other contemporary reform efforts that were heavily infused with religious messages and influences.[2] The Ethical Culture School appealed to several constituencies, including successful immigrants seeking to Americanize their children and provide them with a living conscience sufficient to embrace problems posed by the new industrial order in the United States.

With hopes of becoming an educator, Ulmann spent four years at Ethical Culture, during the same period that a young teacher named Lewis Hine went there to teach biology. At the insistence of the school's superintendent, Hine ended up taking students on several field trips to Ellis Island to photograph newly arrived immigrants. He also began offering lessons in photography, where Ulmann probably had her first contact with him. Their mutual devotion to Ethical Culture's philosophies gave them common ground on which to build their respective photographic achievements. For Hine, the task began almost immediately, as he published both words and pictures addressing society's problems.[3] For Ulmann, the reform impulse lay dormant for nearly twenty years, awakening when she realized that her camera work could transcend its status as a hobby and could make a difference in distinctive communities in the United States. To accomplish her goals, she embraced an element of Hine's approach that had become one of the hallmarks of his socially charged visual images: a focus upon individual faces, not the masses. Hine portrayed dignity in his subjects, despite their horrid living and working conditions in mills and mines and sweatshops. Connecting people intimately with their work, especially that accomplished by their hands, Hine created portraits that bespoke his appreciation for individual laborers. Ulmann's photography in Appalachia and the Deep South in the 1920s and 1930s mirrored Hine's imagery in its emphasis on the individual life, the character of manual labor, and the maintenance of human dignity.

But long before she created the photographs that made her famous, Ulmann spent several years studying. Columbia University proved to be a significant influence in Ulmann's young adulthood. Here she pursued the two subjects that would direct her life's work, psychology and photography; here also she met Dr.

Charles Jaeger, the man she eventually married. Ulmann's attraction to psychology, a relatively new social science, led her to pursue a teaching career at Teachers College, Columbia University. She joined hundreds of single young women who filled the social science departments at major universities in the early twentieth century. Their interests in philosophy and pedagogy, particularly educational psychology, caused them to seek vocational avenues where their scholarship could be directly applied. Many of these women became teachers or ran urban settlement houses or rural settlement schools, carving out socially acceptable careers for themselves as independent women working alone or in single-sex groups.⁴ Although Ulmann never pursued those vocations, she later became closely acquainted with a number of women who did.

While a student at Columbia, Ulmann also took courses in law, but she developed such a distaste for the field that she abandoned it after one term. She felt that "a welter of legal technicalities" smothered the human element. In 1914 Ulmann began serious study of photography at Teachers College with the acclaimed instructor Clarence H. White. She had already taken a few classes with White soon after he arrived in New York City, but her true dedication to the art form began in 1914. She joined a legion of students under White's mentorship, many of them women who later enjoyed high-profile careers as professional photographers, including Margaret Bourke-White, Dorothea Lange, and Laura Gilpin.⁵ Ulmann, known as one of White's "most devoted pupils," later taught at the master's photography school. Given the time and energy she put into developing her art, it seems unusual that Ulmann claimed to have taken up photography as "an excuse for doing something with her hands when her mind was tired." But she was known to suffer from any number of simultaneous physical ailments, including stomach ulcers (which she had developed as a child), arthritic pain, and a general nervousness that led her to seek solace in activities that would calm her. Her physical weaknesses combined with society's expectations of a woman reared in the nineteenth-century bourgeois tradition kept Ulmann from venturing out too far away from her Manhattan home with her camera. But these limitations would soon be eased by the companions she cultivated. In 1915 Ulmann's professional interests and personal interests intersected. She married orthopedic surgeon Charles

Jaeger, who was a friend and physician of Clarence White, an instructor of orthopedic surgery at Columbia University, and himself a photography buff.[6]

Because of their shared interest in photography, husband and wife often traveled to picturesque settings—coastal villages in Maine, Massachusetts, and the Carolinas—with hopes of finding appropriate subject matter for their respective visual studies. The two soon became active leaders in the Pictorial Photographers of America, a group that continued a forty-year-old tradition of creating naturalist-inspired scenes altered by manipulations in the darkroom. At the turn of the century, pictorialism had been supported by gallery owner and photographer Alfred Stieglitz, who served as the inspiration for a number of artists and artistic movements. One of those movements was a branch of pictorialism called Photo-Secession, whose practitioners, such as Clarence H. White, sought to create symbolic art. Stieglitz believed photography should be considered an art and nothing more, an end in itself, certainly not an extension of the muckraking journalists' stories designed to arouse social change. So at the same time Lewis Hine shaped his style employing the camera for reform purposes, Stieglitz had initiated a movement in New York that sought to keep the camera from becoming such an instrument.[7] These were the preeminent standards and approaches in American photography at the time Ulmann was developing her own camera eye.

These two powerful forces in photography—the reform impulse of Lewis Hine and the artistic-pictorialist focus of Alfred Stieglitz and Clarence H. White—are clearly traceable in Ulmann's aesthetic sense. She did not claim to have copied any particular photographic style, but the dominant philosophies of the era are revealed in the thousands of images that make up the Ulmann oeuvre. Reflecting the standards set by Hine's work, Ulmann focused on the unknown individual whom society judged more often by ethnic, religious, or economic affiliations than by personal merits. In a 1917 study she initially titled *The Back Stairs* but later recast as *The Orphan* (fig. 1), Ulmann captured a small, dark-haired child amid the symbols of urban poverty. The child plays barefooted among broken stones, discarded wood pieces, and other debris. Additional messages about the child's existence may be detected in the rickety rail accompanying the stairs to her home

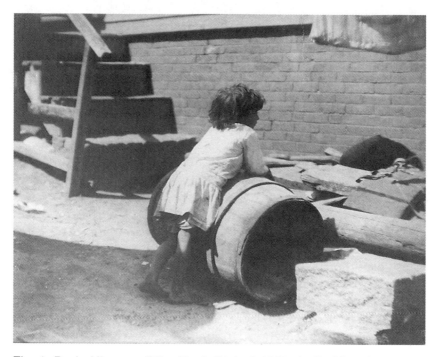

Fig. 1. Doris Ulmann. *"The Back Stairs." 1917.* Audio-Visual Archives, Special Collections and Archives, University of Kentucky Libraries.

and the empty barrel she leans on. Despite the instability and emptiness characteristic of the child's environment, Ulmann portrays her as an angelic figure—a tender face in profile, her tiny body robed in white play clothes made brighter by the natural light. A certain universality in the child's forlorn look, much like a paper-cut silhouette, ensures her status as an innocent in the midst of social disarray.

Like Hine, Ulmann eschewed evaluation according to the group standard, although she did find individuals in certain groups more fascinating to photograph than those in others. Among the groups she studied early in her career were physicians at Columbia University and writers in New York City; she later expanded her examination of groups to include fishermen in Massachusetts, Dunkards in Pennsylvania, Shakers in New York, mountaineers in Appalachia, Gullah African Americans in South Carolina, and

Creoles in New Orleans. Seeking out particular "types" that could be categorized, Ulmann proceeded to isolate particular individuals within a community who possessed intriguing physical characteristics or who worked at unusual occupations. That was a practice not uncommon in the early twentieth century; Lewis Hine had selected extraordinary persons from bands of workers and ethnic groups to propel his arguments about the need for labor reform.[8]

From the Stieglitz association's artistic philosophy, a viewpoint seemingly adversarial to that of Hine, Ulmann co-opted ideas she could assimilate into her own aesthetic. The sensorial appeals achieved by the early pictorialists' romantic imagery also pervaded Ulmann's photographs. The relationship between soft backgrounds and sharply defined foreground foci allowed for a play of textures that remained the single most continuous thread in Ulmann's images throughout her years as a professional photographer. She began her photographic studies with the requisite nature scenes that pictorialists often sought. In one 1917 experiment with light and shadows, Ulmann focused on a barren tree without leaves, its branches and its spindly, dark shadow set against a white building. Other similar treatments of trees, architectural structures, clouded skies, and snowy landscapes are representative of Ulmann's early pictorialist-inspired vision.[9] In one composition (fig. 2), gradations of light combined with myriad textures to form the sensory depths of the photograph, from the softly focused leaves in the lower left section of the frame to the harder lines of the main vine. Geometric patterns are emphasized as the vertical plane is determined by the strongest vine trunk, which divides the frame. The smaller arm cuts across the horizontal plane of the photograph, and the planks on the wooden structure provide subtle reminders that balance has been achieved in these perpendicular relations. Ulmann continued throughout her career to seek the play of light and dark and shades of gray in similar natural settings and in her portraiture. A photograph taken in the late teens or early twenties and entered in a local exhibition was a picturesque landscape she entitled "III Clouds over the Mountain." Her choice of subject matter and textual characteristics reflect the influence of Stieglitz's approach. Clouds were a subject that Stieglitz had obsessively embraced during World War I.[10] To further emphasize

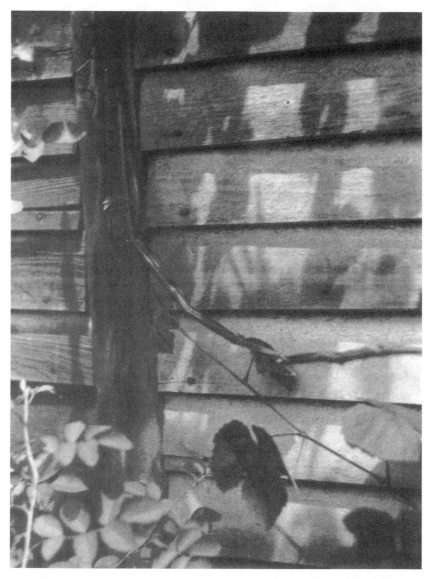

Fig. 2. Doris Ulmann. *Scene at Georgetown Island, Maine, ca. 1918-19.* Photography Collections, J. Paul Getty Museum, Los Angeles, California.

her attachment to this particular artistic philosophy and style, Ulmann joined no other photography collectives but the local pictorialist group and the Pittsburgh Salon of Photography. She generally avoided camera clubs, unions, and similar groups, even though she lived in a city that boasted the most exciting photography community in the nation and, perhaps, the world.

As a student and friend of Clarence White's, Ulmann drew ideas from the Photo-Secession movement, which suggested that one had to assume the mantle of "artist" in order to create art with a camera. Ulmann inculcated this idea, believing herself an artist and thus carrying out many of the same processes a person working with canvas and brush had to master. Nowhere was this more evident than in her oil pigment printing, a method requiring careful brush strokes of lithographic ink on water-soaked prints. Since no two oil pigment prints were exactly alike, they were more like paintings than most photographic prints produced in the 1920s. Although David Featherstone has suggested that Ulmann accumulated "raw sociological data," her finished prints reveal an artistry that transcends mere collection of evidence. She employed light to its fullest effect, sought figured shadows, and focused on patterns, objects, hands, and faces. But these constituted only a portion of her work. The painstaking printing processes Ulmann performed required as much time and manipulation as her choice and recording of subjects. It is this conscious creation and re-creation of her subject matter in the darkroom that keeps her work from constituting simply a mass of empirical data on which historians or other observers can hang hypotheses about particular subcultures in the United States. Those seeking to use her photographs as clear windows through which to view American culture must consider Ulmann's self-professed biases and her conscious deliberation over positioning subjects and using props. From her earliest work in the portrait studio, she sought complete control over her attempts to "express an individual."[11]

In 1919 Ulmann published her initial work as a professional photographer, a handsome portfolio entitled *Twenty-Four Portraits of the Faculty of Physicians and Surgeons of Columbia University*. As Mrs. Charles Jaeger, she had gained entrance into the prestigious circle of physicians to which her husband belonged. In

the years immediately following, she developed a reputation as an outstanding portraitist. In 1922 her second major collection, *A Book of Portraits of the Medical Faculty of Johns Hopkins University,* was published in Baltimore. A marked difference in the publication information recorded in these two collections suggests Ulmann's direction on a path independent of her husband. The author listing she chose for the 1919 Columbia University collection was "Mrs. Doris U. Jaeger," the signature she had most commonly used on her early prints. By 1922 she had begun to use her family name, Ulmann, on her published work and on her exhibition prints. The exhibition entry entitled "III Clouds over the Mountain" reveals her new professional name, along with her impressive studio address—Doris Ulmann, 1000 Park Avenue, New York City. To sever her past ties with Jaeger, Ulmann returned to some of her early prints and erased the original signature that bore his name, replacing it with the name she had reclaimed.[12] Even though they had studied photography together and had been prime motivators behind the local Pictorial Photographers of America chapter, Ulmann sought to strike out on her own. Her act of wiping out her husband's name implies her dedication to a life and profession not only separate from his but also not tainted by her previous relationship to him. However, her title remained vague. She rarely used one on letters, notes, or prints, but her principal traveling companion in later life, John Jacob Niles, referred to her as "Miss Doris Ulmann." Ulmann's brother-in-law, Henry Necarsulmer, insisted after her death that although she had divorced her husband and resumed her family name, she had been married and thus "was known as *Mrs.* Doris Ulmann." Even in the early 1930s, a divorced woman traveling hundreds of miles in rural America with a male companion, especially one of whom her family did not approve, was inconsistent with the demands of upper-class New York social circles.[13] In Ulmann we see a complex woman whose quiet demeanor and upper-crust sophistication were matched by a need to exert personal control over her present, her past, and even her legacy.

The two published books of physicians' portraits provide the necessary clues to understanding Ulmann's use of her skills as a photographer and her need to control her work. With these collections Ulmann exhibited a strong desire to assume and complete

whole projects, comprehensive surveys focused on particular ends. These projects set the stage for future work by giving her a taste of the kind of material she would find most satisfying throughout her career as a professional photographer—theme-centered studies, built on extensive series of images rather than on a single mesmerizing frame. Outside the portrait studio, Ulmann's meticulous examinations of groups and communities helped her shape her niche in photography. One of her more thorough early examinations of a particular place and people—the fishing village of Gloucester, Massachusetts—included scenes of boats, pier buildings, equipment for the trade, and the characters who made their living on the sea.[14]

As a result of Ulmann's drive to embrace complete projects, she carried out each step of the photographic process herself. She handled the glass plates, mixed the chemicals, developed the negatives, made the prints, and mounted the finished photographs. And she preferred to keep her creative secrets to herself, allowing no one to assist or interrupt the magical process that unfolded in her darkroom, a converted bathroom. Only years later, after her health seriously deteriorated, did she allow anyone to help her in the darkroom. She even refused to allow other eyes to view her proofs, explaining, "I see my finished print in the proof . . . but I cannot expect others to see anything beyond what the proof presents. I avoid retouching, but prints always require spotting before they are ready. I believe that I become better acquainted with my sitter while working at the pictures, because the various steps provide ample time for the most minute inspection and contemplation." The relationships Ulmann forged with her subjects through "the pictures" point to a theme in her otherwise solitary existence as a portrait photographer. The camera aided Ulmann with her shyness. She got to know those with whom she was most intrigued by studying them thoroughly through the lens. For one portrait sitting of a single individual, Ulmann would expose a tremendous number of glass plates. She recognized the complexity of human existence and felt that too few shots would simplify and ultimately distort a life. She believed one photograph could not define a person and so offered her sitters "twenty or thirty finished prints instead of the scant dozen or so proofs submitted by the craftiest of commercial photographers."[15] In the process Ulmann gained a deeper

understanding of people she admired by looking at two-dimensional renderings on glass plate negatives, not unlike the nineteenth-century phrenologists who determined character traits by measuring physical attributes prominent in visual depictions of famous politicians and military leaders. Systematic examination of Ulmann's photography reveals that she embraced several long-term projects that would allow her to revel in her infatuation with particular individuals.

A fascination with the literary mind turned Ulmann's attention to writers, editors, and poets in the 1920s; it was an attraction that she fostered throughout her life, never turning completely away from the wordsmiths who so impressed her. She once told an interviewer, "The faces of the men and women in the street are probably just as interesting as literary faces, but my particular human angle leads me to the men and women who write." Her desire to capture penetrating and revealing images of literary figures points to her own love of literature and the word culture in which she had grown up. She reveled in language, read the German classics aloud, and, according to John Jacob Niles, spoke "flawless" English. From Ulmann's childhood to her young adult days, the American population's reliance upon words, not only for information but also for entertainment, had gradually waned. Visual images grew to dominate the messages promoted and delivered by both the public and the private sectors. During the Great War, posters urging support for the cause and "100% Americanism" employed compelling signs and symbols; and by the 1920s, advertising had reached a new height in its sophisticated use of pictures and graphic designs to convince consumers that buying the right products would ensure an easier or more enjoyable lifestyle. Ulmann's exposure to new educational trends and to advances in technology, including those in photography, helped her realize that the written culture was undergoing a radical transformation in the twentieth century. An avid reader, she attempted to sustain and illuminate the world of the literati by opening her apartment doors to a host of exciting American authors. In the same year that the First World War ended, she began taking professional photographic portraits, thus launching her career at a particularly crucial time for the arts and literature, so significant that it led the writer Gertrude Stein to note, "After the war we

had the twentieth century." Meanwhile, Ulmann's reputation as a professional photographer grew with each passing year as she photographed many prominent writers, including H.L. Mencken, Dorothy Parker, Edna St. Vincent Millay, Carl Van Doren, Charlotte Perkins Gilman, James Weldon Johnson, Ellen Glasgow, and William Butler Yeats. Among these portraits were publishable images that prospective readers later saw on book jackets, in magazines, even in the Literary Guild of America's book club advertisements. Ulmann apparently tolerated and even enjoyed listening to a variety of opinions, given her selection of sitters who were decidedly modern and often confrontational voices of the 1920s.[16]

Ulmann developed a rudimentary understanding of her subjects, carefully observing mannerisms and gestures, long before she stood behind the tripod to study their faces. Dale Warren, himself an Ulmann subject, described the photographer's handling of a portrait session. She would serve cocktails and sweets and cigarettes, not solely for her subjects' enjoyment but to "draw [them] out." Warren intimated, "She studies your hands as you pass her a plate of cakes, observes which leg you cross over the other, notices the expression of your eyes, tells you a funny story to make you laugh, and another not so funny to see if you are easily reduced to tears." Ulmann even engaged her sitters in conversations that required them to articulate and defend their opinions. Brief responses were unacceptable to her, noted Warren.[17] After isolating certain peculiarities in each individual, Ulmann built on these in her portraits. There was no one chair or single backdrop or unique angle she preferred. Faces mattered most, with hands nearly as important. The authors Ulmann photographed could choose from a limited collection of props she kept in her Upper East Side apartment-studio. A fountain pen, pads of writing paper, or various sizes and types of books satisfied most of them. But exceptions kept Ulmann and her household staff busy— Robert Frost, who never worked at a table, requested a wooden writing board; and E.V. Lucas, the prolific British essayist, demanded an inkwell instead of the fountain pen that his portraitist offered.

Patient, gracious, and soft-spoken, Ulmann accommodated her subjects to a certain degree, hoping to create "bonds of sym-

pathy" with them. She claimed to have allowed a few individuals to direct the day's events if they wished, but her desire to manage the portrait process is revealed in her fond recollection of a session at Sherwood Anderson's Virginia home: "I arrived at ten o'clock in the morning and did not leave until after midnight. Certainly no photographer could ask for a more interesting subject than Mr. Anderson, nor could anyone have put himself more completely in my power. He even led me to his clothes closet and asked me to look over his suits and choose the one I wanted him to wear."[18]

Ulmann preferred to direct a portrait sitting to this extent. And into the 1920s, as she grew increasingly confident in her abilities as an artist, she wielded greater control over her subjects. Her dominant hand in the positioning of heads and upper torsos is present throughout the bulk of her portraiture. Because she abhorred artificial light, with few exceptions her arrangements are determined by the available light from open windows or doors. Allowing sunlight to shine on her authors' faces, Ulmann disclosed her own reverence for those who were masters of language, moving their readers to anger or compassion or laughter. Sherwood Anderson, who bemoaned the barren nature of a society driven by industrialization, idealized rural life as simple and carefree, and therefore rich. Ulmann came to express similar ideas in her field photography in the early 1930s. The portraits she composed of Anderson show him sitting comfortably in front of a stone wall. One (reprinted on the cover of a 1958 journal issue featuring her photography) reveals a slightly rumpled Anderson. With his tie askew, a full inch off his starched shirt's placket, and his jacket gaping open over his crossed legs, he rests his right arm over the back of a straight chair. Anderson's demeanor is marked by carefully set lips and a furrowed brow, the latter probably due to the direct sunlight in which Ulmann positioned him. But his tanned skin reveals that his face has known days of sunlight, as much as any face of an ordinary Virginia farmer. Disheveled, Anderson's look suggests that he rarely dons a suit and tie and might prefer to be sitting instead in work clothes. At the very least, his outer trappings cannot shake his informality, sitting as he does slung back into the chair. Ulmann's positioning of Anderson makes him appear unassuming and nonthreatening, someone to be trusted,

believed. By the end of the day, Ulmann had so thoroughly sur-
veyed Anderson that he said, "I feel as if you are taking a part of
me away with you."[19]

Ulmann's keen powers of observation and her hours spent
with her sitters' portraits helped her to understand her subjects
better, but in many cases she had read an author's works before
the portrait appointment and so had made her initial acquaintance
from the printed page. Never requesting money for her work,
Ulmann sought compensation, if at all, in other ways. She pre-
ferred to receive a copy of a writer's latest book or a dedication
inside her own personal edition. Her gracious letters to her sitters
show that such rewards greatly satisfied her. To South Carolina
writer and artist John Bennett, Ulmann expressed thanks for the
"precious book" he sent to her; the "beautiful page" he illustrated
and inscribed was "so delightfully done and so in harmony with
the whole book." No bills or order forms or contract agreements
accompanied an Ulmann portrait session. Independently wealthy,
she never worried about money. She considered herself an artist,
not a commissioned employee, and so refused to assume the role
of court painter who made every subject appear beautiful or bril-
liant. She preferred that a subject's portraits "be worthy" of him
or her, as she told John Bennett.[20]

People who came to Ulmann to be photographed frequently
did so at her request, rather than their own. Her friend Olive Dame
Campbell noted that Ulmann "rarely took a photograph unless
interested in the sitter." She created images of writers so that she
might forge relationships with those whom she admired; she of-
ten asked them to sign their portraits for her, next to her own
signature, in essence sealing the relationship between herself and
another artist and making it a matter of both personal satisfac-
tion and public record.[21] One such image Ulmann created of Eliza-
beth Madox Roberts, a Kentucky poet and novelist whose stories
described customs and traditions of the Kentucky mountain people.
In Ulmann's most stunning portrait of Roberts (fig. 3), she high-
lighted the author's hands. Set against a darkly draped background
and a dark, nondescript dress, Roberts's left hand emerges at the
end of her long arm to set the horizontal plane and thus the com-
positional stability of the photograph. Ulmann achieved the per-
pendicular balance by highlighting Roberts's graceful right hand.

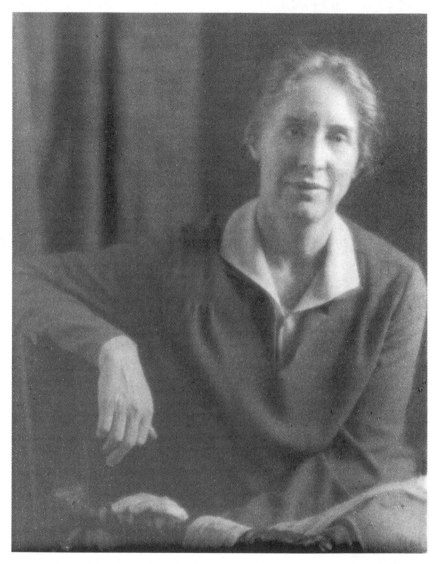

Fig. 3. Doris Ulmann. *Elizabeth Madox Roberts. 1928.* Audio-Visual Archives, Special Collections and Archives, University of Kentucky Libraries.

The long, slender fingers create the image's vertical line and, because they are slightly bent, hint at gentleness. Although she had done so with other writers, Ulmann chose not to put a pen or a book or manuscript pages in Roberts's hands, instead making the right hand itself the prominent feature in the portrait. Secondary in importance is the author's face, half-obscured by shadow on one side and adorned with a contemplative, yet comfortable expression. Ulmann relished studying masters of words like Roberts, those who were simultaneously reflecting and molding the American cultural landscape. And perhaps on a more personal level, Ulmann could appreciate the author's observations on romance. In Roberts's best-known work, *My Heart and My Flesh* (1927), a young woman attempts to find happiness in several different love affairs. Given her own discontent with her personal life and intimate liaisons in the early 1930s, Ulmann may easily have identified with the protagonist, appreciating Roberts's skills on an even deeper level than a mere literary observer would have.[22]

Perhaps nowhere is Ulmann's concern about the influence of writers more evident than in her 1925 publication *A Portrait Gallery of American Editors*. The proliferation of new magazines in the 1920s meant increased circulation of a variety of editorial opinions. Though an admirer, Ulmann also remained skeptical about some editors and the periodicals they produced. She prefaced her portrait collection with a sharp yet diplomatic statement about journals and those who controlled them, contending, "Magazines are so great a part of our daily life that almost unbeknown to us they mould our opinions and colour our views on most of the great problems of the day. Insidiously they have become a part of us and often times the views we hold as our own have in truth been formed by the editors of our favorite magazines. It is but natural that we should care to know what manner of men are these, who have thus formulated our ideas, coloured our thoughts and directed our perception of humour."[23] She does not discuss the public's curiosity, or her own for that matter, to see merely what famous people look like. She drives at something deeper by pinpointing a desire to know "what manner of men are these." In this collection of forty-three images, Ulmann showed that her interests in psychology and portraiture were inextricably bound. Given her confidence that she could, as she told Dale Warren, "draw

[individuals] out," Ulmann trusted that her psychological stud-
ies—the portraits—would reveal the layered complexities that made
up each individual's personality and enable the American public
to examine more closely the sources of their thinking. She warned
viewers against being fooled by other visual images: "Personality
and character are often so illusive, so intangible that they defy
and escape the most seductive efforts of reproduction and instead
of rendering a living likeness, little more than an anatomical copy
is made." Ulmann intended for her portraits of these selected men
and women to exceed such limited dimensions, by providing in-
sight and lending definition to their influential lives. In her book,
each editor's portrait carried alongside it an essay written by the
editor, describing the nature of his or her work, but these were
ancillary to the real purpose of the volume, an effort "to portray
[the editor's] personality and something of their character by means
of photographic portraits."[24]

Among those featured in *A Portrait Gallery* were Ellery
Sedgwick of the *Atlantic Monthly,* Carl Van Doren of the *Cen-
tury,* and Lawrence F. Abbott from the *Outlook.* Ulmann used
four general poses for the collection. The most common one had
the subject seated in a chair, holding an object in his or her hands,
most often a cigarette, a book, or a sheaf of papers; a second pose
or position had the subject seated behind a desk table and either
attending to business or looking up from work. Twenty-seven of
the forty-three portraits feature these positions, with attention given
to the hands as well as the head of the editor. Richard Walsh, editor
of *Collier's,* is viewed from his upper right side, so that the cam-
era eye captures not only his face and upper torso, but also the
page surface where he has previously directed his attention. The
paper in his hand shows several lines of text that have been vig-
orously marked out by a well-sharpened pencil. The dark and light
contrasts, charcoal scratches against white paper, provide Ulmann
the aesthetic qualities she sought but also the story she wished to
tell about Walsh's professional tasks. Her emphasis is on the as-
pect of manual labor required for this editor to fulfill his respon-
sibilities. As in most of her survey projects on specific subjects,
Ulmann connected individuals with the objects they touched and
the work they accomplished with their hands. Whether a doctor
with test tubes, a farmer with a scythe, a quilter with a T-square,

or an artist with brushes, the subjects' hands play a prominent role in determining the quality of their work and thus in defining them.[25]

In the same year that *A Portrait Gallery of American Editors* appeared, Ulmann's career took an evolutionary turn. The change coincided with two events in her personal life—the legal dissolution of her decade-long marriage to Charles Jaeger and the sudden death of her mentor, Clarence White. The shift in Ulmann's photographic vision led her on a search that would require her to approach the men and women she most wished to photograph rather than summoning them to her Park Avenue studio, as she had become accustomed to doing. Ironically, this experimental phase with new subject matter that required greater travel manifested itself about the time Ulmann suffered a fall that temporarily immobilized her. The injury, a shattered knee cap, left Ulmann dependent upon a cane from 1926 on and, according to one friend, "colored the remainder of her life." As a result, she employed traveling companions and servants to escort her and help her move camera equipment from one shooting location to another.[26] In spite of her losses, but more likely because of these significant changes in her personal life, Ulmann's career entered a new phase in the second half of the decade. The confining walls of the studio, treks to the New England coast to find picturesque landscapes, and strolls around Columbia University's campus gave way to the wide open spaces of the Carolina lowlands, hikes to southern Appalachian homesteads to find mountain handicrafts, and walks around the grounds of Berea College, the John C. Campbell Folk School, and several rural settlement schools.

This second stage in Ulmann's photography career, marked by her physical impairment and by the absence of her mentor, allowed room for new mentors and companions to enter Ulmann's life. In cultivating close personal relationships with four of them, in particular, Ulmann merged her private life and personal needs with her professional goals. She met John Jacob Niles, a singer-actor who exchanged his self-proclaimed expertise as a "Kentucky backwoods-man" for Ulmann's financial support of his fledgling musical career. Ulmann also met Julia Peterkin, a Pulitzer Prize–winning author who lived in Fort Motte, South Carolina; Lyle Saxon, a Louisiana writer of romantic southern tales; and Olive

Dame Campbell, a New Englander who spent most of her life running a folk school in Brasstown, North Carolina. Each new acquaintance helped Ulmann circulate through a specific American culture where she was able to gaze upon "the folk" there. Niles, who had collected ballads of mountaineers in the eastern parts of Kentucky and Tennessee, accompanied Ulmann on several Appalachian trips. Julia Peterkin invited Ulmann to her family's own Lang Syne Plantation for extended periods, guiding her through the African American Gullah village where workers were only sixty-five years out of slavery. Lyle Saxon hosted her at a northern Louisiana plantation named Melrose and also in New Orleans, where Ulmann took her cameras into the religious communities, the cemeteries, and among vendors in the lively Vieux Carre. Olive Dame Campbell, in western North Carolina, acquainted Ulmann with an educational method directed toward building "an enlivened, enlightened rural population."[27]

Using these contacts, Ulmann pushed her work in new directions. Had she never created more than her architectural studies, pictorial landscapes, and portraits of famous people, she still would have secured a place for herself in the annals of fine photography.[28] But she developed her photographic eye further, carving a unique niche that bridged pictorialism and documentary. She combined what was considered an old-fashioned tonalistic photographic style in the late 1920s with a documentarian's sense of reform. She arranged scenes and people and objects in rural America in order to show them to audiences with urban sensibilities, not just people who lived in cities but transplanted reformers who wished to celebrate and manipulate agrarian traditions and symbols. Her photographs took their place on the walls of rural schools and country hotels in equal measure to the space and influence they wielded in New York City galleries and at the White House. And as the objects of her camera eye slowly changed, Ulmann ultimately came to realize what photography could achieve. In 1930 she told Allen Eaton, with whom she later collaborated on a book, "I am of course glad to have people interested in my pictures as examples of the art of photography, but my great wish is that these human records shall serve some social purpose."[29] Ulmann's articulation of this desire places her alongside other "documentary"

photographers who used their pictures in the 1930s to evoke social change.[30]

Since the term *documentary,* amorphous at best, is understood differently by its various interpreters, the task of labeling Ulmann's work remains difficult. One biographer maintains that her "need to complete a group of pictures for a specific purpose . . . suggests the documentary intent of her work." This "need" applies to a significant portion of Ulmann's photography, even the portraits of physicians made between 1918 and 1922 that she claimed to have published as a favor to her husband's colleagues. Yet those portraits have not been employed by photography scholars as examples of documentary. Beyond Ulmann's thematic approach to her subjects is her style, described by Jonathan Williams as "earthy, yet savory." Williams places Ulmann in the "great realist tradition," likening her photography to that of Julia Margaret Cameron, Alvin Langdon Coburn, and Eugène Atget. The wide range of her subject matter certainly justifies placing her alongside these three. But when considered a distinct genre, documentary photography frequently hosts subjects that are considered ordinary, common, often anonymous. William Stott has identified documentary's subjects as "individuals belonging to a group generally of low economic and social standing in the society (lower than the audience for whom the report is made)." And James Guimond, in *American Photography and the American Dream,* notes that the great documentarians of the twentieth century focused upon "'ordinary' people, like black students, child workers, sharecroppers, office clerks, and factory workers, rather than the famous people in history books, on the front pages of newspapers and the covers of magazines."[31]

Indeed, Ulmann provided a vast body of scenes and faces never before captured on film. Her subjects, especially those tucked away in remote valleys far from modern conveniences and mass culture, seemed appropriate ones to document. But to define documentary photography solely on the basis of who shows up in the pictures confines its purpose. Documentary, like all discourses, comprises message-laden records. The records require scrutiny, but so does the record-maker. What exists within the four corners of a photographic print is a combination of personal cultural background, technical or artistic training (or both), and expectations

of one's subjects. These factors produce a photograph as much as do compositional arrangement, the sophistication of mechanical equipment, and the subjects themselves. All contributed to the camera "eye" that Ulmann had developed and was fine-tuning in her last decade as a photographer. Together, these characteristics made her a documentarian.

In the mid-1920s, her observations of several religious communities, including Dunkards, Mennonites, and Shakers, prepared her to enter similarly small, distinctive enclaves in the American South, where she chose to invest her principal energies in the late 1920s and the 1930s. Although Ulmann never ceased making portraits of important writers in New York, her attention grew increasingly more focused on groups in rural America. The philosophical link among these groups was that each represented a category of people that she believed would eventually disappear. Louis Evan Shipman pointed out in his introduction to Ulmann's 1925 portfolio of American editors that Ulmann had "collected a distinguished and tragic group—of a fast-disappearing species. Tragic, because they are the last of a line of notable progenitors, who vitalized and adorned a notable profession." This statement could have applied to any of the groups on which Ulmann focused her cameras after 1925—the utopian religious communities whose numbers were dwindling, the Kentucky mountaineers whose land and population suffered under the weight of large mining companies, or the craftspeople who strived to preserve the skills of their ancestors while corporate production lines turned out chairs, brooms, baskets, quilts, and other items by the thousands each year. With her camera Ulmann found what she wanted to find among these people—idealized worlds that she and others had imagined; worlds created in order to challenge the pace of change in America that was rapidly homogenizing its citizens with radio, movies, and mass production.[32]

One of Ulmann's direct challenges to fast-paced technological change in the twenties was her refusal to embrace it in her own work. Despite the ease newer photographic technology could have contributed on her sojourns into southern Appalachia, Ulmann remained devoted to her old equipment. She could personally afford any kind of new camera or accessory, but she most frequently used a 6½ × 8½ inch whole-plate camera positioned on a tripod. Even

in her travels on foot across creek beds and to out-of-the-way home-steads, Ulmann took along the bulky camera, the tripod, a lens box, and scores of glass plate negatives. Since she hated artificial light and never used a flash, she "always carried some white sheets along . . . for reflecting," remembered Allen Eaton. She did not use a shutter or a meter but made a practice of sliding the lens cap off in order to admit light. She once declared, "I am the light-meter." Because composing a single photograph required signifi-cant mechanical preparation, Ulmann took no action shots or candid photographs. John Jacob Niles noted that "moving objects were never effective as subjects for her photography."[33]

Nor did Ulmann wish to freeze a moment of action. She much preferred to capture facial expressions or a pair of hands, some-one sitting quietly rather than in motion. In most of Ulmann's portraits, time itself is arrested. Not captured, but arrested. She allows very few clues about the era to enter into the frame, so that the photograph possesses a timeless quality. The latest gad-getry, current fashion, or other marks that would situate the pho-tograph chronologically are absent. In figure 4, a typical Ulmann portrait of rural America, the absence of motion is achieved by the stillness of the figure, who, sitting bent over in a straight-backed chair, has folded her hands carefully over her rough, thread-bare apron. No prominent prop or clue situates the image in the twen-tieth century. Rather, worn wooden planks on the cabin porch reveal the dwelling's age and contribute to the premodern spirit of the scene. Given its place in the photographer's light, the featured subject of this photograph is the spinning wheel. The pristine rope of thread balanced on the end of the wheel glistens, the spokes shine, and the rest of the object stands in sharp focus while the woman, herself a timeless character, provides a softly focused contrast to the principal icon. Together the human subject and the inanimate object create an atmosphere that transcends time.[34]

When Ulmann's method is examined, her perception of time takes yet another fascinating shape. Ulmann believed a better, truer image would emerge from a technical process that required min-utes, even hours, than from one that took only seconds. She never worried that the sharpness of one moment would escape her. In her opinion the photographers who made quick pictures distorted reality by failing to study their subjects thoroughly and from many

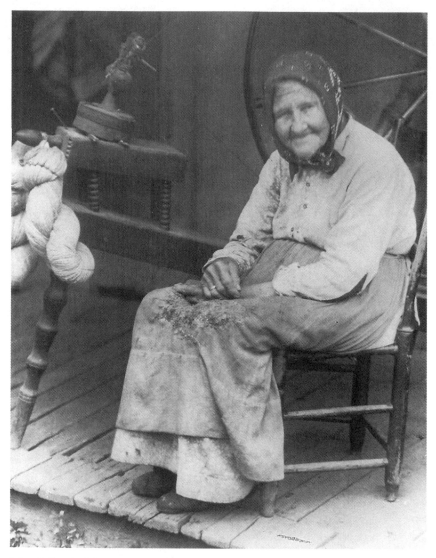

Fig. 4. Doris Ulmann. *Nancy Greer. Trade, Tennessee, ca. 1933-34.* Audio-Visual Archives, Special Collections and Archives, University of Kentucky Libraries.

angles. Ulmann even rejected the newer camera models designed for professional photographers, such as the Rolleiflex, the Leica, and the Speed Graphic. Niles recalled, "There was no hurry-up, no snapshot business. Snapshot photography was the end of vulgarities so far as she was concerned. When I demanded a Roliflex [sic] and got it and everything that went with it, Doris immediately looked upon me as a complete faker." Ulmann was less interested in grabbing a piece of time than in grasping the essence of human character. And she believed it could be accomplished through a collection of images of the same subject over time, as her many proof prints of single individuals demonstrate. Although her choice of photographic subjects changed, from the urban intellectual set to a rural, semiliterate class, her artistic philosophy remained the same. In her opinion a single picture could not adequately portray a person, regardless of his or her background, appearance, or socioeconomic status. She observed a Kentucky knife maker as intensely as she had studied a famous fiction writer or a stage actor.[35] This is evident from the number of shots she composed of each subject; the proof books of her Appalachian work contain not lone portraits, but serial studies. Ulmann often took several exposures of closely similar poses. In one series an unidentified man uncomfortably holds a Bible stamped "Placed in this motel by the Gideons." The fellow's tense facial expression changes just slightly from portrait proof to portrait proof. Perhaps he was an unwilling subject or the prop seemed alien to him or he became too warm to sit patiently in the summer sun. Whatever the reason, it is the *series* that reveals his prolonged discomfort. One frame could have been an aberration, capturing a momentary letdown of defenses; four portraits in sequence reveal to the viewer the subject's awkwardness before the camera. The sitting may have required fifteen minutes or two hours, depending upon the changes in natural light and how swiftly Ulmann removed the exposed plate, covered it, and inserted a new one into her camera. The session's duration, perhaps too long for the sitter, abolished any hope for spontaneity. Through this complex and extended process, then, we see that Ulmann's intentions went beyond reproducing the semblance of one moment's reality. Her old equipment and her methodology prohibited it. And she did not apologize for either.[36]

In 1930 Ulmann stated with conviction, "I have been more deeply moved by some of my mountaineers than by any literary person, distinguished as he may be." The photographer's reference to "my" mountaineers implies her ownership of them, yet her photographs do not project an air of condescension. Rather, the subjects and their surroundings are glorified, cast in what Jonathan Williams described as a "wistful tone of reverie." That Ulmann did not consider her relationship with her subjects reciprocal is obvious; but her tone of possessiveness more likely suggests her personal pride at having mined out some valuable raw material that would engage artistic and literary circles in the late 1920s. Ulmann, with Niles's help, had surveyed small pockets of people who remained untouched by the forces of industrialization and mechanization. Or so her photographs would suggest. Even though she traversed rich coal mining territory in Kentucky, she deliberately avoided it and other similar topics that would reveal the encroachment of corporate America and materialism upon otherwise unique areas. The messages Ulmann recorded on glass plates were nostalgia-laden reminders of an older, simpler America. As a native New Yorker and an urban dweller, Ulmann had witnessed the growth of the city and the vice and deterioration that accompanied industrial progress there. Her training at the Ethical Culture School had only heightened her awareness of these issues.[37]

Her expanding interest in rural America in the late 1920s situated Ulmann in an intellectual context peopled by men and women striving to highlight the virtues of technologically unfettered enclaves. Among the strongest proponents of these virtues were the Agrarians, a group of southern poets, historians, and literary critics committed to what they viewed as the superior side of the dichotomy "Agrarian *versus* Industrial." They laid out their arguments in a collection of essays entitled *I'll Take My Stand* (1930), a provocative book that created tremendous controversy, inviting a wave of criticism in the early Depression years. Seen by some commentators as "utopians" and "nostalgic eccentrics," the Agrarians clung to "the supremacy of tradition, provincialism, and a life close to the soil." Like the Agrarians' impassioned sentiments, Ulmann's photographs fed the imaginations of viewers who, in just a few years, had found much to revere in the hills of the southern highlands. Her images served as an antidote to the wild-

eyed fanatics caricatured in H.L. Mencken's newspaper reports of
the 1925 Dayton, Tennessee, Scopes "Monkey Trial." Ulmann's
images of mountaineers were described by one critic as "strong
reminders of the richness and depth and variety of dramatic trea-
sure to be found in the mountains and valleys of country districts."[38]

The mountain "types" Ulmann produced also fed the nativists'
imaginations in twenties America, although she did not align herself
with the nativist movement, nor did she intend for her photographs
to serve that purpose. Her enlightened upbringing in the Ulmann
household and her training at Ethical Culture would have made
that an unpalatable option. Throughout her youth, hundreds of
thousands of immigrants had wandered through Ellis Island, the
large majority packing themselves into New York City tenements.
As a child of financially successful immigrants, Ulmann stood apart
from many who could not find a place for themselves and their
families in the crowded city or who were taken advantage of in
the urban, industrial whirlwind. The pressure on eastern and cen-
tral European immigrants to assimilate into mainstream Ameri-
can culture increased during the world war, reaching a frenzied
height in the years immediately following the armistice. Urban riots,
local police crackdowns on labor union activity, U.S. Attorney Gen-
eral Palmer's raids on suspected subversives (many of them immi-
grants), and eventually, the passage of immigration quota laws in
1924 marked an environment where ethnic difference proved
dangerous. The culmination of anti-immigrant hysteria came in
1927 with the execution of Nicola Sacco and Bartolomeo Vanzetti,
two Italian immigrants who lost their appeals after being convicted
of a 1920 murder on circumstantial evidence. Theirs was a cause
célèbre for many writers and artists, including some Ulmann sub-
jects, such as Edna St. Vincent Millay. As a participant in literary
and intellectual circles, Ulmann no doubt questioned the impact
of such drastic solutions to fast-paced change. And she seemed
particularly afraid that the forces of conformity and assimilation
would be so successful that distinctiveness would be erased and
lines blurred between groups of people. Of her focus on Appala-
chian mountaineers, Niles observed, "These were the people she
really wanted to get down on paper for posterity. She thought they
would finally disappear, and there would be no more of them."[39]

Ulmann realized that the unique world the mountaineers had preserved could slip easily away, especially as elements of mass culture, bureaucratic government, and corporate business bled into all Americans' lives. The traditions, rituals, and mores of southern Appalachia would not be overtly attacked as had those of urban ethnic groups, but they would vanish slowly. To counter such erasure, Ulmann squared her views, added her own creative touches, and produced hundreds of images preserving the actual faces and gestures of an American pastoral ideal. Highly praised, her work was featured in the June 1928 issue of *Scribner's*. But a *New York Times* writer imposed his nativist interpretation (in an election year) upon Ulmann's subjects when he identified them as "the mountain breed" and stated, "These Republican mountaineers are of British and North Irish stock without intermixture. There are no more clearly pedigreed native Americans than they." Another observer of the Appalachia work described a Kentucky subject as a "strong youth out of the purest English stock of the nation" who hears sung in her home ballads dating from "the beginnings of English history."[40] Ulmann's photographs spurred the nativistic impulse in the United States, even though this had not been her objective.

To accomplish her task in the mountains, Ulmann looked to individuals as her best subjects. Her cordial, gentle manner endeared her to people who might otherwise have balked at the sight of strangers carrying cameras, boxes, and other heavy equipment. Allen Eaton, a collaborator of hers, once remarked that she had a personality that was "very attractive to most anyone. They knew she was earnest and not pretentious. . . . [and had] a way of getting along with people." William J. Hutchins, president of Berea College, witnessed Ulmann's relationships with her camera's subjects and saw in her "a singular gentleness and grace, a self-abnegation joined with an amazing human interest." She would ask men and women about their work, and Niles warmed them up by singing to them or with them, encouraging any inhibitions to dissolve. Olive Dame Campbell noted that Ulmann's "gentle and generous personality disarmed criticism and suspicion."[41]

She arranged individuals in chairs or in doorways, giving her attention to one person at a time. Nearly every photograph has a single individual as its main focus, not a couple, a family, or a

group. Ulmann's corps of images demonstrates that she turned away from group interaction and collective efforts. The lone woodcarver or chair maker or quilter received her fullest attention.[42] As she highlighted a character, Ulmann drew from the person's face a desired "look" that became the trademark gaze of her subjects— intense thought, a faraway glance, neither smile nor frown. Rarely does her sitter peer directly into the camera. Ulmann preferred a three-quarter view or a profile angle (see figs. 5 and 8). In her study of Lydia Ramsey, the sitter changes her facial expression just slightly for each of the five plates. In one photograph she has switched hats, exchanging a flower-topped bonnet for a casual straw. In a series of a different subject, the woman stares contemplatively as she holds up her printed apron for Ulmann to admire. There are few smiles on these faces. In fact, rarely did a smile appear on any of the ten thousand plates that Ulmann exposed.[43]

The mountain people who most intrigued Ulmann were the elderly. She believed their years of experience made them perfect character studies. Attempting to justify her fervent concentration on older people, she explained, "A face that has the marks of having lived intensely, that expresses some phase of life, some dominant quality or intellectual power, constitutes for me an interesting face. For this reason, the face of an older person, perhaps not beautiful in the strictest sense, is usually more appealing than the face of a younger person who has scarcely been touched by life." Through her lens Ulmann focused on long white beards, furrowed brows, bespectacled dim eyes, and parched, wrinkled faces. In an extended series marked "unknown, before 1931," she composed fourteen portraits of an older, copiously whiskered man. In one photograph he tugs slightly at his beard, holding it for her approval. Given her control over portrait sessions, Ulmann probably asked him to show his whiskers proudly for her camera. In another series she photographed a man sporting a long, oddly fashioned, unkempt mustache. Several other portraits highlight her fascination with the bearded elders of Appalachia. About those preferences, Niles astutely observed, "You had to be an individual, a character more or less, before she was interested in you even a little bit. . . . I think she loved most the white mountaineers, the old patriarch types. . . . She saw in their faces the care and the trouble of the

awful effort they had made to carry on life now that they had reached the afternoon or evening of their days."[44]

In their portraits, the venerable give an impression of strength and perseverance that Ulmann seemed drawn to. Since she was physically quite frail, it may not be coincidental that she pursued individuals whose bodies had not betrayed them, whose wrinkled faces and roughened hands were made so by seventy or eighty years of living. When she first encountered them she was not yet fifty years old. The "dominant quality" that she said she sought often revealed itself in her Appalachian portraits as a subtle hardiness, a quiet energy evident behind contemplative faces and dreamy eyes. And she was prepared to look for it at great length. Niles recalled Ulmann's tenacity in seeking out her preferred subjects during their travels together, noting that she was "willing to put up with any kind of weather, any kind of heat, any kind of rain . . . for the sake of getting to some out-of-the-way, God-forsaken spot where some ancient with a long white beard and a shock of white hair was sitting in front of his little cabin." Besides healthy beards, other symbols of age or wisdom appear in Ulmann photographs to categorize further the individual subjects. One sage holds a thick cane; in another print, a toothless woman has donned a huge sunbonnet; in yet another, a man wears tiny spectacles reminiscent of an earlier time. Ulmann's method of convincing viewers that this culture was dying was to narrow her vision overwhelmingly to those who would not live too many more years. These wrinkled faces belonged to the last true pioneers, her images warned. She must have been pleased to read in a 1930 feature that she had produced "an authentic record of a phase of our national living that will soon be no more." Capitalizing on symbols of age, Ulmann challenged the intensely popular movement that celebrated youth. Her few words, combined with thousands of images, spoke to her contemporaries who declared the 1920s a decade of and for the young. Popular fiction thoroughly dissected the attitudes and habits of those in their late teens and twenties, while magazine editors filled their pages with stories concerning the new generation. As literary critic Frederick Hoffman has pointed out, "No aspect of the decade was more thoroughly burlesqued or more seriously considered than the behavior and affectations of the young generation. They lived all over Manhat-

Fig. 5. Doris Ulmann. *Christopher Lewis. Wooten, Kentucky, ca. 1933-34.*
Audio-Visual Archives, Special Collections and Archives, University of
Kentucky Libraries.

tan, at both ends of Fifth Avenue, and disported themselves in a manner that amused *Vanity Fair*'s humorists, impressed its book reviewers, and provoked replies and analyses from its sophisticated journalists."[45] Ulmann's artistic renderings stand in opposition to this popular social phenomenon, challenging the trendy focus on youth and vigor with a message that linked wisdom with the aged.

Another way Ulmann attempted to shape cultural knowledge about southern highlanders was to give them a spiritual quality that was characteristically Protestant. In her attempts to portray religious devotion among mountaineers, she employed the symbol most clearly connected with fundamentalist Protestantism—the Holy Bible. Whether the photographer carried one with her as a prop remains an unanswered question. She could easily have borrowed from her hotel the Gideon Bible that showed up in one series of pictures. In another series, Winnie Felther, of Hyden, Kentucky, holds a Bible in her lap. Ulmann highlights the striking contrast between the dark, leather-bound book and the light apron where it rests. The larger frame for the object is the busy print of Felther's dress. The viewer's eye is drawn to the book, illuminated and cradled in the pure white fabric of Felther's apron and made even more prominent by its place in the woman's lap. In another series of an unidentified sitter, a woman holds open a book of hymn tunes stamped "Revival Gems." The woman's facial expression, stern and serious, suggests the fire-and-brimstone pitch of emotionally charged revival meetings.[46] Ulmann's portrait of preacher Christopher Lewis, of Wooten, Kentucky, carries her message most poignantly (fig. 5). Lewis sits in a cane chair in front of a soft natural backdrop, the sun shining on his white hair. The slight downward tilt of his head marks his humility, a prized Christian virtue. His seriousness of purpose and religious devotion are unquestionable, given the solemn expression on his face. His barely raised shoulders suggest an upward movement of his arms, bringing the sacred book in toward his heart, resting it securely on one hand, while clutching it protectively, even lovingly, with his other. Clearly "the word" is with him. As a symbol the book carried Ulmann's message about this Kentucky mountaineer more clearly than other religious icons would have. A crucifix, for example, would have hinted at Roman Catholicism,

a volatile subject in the United States in the late 1920s. Earlier in the decade, Ku Klux Klan terrorism against Roman Catholics had been widespread. By the late 1920s, the most public arena for debate was the 1928 presidential election, which pitted Al Smith, a Roman Catholic Democrat, against Herbert Hoover, a Protestant Republican. In tying southern highlanders to the Book, the word, Ulmann not only implied that they were literate, but she also secured the quality of spiritual devotion for them. Her message about religious faith and her attention to it echoed that of groups like the Agrarians who felt that the worship of industry and materialism had squeezed out more traditional expressions of faith.[47]

The South Carolina Gullah people gave Ulmann another rich and distinctive culture on which to build her composite studies and promote her antimodernist sentiments. Ulmann made her way into the African American settlements after having met and befriended the writer Julia Peterkin in New York. Peterkin, owner and matriarch of Lang Syne Plantation near Fort Motte, South Carolina, employed more than three hundred Gullah workers to cultivate her two-thousand-plus acres of cotton, asparagus, and wheat. She had lived next to the Gullah village since 1903, and its inhabitants became the principal subjects of her poetry and fiction. The Vanderbilt Agrarian Donald Davidson praised Peterkin's work, emphasizing that she "let the Negro speak in full character," and that she had "forgotten more about Negroes than Joel Chandler Harris (for all his greatness), Thomas Nelson Page, and that prurient modern, Carl Van Vechten, ever knew." In planning what would become her novel *Scarlet Sister Mary* (1928), Peterkin said, "I have been very close to life. It is all about me—several hundred negroes." Equating herself with the Gullah people set her apart from many of her southern literary contemporaries, who depicted African Americans in a romantic Old South haze; this led Davidson to note further that Peterkin's knowledge was "so intimate, so detailed, so exact that one is overwhelmed and asks how a white person could ever know so much (if what she knows is true) about Negro life."[48] At the MacDowell Writers' Colony in the summer of 1928, Peterkin built a story (*Scarlet Sister Mary*) around the life of a poverty-stricken Gullah woman who is expelled from her church but readmitted after her son dies and she sees a vision of

Christ's suffering. The book won Peterkin a Pulitzer Prize the next year.

The religious theme of Peterkin's work inspired Ulmann's photography in South Carolina. Primitive foot-washing ceremonies, river baptisms, and healing rituals in the church were among the practices she photographed. She was privy to these rural scenes because Peterkin paved the way for her, accompanied her to Gullah homes, and talked with those she knew well. Ulmann needed Peterkin, especially on her first trip to Lang Syne in 1929, when she found it difficult to work with and understand the individuals she called "Negro types." Despite her initial insecurity on this venture, she created images that earned her accolades. With regard to the photographs hung in New York City's Delphic Galleries, one *New York Times* reviewer claimed that Ulmann's pictures were "good" because her subjects were "grand." Lang Syne's remoteness, in the central "backwater" section of the state near the confluence of the Congaree and Wateree Rivers, made it a suitable location for Ulmann's work. And it served as a compelling venue that urban imaginations could cling to in their pursuit of rural American "folk."[49]

Ulmann and Peterkin became "very close friends," traveling together throughout the South and living at Peterkin's two homes, the plantation near Fort Motte and the summer retreat known as Brookgreen, located on Murrell's Inlet just south of Myrtle Beach.[50] Ulmann's devotion to Peterkin is evident in several portrait series she completed of the writer, including one of Peterkin in costume for her role as Hedda Gabler in a local production of Ibsen's drama. Peterkin sits in an elegantly trimmed formal gown, reminiscent of a turn-of-the-century wedding trousseau. The friendship transcended the others Ulmann had developed with writers, and its intensity may be felt in a unique series of portraits she arranged for Peterkin and herself. In one of these compositions (fig. 6), Ulmann has positioned herself so as to require Peterkin's support. Peterkin appears comfortably stable, so much so that she is able to smoke while balancing Ulmann on her right shoulder. Their relationship to each other in the image reveals their intimacy, with Ulmann's left arm on her companion's back and Peterkin's erect posture offering a firmness on which Ulmann, who is sitting in a more precarious position, is completely dependent.

Fig. 6. Set by Doris Ulmann. *Doris Ulmann and Julia Peterkin. ca. 1930.*
Photo used by permission of the South Carolina Historical Society.

Their friendship led them to collaborate on a project juxta-
posing Ulmann's Gullah records and Peterkin's narrative descrip-
tions. In 1933 *Roll, Jordan, Roll* appeared in two editions: the
trade edition contained seventy-two Ulmann images, and a finer,
limited edition exhibited ninety hand-pulled gravures. The NAACP
gave *Roll, Jordan, Roll* tremendous approval the year it appeared,
with Walter White, an NAACP leader, calling the book a "mag-
nificent achievement." Ulmann's South Carolina work showed her
expansive artistic range, with landscapes, group scenes, and por-
traits combined in one volume. However, in keeping with her
previous work in the mountains, the more outstanding, more in-
trospective compositions are of one or two individuals, not of
groups. She pictured a father and a son sitting quietly on their front
porch, a couple of men standing beside the cotton weight scale at
the edge of the field, and a middle-aged man sitting in the doorway
of his barn. Ulmann identified several of her sitters, including a man
known as "Black Satin" and another called "Papa Chawlie."[51]

As in her Appalachian portraiture, Ulmann attempted to de-
fine character through her direction of facial expressions, arrange-
ment of hands, and body postures, but she also used the
accoutrements of a pastoral setting to promote the notion of an
idyllic, rural landscape. In her portrait of a South Carolina fish-
erman (fig. 7), the still water and the small vessel support the main
character, who carefully (almost lovingly) guides with his hands
the line on which his sole attention is focused. The line he has
pulled cuts a perfect horizontal angle across Ulmann's frame,
matched in parallel by the boat's rim in the foreground. The man's
position and the heavy, hanging net provide a solid vertical line.
The angle of the boat provides the necessary depth for the photo-
graph, and the result is an image with unwavering compositional
stability. Here artistic arrangement coupled with bucolic subject
matter transmits one of Ulmann's clearest messages about rural
America—that quiet scenes like this one should not be ruined. Her
composite examination of Gullah African Americans revealed yet
another regional culture that Ulmann perceived to be unharmed
by the forces of modernization yet vulnerable to their encroach-
ment. This seemingly stable, pleasant rural existence hid the fact
that depressed economic conditions in the early 1930s had sub-
merged many American farmers under the weight of overproduc-

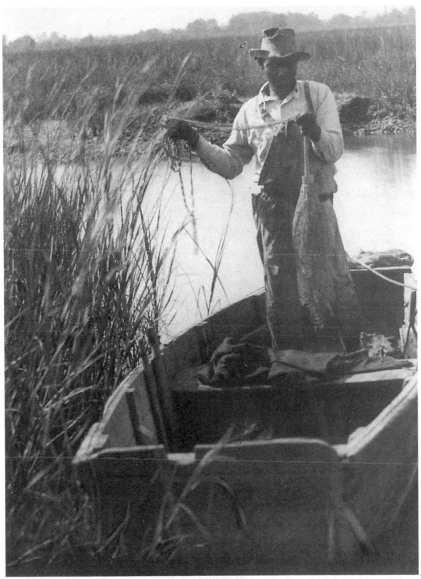

Fig. 7. Doris Ulmann. *Untitled (Man Standing in Boat Fishing). ca. 1929-30.* Collection of the University of Kentucky Art Museum.

tion, accelerated mechanization, worn-out soil, and for a decade, an unsupportive federal government. Romanticizing the country life in visual images steered viewers away from realities that faced agricultural workers at the onset of the Great Depression. Ulmann's glowing portrait of a working plantation in the twentieth century recreated the nineteenth-century ideal that antimodernists like the Agrarians had hoped to promote through local organization and public debate but which failed to get off the ground.[52] Among the group's numerous philosophical and practical disagreements was the question of what role blacks would play in the revived rural South. Although Ulmann did not vocalize her opinions on race, her photographs from those years reveal her close attention to the issues of color and ethnicity.

In *The Darkness and the Light,* a collection of Ulmann's images of African Americans, William Clift argues that Ulmann wanted to record the South Carolina Gullah culture because "she envisioned a gradual blending of the races in which these types of people would lose their particular distinctiveness." Her work at Lang Syne evokes a nostalgic tone, but more than likely this was due to Peterkin's influential presence and her own literary interpretations of the world she inhabited. Ulmann's larger body of photography from this period reveals that the results of miscegenation fascinated her. Some of her more remarkable compositions in terms of subject positioning, prop use, and overall message emerge from her work in the late 1920s and early 1930s. Her curiosity about people of mixed race and various ethnic backgrounds, those who could not be categorically defined, is evident in a number of photographs she took during this period. On one of her trips through the Carolinas, she pictured several "undefinable" individuals, including a young Melungeon woman, an elderly South Carolina woman labeled "Turk," and a South Carolina man called "Cracker." The Melungeon woman was one in a series Ulmann completed on Native Americans living in the Appalachians. The sturdy young wife bends her back over a washboard and tub while staring pointedly at Ulmann with her penetrating, deep-set eyes. In the background a lone log house fixes her situation, emphasizing her physical isolation and implying her social isolation as a native of mixed blood, likely Cherokee and Celtic. Hers is one of the many compelling faces of mixed ancestry that

Ulmann chose to photograph; others revealed African American and Native American features gracing the same face. The South Carolina "Turk," an elderly white-haired woman with a sun-parched face and a cob pipe, was described as a possible descendent of Turkish sailors who, according to legend, were shipwrecked off the eastern coast of North America. More likely she had descended from ancestors who were Native American, African, and Caucasian. In the portrait labeled "Cracker" by *Theatre Arts Monthly* editors, a dark-haired, olive-skinned, broad-shouldered man, with kind eyes and a slight smile, confounds ethnic categorization. He probably appealed to Ulmann because he crossed several defining lines or because he was, as the article description states, "a rural type of uncertain origin." In his portrait, he sits quietly among brush and tall grasses, exuding an air of gentleness, even vulnerability.[53]

Ulmann was probably influenced by the novel that Peterkin was writing during this time. Titled *Bright Skin*, the plot turns on proper skin color and features, as the demands of racial purity dictate. Two sisters have disgraced an African American family by producing children with traits unrecognizable to its members; one sage announces early in the story, "Right is right. Color is color. I would hang my head wid shame if one of Jim's chillen had bright skin." The principal relationship developed in the story is between two cousins, Blue and Cricket. Shocked when he first meets Cricket (who looks like no one he has ever seen), Blue describes his cousin as the "color of a ripe gourd." He grows to love her, even more as she is taunted by the community as an outcast. The novel's message is summarized in an outwardly pious church member's announcement that "A bright skin ain' got no place in dis world. Black people don' want em an' white people won' own em. Dey ain' nothin but *no-nation bastards.*" The concern over belonging nowhere, to no tribe or group, had engaged a number of writers in the 1920s who built on the theme of painful alienation from kinship ties. On into the 1930s, the added dimension of national economic turmoil led to further artistic probes about belonging, particularly about what constituted and defined Americanness. In 1932 Peterkin dedicated *Bright Skin* to Ulmann.[54]

The photographer's curiosity about other cultural enclaves dotting the American landscape was further touched when, with

Peterkin's assistance, she went deeper into the South. The two traveled together to Louisiana between 1929 and 1931, connecting there with the writer Lyle Saxon. A historic preservationist, travel writer, and raconteur, Saxon articulated many of the same concerns that Peterkin and Ulmann expressed in their respective art forms. He appreciated local color, delved into questions about race and mixed blood, and feared the homogenizing influences of modernization upon rural Louisiana. Although his fullest expression of these themes did not appear until he published *Children of Strangers* in 1937, he spent more than a decade dealing with such issues in his conversations, his diary, and his varied other writings. As Ulmann attempted to preserve on glass plates those people and places she believed would disappear, Saxon once wrote that he wanted the rural Cane River country "put down upon paper before it lost its quality and became standardized."[55] Sharing similar passions, Saxon and Ulmann were ambivalent about some of the same things: both thrived in their urban worlds, living among artists and writers, but both had had their imaginations sparked by American rural life, its inhabitants, and its characters. Neither could throw off the romance and nostalgia of bygone days in the country, whether real or imagined. Saxon introduced Ulmann to both of his worlds, the Cane River Country in north Louisiana and the New Orleans French Quarter. In the latter she photographed the faces of several characters, including an ancient bookseller and a vegetable hawker in the French Market. A number of her regionally defined visual studies bespoke Ulmann's keen interest in spiritual and religious influences. In a predominantly Roman Catholic city, whose mingled French and Spanish histories still shaped its character, Ulmann found a craftsman whose work helped fill the community's spiritual needs (fig. 8). Cast in a glow of light, the sacred object and its caretaker mirror each other, with the artist admiring his work, lovingly touching the "saint" he has repaired and retouched. The balance Ulmann achieved in the image by splitting the focus leads the viewer to believe that the icon is as vital as its creator. The product itself seems to have life, a technique that Ulmann cultivated in the early 1930s as she began to feature in her photographs the fruits of artisan labor. Her Appalachian handicraft images, in particular, feature the products as prominently as their makers, so that the objects themselves come

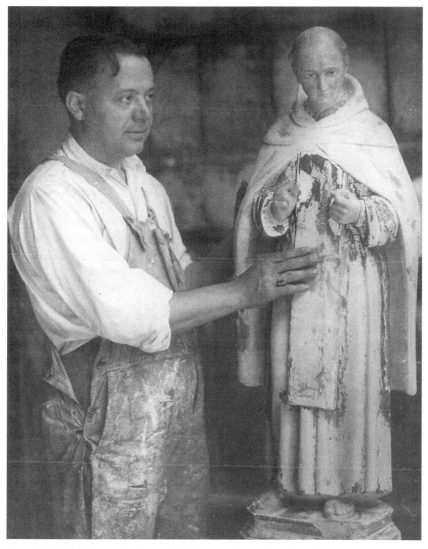

Fig. 8. Doris Ulmann. *Man with Sacred Image. New Orleans, Louisiana, 1931.* Audio-Visual Archives, Special Collections and Archives, University of Kentucky Libraries.

to define a region or a locale. Certainly this may be argued of Ulmann's study of the New Orleans sacred image maker, whose product stands as a symbol for the city's culture and history. In pursuing her curiosity about the city's religious foundations, Ulmann entered the confines of monastic life, composing portraits of women in the Ursuline order and in the Sisters of the Holy Family. Ulmann used her opportunities with the African American Holy Family nuns to experiment with degrees of lightness and darkness. Her visual studies show the blinding, starched white of the sisters' habits framing the quiet solitude of their smooth brown faces. New Orleans provided Ulmann yet another compelling venue in which to pursue her cultural interests in American religion and race.[56]

As with her other sophisticated liaisons, including those with Niles, Peterkin, and Campbell, Ulmann found Saxon a curious study for her portraiture. In one series of him, Saxon is dressed up in a three-piece tweed suit, sporting a boutonniere. A French doll dresser figures prominently in these photographs, as does Saxon's young black servant. The dominant figure in the portrait, Saxon appears to be a protector of both the dedicated craftsman and the uncorrupted black youth. Thus Ulmann cast Saxon in the role he had fashioned for himself in his attempts to stave off change and preserve the past. Ulmann's reverence for Saxon and his talents is evident in this portrait series. That she also was infatuated with him is suggested by John Jacob Niles's jealousy-laden annotations to this series after Ulmann's death. In the posthumous proof books, Niles terms Saxon a "Writer of Sorts," even though Saxon was leading one of the most successful Federal Writers' Projects in the country. Louisiana and its characters mesmerized Ulmann, yet she never returned to accomplish her proposed projects on two unique Louisiana subcultures, the Atchafalaya Basin Acadians (Cajuns) and the urban Creoles.[57] The Appalachian mountains beckoned her again, and it was there where she engaged her most physically demanding, and arguably her most significant, theme-centered photographic project—a survey of the southern highlands craftspeople.

In the late 1920s Ulmann had enjoyed a conversation with Allen Eaton, a fellow New Yorker interested in producing a book on mountain handicrafts. Eaton, by training a sociologist, had be-

come involved with craft exhibitions in his home state of Oregon fifteen years earlier. He had been named the first field secretary of the American Federation of Arts in 1919 and joined the Russell Sage Foundation the next year. That foundation, established in 1907 by Mrs. Russell Sage, directed its activities toward "the improvement of social and living conditions in the United States" by supporting "programs designed to develop and demonstrate productive working relations between social scientists and other professional groups." As Eaton worked for the foundation, he felt driven to combine social work and art, a goal that he felt could be realized in the southern highlands. With the help of Olive Dame Campbell, who ran the John C. Campbell Folk School in western North Carolina, Eaton's objective came to fruition. The Southern Mountain Handicraft Guild (SMHG) was established in 1929 and four years later renamed the Southern Highland Handicraft Guild (SHHG). Impressed with Ulmann's studies of Appalachian people, Eaton asked if she would be willing to illustrate his proposed book on the subject. She eagerly agreed and, according to Eaton, "offered to undertake the project at her own expense." In this instance Ulmann typified the photographic artist described by Stieglitz in his 1899 essay "Pictorial Photography," where he maintained that "nearly all the greatest work is being, and has always been done, by those who are following photography for the love of it, and not merely for financial reasons." Stieglitz's turn-of-the-century pictorialists, many of them independently wealthy, could afford to concentrate their efforts in such a way. Ulmann, following her principles as a pictorialist, embraced Eaton's project "for the love of it." She told Eaton, "If you will make the contacts for me . . . I will be able to get the subjects that I want most and I will photograph the people working with handicrafts that you want." Eaton and Ulmann had the same ideas about this unique group of people tied to the land and dependent upon their hands for survival; both feared that self-sufficient existence and the stability it represented could vanish. The sociologist and the photographer knew that the highlanders' creative endeavors, the "living craft, the moving tradition" had to be recorded. In presenting fifty Appalachian portraits to the SMHG at its 1932 fall meeting, Ulmann took a significant step in committing herself to the arts and crafts enterprise in the region. Her collaboration with Eaton shifted into high

gear in the following months as she entered the third and last phase of her career as a photographer.[58]

Ulmann's focus shifted once again as she embraced the social and educational functions that her photographs could serve. The public's thirst for traditional American craft design had been built up and sustained by the turn-of-the-century Arts and Crafts Movement, but in the early 1930s the deepening economic depression increased the focus on American-made and American-inspired designs. When the editor of the *Annual of American Design 1931* called for complete "emancipation" from European design so that a thorough cultural independence could be enjoyed in the United States, he was referring specifically to freedom for industrial design. Ulmann's exposure of traditional southern highlands handicrafts through her photographs, then, could both fulfill and challenge the call for "Americanness" in design. On the one hand, her focus would be upon processes and products that had been around for decades and thus were firmly situated in the nation's regional histories and cultures; on the other, the processes and products themselves challenged the burgeoning machine-age aesthetic that was inspired by industrial lines and shapes and mass production. Ulmann's visual images, to be successful, had to illuminate the appealing qualities of hand-made, carefully created items. She had to picture beauty in tradition if the SMHG's twenty-five craft-producing centers, many of them settlement schools, were to continue operating during the Great Depression. In the Southern Highland Handicraft Guild meeting reports, Eaton noted that "there had been many calls for inexpensive articles" at the 1933 Century of Progress Exposition in Chicago. He, Ulmann, and other craft supporters could take solace in the fact that although the exposition's nationwide quilt contest, sponsored by Sears, had fielded many entries with innovative themes focused on industrial power in a modern nation, the winning quilt featured a traditional nineteenth-century design made by eastern Kentucky needlers.[59]

Ulmann chose to picture people as well as their products. For years, the constituent elements of character in a person had intrigued Ulmann, who often tied those qualities to the work people did. Faces were important for her portraiture, but so equally were hands. Though she had always striven to entwine a person's occupation with his or her individual character, this aspect of her

photography took on greater weight in her Appalachian handicraft portraits. As one Ulmann biographer has noted of these photographs, "the sitters' hands and the objects they are holding are often as important as the faces themselves." Her portraits included specific materials and tools of trade. Emery MacIntosh, a tombstone maker in Breathitt County, Kentucky, holds a chisel and a hammer in his portrait. Oscar Cantrell, a North Carolina blacksmith, works at his equipment with a wrench, and Aunt Lou Kitchen sits at a low spinning wheel. Attracted to a "person who was doing something," Ulmann often pictured her industrious subjects engaged in the creative process or surrounded by their finished products (see figs. 9 and 10). Her photographs reveal the beauty and simplicity she sought to reveal in Samuel Clark's handmade looms, Cord Ritchie's woven baskets, Ethel May Stiles's tufted bedspreads, and Enos Hardin's chairs. Ulmann situated the objects at the forefront, casting them in the brightest available light, to emphasize their pristine, geometric lines, while their makers occupied the background of the frame. Ulmann's focus on the relationship between creator and product revealed how craftspeople were defined by what they made with their hands. Thus she could picture Enos Hardin in a softly screened light with one of his chairs in the foreground and write about the "appreciation of beauty in the man" and at the same time express astonishment that he could make "such fine chairs when the home is so dirty and slovenly."[60]

Although Ulmann hoped to connect these people with their respective vocations, she rarely had her sitter observe his or her task. The sitters stared off into the distance somewhere while their hands attended to the job. In one portrait (fig. 10), Cord Ritchie protectively secures the raw materials for her task of basketmaking. In another study, Hayden Hensley, an accomplished young carver, holds a knife and a piece of wood but has turned away from his job. In the large majority of these vocation portraits, Ulmann revealed busy minds and active hands without necessarily connecting the two. She seems to have tried to picture craftspeople thinking grand thoughts as they engaged in their work or held their finished products, surrounded by the richness of their talents. The men and women appear to be contemplators and artists, not mere tradespeople. Compositional stability in these portraits is achieved through a kind of motionlessness, or arrested action, on the part

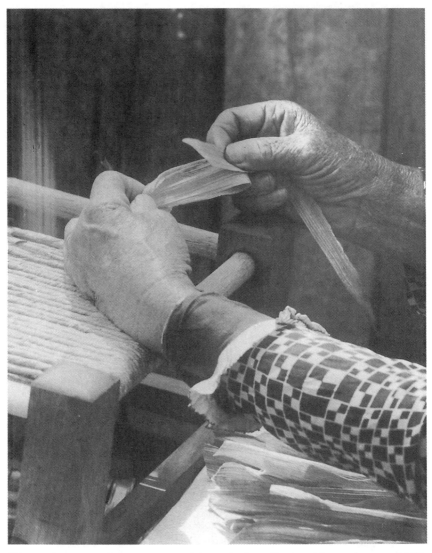

Fig. 9. Doris Ulmann. *Hands of Lucy Lakes. Berea, Kentucky, ca. 1933-34.* Audio-Visual Archives, Special Collections and Archives, University of Kentucky Libraries.

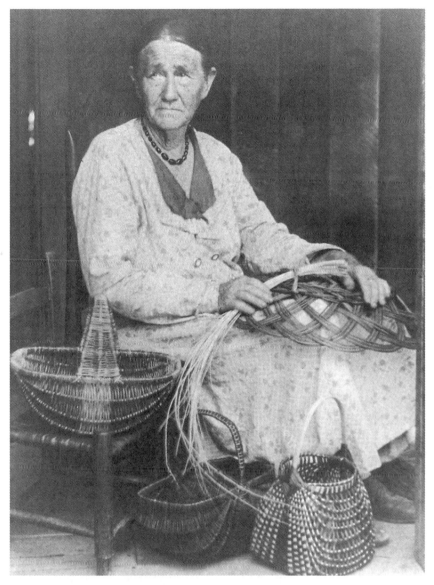

Fig. 10. Doris Ulmann. *Aunt Cord Ritchie, Basketmaker. Knott County, Kentucky, ca. 1933-34.* Audio-Visual Archives, Special Collections and Archives, University of Kentucky Libraries.

of the featured individual. This technique Ulmann had employed for years in her portrait studio, and by using it in the handicraft documentary project she elevated the status of each sitter to that of a featured actor in a vital drama that could not be allowed to cease. Her portrayal of the drama intimated that these artists possessed the secrets for carrying on productive, fulfilling lives. At the end of her first summer on Eaton's project, she wrote, "All these people give one so much to ponder about and meditate."[61]

Ulmann's deliberate compositional style and her artistry continued to reflect the influence of Clarence White even after she had embarked on her documentary project in the southern highlands. In a series picturing Kentucky cloth weaver Aunt Tish Hays, Ulmann combines three complex patterns in the frame. The first and most imposing is a background made entirely of a hanging bed cover sporting nearly two hundred small, tightly woven wheels of contrasting light and dark yarns. The second pattern, which cuts the middle plane of the surface, is Hays's dress, made of a fabric splashed with a floral design. Ulmann, who enjoyed studying the printed fabrics of mountaineers' dresses, often directed her lens toward the lines and shapes of those patterns. The third pattern, covering the lower plane of the frame and lying in Hays's lap, is another bed cover, whose intricate design combines circular shapes and rectangular squares. The play of textures provides sensory depth in this portrait, with Hays's face giving the portrait a necessary softness to break the busy confusion of three distinctive patterns. Compositional stability is achieved by the presence of a large spinning wheel that separates Hays from the constructed background but echoes the smaller wheel patterns in the coverlets. In many of Ulmann's portraits of Appalachian women, their softly screened faces allow exquisite contrast to sharp, geometric designs.[62] In them we see the aesthetic mix Clarence White impressed upon his students—a combination of textures and pointed details that would yield both harmony and multi-dimensionality.[63]

A similar study of Mrs. C.O. Wood, of Dalton, Georgia (fig. 11), reveals Ulmann's attraction to geometrical design. In this image the continuity of patterns is obvious in the backdrop composed of large diamonds on a quilt set against Wood's diamond-patterned dress. The photograph is a study of angles. The table edge provides perceptual depth, running from the lower right plane of

Fig. 11. Doris Ulmann. *Mrs. C. O. Wood. Dalton, Georgia, ca. 1933-34.* Audio-Visual Archives, Special Collections and Archives, University of Kentucky Libraries.

the photo to the back center. Cut perpendicular to this angle is Wood's left arm, which continues into the T-square, forming a secure horizontal line in the image. Beyond the artistic use of geometrics, Ulmann insists in the image that here is craft at its best, not accomplished by chance but by careful calculations (much like her own work). Although Wood looks away from her task and from the camera, intensity shapes her face. Her meticulously manicured nails and smooth fingers hold the T-square securely on the table, where she draws a pattern onto the cloth. Among the other tools the subject employs to accomplish her goal is a new pencil with a sharp point and a glistening metal band, deliberately arranged to articulate Ulmann's message about this craftswoman extraordinaire. White's influence carried through to Ulmann's survey of southern highlander handicrafts. His vision, as well as Stieglitz's, may also be detected in those images where Ulmann remained the traditional pictorialist, especially where she manipulated light to its fullest advantage. In one work of art, she pinpointed a lone hand on a weaving machine, the threads illumined so they appear as fine as angel hair. The cross strands, barely focused, look even more fragile and delicate. As a photographic artist, Ulmann clung to pictorialist principles on into the 1930s, while her contemporaries left behind the soft focus and glimmer.[64]

In Ulmann's attempts to preserve what she believed was vanishing, she occasionally created idyllic scenes out of imagination and mountain lore. She posed her subjects and put props in their hands. She saw nothing wrong with trying to create a certain look, and if a simple tilt of her sitter's head achieved it, Ulmann asked that it be done. Niles recalled that Ulmann wanted to pose "everything she photographed" and that her frequent instruction was "Pose but don't let it seem posed." Just as she had done with her city friends and literary acquaintances, Ulmann attempted to shape her images of Appalachian men and women. She had no intention of falsifying their existence, but she sought to portray the ideal world of a pastoral rural experience. She had people wear costumes they would not normally have worn. According to Niles, young women "would bring down spinning wheels and portions of looms and cards and other things, and show us how their ancestors carried on, and we would photograph them in their granny's old linsey-woolsey dresses." Gene Thornton, in a 1975

Fig. 12. Doris Ulmann. *Wilma Creech. Pine Mountain, Kentucky, 1934.*
Used with special permission from Berea College and the Doris Ulmann
Foundation.

New York Times piece, noted that "in 1933 . . . Ulmann was still dressing her Appalachian hillbillies in grandmother's dresses and posing them with spinning wheels that they no longer knew how to use."[65]

The photographer's posings were not designed to reflect realities of daily living in the mountains, but rather were set up to highlight an appreciation of the rural past that many settlement school students had willingly embraced. In Eaton's text on the Pine Mountain Settlement School, he points out that "several of the grandchildren and other members of the Creech family dressed in old costumes and were photographed at work as in pioneer days." These participants, in what has become Ulmann's most infamous series (completed the last week of May 1934), held deeply personal interest in dramatizing the history of the Pine Mountain institution—their grandfather, William Creech, had donated 136 acres in 1913 for the school to be built. In one image (fig. 12) granddaughter Wilma Creech stands next to a high wheel, which at one time in the mountains was the most commonly used model for spinning wool. Outfitted in a dress and bonnet that belonged to an earlier generation of Creech women, the young barefooted woman peers out into the distance with a deliberate and focused look, neither sheepish nor downcast. Her grip on the wheel spoke and her graceful posture (the ill-fitting dress notwithstanding) deliver a message of pride and confidence. The central place she occupies in the frame, accentuated by her well-lit head against the dark doorway, makes her portrait image stunning. Although Ulmann's purpose was to feature the spinning wheel as part of Eaton's handicrafts story, Wilma Creech's sidelong gaze, her penetrating eyes, and her easy composure dominate the image. Situated in time in her own family's history and culture, she nevertheless defies time in a documentary photograph suggesting that she may regularly operate the wheel, when in fact she was a medical school student home for the summer at the time Ulmann created this image.[66]

Of the many craft locations Ulmann surveyed, two places in particular captured her imagination and made her a believer in traditional arts education—Berea College in Berea, Kentucky, and the John C. Campbell Folk School in Brasstown, North Carolina. The latter, established by Olive Dame Campbell in 1925, was

modeled on several types of folk schools Campbell had visited and studied in Scandinavia in the early 1920s. Her European venture followed the death of her husband, who had been a Russell Sage Foundation field officer in the Appalachian mountains from 1908 until 1919. After his death Olive Dame Campbell completed and published his study of the area, *The Southern Highlander and His Homeland* (1921). Convinced that the ideals of the Danish rural projects she had witnessed abroad could be transplanted in the United States, she returned to Appalachia to begin a school "to enrich the whole content of rural life" by building and sustaining community spirit. With financial support from the Brasstown community for her project, Campbell started the school under the creed "I Sing Behind the Plow," a line she had taken from a Danish folk song. Focusing heavily on cultural education and rural cooperative experiments, the school became one of the producing centers in the Southern Highland Handicraft Guild. Ulmann first visited the Campbell Folk School in July 1933. Within a week she wrote, "The more I see of Mrs. Campbell and her work, the more interested I become, and I admire her and her achievements tremendously." When Ulmann returned the following summer to continue photographing in the region, she considered Brasstown the highlight, noting that "in all our wanderings, we have not found anything or any place that can compare to Mrs. Campbell's." Ulmann grew so attached to the institution that she made plans to help fund a "boys' building" and a "little hotel" in Brasstown.[67]

Located two hundred miles north of the Campbell Folk School was Berea College, a unique institution where students helped keep alive the arts of their Kentucky ancestors. The school charged no tuition; it provided education to poorer students who worked to keep the college facilities operational. One of Berea College's goals was to uphold "the ideal of simplicity" while "contributing to the spiritual and material welfare of the mountain region of the South, affording to young people of character and promise a thorough Christian education." The college president, William J. Hutchins, had made Ulmann's acquaintance initially through a display of her photographs at the 1930 Mountain Workers' Conference in Knoxville. In reply to a note of appreciation he sent to her, Ulmann wrote, "Your words have made me feel that I have perhaps succeeded in expressing a little of the great and deep humanity of

these fine and sturdy mountain people. It helps to know that one's work has been of some value." Hutchins hoped to take advantage of Ulmann's work for his own institution's cause, and his persistence eventually paid off. In the fall of 1933, as a result of the cooperation between President Hutchins and John Jacob Niles, an Ulmann photography exhibit went up on the walls at Berea College. Niles appeared to be quite devoted to what he termed the "Berea movement," which was, in his opinion, "constructive education." At one point Niles recommended that Hutchins try to make some money for the college from an Ulmann photography exhibit—"Perhaps you can do this later at some other city where the rich could be caught and impressed with your needs. . . . Don't [sic] mind about paying me, or Miss Ulmann, we carry on somehow. . . . My motto is 'OTHERS.' . . ." Perhaps it was, until he found out that someone had arranged for *him* to sing at a benefit concert for Berea College in New York City. He abandoned the altruistic tone and expressed displeasure when he learned about the proposed benefit, and the concert was immediately canceled. In the weeks following, Niles's communications centered around Ulmann's possible contributions to the college, including a set of her prints for a permanent exhibition there, an idea she had "long considered." Following Niles's suggestion that the college might like to have photographs of "old men . . . young ones . . . children . . . ancient females . . . musicians," Ulmann selected "enough pictures to cover the Mountain subject" sending them ahead to the college so they would be on display when she arrived during the fall semester of 1933.[68]

Niles and Ulmann made appearances at Berea the last week in October. Their visit was a brief one, allowing Ulmann only a small glimpse of Berea College. But she described her trip as "a very beautiful experience." In a letter to Hutchins and his wife, she said, "It is with impatience that I am looking forward to the time in the Spring when I hope to make pictures of the activity and interesting people at your college. There are many things which I saw which ought to be recorded in the best possible way." Ulmann had little time to take photographs while at Berea in October, but she did manage to take formal portraits of President and Mrs. Hutchins, then cordially offered to make any number of prints the couple might want "to use for publication or any other pur-

pose." Limited to these few portraits, Ulmann grew anxious to return to the college in order "to do some real work." Her admission that photographing the institution's chief official did not thoroughly satisfy her indicates how far she had gone beyond cataloging famous faces. By 1933 she had pushed her work in a decidedly more challenging direction.[69]

Moved by Berea College's mission, Ulmann wrote to the Hutchins that the college had made "a deep and delightful impression" on her—"My thoughts have been busy with your very remarkable and effective institution. It is a blessing to know of a place in the world where everybody is giving out of the fullness of his heart without ever thinking of a spiritual or material return." Hutchins, however, could not ignore the possible financial returns of a wealthy New Yorker's blessings. He and Niles discussed such matters in their correspondence. Ulmann would have been appalled to learn that Niles mentioned their personal finances to Hutchins, and since she had no intention of seeking payment for their work there, she promptly returned a twenty-five-dollar check that Hutchins sent to Niles after his morning assembly performance at the college. Ulmann willingly assumed any expenses Berea College incurred regarding her portraits. She paid all costs to ship her photographs, even if the institution had requested them. Returning to New York taken with Berea, Ulmann thought words were inadequate to describe it and insisted instead that the "whole atmosphere" of the college "must be felt."[70]

In the following months, Niles's influence in Ulmann's life expanded. He often accompanied her to various kinds of winter season entertainment in New York City, including the theater and the opera. And because her intestinal problems had worsened, she finally relented and let Niles assist her as she spent long hours in her darkroom developing the faces and views of her southern summer. But she continued to hold the reins tight on her artistry. Niles remembered, "If I assisted her, she stood over me and watched everything I did, telling me forty times how to do the simplest operation, how to pick up the glass plates and how to put them in a frame to dry. She mixed all the chemicals. She did let me make prints occasionally, but I would get weary of the enterprise about midnight, and move on, and she'd continue working until the early hours of the morning."[71]

Niles held a substantial interest in the plates, since he and his musical fieldwork were featured in many of Ulmann's photographs. He found these trips to Appalachia advantageous; he collected tunes and ballads of the highland culture that he hoped to publish someday, and he searched for unusual words or phrases with possible early Saxon roots that he could include in his prospective "Dictionary of Southern Mountain English." As such, Niles's goals complemented Ulmann's objectives. They conducted their respective searches on common ground, with Niles's face and hands recorded on the plates. In one photograph, labeled "Old Timers' Day," Niles sits with a dulcimer in his lap as several elderly gentlemen listen to his performance. In another pose Niles holds a dulcimer while busily taking notes as a young black boy talks to him. The ballad singer attempted to interview as many dulcimer makers and performers as he could locate. The dulcimer, a stringed folk instrument, remained a southern Appalachian specialty, and Niles made sure Ulmann photographed the unusual ones that he found. One journey took Ulmann and Niles to a remote area where a lone cabin bore a sign announcing, "American Folk Song Society Presents the Second American Folk Song Festival." Nothing indicates how many people attended the event, but in Niles's identification of the image he wrote, "Cabin Where Festival Was Held: *Mostly Bunk.*"[72]

Niles figures prominently in Ulmann's Appalachian work, but he also sat for portraits on several occasions in her studio, appearing to be a willing subject who offered a variety of poses for his companion's camera. Three extended series of him, all taken in a studio, indicate that he was a showman, quite the grimacer. In one series Niles is dressed up in evening clothes, complete with top hat, white tie, and cane. In a couple of these portraits he wears a mysterious facial expression, halfway shielded by his coat. His penchant for music is highlighted in another series. Ulmann focused particularly on his hands—playing the piano or writing notes on a musical score. She connected him with his livelihood and his artistry, just as she had done with the weavers and carvers of Appalachia. But Ulmann also used Niles in a number of "couple" studies, where Niles served as a companion figure to young women in Appalachian scenes. In nearly all of those studies, the young woman and Niles sit close to each other, their hands touching,

their gazes fixed dreamily on a musical instrument or on a point in the distance. In several of them the fresh-faced innocent girl appears to be guided by the teacher, the role performed by Niles. Among the female protagonists Ulmann chose for these series were Carol Deschamps and Virginia Howard at Brasstown, North Carolina. Ulmann posed Howard in several individual portraits, but she also paired the young woman with Niles in an extended series. As the two sit very close to each other in heavily shadowed light, Niles's hands cover Howard's hands, which rest lightly on a dulcimer. Despite their best intentions to show the seriousness of their forced relationship, their tense facial expressions provide an image more comical than romantic. Both the extensiveness of the "couple" studies and the tones of intimacy conveyed in them suggest that Ulmann may have imagined herself in these idealized scenes with Niles, revealing more of her true feelings on the glass plates than she could exhibit in her own real life.[73]

The Ulmann entourage returned to Appalachia in the spring of 1934. Niles took care of the preparatory details, announcing that "on about the 10th of April the 7th Ulmann Niles Folk Lore Photographic Expidition [sic] will set out. With cars and trailers and cameras and note books." One of the early stops took them to the White House, where they were entertained by Eleanor Roosevelt, who had seen and "enjoyed" the Ulmann photographs on display at the Library of Congress. As they moved farther south into the Carolinas and then into Kentucky, Ulmann corresponded regularly with Eaton, who made contacts with particular settlement schools and individual craftspeople for her. He provided introductions well ahead of time so that Ulmann would not startle potential portrait sitters. In one request Ulmann wrote to Eaton that it would "help a great deal if you could prepare the people for our visit so that they could have things ready for us." Eaton's role from a distance preceded that of another photographers' mentor, Roy Stryker, who paved the way for his Farm Security Administration (FSA) government photographers from 1935 until 1943. Stryker's contact with regional FSA offices, especially in the early years, prepared the locals for an invading photographer who might ask too many probing questions of government aid recipients. In Stryker's case his organization depended upon his scheduling and assignments; his photographers expected him to

grease the skids for them. Eaton's preparation for Ulmann amazed her to the extent that she thanked him repeatedly for communicating with her subjects, reiterating to him that it would be "so difficult to work without your introduction."[74]

Eager to please Eaton, Ulmann asked him to send her lists of subjects he wanted to have in his book. Seeing her work as a sort of mission, she desperately wanted to provide publishable illustrations and was willing to accommodate Eaton's wishes, noting that she hoped he would "find all the important and interesting things here." She acquainted herself with individuals and schools before she arrived to see them. She studied maps, attempting to use her time on the road as efficiently as possible. And she judged her productivity according to the willingness of craftspeople to cooperate with her and to demonstrate the steps in their various enterprises. Describing her study of tufting specialist Ethel May Stiles of Ringgold, Georgia, Ulmann wrote, "I worked with her and in my pictures tried to show the *process* of making a tufted spread." Tufting yarn, a coarsely spun cotton of many strands in various colors, was used to decorate bed covers, curtains, and other decorative articles made of heavy cloth. In the 1930s tufters in northern Georgia fed a national market hungry for their products. Some handiwork they sold on the roadsides in Georgia, but most went through a dealer in Dalton who sent the merchandise on to department stores. It was Ulmann's careful attention to processes like tufting that revealed the documentary spirit she harbored and nurtured.[75]

In four weeks at Berea in 1934, Ulmann provided an exhaustive treatment of the college's departments and operations. As soon as she arrived, President Hutchins requested permission to make "all manner of suggestions to you as to pictures of men, women, and things, always with the understanding that you will do exactly as you please, without feeling the remotest constraint from me." Whether Hutchins directed Ulmann's work is unknown, but the photographs she completed in her few weeks at the college must have pleased him. She observed Berea's various departments and provided extensive coverage of its operations. She took photographs of drama students parading in costume and of woodworking students using hammers and saws. Her documentation of the students' sheepshearing process began with an unsheared

animal. She followed the complete procedure, recorded each step, and ended her series with a telling photograph—a sack stuffed with wool sitting on the market scale. Berea College, since it made no money from student tuition payments, perpetuated itself through such agricultural endeavors. Ulmann hoped to reveal the unusual nature of the school, along with the contributions made by its hardworking young men and women. She recorded the dairy and creamery operations, again showing various stages in the production process. She took pictures in the candy kitchen, the bakery, and other food service areas. Many of the products made in these kitchens served guests in the college's downtown hotel, Boone Tavern. As with all her Berea work, Ulmann wanted to highlight the "process." She made photographic studies of girls kneading flour, stirring pastry mix, and decorating cakes. Several still-life photographs show the intricate work done on tiny sugar candies. After her thorough documentation of the college's operations, she more than likely was unable to fill President Hutchins's self-described "*impossible* order" of choosing one photograph that would "incarnate the ideals of Berea."[76]

The Berea images by Ulmann stand closely in line with traditional documentary photography as it came to be measured in the 1930s. The visual records Ulmann made of procedures anticipated the similar subject matter that emerged a few years later in U.S. Government–sponsored photography. WPA photographers' assignments included recording various stages of building projects, photographing audiences at Federal Music Project concerts, and shooting Federal Art Project shows as they went up on gallery walls. Other government employees with cameras recorded living conditions in poverty-stricken areas, then later returned to those regions to evaluate the effectiveness of New Deal aid programs by examining how the money was spent. Certainly the candid expressions Ulmann captured on some Berea College students' faces bear out the documentary nature of her work there and show how far she had reached beyond conventional portraiture. In one series Ulmann framed a classroom scene where the dean of the college was surrounded by students, all men. The boys attempted, with obvious difficulty, to get rid of their smiles, but the serious business of education was lost on them. They managed to look contemplative in only one photograph in the series. This series, among

others at Berea, sets Ulmann's survey apart from a similar project carried out by photographer Frances Benjamin Johnston at Virginia's Hampton Institute in 1899. The *Hampton Album* shows the seriousness of purpose of all the students and the graduates pictured. The Victorian expectations of balance and conformity dominate, resulting in highly stylized scenes in the classroom and laboratory settings. James Guimond notes of the students in Johnston's photographs, "None of them is crowded, inattentive, bored, or distracted by anything—least of all the photographer and her camera." Ulmann's collective portrait of Berea College students and their work shows the extent to which she developed a documentary style that could allow spontaneity and ease in front of the lens.[77]

But Ulmann's need to control her artistic vision reveals the limits of her willingness to operate as a pure documentarian. Despite Eaton's initial direction, Ulmann did impose her aesthetic tastes on him and the handicraft book project. When he discussed using other photographers' illustrations alongside Ulmann's work, she forcefully replied that he should either use her images exclusively or omit them completely. In a heated letter, she wrote, "I would not care to have some of my pictures used and some done by somebody else. After all the rather intensive work of last year and this year I do think that you will find enough subjects from which to choose." Ulmann, on advice from culture workers in the region, had begun making decisions about which states, towns, and craft workers to visit, despite Eaton's appeals for her to travel elsewhere. She avoided a few schools that did not exhibit the "real mountain spirit." Her conflict with Eaton revealed her steadfast belief in achieving depth over breadth. The portrait photographer who spent hours with each woodcarver wanted to cover those individuals thoroughly rather than snapping a plate of every whittler within a one-hundred-mile radius. Ulmann's vision had been molded by her training as an art photographer, which she never relinquished. Her disputes with her colleague in 1934 bear similar characteristics to the clashes a few years later between FSA mentor Roy Stryker and his "art" photographers, especially Walker Evans and Dorothea Lange. Stryker struggled with Walker Evans, who tended to disappear on the road, failing to communicate with the Washington office for days at a time. Lange, whom Stryker once labeled his

"least cooperative" photographer, refused to send her film back to the Washington lab, not trusting the technicians to develop it properly. And although Lewis Hine sought employment on the FSA team, Stryker would not hire him because he feared the well-established photographer was too inflexible to produce the kind of documentary work the agency needed. This generation of artists who worked with cameras declared their independence by refusing to have their individual visions shaped by organizational demands.[78]

Since Ulmann was funding the handicrafts tour almost entirely, she could afford to preserve her artistic integrity, and Eaton could not afford to lose her. The determination Ulmann exerted here underscores her status as a financially independent woman whose money gave her a freedom that other photographers in the Depression years did not enjoy. Being wealthy also allowed her to sidestep some of the challenges other female documentarians faced while on the road. As no organization's employee, Ulmann could choose the causes and the specific subjects she wished to photograph. She traveled comfortably in a luxury sedan with a driver and set her own shooting schedules. Any restrictions Ulmann faced were self-imposed, based on her dependency upon companionship and, more specifically, her need to forge relationships with writers, artists, and educators. Her emotional needs coupled with her ability to pay assistants kept her from having to travel or work alone or meet the challenges of attempting to do so, unlike several of her documentary counterparts in the 1930s. WPA photographer Berenice Abbott suffered the pranks of construction workers on New York City streets; FSA photographer Marion Post not only aroused suspicion but faced hostile inquiries in several states arising from her status as a woman alone on the road. Ulmann managed to avoid such treatment, in part because she did not fit the "modern career girl" stereotype or face its challenges, as did Abbott, Post, and Margaret Bourke-White. Ulmann's primary conflicts remained more personal than public, enlarged by her willingness to reveal her physical and psychological vulnerabilities.

Shaped by her experiences in the summer of 1934, Ulmann's truest devotion was to Olive Dame Campbell and the Campbell Folk School, where she spent the final weeks of her last Appalachian trip. Earlier she had told Eaton, "How I do love Mrs.

Campbell and all her people!" By the end of the summer Ulmann
had come to depend on Campbell's advice and direction for her
photographic studies. When Ulmann and Eaton suffered their
breach over the book illustrations, Campbell mediated the alter-
cation. Although Eaton was directing the book project from New
York, it was Campbell who advised Ulmann on which craft cen-
ters to omit from her travel schedule, suggesting that some places
"would probably not have any new or any exceptionally interest-
ing material." As Ulmann gained more confidence with each suc-
cessive visit to new schools, she increasingly questioned Eaton's
lists, replying that she felt "doubtful about Hot Springs" and did
not "know anything about Higgins." Some of her doubts about
traveling to particular places were driven by her own fatigue and
deteriorating physical condition. She argued that she wanted to
cover individual subjects thoroughly and in one place, rather than
fanning out to come away with repetitious images of the same
crafts in many places. She claimed it would be a poor use of her
time to drive to South Carolina, Alabama, and Virginia to photo-
graph the same processes and products she had surveyed in Ken-
tucky, North Carolina, Tennessee, and Georgia. Ulmann used the
power of Campbell's clout and expertise in the realm of southern
handicrafts to back her up, implying that Campbell was a com-
pletely objective observer who had sided with her in the dispute.[79]
In one of the last letters she wrote, Ulmann said, "It is always
hard to leave Mrs. Campbell,—the more I see her the more deeply
I appreciate her. I think that she is the wisest and finest woman
whom I have ever met. . . . Many times I wonder whether all these
young mountain girls and boys will ever appreciate the rare oppor-
tunity which they are having in being so greatly influenced in their
lives by a person like Mrs. Campbell. There is not a school or a
university where they could have this beautiful, personal attention."[80]

In August, a few days after she expressed these poignant sen-
timents, Ulmann's physical limitations, the exhausting schedule,
and the summer heat overtook her. She was near Asheville, North
Carolina, making photographs for the Farmers' Cooperative Union
of Asheville.[81] Following the session at Top of Turkey in Buncombe
County, Niles and the rest of the Ulmann entourage rushed the
photographer to Pennsylvania for medical treatment, then on to
New York City.

In the days before she died Ulmann composed a will, generously leaving the bulk of her life's work and wealth to the John C. Campbell Folk School, Berea College, and John Jacob Niles. She was quite explicit in her wish that no one person profit from her photography. She indicated that "in no event shall any one except a public charitable, scientific, art or educational institution or other public institution or the public in general acquire any beneficial interest in the money or property held hereunder." She also requested that any printing, exhibiting, or distribution of her work be done solely to "further the development of photography as an art and further the understanding of American life, especially of the South." The South's multitude of subcultures had drawn Ulmann to the region, their complexities enticing her out of her urban environment. William Clift argues that Ulmann's photographs of Appalachian residents and Gullah African Americans prove that she was not interested in "social commentary" since they recorded no poverty, misery, or racial conflict. Perhaps that is so, but certainly she wished her photographs to provide cultural commentary. Focusing on ethnic distinctiveness, personal talents, regional rituals, religious devotion, and rich local traditions, Ulmann made a significant contribution to an "understanding of American life" that she hoped would continue after her death.[82]

Reared and trained as a turn-of-the-century educator at the Ethical Culture School, the rich urban dweller combined her vision and her camera work in order to present a composite picture of a fleeting rural America. She attempted to record specifically defined groups that did not yet bear the marks of an ever-encroaching mass culture destined to blur the lines of ethnic and geographical distinctiveness. She sought to arrest time through the vehicle of compositional stability, creating portraits of individuals situated in natural stillness, mental solitude, or fruitful work. Ulmann hoped to illuminate the nobility and dignity of the men and women she encountered, an idea carried on through the decade of the 1930s by better-known documentary photographers such as Walker Evans and Dorothea Lange. Like her successors, Ulmann found herself working for an organization dedicated to improving living conditions of lower-class groups in the United States, those who would come to be celebrated as "the people" and would receive support

from federal government programs in the second half of the decade. But Ulmann's vision transcended that of the U.S. Government employees with cameras who succeeded her. She delivered the prints back to the schools and the subjects she had photographed; her fellow documentarians did not. Knowing that three thousand undeveloped negatives remained, Ulmann made provisions in her August 1934 will to have distributed to Berea College and to the Campbell Folk School the prints concerning their respective activities. She further instructed "that each person who was the subject of any photograph taken in the Southern Mountains . . . be given a copy of the print." It is this specific request that made Ulmann more than an uninvited observer or a voyeur. The ultimate students of the highlanders' lives and work became the mountaineers themselves. Ulmann, who referred to her portrait sitters as "patients," always kept in mind that her subjects themselves were their own most vital observers, whether they were physicians at Columbia University, writers in New York City, or craftspeople in the Appalachian mountains.[83]

Although Ulmann produced an impressive body of photographic work for Allen Eaton, she never saw full fruition of the Appalachian project. *Handicrafts of the Southern Highlands* appeared in 1937, three years after she died. Eaton later said that Ulmann "didn't realize that she had made the most definitive collection of rural characters, certainly in the field of handicrafts, that's been done any place in the world." Loyal Jones, who directed the Appalachian Center at Berea College for a number of years, noted that Ulmann easily bridged the gap between "her world and theirs," offering up thousands of images bearing "no condescension for the harshness of her subjects' lives, but rather an appreciation of mountain people for the uniqueness of their faces." But Jones also pointed out that "those who look at Southern Appalachia usually find whatever they are conditioned to find." Ulmann had been educated to seek beauty in each individual, had been convinced of the bucolic pleasures of rural existence, and had embraced the traditional craft movement as an antidote to mass production. Her tastes and methods kept her from recording some of the harsher aspects of mountain life, particularly in Kentucky's coal mining counties. People in western North Carolina in the 1930s much more easily recognized themselves in the

snapshots taken by their neighbor, the "Picture Man" Paul Buchanan, than in Ulmann's portraits or the photographs made a few years later by Bayard Wootten for Muriel Sheppard's text *Cabins in the Laurel* (1935).[84]

Using her finely tuned observation skills as a student of psychology and photography, Ulmann first studied individuals and then created portraits, scores of them. Her subjects were appropriate for documentary work, but her equipment was not. Since she never used a Rolleiflex, a Speed Graphic, or a roll of 35mm film, she never snapped a quick picture. Although she captured a few smiles on the faces of students, her subjects were rarely caught off guard in the split second of a shutter snap. Ulmann's subjects' faces were recorded over minutes and hours on heavy glass plates, most of which were destroyed after her death. President Hutchins of Berea College declared, speaking of Ulmann, "It is fortunate indeed that before her passing she was able to capture and hold forever before the American public these portraits of types which may pass all too soon from the American scene." In Ulmann's search for types, she found individuals, many of them living on land and in homesteads that their great-grandparents had occupied. She helped to lead the cultural resurrection of rural life in the late 1920s and early 1930s by picturing rural existence in all "its color and picturesqueness and excitement." Yet she never considered one picture's worth. Instead, she believed in the magic a thousand pictures could wield over the power of mere words. As a result she helped set the stage for documentary to become the principal vehicle of photographic expression in the 1930s.[85]

Portraitist as Documentarian

DOROTHEA LANGE'S DEPICTION OF AMERICAN INDIVIDUALISM

The secret places of the heart
are the real mainsprings of one's action.
—Dorothea Lange

DOROTHEA LANGE SPENT MORE THAN SIXTY YEARS living what she called a "visual life." She admitted that such an existence was "an enormous undertaking, practically unattainable," yet she claimed to have pursued it from a very early age. Lange's most vivid childhood memories revolved around the skills of observation she cultivated and finely tuned on New York City streets in the first decades of the twentieth century. Her experiences there as a young girl affected her approach to the world and to the lives she studied throughout her career as a photographer. Like her uptown New York contemporary Doris Ulmann, Lange chose to focus her camera on individuals rather than groups or their external surroundings. The primary carrier of Lange's personal messages was the human face, as it was for Ulmann. But Ulmann's approach to a hobby assumed midway through her life stands in significant contrast to Lange's full-fledged visual life. Lange claimed to have made no conscious decision to become a photographer, but she felt that

she had always been, at some stage in the development of her craft, either "getting to be a photographer, or wanting to be a photographer, or beginning to be a photographer."[1] Things visual piqued an insatiable curiosity in Lange, one to which she devoted a lifetime of care and attention.

Although she found it difficult to explain, Lange felt that she had been led to photography by instinct. After spending many years in her chosen career, she learned that her great-uncles who had come to America from southern Germany had all been lithographers. The sons had followed their fathers in the trade, making visual images with grease, water, and ink. Lange believed that her love for pictures came from those ancestors, whom she never knew. She once said, "I've sometimes wondered whether these things that we do on our own, the directions that we take and the choices of work, are not determined by something in the blood. . . . I think that there is some kind of memory that the blood carries. . . . There are certain drives that we have." Despite the instinctive impulses that her forebears may have passed along, Lange grew resentful of her Teutonic heritage at a young age, consciously rejecting a trait that she believed to be inherent in all Germans— an unwavering respect for authority. Exhibited by her mother and other relatives, such reverence bothered Lange, who complained that Germans were constantly concerned about "what other people would think of them."[2] Throughout her career, Lange enjoyed a personal independence that she had nurtured as a young girl. A profession in photography suited her, since it freed her from the control of supervisors and superiors and enabled her to preserve "a very great instinct for freedom." Lange, born in 1895, matured in an age when women were challenging the boundaries that had been set for them earlier in the nineteenth century. Many found that professional lives in social work, political organizations, or radical labor movements offered alternatives to the constricted ground their mothers and grandmothers had occupied. Living in New York City as a young adult, Lange was poised to view some of the outlets that provided independence to a new generation of women in the new century.[3]

The fierce sense of independence that buttressed Lange's disdain for authority also set her apart from others. As a child Lange developed a serious outlook toward the world, and she coupled it

with a strong will. Both developed out of a yearning for self-protection. At the onset of Lange's pubescence, her father abandoned the family. The incident was terrible enough that Lange uttered not a word about it, even to two husbands and her children, for the rest of her life. In the wake of her father's disappearance, Lange's mother, forced to become the sole breadwinner, sought employment across the river from their home in Hoboken, New Jersey. She took a job in a library on New York's Lower East Side and enrolled young Dorothea in a nearby public school. Lange saw firsthand the steady stream of immigrants who packed themselves into the bustling Jewish neighborhoods. And she competed daily with ambitious children who strove diligently to succeed in their new homeland. Lange was a German Protestant, the only non-Jew in a school of three thousand Jewish students. It was here that she learned what it was like to be in the minority, but as she later pointed out, "I was a minority group of one." A loner, Lange shielded herself from her classmates' world, closely observing it but never becoming part of it. After school she spent the late afternoons staring out the windows of the library where her mother worked, studying the frenetic activity of "the sweatshop, pushcart, solid Jewish, honeycomb tenement district." The window panes separating Lange from the subjects she viewed served much the same purpose as the camera lenses she used in later years. Lange hid behind them, appeared unobtrusive, and studied tirelessly with her eyes.[4]

Her desire to become part of the environment without drawing attention to herself developed as a response to her physical disability. A victim of polio as a child, Lange walked with a limp, and at her mother's constant urging she attempted to conceal it and appear normal. She tried to wrap herself in a "cloak of invisibility," hoping to avoid notice by those around her. Lange would later attempt to do the same when she began photographing, so that her subjects would not be distracted by her presence. In downplaying, even hiding her appearance, Lange challenged the cultural prescriptions of the teens and twenties, when advertisements directed at female appearance and health multiplied by the hundreds. These ads were frequently accompanied by visual images of the physical ideal, depicted as a rosy-cheeked and athletic young woman, a bicycler in the 1910s and a dancer in the 1920s.

Ever conscious of her disability, Lange perfected her method of invisibility as a teenager, hiding from the inherent dangers in a poor, urban environment. Walks home through the threatening Bowery section taught her to mask her emotions so she would attract no attention and therefore no trouble. The effort helped her to dispel any fears, further creating a shield between her and the strangers she encountered. She remembered consciously altering her facial expressions so that "eyes [would] go off me." In essence her manipulations of face gave her power. Using the face to effect certain reactions became a common tactic of Lange's. She began with her own face as a teenager; as a photographer she worked with other faces to achieve the looks, and thus the images, that she desired. In drawing out certain expressions on her subjects' faces, Lange attempted to control the reactions of those who viewed her photographs. It seems that she deliberately brought the human face into focus so that the rest of the body would be overshadowed by the complexities found in eyes, mouths, and other compelling features.[5]

Though Lange attempted to keep others from watching her as a teenager, she continued to watch them. Her short stint in an all-female high school in uptown Manhattan further encouraged the solitary individual in Lange to grow. She had few close friends there and chose to spend more and more of her time outside the institutional walls. Lange recalled wandering up and down the streets of the city, watching the people, looking at pictures, sharpening her observational skills. Because she felt that she was developing her artistic sensibilities, Lange defended her frequent absences from school, claiming that such activity was *not* "unproductive truancy." She managed to graduate from Wadleigh High School and at her mother's insistence pursued a teaching career by enrolling at the New York Training School for Teachers. Her senses dulled by the educational routine, Lange decided to indulge her visual curiosity. A visit to Arnold Genthe's Fifth Avenue studio proved fruitful. He gave her a job and a camera, but more importantly, he revealed to her his tremendous love for the human individual. Lange learned little about the technique of photography but much about the art of engaging people before the camera.[6]

Genthe possessed a sense of beauty that his young assistant came to appreciate, even though she was already composing a

definition of beauty that would set her apart from her male mentors. Lange observed Genthe's interactions with his subjects, most of whom were women, and later described him as "a man who really loved women and understood them." Genthe had one particular client, the modern dancer Isadora Duncan, who fascinated Lange. Duncan's departure from traditional movements and strictures of classical ballet secured a place for her in dance history. But so, too, did her challenge to conventional social expectations regarding the female body. Duncan's veil-like costumes, some similar to Greek chitons, revealed bare legs and bare feet. Off stage, Duncan dressed in classical Greek-style clothing that draped loosely over her body. Lange observed that Duncan was "rather sloppy-looking, rather fat, with very heavy upper legs" but that the dancer's movement in space was beautiful. In a penetrating examination of Lange's obsession with the body as a defining characteristic of identity, Sally Stein argues that Lange's own lameness impelled her to express difference "in terms of the well and ailing body as it intersected and could be aligned with more conventional forms of difference like class, race, and gender." Lange's scrutiny of the body and her unrelenting attention to its component parts became an underlying theme in her work. And it was her own physical difference, her alienation from the acceptable ideal of human health and perfection, that informed her artistic vision very early in her professional apprenticeship. That element joined with the other overriding impulse from her youth, the desire for personal freedom, as Lange continued her informal study of photography.[7]

 Alongside her aesthetic ponderings, Lange gained expertise in the photographers' trade through various part-time associations. In one job, for Armenian portrait photographer Aram Kazanjian, she solicited business by telephone. For another employer, Mrs. A. Spencer-Beatty, Lange became a camera operator. She was responsible for exposing the plates; others in the studio took care of spotting, printing, and mounting the photographs.[8] Finally, in 1917, armed with plenty of applicable knowledge, Lange turned her back on assorted part-time jobs and enrolled in a photography seminar given by Clarence H. White at Columbia. Upon Arnold Genthe's advice, she sought to absorb everything White could teach her about the art. White's influence had already touched a generation of young photographers. Doris Ulmann Jaeger, among others, had listened

to his meditations on style and the direction of American photography. Lange found the teacher's methods unusual, but she learned a great deal from him. She appreciated his subtle way of getting his message across without criticizing his students' work. She remembered that he "always saw the print in relation to the person." Though she clung to his words, Lange never completed White's seminar assignments. She drew more from his personal and professional example than she learned in his classroom. Lange considered White an outstanding teacher despite being "vague, indefinite, [and] non-didactic."[9]

Perhaps she recognized in White one who shared her love for the visual life. Rarely had Lange found anyone with whom she could claim a common interest. White was "a man who lived a kind of unconscious, instinctive, photographic life." Her respect for his pursuit of photographic excellence led her to remark, "I never saw any photo of his that had a taint of vulgarity." A few months into White's seminar, Lange knew she wanted to devote her life to pictures. But as she made quite clear in later years to interviewer Richard Doud, "[i]t was more a sense of personal commitment . . . [than] a conscious career." She was convinced that her mind "had made itself up" about photography. Lange's reflective look and personal narration of her path to photography places her squarely within the tradition in which she grew up, where careers and causes "found" women and swept them away. We do not know whether Lange read published autobiographies of the nation's more accomplished women in the early twentieth century, but if their public personae or written testimonies impressed her, then she followed their paths and told her own story as they had articulated theirs. Literature scholar Carolyn Heilbrun, in *Writing a Woman's Life,* describes a study conducted by Jill Conway on independent, successful, cause-driven American women in the early twentieth century. Each woman in her autobiography downplayed her career choice, following the only acceptable "script" for the female life which "insisted that work discover and pursue her, like the conventional romantic lover." For example, the controversial subject of the Standard Oil Company just "happened to be there" for Ida Tarbell. Beyond their lives designed for public consumption, though, these women's personal letters revealed aggressive, authoritative, and deliberative individuals. Even

though Lange never admitted having consciously chosen photography as a career, she carefully molded her artistic style and staunchly defended her independence as an artist; her attitudes at times alienated some of her friends and family and at least one employer.[10]

In 1918 Lange left New York City on a journey to see the world. She and her traveling companion, Florence Ahlstrom, made their way to New Orleans by boat and from there to the California coast by train. On her first day in San Francisco, Lange was robbed of everything but the change in her pocket. Forced to find employment, she immediately landed a job as a photo finisher in a store on Market Street. What had first appeared to be an unlucky turn of events proved fortuitous; across the counter Lange met a number of well-known photographers, including Imogen Cunningham, Roi Partridge, and photojournalist Consuela Kanaga. Photography curator Joyce Minick later remarked that Lange's employment there was "one of the first instances in her career when time and events were clearly in her favor." Not long after she took the Market Street job, a friend of a friend supplied three thousand dollars so that Lange could set up her own studio, which she opened on Sutter Street.[11] Achieving instant success, she marked her accomplishment as an up-and-coming photographer with a symbolic gesture—she dropped her father's family name, Nutzhorn, and took her mother's maiden name, Lange. This expression of independence, spurred by financial success, separated her from a ghostlike figure whose memory she had battled for over a decade. That she abandoned the patrilineal name in favor of the matrilineal name instead of choosing a completely new name suggested that her true freedom lay in separating from the principal male figure in her life and that the connection to her mother, however remote and filled with resentment, remained intact. These gender identifications would press Lange later when she married and had two sons, embracing burdens that would manifest themselves in the commissioned family portraits she made for her patrons.

Artistic and financial success allowed Lange to challenge her painful childhood status as a loner, as she joined a circle of artists who also happened to be friends. Roger Sturtevant, Lange's printing assistant, remembered the close-knit group that gathered daily

in her studio. He described a gag picture in which photographers Edward Weston and Anne Brigman, posing as parents, held Lange's camera (wrapped in a black photographer's cloth) in their arms. Imogen Cunningham and Lange, as the other children, rounded out the "family" portrait. Such evidence reveals not only Lange's pleasure in her work but also her comfort among peers. Ironically, the mock family portrait also showed Lange's preference for sharing intimacy with friends rather than with family members; that issue created a taxing struggle for her for most of her life. Lange enjoyed having an open door to her studio, where people gathered day and night. Each afternoon she served tea in an effort to attract patrons, but, she recalled, "by five o'clock that place was full of all kinds of people . . . [as] everybody brought everybody." Like other famous gathering places, such as those on Paris's Left Bank or in New York's Algonquin Hotel, the Lange studio radiated a club atmosphere. Its members worked, however, as much as they talked about their work. Sturtevant, who at the time was a high school student with an interest in photography, was impressed by his friends' work habits and believed they all prospered because they "only believed in working" and because they were reluctant to let politics dominate their craft or popular art trends guide their hands.[12]

Combining her talent behind the camera with her subtle promotional technique in the salon, Lange developed a large and devoted clientele rather quickly. Her reputation as a portraitist grew as news of her craftsmanship spread; Lange depended upon her wealthy patrons to tell their friends about her photography. Many of them had had their first glimpses of her work in the Hill Tollerton Print Room that adjoined Lange's studio. The gallery attracted loyal customers who could afford original etchings and prints. Lange was fortunate to draw support from a such a group, comprised primarily of families willing to spend unlimited sums of money on portraits. Lange described her rich San Francisco patrons as "large families who knew each other, and had a very strong community sense . . . , [with] children and education and buildings and pictures, music, [and] philanthropy . . . [tying] their private personal life and their public life together." By an ironic twist, nearly all of Lange's customers were prominent members of San Francisco's Jewish community. As a young child in New York,

Lange had stood outside her Jewish classmates' world as a mere observer of what she could not understand. As a highly sought-after professional, she entered the mansions, strolled about the manicured lawns, and befriended the children of her loyal Jewish patrons.[13]

Employing her invisibility tactics, Lange sought to put her subjects at ease by blending into the surroundings. Richard Conrat, one of Lange's assistants, described her unique approach in trying to capture "the essential person without managing to have her presence *felt* in the finished photograph."[14] Rarely did an individual appear anxious or tense before Lange's camera, because she preferred natural poses over stiff, formal ones. Her method of arranging her subjects provides a striking contrast to that of her contemporary Doris Ulmann, whose bustlike figures of writers, doctors, and academics harked back to the Roman style of preserving great men. Lange's subjects appear carefree, their bodies resting comfortably across chairs or their arms draped over fellow family members. This ease of posture indicated Lange's personal desire for effortless movement and brought her into the frame alongside her subjects, despite her attempts at invisibility. Perhaps, too, Lange was able to cross an ethnic and cultural barrier that had seemed too great for her years before, when she sat at the library window watching her classmates in the streets of New York City.

Beyond the soft lighting and simple backgrounds arranged in her portrait studio in 1919, Lange discovered early in her career the benefits of working outdoors. In addition to the advantages of employing natural light, she realized it was vital to picture individuals within their own environments. Lange would continue this practice on a larger scale during the Great Depression, when she expressed a profound desire to picture "a man as he stood in his world." Doris Ulmann ventured outside her portrait studio less frequently in the early years of her career. Once she began her fieldwork in the late twenties, dealing with a myriad of cultures in the rural northeast and the South, she recreated her studio everywhere she went. Lange exercised a greater desire to enter and be welcomed into the various personal worlds of her subjects, rather than creating a world around them or for them, as Ulmann did. In the numerous photographs Lange took of the Katten children,

most have a background of sunshine and wide open spaces. The subjects are not posed, nor have they combed, curled, or otherwise primped for the occasion.[15]

Lange's devotion to photographing families in the 1920s was juxtaposed with her own complex set of family relationships and responsibilities during that decade. In 1920 she married the painter Maynard Dixon, a friend of Roi Partridge and a frequent guest at the daily social gatherings in her studio. Dixon's carefree temperament and calculated eccentricities were well known in the San Francisco bohemian community. And although Lange was twenty years younger than her husband, she provided the necessary complement to a man who had an infamous reputation for irresponsible behavior. Lange contributed the serious, more introspective side of the liaison. Lange and Dixon had two sons together in the twenties. They often traveled to the Southwest so that Dixon could revive his artistic self and dwell on the themes that interested him most—the haunting, spiritual elements characteristic of Native American culture. These trips left Lange limited time to satisfy her own artistic curiosity, since she believed her purpose should be to maintain a comfortable environment for her husband, her stepdaughter, and her two young sons. She later told an interviewer, "The largest part of my energy, and my deepest allegiances, were to Maynard's work and my children." Her struggle with these choices eventually manifested itself in an unhappy marriage and alienation from her children. The situation grew worse as her desire for independence coincided with the onset of the Depression. Lange decided to live apart from Dixon in her photography studio and to board their sons, Daniel and John, elsewhere.[16]

The substantial body of family portraiture that she completed during the years she was married to Dixon bespeaks her longing to remain a separate and independent entity despite her role as wife and mother. In Lange's family portraiture (of other families, not her own), she highlights the individuals within a family. Although they may share a physical connection or a touch, the single individual's role in a photograph transcends the importance of the pair or the group. David Peeler has argued that Lange's "romantic depictions" of family during the years she was nurturing her own family stand apart from her later work. But a closer look at the example that Peeler included in *Hope Among Us Yet* (fig. 13)

Fig. 13. Dorothea Lange. *Mrs. Kahn and Child, 1928.* © Dorothea Lange Collection. The City of Oakland, Oakland Museum of California. Gift of Paul S. Taylor.

is necessary. In *Mrs. Kahn and Child* an infant is being pressed
upon, nearly smothered, and definitely obscured by the figure of
the mother. The position of the child's arm, an erratic wave indi-
cated by the blurred portion within the frame, suggests self-de-
fense, perhaps even a gasp for breath. Lange created this family
scene when she herself was caring for two young sons, one an
infant, the other a toddler. Lange had become a mother in a de-
cade when standards of motherhood jumped significantly. Society
required that women assume much more personal responsibility
for their children's health and cleanliness than they had held be-
fore, thus creating heavy psychological burdens in the process. The
pressure to rear children properly, to appease a temperamental
husband, and to nourish a burgeoning career, was visible in Lange's
family portraits. Rarely in Lange's work is an entire family posed
in a portrait, because she preferred not to line up the whole clan.
She did not believe that the "intense alliance" within the human
family could be adequately recorded. And she found it especially
difficult to photograph her immediate family members together.
Later comments about her own children reveal a separateness from
them: she referred to them in an interview as "the little boys" and
"the two little boys" rather than "my" boys or "our" children or
by name.[17]

Lange focused overwhelmingly on the individual stranger's
life, using her images to imply that a single human was much more
important than anything that surrounded him or her. Even in the
1930s, when Lange began photographing Depression victims, she
concentrated upon the individual man, woman, or child. The human
element surpassed mere symbols of financial disaster such as the
eroded soil or an empty pocket. The images of Lange's wealthy
patrons in the 1920s disclose many of the same characteristics
present in her later portraits taken for the federal government.
Lange's studio print books reveal hundreds of faces bearing the
dignified, almost heroic, look that the photographer captured so
well on film. The style Lange developed early in her studio career
is clearly expressed in an undated series of sitter Erika Weber. A
couple of poses were taken outdoors, though these offer few clues
about the location. In one pose, Weber's head is tilted slightly to
the right as she observes something in the distance, outside the
frame of the photograph. Lange's purposeful omission of such

evidence infuses the image with mystery. In another proof Weber wears a scarf tied around her head as she stands with hands on her hips. In such an unlikely pose for a rich urbanite, the subject could as easily have been a farmer's wife surveying the year's crop. But the viewer is not allowed to see the ground Weber occupies. Lange peers up at the subject, making her the principal focus and ignoring the ground on which she stands. This stylistic preference, the photographer's upward gaze, helped Lange achieve a certain "look," one that appeared in her early studio work and showed up again and again throughout the 1930s. Defining this quality as a certain "tonality" rather than a "style," Lange admitted that particular photographs would make her exclaim, "Well, there's a Lange for you."[18]

Although Lange was a commissioned artist who had to keep her customers' satisfaction in mind, she eschewed "pandering to their vanity" and offered what she believed were accurate representations of character and personality. Of her portraiture, Lange said, "I was a professional photographer who had a product that was more honest, more truthful. . . . there was no false front in it. I really and seriously tried, with every person I photographed, to reveal them as closely as I could. . . . No posturing, no dramatics." This approach helped Lange depict the world of the San Francisco wealthy beyond the trappings of wealth, narrowing the focus to those elements common to all human beings. She admitted that in her early years as a portraitist, she encouraged her subjects to wear "odd, simple clothes" so that "the images would be timeless and undated." The goal of achieving timelessness aligns Lange's intentions with those of Doris Ulmann. Both photographers sought to eliminate the present from their images. Ulmann encouraged her sitters to don ankle-length frocks and bonnets to achieve this objective, but Lange preferred clothing that would betray no particular era. In addition, Lange's philosophy for accurately revealing personalities through the medium of photography differed from that of Ulmann, who believed that certain props—pens for writers, costumes for actors, knives for woodcarvers, and other accoutrements of skill or interest—drew out individual characteristics and distinguished one person from another, thus making him or her unique. Whereas Ulmann depended upon physical objects and backdrops that set individuals apart from each other,

Lange cared more about the common experiences of human be-
ings that tied them together. No doubt the reason Lange relied
less upon props than Ulmann did was that she considered them
secondary to the overwhelming marker of experience—the human
face.[19]

Nothing intrigued Lange more than the human face. Within
the body of her work, no other subject received as much atten-
tion. She believed the face spoke a "universal language." Of its
power she said, "The same expressions are readable, understand-
able all over the world. It is the only language . . . that is really
universal. It's [sic] sad, shades of meaning, it's [sic] explosions of
emotion and passion . . . I'll concentrate on just this part of the
human anatomy where a slight twinge of a few muscles . . . runs
the gamut of that person's potential."[20] She remembered well the
poignant, pained expressions in "that noble wasted face" of Presi-
dent Woodrow Wilson as he desperately tried to garner support
for the League of Nations outside the St. Francis Hotel in San
Francisco. From her earliest years as a portrait photographer, Lange
viewed sanguine, unhappy, angry, hopeful, and contemplative faces,
capturing on film the wide spectrum of expressions arising from
the human condition. Two notable studies composed on one of
her journeys to the Southwest reveal Lange's unique ability to
extract meaning from a face and record it. In one photograph the
surrounding darkness frames the face of a Native American woman
deep in thought. Because her head is covered, even more atten-
tion is directed toward her facial features and the contemplative
expression they form. In the second study, a series of an ancient
man wrapped in a blanket, Lange used light to illuminate the signs
of age on the Indian's face. A wrinkled jowl in profile shows the
desert sun's parching effects. In another image within the same
study, Lange pointed her camera directly at the old man, whose
eyes were turned away from her as he stared off into the distance.
Rarely capturing superficial smiles, Lange preferred to record her
subjects' more complex expressions. In her portraits of Hopi natives,
Lange places herself, serious and brooding, yet invisible, along-
side them. Or in many ways, inside them. Her early images were
largely about who she was, not who the Hopi Indians were. Lange
realized that her pictures revealed as much about who stood be-
hind the camera as about who sat in front of it. She once said, "A

photographer's files are in a sense his autobiography. . . . As fragmentary and incomplete as an archaeologist's potsherds, they can be no less telling." She expressed the same sentiment when she stated, "Every image [a photographer] sees, every photograph he takes, becomes in a sense a self-portrait."[21]

Her camera work in the southwestern desert paved the way for Lange's later work with federal relief agencies. Here she saw for the first time people who did not share in the abundance of twenties America. Although she experimented on a limited basis with southwestern landscape, Lange believed the native inhabitants were far more interesting subjects. Her documentation of Indian life covered the region around Taos, New Mexico, and northern Arizona. While her husband looked inward to cultivate his own artistic tastes, Lange spent time exploring the everyday life, rituals, and work habits of the Hopi tribe members. In keeping with her focus on the individual, Lange brought her portrait-studio mentality to the wide open spaces of the desert. When she discovered a particularly fascinating subject, she chose to take a series of photographs of the person or scene, thus creating a composite study. Lange's catalogs of negatives reveal the wide range of interests she nurtured during her Southwest adventures. She concentrated equally upon mothers, children, young men, and village elders. These images of Native Americans taken in the 1920s are similar in style and content to the pictures she took for the U.S. Government in the 1930s. The choice of subjects, the use of light, the preferred camera angles, even the dominant themes of individual independence and human dignity, remain constant throughout the twenty-year period.

A favorite stylistic technique enabled Lange to draw from her subjects expressions of pride and dignity. To achieve the "look" for which she later became famous, Lange crouched down a bit so she could point the camera up at a slight angle. This device, though subtle, infused an image with an easily readable message—the pictured individual deserved respect since the camera (and thus the viewer) peered up, rather than down, at him or her. Lange's equipment required her to look down into a viewfinder, with the camera held about abdomen level, thus creating the image of a reverential bow to her subjects. A few of Lange's earliest portraits, dated either "1920s" or "1923–1931," reveal this particular tech-

nique. In one experiment with light and dark contrasts, Lange composed a portrait of an adolescent Indian boy shown from torso to head. Though he looks directly into the camera, his head is bent downward to make eye contact with the photographer. In another similar series, Lange focuses on a Hopi man, maintaining her lowered position so that the image appears full of pride and hope. In a closer view of the same subject, the man, who has taken off his shirt, exudes an air of confidence, but confidence devoid of conceit. Lange managed early in her career to discern the difference. She was able to isolate and highlight commendable traits, while neglecting the less appealing side of human nature. Perhaps she attempted to find what was exemplary because she believed it existed everywhere and in everyone, regardless of ethnic background or social class or economic constraints. But she did not force a formulaic vision upon her artistry. Her method resembled the American expatriate writer Gertrude Stein's attempts to clear her mind before writing a portrait. Lange's contemporary, Willard Van Dyke, described his colleague's method in 1934—"For [Lange], making a shot is an adventure that begins with no planned itinerary. She feels that setting out with a preconceived idea of what she wants to photograph actually minimizes her chance for success. Her method is to eradicate from her mind before she starts, all ideas which she might hold regarding the situation—her mind like an unexposed film."[22]

All of the images that Lange created reflected her aesthetic sense. An examination of her 1920s studio portraits, her commissioned family pictures, her Native American studies, and her 1930s farm relief photographs reveals that Lange altered her visual preferences very little, if at all. The years from 1919 to 1940 were her most active as a photographer, and during those years her focus on the human individual remained unchanged. Because of Lange's respect for humanity, she depicted inner stability and downplayed external circumstances. The basic vision she had developed as a young child in New York City endured, but it was augmented by two memorable episodes that helped solidify Lange's direction and purpose as a photographer. The first occurred one summer when Lange was experimenting with landscape photography in the California mountains. She was caught in the midst of a raging thunderstorm and

said that she realized during those brief, frightening moments that she should devote her attention only to human subjects, that she must "take pictures and concentrate upon people, only people, all kinds of people, people who paid me and people who didn't." After her life-changing experience in the desert thunderstorm, Lange began advertising her studio work on printed flyers that read simply "PICTURES OF PEOPLE—DOROTHEA LANGE PHOTOGRAPHER." Documentary filmmaker Pare Lorentz once said of Lange's work, "You can usually spot any of her portraits because of the terrible reality of her people; in short, she is more interested in people than in photography."[23]

The second memorable episode that helped Lange to clearly define her role as a photographer occurred three years after the thunderstorm epiphany. At the height of the Depression in 1932, Lange sat in her studio window watching the unemployed men drift by on the streets while she examined the proof prints of her wealthy sitters. She recalled that "the discrepancy between what I was working on in the printing frames and what was going on up the street was more than I could assimilate." That view through the window crystallized for her a few months later when she and Dixon went to see the Noel Coward movie, "Cavalcade," a story about nineteenth-century Victorian life. As they strolled out of the theater, newsboys walked the streets yelling "EXTRA! EXTRA!" about President Franklin Roosevelt's declaration of a bank holiday. Roger Sturtevant remembered that Lange visited him the next day, still "stunned" by her experience. She "had come out at the end of one era and the beginning of another." He noted that "from then on she became interested in photographing the poor [and] downtrodden."[24]

Lange's pivotal experiences coincided with the burgeoning documentary tradition in the United States that encouraged writers, artists, sociologists, filmmakers, photographers, and others to go out into city streets, rural highways, and fields to observe people coping with the effects of economic depression and social dislocation. The prevalence of such subject matter, hundreds of thousands of hungry and displaced Americans and their environs, compelled the creative eye and mind in the 1930s. Lange joined fellow artists in the 1930s whose close scrutiny of Depression Americans resulted in texts, written or visual or both, that were designed to

shape public opinion. The persuasive nature of documentary texts produced in that decade engaged the viewer and the creator in direct dialogue with each other. Even the titles of the works suggested that readers could claim part of the examination process or, at the very least, identify with the subject. Among those published were *You Have Seen Their Faces, Let Us Now Praise Famous Men, Twelve Million Black Voices, Preface to Peasantry,* "The Plow That Broke the Plains," and "The River." As William Stott pointed out in *Documentary Expression and Thirties America,* "Thirties documentary constantly addresses 'you,' the 'you' who is we the audience, and exhorts, wheedles, begs us to identify, pity, participate." British film critic John Grierson, who in 1926 had coined the term "documentary" to describe films, argued that such films "should educate and persuade," not merely chronicle factual data.[25]

Though Lange never mentioned and probably never heard of Grierson, her pictures nonetheless satisfied the simple requirements he had articulated. She created visual images that spoke to a viewer's conscience. Lange believed that a photographer could cause a viewer to look at a picture of something commonplace and find some extraordinary quality in it. The photographer as facilitator, then, helped the viewer eradicate mental walls, rethink misconceived ideas, and sharpen dulled senses. Insisting that a photographer always keep the potential viewer in mind, Lange articulated the desired results. Of the person who saw her pictures, she said, "My hope would be that he would say to himself, 'oh yea, I know what she meant. I never thought of it, I never paid attention to it.' . . . You have added to your viewer's confidence or his understanding." Well beyond enhancing a viewer's understanding of a chosen subject was the responsibility of selecting what would be looked at. The tremendous power of documentary resided in the choice of subject matter for an audience's consideration. This selection process made documentary form a type of "biased communication" that allowed a photographer or reporter or social scientist to reveal only as much as he or she wished.[26]

Lange believed that her deeply personal experience and struggle with the Great Depression and its victims led her into documentary photography, although she later said that she was

practicing a style that "at that time . . . [had] no name." Years before the term *documentary* gained popularity and well before the Depression, Lange had cultivated the photographic vision and accompanying technique necessary for shaping solid social documents. Human subjects had always been the most important to Lange, and they continued to demand her full attention in the 1930s. Alone in her Montgomery Street studio in 1933, Lange found time to contemplate her own situation while she stared out the windows at unemployed passersby. Street life seemed to divide her concentration. She neither wanted nor could afford to turn away from her wealthy patrons, but she felt the outside world pulling at her. She said of this need, "I was compelled to photograph as a direct response to what was around me. . . . I was driven by the fact that I was under personal turmoil to do something." The inner disquietude of her solitary existence without her children combined with the restlessness she witnessed in others heightened in Lange the impulse to create photographs with social significance. This motivation placed her squarely within the emerging documentary tradition, and it led her to return to the streets, to observe the people there just as she had done as a child in New York City. This time, though, she carried a camera with her.[27]

On her first trip out among the unemployed, Lange managed to capture an image that would become an icon of the worst Depression years. Neglecting her friends' warnings to stay away from the areas where desperate victims congregated, Lange ventured over to a breadline set up by a wealthy San Franciscan called the "White Angel."[28] In the hungry crowd Lange found a solitary individual (see fig. 14). Having turned away from the other men, his singular presence overwhelms the others so that they serve as a mere backdrop for the portrait. The man's eyes are hidden, but his bewhiskered mouth and jowl are set in a pose from which his misery emanates. His hands together, the left hand is spread to cover and protect his right hand, which at first glance appears to be a fist. However, the position of his right thumb, which rests on top of his left thumb, keeps him from harboring a readied fist. The gesture suggests, instead, a wringing of one's hands. The figure only loosely steadies his empty, beaten tin cup, rather than clinging tightly to it, and thus exudes a patience not demonstrated by the other men in the photograph. The other element that sets

this individual apart from the others is his appearance. He has the only unshaven face and the dirtiest, most ragged hat in the crowd. He stands in a breadline among men who have enjoyed higher stations in life than he obviously has. And he represents numerous poverty-stricken Americans in the early years of the Roosevelt Administration who seemed to fall through the cracks of federal government relief. The conservative measures that constituted the early New Deal in 1933 left men like the loner in *"White Angel" Breadline* as they had always been—voiceless and without help. Those in the better hats and cleaner coats with neatly trimmed mustaches received the first nods during the Depression; here, in this scene, they push through to the front of the breadline. Lange's ultimate message is one of desperation, not defiance, and it set the stage for the way she would depict the poor throughout the 1930s.[29]

The subject of her first "street" photograph, the man in the White Angel breadline provided the substance Lange had been searching for. Lange remembered, "I knew I was looking at something. You know there are moments such as these when time stands still and all you do is hold your breath and hope it will wait for you. And you just hope you will have enough time to get it organized in a fraction of a second on that tiny piece of sensitive film."[30] What Lange found fulfilled her need to answer the Depression, to react against a horrid economy that had forced her to live in her studio and place her children elsewhere, away from her. But the *"White Angel" Breadline* print represented much more. It was Lange's reacquaintance with street life; it suggests a rekindling of her own memories of a dismal childhood spent as a loner on the Lower East Side. The *"White Angel" Breadline* image, an autobiographical document, shows a man turned against the flow of the crowd—at once unique, despondent, and alone. Perhaps Lange saw in this man's circumstances an accurate, if uneasy, parallel of her own experiences. In those few moments at the breadline, Lange's training as a portrait photographer and her inspiration as a documentarian came together. At once, her documentary style solidified. The substance would be the patient and deserving poor, with dignity intact, waiting for help rather than violently demanding it; the form would be the single individual contemplating his or her circumstances. But one question remained—Who would be her audience?

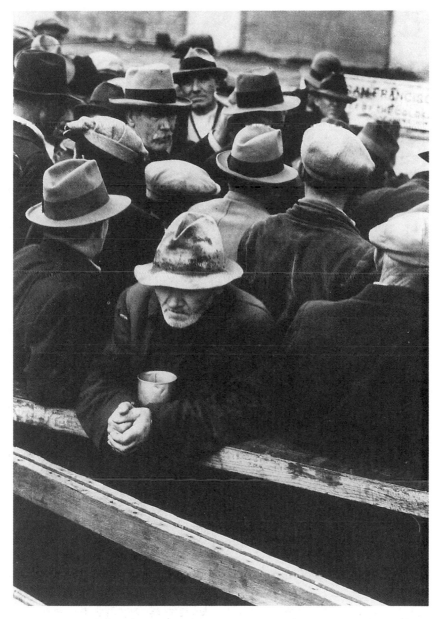

Fig. 14. Dorothea Lange. *"White Angel" Breadline, San Francisco, 1933.*
© Dorothea Lange Collection. The City of Oakland, Oakland Museum of
California. Gift of Paul S. Taylor.

The day after she discovered the White Angel breadline, Lange developed her film. She immediately hung the print in her studio, and in a significant move, she also bridged the distance to her long-neglected East Coast home by sending a copy of the print to a gallery in New York City. Edward Steichen, a highly regarded photographer and critic, was astounded when he viewed the Lange picture in an exhibit. As Roger Sturtevant remembered, "Steichen saw it and everything else in this exhibit was wiped out as far as [he] was concerned. This man with the tin cup . . . this was real photography and this was the essence of what photographers should be doing." A representative image, *"White Angel" Breadline* helped open Lange's eyes to new possibilities for her career, while encouraging her to examine the very personal reasons behind her use of the camera. She hesitated to abandon her wealthy patrons, but she yearned to explore what she called the "bigger canvas *out there.*" Despite her exciting initiation on the streets of San Francisco, Lange chose to continue studio portraiture for a few more months so that she could eat, pay her sons' board, and finance her "other" photography. But she soon realized that doing both kinds of work was "a strain."[31]

General unrest over her work and her personal life sealed the transition for Lange. Her initiation into street photography sparked a political conscience. Strikes on San Francisco's waterfront and other worker demonstrations encouraged her to take her camera into highly charged, sometimes violent situations that she could view from her Montgomery street studio. But Lange's photographs rarely highlight mayhem or destructive action. At a 1934 May Day demonstration, Lange shot scenes of the featured speakers and of listeners in the crowd. In one image (fig. 15) a woman listens intently to the message, but the sun on her face distorts her expression to one of skepticism. Lange positioned herself so as to show the subject in a dignified pose, with her chin up and her head held at a slight angle. The woman's calm demeanor implies that she will not resort to violence, despite the impassioned rhetoric that the rally speakers spout. The newspaper headlines—"The Workers Took the Wrong Path in Germany and Austria" and "What is 'Americanism?'"—promote a tone of responsible, educated citizenship. This urban worker is a reader who after listening to the speeches will peruse the written arguments and make an informed

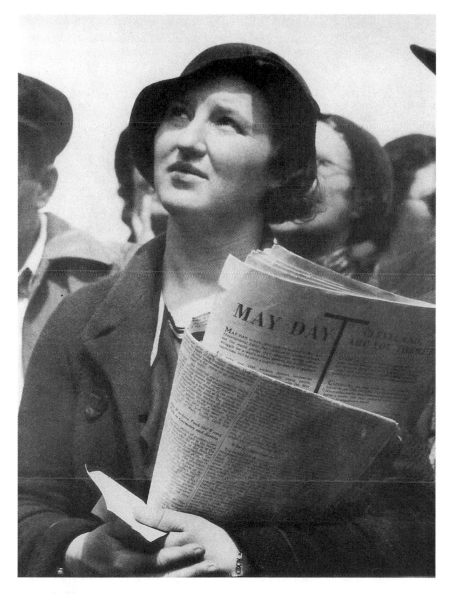

Fig. 15. Dorothea Lange. *May Day Demonstration, San Francisco, 1934.*
© Dorothea Lange Collection. The City of Oakland, Oakland Museum of
California. Gift of Paul S. Taylor.

decision based on logic and rational thinking. Nothing in Lange's frame suggests a situation out of control. In fact, the participants appear ennobled by their controlled reactions at the rally. Lange's signal to the viewer of this image is one of reassurance about the notion of mass demonstration. She dilutes the crowd by showing the full head and expression of only one participant. In the rest of the frame are partial faces, including one person's ear, another's jawline, and yet another's profile. But we do not see their eyes, because they would have detracted from the principal subject of the portrait, the calm, informed, attentive listener. Nor does Lange show the feet of the crowd, which could have revealed frenzied activity or, at the very least, a sense of motion. Nowhere does she hint that the labor situation was volatile enough to turn into the bloody fiasco that it did a few weeks later. In July 1934 the worst strikes in San Francisco's history injured many laborers and claimed the lives of two people, whose funeral procession included an estimated fifteen thousand to twenty thousand union members and supporters. Yet Lange's portrayal of labor chaos evokes control, not madness. Photo historian Anne Tucker has described Lange's intent in her documentary work as "gentle," noting that "[s]he did not want to introduce, but to remind us of things."[32]

Like many of her contemporaries, who also grew more politically aware in the 1930s, Lange did not allow radical leftist ideology to overwhelm her. Clark Kerr, who was a Stanford graduate student writing a thesis about the unemployed in the 1930s, worked with Lange in the midthirties. He described her as "one of the most nonideological persons I have ever known. . . . I never heard one word or saw one gesture that in any way indicated that she was a committed ideologue." David Peeler has cast her with a group of well-known thirties documentarians who he says were more interested in their personal "emotional quandaries" than in ideology, so that there "was a certain intellectual softness, an unwillingness to employ ideology, among American thinkers of the 1930s." Such an unwillingness led Lange to create images that exuded quiet desperation, controlled action, and individual, not collective, contemplation. As a result the subjects in her thirties work take on a characteristic that was common among figures used to appeal to viewers' emotions. They were "sentimentalized," argues William Stott.[33]

Lange's primary emotional quandary during this transitional phase in her career was a widening philosophical gap between her and Dixon. He argued against her newfound interests and discouraged her from getting involved in political activities. Lange later said of the left-wing groups that sought her support, "I'm not sure that it wasn't the right thing to do . . . participating in groups of people who were ready to take action," but she resisted the temptation. Dixon looked skeptically upon political loyalties, and he dissuaded his wife from attending party gatherings. But armed with a fresh sense of social responsibility, Lange continued to pursue subjects outside her studio. The distance separating Lange and Dixon increased as their respective artistic philosophies took divergent paths. Dixon clung tenaciously to an aesthetic standard that praised art for its own sake, whereas Lange felt that her photography could serve a larger social purpose for the cause of humanity. She sensed a deeper connection to her surroundings than her husband did to his. Though she was not speaking of Dixon specifically, Lange once noted that an "artist" photographer maintained only a "very slight . . . alliance with the world." This explains in part why she felt more comfortable working on the West Coast, away from her native New York City with its artists' colonies and photography groups. Lange's friend Willard Van Dyke offered similar sentiments, explaining that there was "a feeling that the Eastern photographic establishment was too theoretical . . . too parochial—they couldn't see anything except their own little worlds." Lange, it seems, began to realize the same about her husband's frame of reference, contrasting the contributions her photography could make to society with the limitations of his paintings. Therese Heyman, curator at the Oakland Museum, in discussing the differences between Lange's and Dixon's work in those crucial months, notes, "In her 1934 photographs, Lange was an articulate witness to the most stubborn and intractable truths of her time—the possibility of civil insurrection. She made memorable images, partly eulogistic, partly despairing as in "White Angel Breadline," but unlike Dixon, the rebellion is never out of control. Dixon's visions are suffused with fear; Lange's, on the other hand, are confident and human."[34] Even if her photographs exuded confidence, Lange herself remained unsure about forging ahead in a new direction until she had received reassurances. These

came from two sources, Oakland gallery owner Willard Van Dyke and University of California economist Paul Taylor.

Van Dyke put up a Lange exhibition in his Oakland studio, Brockhurst, in 1934. Comparing Lange's talents and pictures to those of Civil War photographer Mathew Brady, Van Dyke said in his commentary, "Both Lange and Brady share the passionate desire to show posterity the mixture of futility and hope, of heroism and stupidity, greatness and banality that are the concomitants of man's struggle forward." Attempting to prove his point, he showed the public Lange's images of hungry bread-seekers, May Day demonstrators, impassioned union leaders, and determined strikers. One viewer who was impressed by what he saw was social scientist Paul Taylor of the University of California. He had been gathering information on labor by carrying out field research among striking agricultural workers in the San Joaquin Valley. An assistant praised Taylor's approach, noting that "Paul was always out there finding out what was really happening while others played around with their theoretical models and ran their regression analyses." Part of Taylor's hands-on methodology included the use of photographs. He recognized immediately the breadth of Lange's talent and her vision. Within a few months, the two were working side by side for the Federal Emergency Relief Administration in California.[35]

Taylor helped Lange gain the confidence she needed to continue photographing in the outside world among the unemployed poor and dispossessed. Although she had always energetically pursued her visual interests, she lost a fraction of her verve when Dixon failed to confirm her socially inspired work. His opposition created doubts in Lange's mind, forcing her to seek approval for her pictures elsewhere. Recognizing Lange's apprehensions, Van Dyke noticed the impact of Paul Taylor's support of the government's newest employee. Van Dyke said that Lange was seeking "validation for an approach that she was struggling with as far as this photography was concerned. And Paul gave it." The professional collaboration soon expanded to include a personal relationship between the two, as they undertook field trips throughout the state. In spite of their respective marriages, Lange and Taylor found their intimate liaison a necessary complement to the work they were doing. Lange reciprocated the support Taylor offered

and justified her request to Dixon for a divorce in 1935 by say-
ing, "I want to marry Paul, he needs me." In the same year that
Lange forfeited her life with the wild-natured, often unpredict-
able artist, she closed her San Francisco portrait studio for good,
casting her future with a man who was the personification of solid,
respectable citizenship. In a professional sense, both the photog-
rapher and the economist felt that their complete devotion to each
other would strengthen their collaborative efforts.[36]

The realization that she was serving an expanded audience, be-
yond the wealthy families who had supported her portraiture
business, prompted Lange to reconsider the function of her pho-
tographs. If her pictures were to be as useful as she hoped, she
thought they needed to be accompanied by words. She believed
one was incomplete without the other—words had to help explain
pictures, and the visual had to illuminate the verbal. Lange saw
the inherent weakness of photography, one person's act of select-
ing a small piece of the present. She noted, "When you take it out
and isolate it, a good deal falls through the slot." To characterize
her concern, Lange described the life of one particular woman
depicted in a photograph, pointing out that the viewer might see
the woman in the picture but would never see all the things that
surrounded her and influenced her life. As the photographer, Lange
experienced what she termed a "visual flood," but knowing that
her viewer would not have the same opportunity, she asked dis-
concertingly, "How can you put that . . . so somebody else will
understand it?"[37]
 Lange felt that Taylor's words would help bridge those gaps
and would complete her pictures; she found a voice for her im-
ages as Ulmann had discovered several wordsmiths for hers.
Novelist Julia Peterkin penned stories around Ulmann's photo-
graphs; Allen Eaton provided sociological data; and John Jacob
Niles was the one who engaged Ulmann's subjects, seducing them
into having their pictures made. Thus for both Lange and Ulmann
the most important "talkers" were the men with whom they trav-
eled in the field, the voices of authority who asked questions of
their subjects, recorded or wrote down the answers, and lent a
certain amount of credibility to the photographers' visual images.
Both women felt it necessary to include their research partners

alongside their subjects inside the photographic frame. Taylor appears with pen in hand in several of Lange's photographs (although he was usually cropped out by editors), and Niles is a subject in several Ulmann series, including an extensive one in which he engages a young Appalachian woman holding a symbol of the mountains, a dulcimer. After Ulmann died, Niles's captioning of her proof books left an indelible mark on her work, expressing opinions that reflect his tastes and prejudices much more than hers. Taylor's influence on Lange's photography was similarly significant; it was characteristic of the word-and-picture marriage that social documentarians of the 1930s embraced so readily.

The combination of visual and written sources gained popularity among socially conscious artists, writers, and scholars during the Depression. Many pooled their diverse talents to produce pamphlets, books, exhibits, films, and reports that employed both visual and written evidence. A photograph had the capacity to reach millions through the popular press, but if the picture had no caption, viewers could interpret it for themselves in any number of ways. With the right message attached, however, a viewer's opinion could be molded, crystallized, even changed completely. Lange believed that words were necessary to sharpen the visual acumen of most viewers and help them "see"—she once said that all photographs could be "fortified by words." The words Taylor wrote to accompany Lange's photographs came directly from the notes he took during field research. His training as a social scientist, with its requisite demands for objectivity, played a vital role in his choice of evidence. Both Taylor and Lange abhorred "poetic captions," favoring instead comprehensive, fact-driven, descriptions of the circumstances they had studied. Contemporary critic John Rogers Puckett has said that Taylor's captions "have the virtues of being interesting in their diversity and being factual descriptions or transcriptions rather than fabrications." Lange's 1930s photography was distinguished from the earlier work of Jacob Riis and Lewis Hine precisely by being "buttressed by written material and by all manner of things which keep it unified and solid." In Lange's opinion Hine and Riis had not produced true documentary, since both men considered words subordinate to the visual image. Lange agreed with her friend Willard Van Dyke, who later declared, "Words at that point were

so important . . . there was so much to be said. Our feelings were so strong about the Depression that just to show a picture just wasn't point enough." Despite their reflections years later on the role of words in thirties documentary, the image makers, the photographers themselves, wielded tremendous power through their construction of particular messages to be delivered to American audiences. A number of those photographers, including Dorothea Lange, gained access to a very large American audience by signing on with the U.S. Government, one of the most significant producers and users of the visual image–written word combination in the 1930s.[38]

In 1935, in the wake of heavy criticism from radical protesters and desperate pleading from displaced Americans, the Roosevelt administration turned its attention to those groups that were either left untouched or adversely affected by early New Deal programs.[39] Among the neglected groups of Americans were tenant farmers, migrant laborers, and victims of drought in the southern plains. A new federal agency named the Resettlement Administration (RA) was created by executive order in April 1935 to aid those hit hardest during the Depression years—rural Americans. Among the RA's proposed plans were to remove poor farmers from unproductive land, to provide housing and instruction about better land use, and to reorganize migrant labor camps, which to some conservative Americans and their congressional representatives seemed too radical, even socialistic. To counter expected opposition, RA administrator and Roosevelt brain truster Rexford Tugwell immediately organized a division within the agency called the Historical Section to sell the RA's objectives to the public.[40] Tugwell brought in Roy Stryker, his former graduate student assistant at Columbia University, to head this information division. Stryker's credentials included a brief tenure at the Agricultural Adjustment Administration in 1934, but he also had, more importantly, a commitment to disseminating information through the use of visual aids, including pictures, graphs, and other imagery. His previous work as illustrations editor for the textbook *American Economic Life and the Means of Its Improvement* (1924) and the place of photographs in his classroom presentations years earlier demonstrated Stryker's long-nurtured interest in visual images as educational material.[41]

That photography was chosen as the most appropriate and expedient vehicle for increasing and sustaining support for the RA, then, is not surprising. Glossy "picture" magazines, such as *Fortune, Look,* and *Camera,* were flourishing, and Stryker knew he could get the RA's photographs published nationwide, especially if he offered them free to any magazine, journal, or newspaper that would print them. Supporting the visual images produced by RA photographers would be words the agency deemed appropriate. And the overwhelming message in the RA's early months was that taxpayer dollars would be spent on people who deserved government assistance. Potential rebels and rioters, drifters, and derelicts stood outside the RA photographic frame; those who had been struck by natural forces or circumstances beyond their control—dust storms, flooding, erosion, mechanization—became the preferred subjects.[42]

Having worked briefly with the Federal Emergency Relief Administration in California, Lange understood the role of a government propagandist well enough that Stryker wanted to draw upon her experience. He hired her, Ben Shahn (a muralist), Walker Evans (an art photographer), and one or two others to complete assignments for the RA in the early months. Given the artistic backgrounds of this cadre of employees, it is evident that Stryker wanted to call upon not only their collective experiences but also their respective aesthetic senses. He believed that these three individuals would provide a balance for the agency's otherwise scientific survey of economic conditions. A close student of John Dewey's philosophies, Stryker sought to combine the products of art with the strengths of social science in order to appeal to the American public. The RA's objectives went beyond pure reportage and statistical tables to include actual people, whose facial expressions and bodily postures revealed a myriad of economic, social, and physical hardships. Distinguishing the Historical Section's work from other informational sources, Stryker interpreted RA photography as "the adjective and adverb. The newspicture is a single frame; ours a subject viewed in a series. The newspicture is dramatic, all subject and action. Ours shows what's in back of the action. It is a broader statement—frequently a mood, an accent, but more frequently a sketch and not infrequently a story."[43]

Though propaganda, the RA sketches and stories possessed

human interest value, a requisite quality for softening the role of the messenger, the federal government, without harming its credibility. In the 1930s the aim of social publicity was, as historian Maren Stange has pointed out, to "portray social and economic management as a matter of smooth, humane, bureaucratic administration." Lange understood completely her role in promoting the New Deal government's newest objectives because they had become her own passions a year earlier. She explained her devotion: "The harder and more deeply you believe in anything, the more in a sense you're a propagandist. Conviction, propaganda, faith." Lange's "innocent" victims of the Depression bore the appropriate characteristics of thirties propaganda, which according to William Stott arranged subjects so they appeared "simplified and ennobled." More than one analyst of Lange's RA pictures has said that the photographer knew how to create an image that made viewers turn their heads again and again to absorb her messages. When scholarly interest in RA photography began to emerge in the 1960s, one of the earliest critics to examine the RA file, Robert Doherty, noted that Lange "probed deep into humanity to come up with fragments of life that pulled the heart strings of all that could open their eyes to see." This is exactly what the RA hoped to accomplish—to make viewers look again, a second, a third, even a fourth time. Seeing their work "invested with spiritual significance," Allan Sekula suggests that certain documentarians are more than mere witnesses to situations and appropriately describes them as "seers." Indeed, Lange's desire for social change, combined with an unaltered camera style that highlighted human dignity and independence, made her that well-suited *seer* for the RA.[44]

From the desperate yet proud individuals who were her subjects, Lange created an inextricable combination that proclaimed a powerful message—she recorded personal character wrapped in adversity in order to argue that government funds could promote stability in the nation if they were distributed to people whose personal initiative and self-respect remained intact. Whereas Doris Ulmann had discovered that work promoted dignity, Lange seemed to intimate that this intangible quality had been sustained, perhaps enhanced, by a lack of resources. And that the government could serve to reward those whose fortitude had brought them through several years of economic devastation. In a series on

drought refugees who had made their way from Oklahoma to California, Lange produced an image whose female character exudes personal strength (fig. 16). She sits unflinchingly, with arms draped in a graceful, relaxed pose around an aggressively nursing child who has misshapened his mother's exposed breast with a turn of his head. He appears as determined as she is, drawing on her life nourishment and also internalizing the courage that has enabled her to travel a thousand miles west in search of a better existence. She appears not unlike her probable ancestors, whose facial characteristics she wears proudly. Her wide, flat-cheeked face with a sharp-angled jaw and close-set eyes reveal a tie to the Native American inhabitants of her home state; their one-thousand-mile trek one hundred years earlier had placed them in an environment as foreign to them as the one she now inhabits. She makes no effort to hide the tears along the side seam of her dress as she sits erectly in a makeshift shelter. Of the photographs Lange made in this series, this frame's iconography sends the most powerful message. Others, which show the woman in a less confident posture alongside her much more desperate, reclining husband (who takes up half the frame in the foreground), do not offer the simultaneous poignancy and complexity that the mother and child alone offer. Without the father figure in the photograph, Lange promoted within the RA her preferred view of the family, a fragmented unit comprised of staunch individualists.

That Lange's personal vision and the RA's initial objectives dovetailed reveals the weight of nineteenth- and early-twentieth-century standards in the prevailing cultural values of the 1930s. Lange had matured in an America that revered the strength of the individual making his or her own way regardless of the costs. Dependence on others was an admission of cowardice or laziness. From her painful childhood days Lange had developed a psychological stamina, an inner source of strength. One of her cousins pointed out that Lange was "tougher than any of the ones in our family. She had a much better sense of where she was going and nothing was going to stop her."[45] Lange believed that the potential for personal courage resided within everyone and that it came to the front when circumstances demanded it. A large portion of her work illuminates her ability to isolate and record this intangible quality on film. In a 1937 study of South Carolina share-

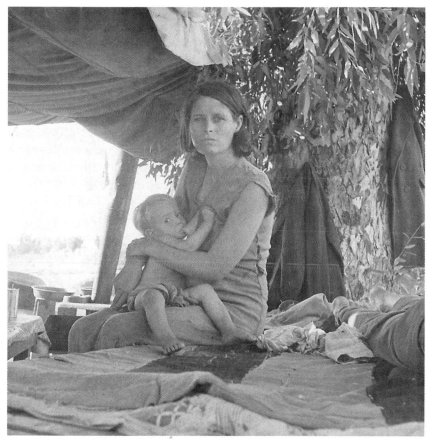

Fig. 16. Dorothea Lange. *Oklahoma Drought Refugees, 1936.* U.S. Farm Security Administration Collection, Prints and Photographs Division, Library of Congress.

cropping, Lange's values are emitted by a farmer who has paused in his field to strike the portrait pose that Lange so often preferred (fig. 17). With a firm grip on his manual plow, the man looks confidently into the sunlight, his spectacles reflecting it, appearing to ponder some serious question. Holding his chin and head up in a position of assurance, he exhibits the 150-year-old American sentiment that hard work in the soil can bring prosperity and lift one above other laborers who will never enjoy such independence. Although the viewer is allowed to see the farmer's neat furrows, Lange does not provide a glimpse of the immediate ground on which her subject stands. She omitted from the frame the actual object to which the sharecropper is bound by a wrist rope, allowing an element of mystery in the image. Any contemporary viewer familiar with farm equipment could have filled in this gap, but the uninformed viewer, especially the urban dweller, had to internalize the larger symbol—a man tied to the land but ennobled rather than trapped by his connection to it. This American farmer, as Lange depicts him, is the perfect icon for the RA audiences, who desired reassurance that RA money was being spent on the "right" kind of people. Photography historian James Curtis has argued that the principal viewing public for RA photographs was an urban middle-class audience who gazed upon images that had been carefully selected for them by Stryker's photographers.[46] The South Carolina sharecropper was an ideal subject for such audiences. His field suit shows no signs of carelessness, no rips or tears, and his chest pocket reveals the outline of a watch attached by safety pins to his suit. The secondary message promoted, then, is that the farmer's careful attention to his appearance denotes personal responsibility. Would this man not be a safe bet for RA funding, a good investment for the government aid? What better insurance for the nation's future than this proud, astute, and clean tiller of the soil? Like this lone farmer, many people depicted in Lange's thousands of RA photographs run parallel to the RA's fundamental beliefs about the role of individual fortitude.

The price of visually depicting personal independence was forgoing a focus on human intimacy. As adept as she was at getting people to cooperate with her, Lange seldom photographed them interacting with each other. More often than not, members

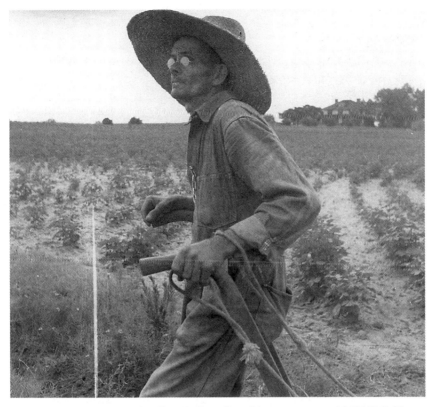

Fig. 17. Dorothea Lange. *South Carolina Sharecropper, 1937.* U.S. Farm Security Administration Collection, Prints and Photographs Division, Library of Congress.

of a group or a family had little or no contact in Lange's pictures. No image better illuminates this point than Lange's most famous photograph, *Migrant Mother* (fig. 18). Even though the mother's children surround her, touching her on all sides, she is separated from them by her thoughts and her faraway gaze. The children are merely appendages to the primary subject, the woman. Photo historian John Rogers Puckett, who believes the image is indicative of the entire Lange oeuvre, has said, "Like many Lange photographs . . . [Migrant Mother] depicts a moment of withdrawal into self—of isolation and alienation from the world. The theme of human estrangement runs through all of Lange's work." A very personal reflection of her own life, Lange revealed this isolation as a common thread in human existence, focusing upon it in her fieldwork as often as she could. Critic George Elliott identified *Migrant Mother* as "a sort of anti-Madonna and Child. . . . The mother, who, we feel without reservation, wants to love and cherish her children, even as they lean on her, is severed from them by her anxiety." Thus, the most widely published photograph that Lange ever took can be interpreted to reflect the most difficult decision she had made in her life up to that point—to board her children at school when the family finances would not allow her to keep them with her. James Curtis, who has conducted the most thorough study on the *Migrant Mother* series of photographs, discusses Lange's conscious arrangement of the composition. In her notebook Lange recorded that the woman had seven children, yet only four are present in the pictures. Curtis suggests that Lange did not want several more people in the photograph, since "five figures posed enough of an obstacle." Lange even positioned the children to achieve the desired effect. Curtis explains, "She had the youngsters place their heads on their mother's shoulders but turn their backs to the camera. In this way Lange avoided any problem of competing countenances and any exchanged glances that might produce unwanted effects. She was free to concentrate exclusively on her main subject."[47] And the "main subject" for the RA employee whose training had been in portraiture was the single individual, contemplative, perhaps anxious, but more stable than rebellious.

Lange's decision to focus on the separate individuals helped her avoid the complications of human exchange. This preference

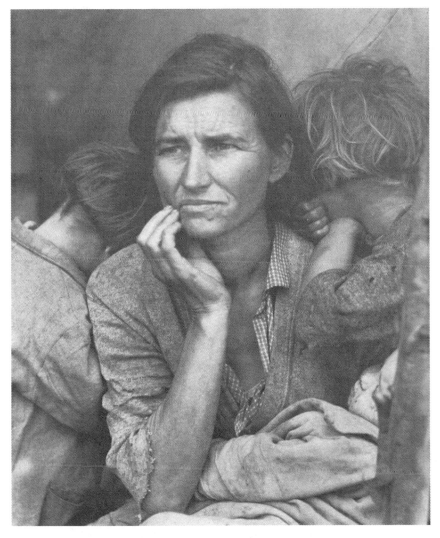

Fig. 18. Dorothea Lange. *Migrant Mother. Nipomo, California, 1936.* U.S. Farm Security Administration Collection, Prints and Photographs Division, Library of Congress.

may be seen in numerous other photographs, including a 1938 study of displaced tenant farmers in Hardeman County, Texas (fig. 19). Though all six men are in the same predicament, unemployed and disfranchised, they remain separate from each other, neither looking at nor talking to one another. Their personalities emerge, in part, through their various stances, two men with their arms folded, another with his hands in his pockets, and yet another with his hands behind his back. Their caps and hats, ranging from wide-brimmed to deep-billed, sit at dissimilar angles, from one that obliquely covers a right eye to another that shows a man's full forehead. Although the men constitute a group, through common distinguishing characteristics of gender, geographical location, and economic circumstance, they are not a unit. All of them emit personal dignity, but each is so different from the others that Lange could have made six individual portraits and achieved exactly the same end with her message. Another frame in this series shows the same men sitting on the ground. They cast their gazes in myriad directions, with not one crossing another's visual path. Despite their similar economic condition, individual diversity transcends what they have in common. Lange made an interesting observation about her penchant for seeking out individuals among the masses. Describing a photograph she took at the Richmond shipyards during World War II, she said, "The shipyard workers were coming down steps. . . it was a mass of humanity. . . . But what made the photograph so interesting was that they were all looking in different directions. There was no focus, there was no cohesion in this group. They were not a group of people united on a job. It showed so plainly. Their eyes were all over."[48] Lange understood the importance of remaining independent while under pressure to conform. Forced to become self-reliant at an early age, she always felt sympathy, even empathy, for individuals struggling against powerful voices of authority that sought to squelch individual expression. Although Lange and Doris Ulmann both preferred to focus on the single human life, Lange brought to her socially inspired photography one vital element that distinguished her from her rich New York counterpart. Lange always sought words to provide information that a visual image could not emit, regardless of its aesthetic beauty or its penetrating portrayal of the human spirit.

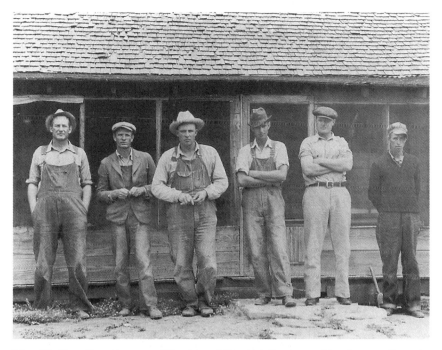

Fig. 19. Dorothea Lange. *Displaced Tenant Farmers. Hardeman County, Texas, 1938.* U.S. Farm Security Administration Collection, Prints and Photographs Division, Library of Congress.

Of all the field photographers Stryker employed, Lange wrote the longest captions. They rarely contained her personal interpretations, since she relied upon her eyes and her camera for that. In fact, Lange's word accounts showed much less conscious creative construction than did her visual images. She chose to record the exact words her subjects uttered, sending to Washington "verbatim accounts to accompany her photographs." Her husband, Paul Taylor, remembering that Lange carried a loose-leaf notebook for such purposes, claimed that she carefully practiced "using her ear as well as her eye." Taylor wielded a great deal of influence in this area, since he accompanied Lange on most of her field assignments and in some cases interviewed the people whom Lange photographed. She had learned the technique from Taylor after observing his style on their earliest trips together.[49]

The best-known Lange image that includes Taylor in the frame conducting an interview was one she took near Clarksdale, Mississippi, in 1936 (fig. 20). A husky plantation owner, in a cocky stance with one foot propped on his new automobile, converses with Taylor as one black man stands and four others sit quietly in the background. Various editors cropped Taylor out of the picture for their publication purposes, even though the original negative shows him prominently. When Archibald MacLeish used the photo in his 1938 publication, *Land of the Free,* he further cut the picture, leaving out the African Americans. The plantation owner's image illustrated MacLeish's poetry, which included the words "freedom," "American," and "pioneers." The irony of MacLeish's verbal message placed beside the original photograph would have been too overwhelming for the Jim Crow South, so MacLeish purposely avoided the potentially explosive combination. Three years later, Richard Wright and Edwin Rosskam used the photograph in *Twelve Million Black Voices* as a parallel text on the same page with a definition of the word "Negro," which does not include the word "freedom." Wright exposes the socially constructed weight of the term "Negro" by declaring it "a psychological island" sustained by "a fiat which artificially and arbitrarily defines, regulates, and limits in scope of meaning the vital contours of our lives, and the lives of our children and our children's children." His words more aptly reflect the conditions represented in the original photograph, but the departure from reality that docu-

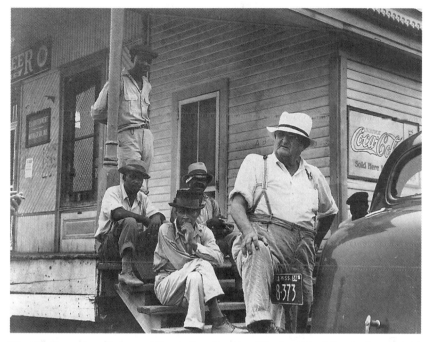

Fig. 20. Dorothea Lange. *Plantation Owner. Clarksdale, Mississippi, 1936.* U.S. Farm Security Administration Collection, Prints and Photographs Division, Library of Congress.

mentary texts allowed can be seen in both books. Since Lange's picture belonged to the federal government, which had sole control over its use and distribution, her thorough captions could be changed, deleted, or ignored altogether. But by altering Lange's word stories that accompanied her photographs, one compromised the photographer's original intention, which was to create "documents that were both visual and verbal." As a thirties documentarian, Lange depended upon words and had developed such keen interviewing skills that "her conversations with the people she photographed and her understanding of their way of life were as much a part of the print she achieved as the camera or the film." When she felt that her aesthetic sense was being challenged, Lange fought back.[50]

As Lange was allowed increasingly less control over her words and her photographs, her relationship with Stryker grew more tense. The slow start the RA experienced in distributing photographs left most images in the hands of government agencies and inside government publications. But eighteen months after its creation, the RA's Historical Section was placing its photographs in widely circulated national magazines and journals; in addition they were gracing the walls of exhibit halls and galleries in several U.S. cities. A reorganization at the agency in 1937, which gave it a new name, the Farm Security Administration (FSA), and placed it under the control of the Department of Agriculture, meant even greater exposure than the RA had enjoyed. Accustomed to personally completing every step of the technical process as a portrait photographer, from selecting subjects to developing film to making prints, Lange had never been comfortable sending her undeveloped RA film to the Washington office to have it become U.S. Government property. Early on Stryker had allowed her limited control over her own film development when she was on assignment in California, but when she traveled in the South and had no studio darkroom, Lange was forced to send the film to the FSA office. As her audiences grew larger, Lange desired even more control over her negatives in order to see whether she was capturing on film what she had intended. Often several weeks passed before she was able to see the proof sheets the FSA darkroom had produced. Entire assignments were jeopardized, Lange thought,

without her constant scrutiny of her creative process. Lange had never ceased to consider herself an artist, even though her subject matter had changed dramatically from her days in the portrait studio.[51]

The uneasy working relationship between Lange and Stryker was further complicated by Paul Taylor's overwhelming presence. Taylor posed a threat to Stryker, who needed to have his FSA photographers follow his direction and inspiration. Of all the traveling companions that accompanied Stryker's photographers, Taylor was the one for whom Stryker showed the least support. It is through this case, where the FSA employee was a woman and her traveling companion her husband (a university professor and respected economist, no less), that Stryker's bias toward his female employees reveals itself. He showed no such concern, for example, when Jean Lee accompanied her husband, FSA photographer Russell Lee, a few years later. It is not surprising, then, that nearly every female field worker that Stryker chose to hire in the wake of his troubles with Lange was an unknown and unattached photographer to whom he could dictate specific orders. Although Stryker has been praised for allowing his photographers to "follow their instincts," he clearly treated FSA women differently from their male counterparts, writing letters to them more frequently and admonishing them more casually.[52] Foreshadowing the fractious relationship that emerged between Lange and Stryker were the two motivations for his hiring her in the first place. First, he wanted a portrait photographer, an artist with an aesthetic sense; Lange, the independent artist, expected the same kind of control over the creative process she had always enjoyed. Second, Stryker sought experience, which Lange had gained in her early fieldwork as Taylor's photographer; Lange, as Taylor's companion, remained devoted to the person who had given her initial support as a documentarian. Drifting slightly from the agency but still on its payroll on a per diem basis, Lange maintained her truest loyalty and her hallmark style. Both found expression as she and Taylor embarked on their own word-photo project, an examination of 1930s displacement and the ensuing massive movement across the continent.

After two years of traveling, recording, interviewing, and photographing, the Lange-Taylor project appeared under the title

An American Exodus: A Record of Human Erosion (1939). The work challenged a similar and wildly popular 1937 publication entitled *You Have Seen Their Faces,* by the photographer-writer team Margaret Bourke-White and Erskine Caldwell. But the Lange-Taylor collaboration bore the marks of social science that were missing in their counterparts' earlier study; their extensive field work penetrated contemporary economic, social, and political realms of activity and was reinforced by statistics and the actual utterances of the people Lange had photographed. In addition, *An American Exodus* played upon the vital dialectical relationship between the past and the present in American rural life, examining the effects of mechanization, drought, sharecropping, and the South's severest tyrants, cotton and the boll weevil. Taylor even compared the displacement of landless farmers in the United States to the devastation caused by sixteenth-century British enclosure policies. In composing this portrait of a substantial segment of the populace, Lange found full expression in what became the second distinguishing theme of her camera eye: movement. In addition to her focus on the American "individual," she highlighted Americans in transit. In a larger sense, this recurring theme in Lange's work could be defined as the culture's obsession with mobility. Lange captured figures walking along the highways, relaxing in overstuffed jalopies, and dwelling in makeshift shelters. Many of her FSA pictures were taken before government efforts had effectively addressed the small-scale farmers' problems, when thousands were moving—away from tired soil or dust-filled houses and toward fresh land and new prosperity.

The final chapter of *An American Exodus,* entitled "Last West," opens with a statement Taylor composed while on U.S. Highway 99 in the San Joaquin Valley: "For three centuries an ever-receding western frontier has drawn white men like a magnet. This tradition still draws distressed, dislodged, determined Americans to our last West, hard against the waters of the Pacific." The first image in the chapter shows a loaded automobile sitting in the hot desert sun (fig. 21). The driver has stepped out of the car, leaving the door ajar, while a young girl peers out of a side window at the camera. The shadows on the ground, as well as the man's slightly turned head, indicate that he is talking to someone on his immediate left. The cropped photograph omits

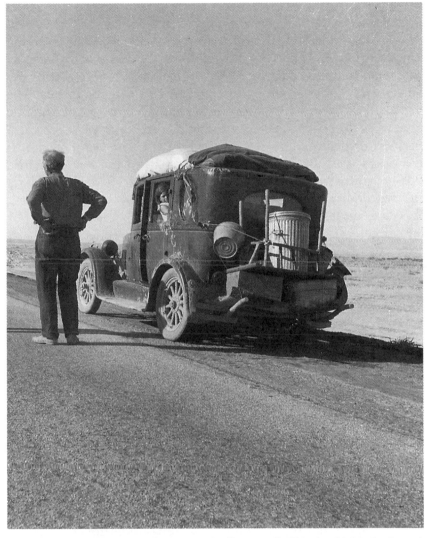

Fig. 21. Dorothea Lange. *Stalled in the Desert. California, 1937. An American Exodus* (1939). U.S. Farm Security Administration Collection, Prints and Photographs Division, Library of Congress.

the interviewer, allowing a much more mythic image to emerge. The sharp shadows on barren land suggest a waiting place, appropriately the desert, that must be crossed before the promised land is reached. The angle Lange chose allowed the highway to cut across the entire horizontal line of the frame at a roughly thirty-degree angle, thus situating the travelers on a slight incline. The incline may be read as a gradual path toward socioeconomic betterment, but it seems to represent more clearly the upward, perhaps difficult, climb that the transients have before them. If the photo were superimposed upon a map of the United States, this Oklahoma family would be headed in the right direction; both the male guide and the front of his vehicle focalize left, suggesting their westward movement. The active portion of the frame is the left center third, from the back wheel of the vehicle to the left edge of the image. Were the young girl not distracted by the photographer, all of the photograph's action would be centered in one-sixth of the frame. What remains behind the automobile is past, forgotten, gone. Cultural historian William Jordy has connected Lange's depiction of mobility with the regional fervor that gained popularity in the 1930s. He sees the jalopy as an important symbol of the age, with westward travelers imitating "the saga of earlier pioneers." In Lange's image of the Oklahoma family, the heavily weighted automobile is not unlike nineteenth-century wagons bearing the accoutrements of life necessary for cooking, cleaning, sleeping, and storing goods. Here a milk can, buckets, and tubs in several sizes are prominently visible. The family's holdings are out in the open, for everyone to see. Privacy no longer exists for them.[53]

The hope inherent in mobility was that a better future lay ahead, an idea that had long been a principal element in the American consciousness. Freedom to move was viewed as an opportunity and a privilege in the dominant culture. As early as the 1830s, Alexis de Tocqueville had identified this cultural peculiarity. He believed that Americans possessed an anxious nature, a driving quality, that kept them constantly uprooting themselves in search of better lives. In the years just prior to the Civil War, the threat to mobility affected both northerners and southerners. Among the concerns of Americans in the Northeast and the Midwest was preservation of western lands as places to which they could move and be afforded the privilege of a familiar lifestyle—

one of "free soil" and "free labor." Southerners thought along similar lines. James Oakes, who has turned traditional perceptions about the South upside down, has shown that transience was "a normal part of existence in the Old South." The great majority of antebellum slaveholders had not sunk their roots into the soil, nor had they lived on plantations for generations with grandparents, parents, and their own children. Instead, most southerners were migrants. Women "complained that their husbands and children seemed determined to move every time they got the chance. Success seemed as much an excuse for packing up and leaving as did failure." In the 1890s one of the great contributors to the psychological crisis in the United States was Americans' fear that there was "no more frontier." When historian Frederick Jackson Turner gave his renowned 1893 address, "The Significance of the Frontier in American History," he emphasized the importance of land access to the society's evolution, success, and prosperity. Thus, the safety valve for Americans who wished to create better lives and new starts for themselves or their families had historically rested upon their ability to move.[54]

In the 1930s, when nearly every excuse for moving was tied to failure, Lange photographed Americans who were on the road in search of a prosperous, successful existence. The idea of a restless nature in Americans had appealed to Lange even in her early years as a photographer. In her pictures of the southwestern Indians, Lange frequently depicted men and women on horseback, turned away, riding out across the desert. She photographed Native American family members perched on wagons or walking alongside them. These images were strikingly similar to those she created for the FSA and others she made while working on *An American Exodus*. To broaden the theme of mobility in her work, Lange included those who had not discovered the good life they had wished to find in California. In one study (fig. 22), a reticent, contemplative, antihero is the focal point. He is the disappointed searcher returning home. We see little of the road behind him; the road is no longer important, since it failed to lead him to the promises he had hoped for. His words belie the misleading messages regarding the West, and California in particular: "[T]hey appreciate the cheap labor coming out. When there's a rush for work they're friendlier than at other times." His value rested in

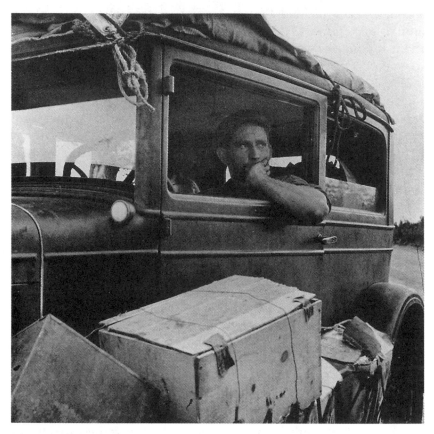

Fig. 22. Dorothea Lange. *Laborer Returning Home. California, 1937. An American Exodus* (1939). U.S. Farm Security Administration Collection, Prints and Photographs Division, Library of Congress.

what he could offer as a laborer, nothing more. The good life eluded him and his family; there was no more frontier that could guarantee success and prosperity in America. Mobility, then, had lost its strength and its attraction, developing a tarnished reputation among many Americans during the Depression.[55]

For all of their appeal in the mid-1930s, these messages in Lange's photographs grew increasingly less popular at the FSA office by the late thirties. Stryker's other photographers, especially Russell Lee and Marion Post, were concentrating upon the small town, the community, and the stability offered within those comfortable congregational confines. The idea of mobility, which Lange had viewed as a thoroughly American notion indicative of courage and independence, diminished as an American value, as did the single individual or the lone hero. These cultural barometers were surpassed by newer ones—community effort, group support, and identity with place. Yet Lange chose not to embrace them. The government photographs that she took from 1935 to 1939 reveal that her primary visual interests and her aesthetic approach changed very little. Beyond her squabbles with Stryker, perhaps it was her intractability, combined with what was essentially a nineteenth-century view of the United States and its inhabitants, that cost her the job with FSA. She admitted to an interviewer, "I go over some of the things . . . done in this Sutter Street period and I see plainly that I'm exactly the same person, doing the same things in different forms, saying the same things. It's amusing sometimes . . . to look at my own early endeavors and [say], 'There she is, there she is again!' It's built-in. Some things are built in."[56]

Although Lange had embraced FSA goals in the agency's early years and helped to mold the Photography Unit, by the end of the 1930s the FSA had shifted its objectives and its vision. Stryker needed to prove that the FSA was working, so photographs of contemplative migrant mothers and exhausted travelers no longer filled his needs. In fact they tended to hurt his case with the much more conservative Congress that had swept into office in the 1938 midterm elections. Stryker had begun to see his photography group as a producer of a tremendous historical record, and in his opinion the more records they amassed, the better. Stryker wanted photographers who were willing to cover a lot of ground in a short

time and send back hundreds of photographs composed in brief stints on the road. He was willing to forgo lengthy captions to get a substantial number of visual images in the file. As a result, the facets of Lange's work that had made it so compelling, so appropriate for the FSA in the midthirties, had made it obsolete by the end of the decade. Lange's two-year struggle with Stryker over her approach, her loyalties, and her handling of negatives, gave him the excuse he needed to release her for good. In 1939, when Stryker was forced by budget constraints to fire one photographer, he claimed to have chosen the "least cooperative" one. Lange's signature style and its accompanying themes, individual independence and success through mobility, were surpassed by fresher ideas coming from new directions.[57]

A Radical Vision
on Film

Marion Post's Portrayal
of Collective Strength

Speak with your images from your heart and soul. . . .
Trust your gut reactions; Suck out the juices—the
essence of your life experiences.
—Marion Post Wolcott

WHEN MARION POST MOVED TO WASHINGTON in 1938, she carried cultural baggage heavy with radical politics and innovative art. About her personal convictions, she remembered, "I had warm feelings for blacks, could communicate effectively with children, had deep sympathy for the underprivileged, resented evidence of conspicuous consumption, [and] felt the need to contribute to a more equitable society."[1] Nearly every image Post produced with U.S. Government equipment and on U.S. Government time reflects those convictions; her photographs also show that she sought out the vitality effusing from everyday life and ordinary people and their relationships with one another, even in the midst of the Depression. Her previous camera work, although limited, had been devoted to cooperative efforts, revealing her inclination toward the strength of collective action. And her preferences translated

onto film a firm commitment to the group as an effective vehicle for handling economic and social needs.

Unlike her fellow documentarians Dorothea Lange and Doris Ulmann, Post could not claim a history or a reputation as a distinguished portrait photographer. She had no experience recreating a studio in the field and had spent very little time filling her frames with faces of single individuals posed to appear talented or dignified or hardworking. But she could effectively show the intensity of human interaction, the omnipresent heat emitted from people who lived together intimately or worked together closely. Twenty-eight-year-old Marion Post brought to her job as FSA documentarian a worldview colored by her upbringing in an unconventional household, an aesthetic sense molded by her training as a modern dancer, a photography education initiated in Europe amid Nazi terrorism, and sharp, recent memories of abuse heaped on her by an all-male photography staff at a Philadelphia newspaper. Her experiences in all of these venues had shaped her political and social opinions; they also defined her artistic temperament, which led directly to her developing the camera eye she turned on Americans in the late 1930s.

A vital member of Roy Stryker's team, Post came to the FSA Photography Unit at a transitional time for the agency. What had begun as a public relations project in 1935, a job to convince taxpaying Americans that New Deal resettlement programs were desperately needed, changed a couple of years later.[2] Stryker, who recognized that pictures of poverty-stricken farmers and disease-plagued families overwhelmed the FSA photo file, reconsidered his strategy and the role of the Photography Unit in 1937. An economic downturn that year had left New Deal agencies open to severe criticism, and by 1938 an increasingly skeptical and often hostile Congress demanded evidence that programs such as the FSA were effectively handling the problems of poverty. Stryker saw that the FSA would survive only if he redirected his hired cameras and expanded the agency's goals. The immediate usefulness of FSA photographs had already been demonstrated by their broad exposure in the country's best-selling picture magazines and newspaper photogravure sections. Stryker willingly shared the photographs with popular publications of the day, including *Life*, *Look*, *Camera*, and *Midweek Pictorial*. Other federal agencies,

such as U.S. Public Health, took advantage of the mounting FSA collection, as the "honest photograph" proved its "inherent educational power." With an expanding FSA file on his hands, the director recognized what tremendous opportunities lay before him to show America to Americans. In Stryker's opinion, the collection would someday be of historical value, and he wanted to make it as complete and representative a picture of the nation and its people as possible. Alan Trachtenberg has pointed out that Stryker "adopted the idea of a historical record with evangelical fervor." As a result the original New Deal public relations project became a nationwide search for America, one conducted principally with cameras and only peripherally with notepads.[3]

Post's contribution to the search was in volume, breadth, and subtle social commentary. Before joining the FSA staff in 1938, she had completed a couple of "documentary" projects—a photo shoot of a farmers' cooperative for *Fortune* magazine and a job taking still photos for a film about political activism. At the time she did not articulate any personal theories about or definitions of documentary photography. Nearly fifty years later, though, she pointed out to a group of photographers and scholars that the most important quality a documentary photographer could possess was the ability "to empathize with the people directly and indirectly involved."[4] She felt that her cultivation of this ability had prompted her to shape the images she created for the FSA in her three years there. Because of the social conscience she had honed, she developed not just a rudimentary understanding of, but an empathy for her subjects and their lives. Her socially charged political education began in an extraordinary household.

Marion Post was born in June 1910 in Montclair, New Jersey. Located eight miles northwest of the county seat of Newark, Montclair sat on the edge of the most concentrated industrial area of the state. Between Montclair and Newark was Bloomfield, where Dr. Walter Post had made a home for his wife, Nan, and their older daughter, Helen. They lived just a fifteen-minute commuter train ride from bustling New York City. Two hundred miles south of Boston and ninety miles east of Philadelphia, Marion Post's hometown was located in the center of the most heavily populated urban-industrial region in America. As a result she was exposed at an early age to the region's social and economic prob-

lems. She attributed much of her awareness to her mother, an idealistic woman who supported racial equality, labor union activity, and leftist political causes. Nan Post's liberal opinions on everything from Bolshevism to modern art and her own unfettered sexual expression caused her neighbors and, eventually, her own husband to consider her too eccentric and too radical. Walter Post, a practitioner of holistic medicine, divorced his wife when their daughter Marion was thirteen years old. Older sister Helen, the "overachiever" of the two Post girls, aligned with her father; Marion chose to spend more time with her mother. Marion watched an already-scandalous situation become even more so when her mother refused the customary financial assistance from her former husband. Old friends abandoned Nan, but the staunch independence she displayed made a lasting impression on her adolescent daughter.[5]

In her capacity as a registered nurse, Nan Post took a job with Margaret Sanger at the Birth Control Research Bureau in New York City. Fighting hard to eliminate the social stigma and oppression that accompanied unwanted pregnancy, Sanger organized birth control clinics all over the country, addressing in particular the birth control problems of working-class women. Post took pride in working with Sanger, particularly as they guided the New York clinic through the growing pains of its early years. Sanger was so impressed with her colleague's work that she asked her to travel nationwide to set up new clinics. Marion remembered, "Mother became a field worker and a pioneer, traveling alone in her car around the country to rural and urban areas, first doing the ground work (obtaining support of the clergy and local influential citizens) for the establishment of birth control clinics—for her a crusade. Then after the Sanger Research Bureau and American Birth Control League merged . . . my mother became their spokeswoman. I admired her not because she was my mother, but for her courage, dedication, strength and compassion." Perhaps unknowingly, the daughter was describing herself as well—as a young FSA photographer, she too was a "field worker" who traveled alone by car to villages in New England, cities in the South, and wide open spaces in the West, experiencing rural and urban life, talking to officials, laying the foundation before she took her cameras into the places the federal government wanted her to see.[6]

Her mother's influence loomed large. In the 1920s Nan rented an apartment in Greenwich Village, a fertile artistic environment that exposed Marion to musicians, painters, and actors. The messages she received while living with her mother encouraged her free expression of the physical and the sexual. As a result the teenager chose to develop an art form in which she used her body as the primary vehicle for self-expression—dance. After completing high school at Edgewood, a private boarding institution in Greenwich, Connecticut, Post enrolled in the New School for Social Research in 1928. The New School served as a training ground to inspire and encourage liberal thought and action among its artists, educators, and intellectuals. Sensitive to the avant-garde, the institution sponsored modern dance teachers as lecturers. By this time Post had devoted much of her time to studying dance with Ruth St. Denis, a pioneer of modern movement. The lessons she learned from St. Denis at the Denishawn School of Dance often echoed her mother's emphasis on maintaining and projecting a positive sense of self. "Miss Ruth" viewed dancing as "an elixir for the attainment of health and beauty." Her style brought dance down from the high–culture pedestal it had long occupied, allowing a wider audience to appreciate the spectacles she presented. This style helped to influence Post's own developing ideas about the close connections between culture, experience, art, and education. But Post's truest mentor in guiding the development of her aesthetic sense was Doris Humphrey, a longtime student of St. Denis and a classmate of Martha Graham. Post was so impressed with Humphrey that she abandoned her university studies in order to study dance full time.[7]

Among the lessons Humphrey taught, three in particular resonate through Post's later artistic expression. The first was that the ultimate achievement in art (in this case, dance) was balance; the second called for a stage to be precisely marked in time and space; and the third was that emotion should guide one's life. As a result of her belief in the last of these, Humphrey designed many dances offering social commentary.[8] Although Post constantly relied upon these maxims as a photographer, the venue where she employed her teacher's lessons to their fullest was in the Mississippi Delta region in 1939. So often reproduced in the last twenty years that it has become a Jim Crow South icon, one image (fig. 23)

draws upon all that Humphrey had impressed upon Post. An African American ascends the exterior stairs to a movie theater in Belzoni, Mississippi. Amazingly, Post managed to situate the human figure at almost the dead center of her frame. The words and other objects are secondary to the single most vital element in the photo, the lone black man being pulled by a heavy, deliberative arrow that dictates "Colored Adm." He occupies center stage. Had Post waited one moment longer, the figure's much larger shadow would have occupied a more prominent position against the sunhot white bricks, dwarfing the real man. But Post did not wait, and her result was a perfectly set stage in time and space, with balance achieved, the principal dancer in place, and each subordinate object playing its own role. In the left corner, a restroom door marked "White Men Only" serves to support the arrow's directive. The sharp shadow cutting precisely through the clock at ten and four provides an inner frame as well as a breath of mystery about the moviegoer's ultimate destination. And the cheery message "Good for Life!" on the Dr. Pepper advertisement offers an ironic twist on the social situation for this black Mississippian and all other African Americans living in the segregated South. Whether or not she deliberately intended it, Post's emotional investment in this message on race fills the frame. In *Man Entering Theatre* and many other images that Post produced for the FSA, Humphrey's aesthetic precepts are detectable; but the dance teacher provided even more to her pupil by sending her off to Europe to study dance in a volatile political climate.

Encouraged by Humphrey to take advantage of the new directions being explored in dance, Post crossed the Atlantic in 1930. An excited twenty-year-old, she arrived in Germany anxious to take on new challenges, but the physically and emotionally draining program quickly took its toll on her. She left the dance troupe, returned to the United States to work briefly on an elementary education degree, and taught in a small western Massachusetts town. Post's teaching experience in the mill town alerted her to striking disparities based upon socioeconomic status. Beverly Brannan has pointed out that Post became "increasingly uncomfortable with the class differences she observed between the upper middle class children she taught and the poor children in the neighborhood where she boarded." Carrying the seeds of a grow-

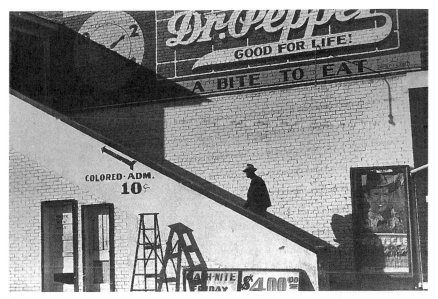

Fig. 23. Marion Post Wolcott. *Man Entering Theatre. Belzoni, Mississippi, 1939.* U.S. Farm Security Administration Collection, Prints and Photographs Division, Library of Congress.

ing political conscience, the restless Post returned to Europe in 1932, joining her sister in Vienna. She chose not to pursue serious dance any further, but instead resumed the studies in education and child psychology that she had begun in New York.[9]

The University of Vienna offered new experiences and provided a stimulating education for a young, impressionable student. Living amid student activists, Post got a firsthand glimpse of the tense and often violent political scene in Austria. During her second year at the university, a general strike shut it down. As the National Socialist Party gained ground in Austria, demonstrations became more frequent. Post recalled, "I heard the heavy artillery bombardment of the Socialist workers' housing in Floridsdorf, whose occupants had demonstrated against encroaching Fascists. The complex was demolished and the uprising quelled."[10] Students in Vienna played active roles in politics, and significant changes took place in a city previously known for its political conservatism. The students employed every possible method to spread their messages but found photography to be a particularly useful medium. Because of the popularization of photography on the European continent, especially in German and Austrian metropolitan areas, the public saw a great number of photographs in the daily newspapers and in other publications. The emergence of photo clubs provided outlets for both amateur and professional work. But perhaps the most significant influence was the workers' photography movement, which emphasized the importance of recording everyday activities. The photographer and the subject were bound together through their understanding of each other. Above all, the movement preferred the documentary approach and focused its cameras upon "working environments and working conditions." Photography scholars Hanno Hardt and Karin Ohrn point to the emphasis on collective endeavor in the worker photographs, noting, "The theme is not one of individuals, but of a mass—even 'the masses'—of people engaged in a coordinated activity. The context of that activity, whether in the streets or in the work place, defines their role, while the size of the group suggests their power to define the setting as their own, one in which they, as a group, assert control."[11] The workers' movement reached its height while Post lived in central Europe, where she received not only a sound political education but, perhaps more importantly, her first camera.

Borrowing a small 4 × 4 Rolleiflex camera from her sister's friend, photographer Trude Fleischmann, Post gave the instrument a trial run. Since she knew little about cameras and had nothing to compare the borrowed camera to, Post was impressed by the Rollei's twin lens reflex, which allowed the photographer to view a scene before recording it. This feature permitted more accurate composition than older camera models allowed. A type of "candid camera," the small four by four was an extremely popular, quite versatile, model. Post remembered that the Rollei was appropriate for the documentary style of photography that was growing more fashionable at that time in Vienna and throughout Austria. A good price and a favorable exchange rate made it possible for Post to purchase her own Rollei. Having her photographs praised by Fleischmann increased Post's excitement about her newfound hobby, but she had only a limited time to capture Austrian scenes. By the summer of 1934, all political parties had supposedly been dissolved by Chancellor Engelbert Dollfuss's authoritarian regime. The strongest opposition remained the growing National Socialist Party, whose Austrian members opted to protect themselves by murdering Dollfuss in July of 1934. Though interested in the political scene in Vienna, Post sensed the oncoming defeat of any democratic movement. She had seen local fascists harass peasant families in the mountains and destroy their crops. An unforgettable experience in Berlin also left its mark on her. While on a brief visit, Post attended a Nazi rally. She found herself surrounded by hundreds of people aroused by the emotionally charged words of Adolf Hitler. The frenzied exhibition shocked and frightened her. Unable to withstand the uncertainties connected with increasing political violence, Post returned to the United States armed with plenty of fresh ideological ammunition and a new camera.[12]

Upon her return Post accepted a teaching job at Hessian Hills, a private "progressive" school in Croton-on-Hudson, New York. She was fortunate to be hired at a time when many schools were closing or the school years were being shortened because of the Depression. What made it more remarkable was that she, as a young single woman relatively new to the teaching field, received the offer even though national attitudes had grown more antagonistic toward single women who filled the places unemployed men

needed so desperately. Men made considerable gains in the teaching profession at this time, whereas young single women "lost ground." Post had returned from abroad to teach in a country where "economic competition, structural changes, and public sentiment all worked to the advantage of men at the expense of female teachers." Post seized the opportunity in her teaching environment to sharpen her photographic skills; she snapped pictures of her school children busily engaged in daily activities. With help from her sister, Helen, who had been a photographer's apprentice in Vienna, Marion learned the basics of developing and printing film. When some of her students' parents offered to buy her photographs, Post saw the potential profit her hobby could bring. She decided to leave what she considered an unappealing job to spend more time with her camera, hoping to "earn at least a partial living on it."[13]

A venue more exciting to her than the classroom had further inspired Post's camera work. While teaching, she had spent her weekends in New York City, capturing scenes of Group Theatre activities—initial rehearsals, dressing-room preps, and opening-night performances. She even attended their summer workshops. The enterprise not only gave Post more camera experience, but it also exposed her to another art form inspired by radical politics. Group Theatre, which determined to bring "social consciousness to Broadway," built itself on the strength of community interaction. Modeled after the Moscow Art Theatre, the company's individual players were charged to develop their personal identities through the group's identity, which each actor and participant helped to forge. Moreover, the audience was to be brought into the stage action, making the entire artistic production an effort in which all present were actively involved. The earliest and perhaps the most successful Group Theatre production to elicit this effect was Clifford Odets's *Waiting for Lefty* (1935), which called on full participation as the characters in the drama (who are contemplating a workers' strike) direct their appeals to audience members. Witnessing the idealism on which Group Theatre perpetuated itself, Post absorbed its message that collective strength transcended individual power. The emphasis on collective identity would soon become the single most important defining element of her photography. But she still needed training.[14]

Enthusiastic about her future possibilities, Post set out in 1936 to establish herself as a freelance photographer. In the midthirties, the Workers' Film and Photo League frequently sponsored lectures and exhibits at various photo clubs. Just a few weeks before she resigned her teaching job, Post attended a photo club meeting in Manhattan, where Ralph Steiner spoke as the featured guest. After the lecture Post approached him, introduced herself, and expressed her growing interest in photography. Steiner asked her to assemble some of her photographs and bring them to his studio the following weekend. After scrutinizing Post's work and discussing it with her, Steiner invited her to join a small group of students who met with him on weekends. For several months Post attended Steiner's informal workshops, and she found them to be helpful. Each week the students examined samples from Steiner's large assortment of photographs. He guided them in analyzing other photographers' work, as well as their own. He gave weekly technical assignments to the young aspiring photographers, and when they reassembled he critiqued each student's work and offered advice when appropriate. Post recalled that Steiner's assignments were "very vague"—he wanted the novices to use their own material and to employ individual creativity to its fullest extent. Steiner felt it was necessary for them to record their "own impressions" in their "own way." He used to ask the photographers, "Which is worth more—an apple or a photograph of an apple? After all, the apple has taste, smell, nutrition, three dimensions, life, while a photograph is flat, inedible, etc. Naturally, the answer is that if the photographer has included a bit of himself in the photograph, then the photograph outweighs the apple itself, since a man outweighs an apple." Adhering to a strict policy of honest photography, Steiner believed if people made statements in pictures *or* words that were false to their own identities, they were lying.[15]

The inspiring combination of Ralph Steiner's teaching and his colleague Paul Strand's photography left an indelible impression on Marion Post. The critical eye Steiner applied to her work—the eye concerned solely with what photographs had to say—helped Post finely tune her technique. Steiner's earliest criticism addressed her approach as being "too artistic and somewhat directionless." Though not as explicitly critical of Post's photography, but certainly as influential, Strand led by example. Post revered his work,

the rich tones and textures he created on photographic paper. As she strove to improve, Post reaped the benefits by marketing some of her photographs, a few to educational magazines and similar publications. Her rapid development as a photographer did not escape Steiner, who respected Post's work so much that he asked her to accompany him to Tennessee on a documentary film project undertaken by his new organization, Frontier Films. Frontier was guided by Steiner's desire to explain social problems with actual participants rather than actors and fictional texts. The Tennessee project, codirected by Group Theatre actor Elia Kazan, focused on the Highlander Folk School, an institution near Chattanooga that trained people to lead campaigns for social justice, among them rights for labor and enfranchisement of blacks. The school posed a threat to southern businessmen and appeared to some politicians to be a breeding ground for subversive ideas. Steiner and Kazan's film, entitled *People of the Cumberland,* promoted union organization by showing inspired group meetings at Highlander in addition to union celebrations. The bleakness of isolation and individual effort is set against the brightness of cooperation, played up by a narrator's voice offering carefully timed lines such as "They're not alone anymore; they've got a union." Post took still photographs for promotional purposes during the filming. The trip proved more than educational for her, as she admitted: "My social conscience was nourished." In April 1937 *Variety* labeled Frontier Films the "Group Theatre of motion pictures." Of Post's experiences with Group Theatre, Frontier Films, and the Photo League, she remembered that their concerns about fascism and about "social and economic injustices were in tune with my own." Her participation in leftist groups that blended art, politics, and culture made her as partisan a documentarian as anyone who claimed the title in the late 1930s.[16]

Post's other travels in 1937 included a *Fortune* magazine assignment that sent her into the rural Midwest. Her photographs were to accompany a feature story on consumer cooperatives, an increasingly popular means used by farmers and small community dwellers to obtain necessities at cheaper prices. In Waukegan, Illinois, Post captured scenes of a Finnish co-op where workers baked their own bread, homogenized and bottled local milk, carried a full line of groceries, and sold gasoline. With the assign-

ment she also traveled to Noble County, Indiana, to photograph a farmers' cooperative with its own flour mill and to Dillonvale, Ohio, where one of the country's oldest cooperatives was located. The *Fortune* assignment gave Post considerable exposure as a serious photographer. Of the negatives printed, twenty-one were published in the March 1937 issue of *Fortune,* along with a thirteen-page story entitled "Consumer Cooperatives."[17]

After completing a few Associated Press projects, Post received a recommendation to work as a staff photographer at the *Philadelphia Evening Bulletin.* With no previous newspaper experience, she took the job, joining nine other staff members, all men. Being a woman on a major newspaper staff was quite a rarity; according to Penelope Dixon, Post was probably the only woman in the United States to hold such a position. The pressure and competition in a profession dominated by men kept her busy perfecting her technical skills. The *Bulletin* provided her with a large Speed Graphic, a camera common to news work but completely unfamiliar to Post. She recalled that her fellow photographers on the staff gave her all the help she requested about learning to operate the new model, but she first had to prove that she was serious about her work. After they had properly initiated Post by spitting into and putting out cigarette butts in her developer and by bombarding her with spitballs, she lost her temper: "Finally I exploded— telling them that I was there to stay; I had to earn a living, too; this was where I was going to do it, and they'd better darned well like it. I told them how and when I could be very useful to them and that I needed their help in return. . . . We reached a truce." The first few months Post did "the regular run of newspaper assignments"; then the *Bulletin* decided to step up its fashion service. Of the ten photographers on staff, Post was chosen to cover this new area of emphasis. It seemed the editors at the *Bulletin* found it convenient to expand their coverage of fashion since they had a female photographer they could rely on. Initially Post was paired with a reporter, but she ended up doing practically all the material for the fashion and society pages alone. She soon felt stifled by having to shoot too many garden parties and designer shows. Her hopes of embracing hard news stories shrunk. So she decided to take a trip to New York City and air her frustrations to her critic-mentor Ralph Steiner.[18]

Steiner listened as Post described her disgust with the mundane *Bulletin* assignments. Sensing her strong desire for more interesting tasks, he told her about Roy Stryker's team at the Farm Security Administration in Washington. Steiner showed her a few FSA photographs and explained the purpose of the Historical Section, since she was not acquainted with the project. He suggested that she contact Stryker in order to set up an interview. Steiner not only helped her make photo selections for her portfolio, but he also wrote a recommendation for her. And he provided a second note of introduction to a friend of his at the Housing Administration. Armed with two letters from a highly reputable source, Post promptly began planning a trip to Washington. While she planned, Ralph Steiner traveled to Washington carrying some of her photographs, which he personally presented to Stryker; at the same time Paul Strand wrote a glowing recommendation to Stryker, stating, "If you have any place for a conscientious and talented photographer you will do well to give her an opportunity." The following week Stryker received a simply stated request on *Philadelphia Evening Bulletin* letterhead. It read, "At Ralph Steiner's suggestion I am writing you concerning a job. He showed you some of my photographs last weekend, and I am very anxious to discuss the possibilities with you." In less than two weeks, Stryker decided to hire Marion Post as a full-time photographer with the Farm Security Administration. He made his official offer a few days after one of Post's stills from *People of the Cumberland* graced the cover of the *New York Times Magazine*. With the nationwide exposure and a new position, Post's career took a serious turn. She made a "painless and friendly" departure from the *Philadelphia Evening Bulletin.*[19]

Stryker's newest appointment to the FSA crew may have surprised his other staff members. Post was young, still in her twenties, and she had handled a camera for only three and a half years. Although some of the original FSA photographers had left the agency, nearly all had been veterans of the craft, having mastered every step of the photographic process from initial light judgment to final print development. Several, including Dorothea Lange and former employee Carl Mydans, could boast numerous nationwide photo publications in *Life, Look,* and other magazines. Painter-turned-photographer Ben Shahn was well known for his

politically charged canvases before joining the FSA. Art photographer Walker Evans, who had accompanied author James Agee on an Alabama assignment in the summer of 1936, was looking for a publisher for the book the two had produced. The FSA photographers' various successes may have outnumbered those on Post's résumé, but Stryker saw freshness in her approach that the agency needed. Speaking of her FSA appointment, Post later said, "Roy E. Stryker took a chance."[20]

Twenty-three hundred dollars a year, five dollars a day for field time, four and a half cents a mile to pay for gas, oil, and car depreciation—these figures represented the total salary offered to Marion Post as a new FSA employee. In addition, she could count on the agency to provide her with film, flashbulbs, and some other equipment. Stryker informed her that the section's photographers primarily used three camera models, the Leica, the Contax, and the $3\frac{1}{4} \times 4\frac{1}{4}$ Speed Graphic. In a letter to Post explaining the terms of employment, Stryker reiterated that *all* negatives had to go into the official file. His struggles with Dorothea Lange over control of negatives had so infuriated him that he made his expectations quite clear to Post. Each time her camera shutter clicked, the negative automatically became the property of the U.S. Government, which had sole authority over its use. Public ownership did pose a problem for Stryker, though, as he fought newspaper and magazine editors in order to secure credit lines for his FSA photographers.[21]

After finally making her way to Washington the last week in August, Post received a spectacular initiation. Rather than subject his new employee to lengthy explanations and detailed instructions, Stryker turned her loose in the photograph files, the thousands of prints, among them Arthur Rothstein's Dust Bowl scenes, Dorothea Lange's hopeful faces, Walker Evans's proud sharecroppers, and Russell Lee's yearning children. The magnitude and the depth of the imagery overwhelmed Post. She recalls that she was "overcome and amazed and fascinated. . . . The impact of the photos in the file was terrific." Besides their sheer quantity, the file pictures projected a quality of honesty that motivated Post. Viewing them not as individual works but as a unique group of documents overflowing with emotional strength, Post realized,

without a doubt, that she wanted to contribute to this vast collection. The first month's experience, though wonderfully stimulating and thought-provoking, also left Post feeling somewhat inadequate, since the previous year had been devoted to nothing but soft news work. She feared that she might fail to live up to the high standards set by previous FSA photographers, most of whom considered themselves artists as much as camera operators. Logistical matters also threatened Post. She wondered if she would be able to keep up the travel pace, find time to write background notes, remember to caption every negative, and get the material back to Washington not only in an orderly form but also on schedule.[22]

Nervous as she might be, Post remained ecstatic about her new position, believing she could "contribute something important, work that might inform and influence the American people and affect legislative reforms. Be a crusader!" Her first month in Washington, Post stayed close to the FSA office, reviewing procedures and reading the literature Stryker recommended. Stryker, ever the academic, usually suggested that his photographers read a variety of books, essays, and reports to prepare themselves for the regions where they would be traveling. In her early days at the agency, Post also listened to the sound advice offered by Arthur Rothstein, a twenty-three-year-old seasoned veteran on the FSA team. When Post received her first field assignment, she collected and packed supplies Rothstein had helped her acquire, including an axe he insisted she have close at hand when traveling.[23]

The initial journey Post made as a field photographer took her into the Bluefield and Welch coal mining regions of West Virginia. Her brief time in the area fascinated her, despite the continual frustrations of inclement weather. She reported to FSA office secretary Clara "Toots" Wakeham, "If it hadn't stopped raining, I'm afraid I'd have been driven to the Christian Science Reading Room or Myra Deane's Elimination Baths (both right next to the hotel), just for a change or purge, you know." Earlier, Stryker had advised her not to let weather, among other things, get her down. As the skies cleared, Post turned her attention toward the people, especially those whose critical mine-related health problems appalled her. One photograph (fig. 24) shows a thin young woman, a tuberculosis and syphilis sufferer, perched upon a tiny porch rail. A half-smile offsets her dark, tired eyes. The softness

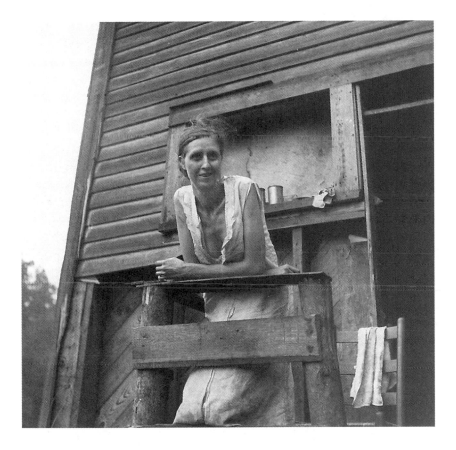

Fig. 24. Marion Post Wolcott. *Miner's Wife. Marine, West Virginia, 1938.*
U.S. Farm Security Administration Collection, Prints and Photographs
Division, Library of Congress.

and ease of her manner—arms crossed to support herself, knees slightly bent, tousled hair pulled loosely away from her face— contrast sharply with her rugged surroundings, particularly the makeshift log rail on which she kneels. More striking is her confidence. Uninhibited by nearly bare breasts, she exudes a comfortable sexuality despite her illness. Post's earlier training and her own sense of self permeate this image, as the former modern dancer focuses here on the physical, heeding her mother's lessons about bodily freedom and sexual expression. Fifty years after she made the photograph, she said of her subject, "She's pretty erotic, isn't she? I probably admired that. . . . She was so beaten down by life and yet there was all this sexuality in her, not just sexuality but sensuality." Seven photographs in the series provide more details about the woman's life; in one she holds a fist up to her mouth while coughing into it; in another, two young children appear; and in a third her surroundings show torn paper and cardboard affixed to the walls of an abandoned mining company store. Forty years after the prints became part of the immense FSA collection, Witkin Gallery in New York City displayed the famous porch scene in a Marion Post Wolcott exhibition. In his review of the show, critic Ben Lifson wrote of this particular picture that he saw not a pathetic, sick woman whose miner husband had lost his job, but "an image full of rough and perplexing sexuality." In a more disturbed tone, he continued, "[W]e're supposed to see these poor people as sufferers, not as vital and occasionally alluring."[24]

Lifson's comment not only raises a pertinent issue regarding the documentary genre, but it hints at Post's willingness to mold her own documentary vision, departing from the FSA standards set by earlier photographers. William Stott, in *Documentary Expression and Thirties America,* notes that these politically driven images (even a series of the same subject) reveal very little about the actual "real life" experiences of the men, women, and children in the pictures. He points out that the subjects "come to us only in images meant to break our heart. They come helpless, guiltless as children. . . . Never are they vicious, never depraved, never responsible for their misery." As a result Great Depression images often fail to allow their subjects complete humanity. Stott's description aptly characterizes the people in photographs made by Walker Evans, Ben Shahn, and Dorothea Lange in the pre–

Marion Post years at FSA. Although Post admitted that she and her FSA colleagues had similar views about their work, that each photographer possessed a depth of social consciousness and felt genuine concerns about "the plight of human beings," she emphasized that their individual approaches remained varied and distinctive. On the West Virginia assignment, Post was beginning to show just how different her vision would be from those of her FSA predecessors. She took interest not merely in the "plight" of human beings but in the people themselves.[25]

Her views of the tubercular woman and other subjects in the coal mining world disclose Post's developing eye, which was moderate enough to please Stryker yet sufficiently radical to satisfy her own personal politics and tastes. Although Post's image of the unemployed coal miner's wife is in some ways derivative of Lange's style, it more forcefully projects Post's own outlook. She wanted to show dignified humanity, so she ennobled the figure by the angle of her shot; the woman looks over and down at the photographer, a technique Lange frequently used. But unlike the subjects in Lange photographs, here the body approaches the viewer, moves forward in the scene with her shoulders and her toothy smile; the subject is obviously comfortable with the photographer and may even have shared with her a few intimate details of her life. This picture reveals one of the most stunning differences between Lange's and Post's approaches—the treatment of sexuality. Lange had pictured bare breasts before, but usually to show mothers nursing their children. There are no children in Post's frame, therefore allowing the suggestion of sexual desirability rather than maternal responsibility. This vital photograph from her first assignment foretells the nature of Post's contributions to the FSA files.[26]

Not only would the photographer attempt to portray the full humanity of her subjects and their lives, but she would cover issues that addressed "blind spots" in the collection. For example, she produced several images in a series showing miners of varied ethnic backgrounds and their families. A challenge to Doris Ulmann's vision of the Anglo-Saxon descendants who occupied the Appalachian hills, Post photographed several Bohemians, Hungarians, Poles, and Mexicans, emphasizing the Mexicans' role in breaking a 1926 miners' strike. In her photographs she attempted

to evoke a sense of easy camaraderie between those of different backgrounds, capturing on film their conversations and leisure pursuits. On her first assignment Post provided further examples to prove her departure from earlier FSA work and her enthusiasm to take risks. In one image, a man stands fully naked in a shower he had constructed. How Post arranged such a scene is uncertain; no doubt Stryker was shocked to see it surface on the contact prints. Clearly, the transition already under way in the FSA Photography Unit accelerated as soon as Post's undeveloped film arrived in the Washington offices. The final prints from Post's West Virginia negatives, a wide spectrum of provocative images, showed the FSA director the "undisputed" superior quality of his newest employee's work.[27]

Having proven her skills on the inaugural journey, Post prepared to make her first FSA trip into the rural South. A challenging venture lay ahead, for in no other region of the country had the FSA met with such vicious opposition. The agency was considered "a disturber of the peace" in the South, where "virtually every FSA program and policy seemed to touch a nerve." The FSA had never enjoyed a strong political constituency in the region, since scores of sharecroppers and migrants were "voteless or inarticulate." The natural enemies of the agency, southern landlords and operators of large farms, possessed both votes and voices and certainly wanted to maintain their supply of cheap labor. They objected to any aid the FSA might offer to tenant farmers. As a result, strong congressional representation of the FSA's opponents purposely kept the agency's appropriations as low as possible. The rural victims of 1930s politics, according to FSA historian Sidney Baldwin, were "southern tenants, sharecroppers, and laborers for whom restriction of cash crops meant eviction from their rented lands and homes or complete destitution where they were; subsistence farmers of Appalachia who were actually outside of the farm economy; and migratory farm laborers for whom the filtering-down effect of rising prices was a snare and a delusion." A 1937 recession further deepened the problems of those living on the land. This downturn in the economy, tagged "Roosevelt's Depression," also dealt a grave blow to New Dealers, proving to them that their programs had not packed the force necessary to break economic cycles. Agencies such as the FSA then were forced to prove their

effectiveness or suffer the withdrawal of congressional appropriations.[28]

In the wake of economic and political rumblings, Stryker opted to give Post a different role from those his earlier photographers had assumed in southern states. The major projects, such as FDR's "lower third" of the nation and the Dust Bowl, had been completed. Post would survey FSA successes while simultaneously building Stryker's historical record of the nation. As she described it, Stryker "wanted to fill in, wanted pictures of lush America, wanted things to use as contrast pictures in his exhibits, wanted more 'canned goods' of the FSA positive remedial program that they were doing. Partly, I think, to keep his superiors happy so that they would continue to support his program." The agency's new direction would require Post to meet with FSA supervisors so that they could show her the "good side" of local programs. And, as a result of a directive from Department of Agriculture information director John Fischer, she and her fellow photographers would continue to take fieldwork assignments for agencies such as the U.S. Public Health Service and the U.S. Housing Authority in order to keep the FSA Photography Unit solvent. Stryker was very accommodating in scheduling and rearranging his field photographers' travel plans to include such assignments. He recognized their importance to the system as a whole, but more importantly he remained eager to please the "higher-ups" in Washington and to keep the FSA Photography Unit alive.[29]

Barriers stood high for any outsider traveling in the rural South, but a U.S. Government employee who happened to be a twenty-eight-year-old unmarried white woman driving her own car could expect to be treated with great skepticism. Post's mere presence would pose threats in certain areas, Stryker told her. Soon after hiring Post, Stryker warned her about the segregated culture's expectations, noting, "[N]egro people are put in a very difficult spot when white women attempt to interview or photograph them." He expressed serious doubts about subjecting her to possible mistreatment, but at the same time he was confident in her ability to take care of herself. Although the FSA photography director treated all of his field employees with a degree of paternalism, he seemed particularly protective of Post, who later said, "From the very beginning, being a woman, I was considered by Stryker

to be in a different category." But he had not expressed similar concerns to Dorothea Lange. Her situation was safer, in his opinion, because she almost always traveled with her husband, Paul Taylor.[30]

Even before Post made her first trip on the FSA payroll, she "felt challenged" by Stryker's attitudes and intended to confront him about his chauvinism. One of their more heated exchanges resulted from an incident on her second field trip. In South Carolina a small group of people whom Post described as "primitive" accused her of being a gypsy. Her deep tan, bright bandana scarf, and elaborate earrings intimidated them, as did the mysterious boxes of equipment in her convertible. Afraid that she might kidnap their children, they demanded that she leave immediately.[31] When Stryker learned of the ordeal, he reprimanded Post on her appearance:

> I am glad that you have now learned that you can't depend on the wiles of femininity when you are in the wilds of the South. Colorful bandanas and brightly colored dresses, etc., aren't part of our photographer's equipment. The closer you keep to what the great back-country recognizes as the normal dress for women, the better you are going to succeed as a photographer. . . . I can tell you another thing—that slacks aren't part of your attire when you are in that back-country. You are a woman, and "a woman can't never be a man!"[32]

Assuring Stryker that he had "touched on a sore subject," Post shot back, "I *didn't* use feminine wiles . . . My slacks are dark blue, old, dirty & not too tight—O.K.?" As for the trousers, she argued that female photographers might appear slightly conspicuous with too many film pack magazines and film rolls stuffed in their shirt fronts. FSA historian Jack Hurley has noted that "Stryker never knew quite how to take this disconcertingly frank young woman, but he knew he liked her and the pictures she was producing."[33]

The gender-related issues presented irritations that separated Post's experiences from those of her FSA colleagues. As a young woman on the job, Post suffered from officials' not taking her assignments seriously and from general suspicions about her in-

tentions. She stepped out of her car alone, not with a well-known economist as Lange had or with a controversial novelist as Bourke-White did or with a lively native son as Ulmann had. Early in December 1938, in the first days of her journey south, Post expressed anxiety about her experience at Duke University, where she confronted a number of "disturbing circumstances & problems" because of the local officials' lack of preparation. They had failed to arrange an agenda of shooting sites and prescheduled meetings with FSA project clients. She found her assistants not the least bit aware of which subjects she wished to photograph. In Columbia, South Carolina, a couple of days before Christmas, Post hoped to get several shots of people celebrating the holiday season. But her slow-moving FSA guide made her wait in his office for several hours while he finished other business. Angry that she had missed good morning light for shooting, Post resolved to take advantage of the waning afternoon light. Instead, she spent the better part of the afternoon hours admiring holly trees with the FSA guide's wife, who had insisted upon going along for the ride. With sunlight fading at day's end, Post rued the precious time wasted. The next morning she awoke to pouring rain, conceded defeat in Columbia, and packed her bags.[34]

General suspicions also impeded the photographer's work, requiring her to come up with creative solutions. In particular she found the people of South Carolina's swampy lowlands extremely cautious and unfriendly. They allowed no strangers inside their homes, and they would not let her take any pictures outside the houses. Mimicking her subjects, Post explained their excuses to Stryker—they "didn't like for no strangers to come botherin' around because they mostly played 'dirty tricks' on them or brought 'bad luck.'" Post often resorted to begging and bribing to win them over and therefore kept her pockets full of coins and small pieces of food. Some individuals boldly refused the nickels she offered, asking instead for "*real* money." Another challenge Post faced in the southern states was resistance to any woman with a camera who might have the same agenda as Margaret Bourke-White, a freelance photographer whose collaborative work with Erskine Caldwell entitled *You Have Seen Their Faces* (1937) presented a scathing depiction of the South and its problems. In that popular documentary book the region's inhabitants came off as pathetic

and depraved, Caldwell's objective in attempting to prove that his fictional works were based in fact.[35]

The initial southern trek presented Post with cultural differences that shocked her. Appalled by southern eating habits, she observed that vegetables for one meal usually included "fried potatoes, mashed potatoes, sweet potatoes, rice, grits, or turnips!" The treatment of time in the South also caught her off guard, as she told Stryker, "It's amazing. . . .the pace is entirely different. It takes so *much* longer to get anything done, buy anything, have extra keys made, or get something fixed, or pack the car. Their whole attitude is different—you'd think the 'Xmas rush' might stimulate them a little, but not a chance." The differences in the manner of holiday celebration also surprised Post, who was taken aback by the overt gaudiness of it all. She observed that the southern towns she visited were "decked out fit to kill, with more lights and decorations and junk than you could find in the 5th Avenue 5 & 10-cent store." But what most startled her was the constant crackle of exploding firecrackers, sounding off throughout the day and well into the night.[36]

Through January and February of the new year, Post followed the migrant camp circuit in Florida. It was the first of three trips she would make to the state in order to record the FSA's success there. The agency had attempted to provide organized, clean dwellings for migratory laborers. Before FSA intervention, living quarters in the tourist and trailer camps where migrants stayed were drastically overcrowded and unsanitary. Large families lived in one-room cabins or small tents. Privacy and respect for property were nonexistent. Frequently a man and a woman would live together as "good friends" until the season was over, and then they would go their separate ways. Among the many health problems that camp residents suffered, one of the most common was venereal disease. Post's preliminary reading, which included previous reports by FSA photographers, introduced her to migrant life, but nothing compared to her firsthand experience in Florida. And what she found convinced her that the FSA had only minimally improved the basic needs of migrant laborers. Most facilities remained unsanitary, as her photographs prove, showing dwellings without lights, running water, or toilets (indoor or outdoor). Her written records and photographs reveal afflicted, des-

perate communities, ravaged by natural disasters. In one of the more poignant series of images, workers in Lake Harbor stand by hopelessly as one of their homes burns to the ground. Post situated herself behind them, as a witness to their impotence to stop the swelling flames. A few items saved from the home occupy the foreground of Post's frame, signaling what poverty of possessions the occupants have been reduced to.[37]

Early encounters with fruit pickers made Post aware that the previous season had been disastrous, especially for citrus growers in central Florida. Crates of fruit sold at the lowest prices ever, leaving the pickers with even fewer resources than usual. Since Florida had experienced no rainy season that year, the added expense of irrigation drove many growers out of business. Post photographed the remnants of a bad season—houses and camps abandoned, blown down, or taken apart. The present season promised little relief, as she soon realized. Migrant pickers were idle, anxiously awaiting peak season, which had been delayed by the lack of rain. In the Tampa area, a strawberry-growing region, the crop gradually dried up. During an ordinary season, the "fruit tramps"—men, women, and children who followed the crops—would travel a route from Homestead, Florida, in January to Ponchatoula, Louisiana, in April; to Humboldt, Tennessee, in May; to Paducah, Kentucky, in June; to Shelby, Michigan, in July. By August they would start the trek back south to Florida. But Post found the 1939 season to be an exception. Her research in Belle Glade revealed that about half the usual number of transients were there and that most of those were employed in the packing houses, not in the fields. Post learned that the majority had not traveled long distances to find work but had come from nearby towns, Key West, or the Miami area.[38] Since during an ordinary season, migrant fruit harvesters spent a considerable amount of their earnings on transportation, extended traveling in a bad season was economically infeasible.

The difficulties of migratory work during a poor citrus fruit season seemed slight compared to the troubles of people engaged in vegetable field work. In the vegetable area, located in the drained swamplands of Florida, the availability of jobs depended solely on weather conditions. Tomatoes, celery, lettuce, and bean crops had to be picked at precisely the right time. The 1938–39 winter,

with its frosts and its cold, windy weather, had killed almost everything, including a large crop of English peas, a substantial portion of the tomatoes, and most of the beans. Only a small amount of celery, cabbage, and sugar cane survived. A major difference between citrus work and vegetable work in the region was the necessity that individuals hired for the latter labor on their hands and knees in the fine, powdery soil dust known as "black muck." Post witnessed and recorded its effects on children, who had skin rashes and sores scarring their bodies. She complained fiercely to Stryker about the soil dust, and she struggled continuously to keep it out of her cameras and off her film. In jest, Stryker replied to her complaints, "We really don't care what the black dust does to you as long as you can work, but I hate like the devil to see it get into your camera, because it hurts your negatives." Many of Post's images in the Florida vegetable region were unusable because of the powdery soil's damage to her film.[39]

Time was a key factor in Post's Florida excursion. Because peak picking season had been delayed three to four weeks, Post was unable to capture the choice field shots she desired. She photographed a few workers combing the vegetable fields, but the action she had hoped to find was limited to an afternoon picking session during which several horrific screams and rifle shots drew her to a side road. There she eyed a ten-foot-long rattlesnake "as big around as a small stovepipe." Even though the picking season was slow, Post was willing to wait it out and stay in the Belle Glade–Okeechobee area for a few more weeks, hoping that transients would again fill the streets and the packing houses. Interested especially in packing-house activity, Post wanted to produce a photo story of life there—"the hanging around, the 'messing around,' the gambling, the fighting, the 'sanitary' conditions, the effects of the *very* long work stretch." Her desire yielded rich stories, which she took down as "General Captions," but not many photographs of group work. One woman explained to Post that the packing houses opened their doors only a few hours a week. The woman had waited outside one house all day hoping to get work; when she finally got in, she was allowed a mere nine minutes of work time, compared to her usual sixteen- or eighteen-hour day during peak season.[40]

In attempting to create her photo essay on packing houses,

Post focused on a thirty-two-year-old mother of eleven children, whose husband worked in a packing house. To connect the story with the visual image, Post photographed the woman talking (fig. 25). With clasped hands and a dependent child in a torn garment clinging to her neck, the woman looks away while relating that she had been "frozen out" when the employer got rid of the "old ones" at the packing house. He kept young girls instead of mature women in the plant for the long stretches of packing time. The woman offered Post the kind of material on gender experiences that she was seeking—in addition to releasing the woman from work, her employer told her that since she "looked pregnant" he would not give her further work even when the house needed laborers. Post hoped that the combination of her verbatim accounts in general captions and photographs of the storytellers would impress the FSA enough to step up its presence in Florida in order to improve migrants' lives and working conditions. Even though the idle laborers' stories intrigued Post, they did not offer Stryker sufficient substance for FSA photography. He wrote to her, "We mustn't spend too much time in Florida unless there is an awful lot of pay dirt." He promised her that she could return later but insisted that she concentrate on other subjects. Post was willing to move on but asserted her independence by instructing her boss, "It takes time, Roy, but you'll see that it's worth it."[41]

Turning her cameras in another direction—toward Miami Beach's rich tourists and residents who lived just a half hour's drive from the miserable migrant camps—brought the "pay dirt" that would make Post's FSA work exceptional. Among the most highly praised photographs in the collection, Post's images of the wealthy provide sharp contrasts to the plight of the underprivileged. In an indirect manner she made her case about class division in the United States. Her characterizations of the rich reflect a well-directed intention by the socially conscious young photographer to illuminate the gap between wealthy Americans and their impoverished counterparts. She later explained her objectives on the job: "To create a general awakening and concern for [the migrants'] appalling conditions, I tried to contrast them with the wealthy and with the complacent tourists in Florida." Post stayed in Miami overnight, then drove twenty-five miles to the migrant camps during the day. The disparity between the two worlds amazed her. She

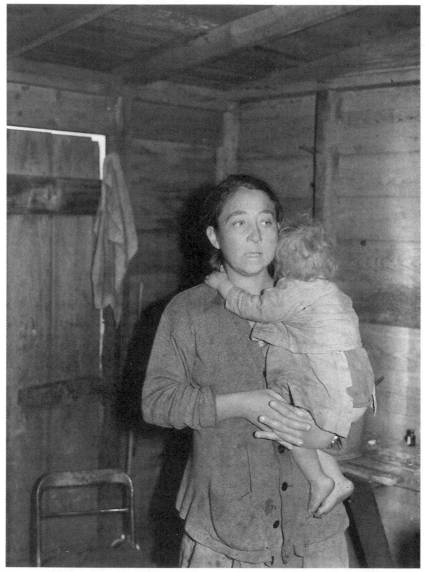

Fig. 25. Marion Post Wolcott. *Wife and Child of Migrant Laborer. Belle Glade, Florida, 1939.* U.S. Farm Security Administration Collection, Prints and Photographs Division, Library of Congress.

later told an interviewer, "I thought: 'Wow, this is great. Why not use this material in exhibits and as contrast material?'" Until Post joined the staff, the FSA files lacked any pictures of those situated at the upper end of the income scale. Post noted the omission and believed photographs of the elite at play would help tell the American story. Indeed they did document socioeconomic conditions in the late 1930s, sending the clear message that some people were oblivious to the nationwide depression. Photography historian Stu Cohen contends that Post's Miami Beach series was "a perfectly reasonable addition to the FSA files; it is simply unfortunate that they stand there so much apart."[42]

To accomplish her purpose Post employed the techniques learned years before from her dance instructor Doris Humphrey—use of perfect balance and space. With the playgrounds of the wealthy as her stages, Post created images that made hotel entrance archways appear massive and long, shiny automobiles seem larger than life. Her keen eye helped her achieve a superior manipulation of space and scale. Fully reclined in lounge chairs, relaxed tourists smile carelessly as the sun beams down on their faces. Inactivity is cherished, expected, and serves as a stark contrast to the migrants' idleness, which was characterized by worry and anxiety. In one image (fig. 26) Post took her place above a trio of already-bronzed sunbathers. Her display of open space in the upper right quadrant of the frame shows one of the privileges that a private beach club could offer its patrons—plenty of room away from the hordes on a public beach. Here complete relaxation is possible, as the woman demonstrates with outstretched arms delicately crossed above her head. And between the two sun-drenched men, thoughtful conversation can transpire uninterrupted because they are far removed from the bustling activity of a crowded beach. The exhibition of so much flawless skin provides a stunning contrast to the arms and faces of migrant workers, miners, and poor children, whose bad teeth, soot-covered faces, tousled hair, and skin sores Post had recorded. Here the woman's face reveals the careful attention she has given to penciled eyebrows and colored lips and eyelids. Both men have oiled, carefully combed hair. In addition to the relaxed position of each subject—the sheer enjoyment of idleness—another indication of comfort is the healthy stomach shown off by the seated man who has his legs casually

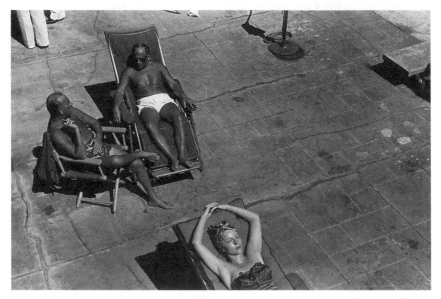

Fig. 26. Marion Post Wolcott. *People Sunning Themselves. Miami, Florida, 1939.* U.S. Farm Security Administration Collection, Prints and Photographs Division, Library of Congress.

crossed. To experience physical hunger in this setting would be impossible, as Post notes in yet another of her series images. Analyzed by Sally Stein in her provocative commentary on Post's class messages, the photograph is a voyeur's view of a patron being served a multicourse meal by an attentive waiter on a club sundeck. Given an aerial perspective of an exquisitely set table, the viewer sees numerous plates, bowls, and utensils being used by a single individual. Among the small absurdities the photographer identifies are perfect squares of butter kept cool by miniature ice cubes, all exposed to the beaming Miami sun. Stein saw that Post's clear message was about the gap between the server and the served here, as the waiter keeps his reverent distance from the customer while providing the man's every need in a substantial brunch. Ben Lifson identified in Post's Miami Beach collection a "sense of uneasiness," noting that the photographer managed to show "just how much of her world is out of whack."[43] Post's social conscience often translated into irony in her Miami series.

Post found the leisure class as difficult to deal with as any she had previously encountered, which is why most of her scenes appear to be captured from safe distances, odd angles, or undetectable locations. These distances also meant Post rarely talked to her subjects; so the photographs had to stand alone. Most of her captions are brief, such as "A beach scene" or "A street scene" or, more frequently, "A typical scene." Use of the word *typical* on a good number of her image descriptions suggests that Post may even have grown disgusted with the opulence and display she digested on a daily basis while in Miami. Although the majority of her "idle rich" photographs were shot in resort palaces and dwellings and on beaches, Post spent time in another haunt of the wealthy—the racetrack. Besides taking crowd shots of stands full of horse-racing enthusiasts, she attempted to record some gambling scenes. The betting men, irate at her temerity, snatched her camera away. They eventually gave it back, but the gamblers kept her film and instructed her to get out and stay out. As she related the story in a personal interview years later, Post explained that the men were most annoyed that she had tried to get away with the stunt simply because she was a woman—"which was exactly what I was trying to do," she admitted.[44]

The Miami area suited Post's need for rest from lugging her

cameras and other equipment around. At the resort beaches she could safely swim and sunbathe, away from the spiders and "red bugs" that infested grasses in the migrant picking region. While taking a break, she secluded herself and began the long-overdue task of captioning some three hundred prints Stryker had mailed from the FSA lab in Washington. Post assured Stryker that she would devote full attention to the job, attempting to find "some quiet spot where I will be a completely unknown quantity & not be disturbed. I'm going to put on *very* dark glasses & hang a typhoid fever sign on my front & back & *dare* anyone to come near me." Captioning complications frustrated every FSA photographer, including Post. Since the photographers were required to send all film to the FSA lab in Washington for development, it could be weeks before they actually saw their own finished products. One group of negatives that Post sent from Florida showed watermarks when printed; another set was smudged with the "black muck"; and yet another came out blurred, revealing serious shutter maladjustment in the Rolleiflex camera. When her negatives turned out satisfactorily, Stryker offered his praise along with a gentle nudge for her to edit scrupulously and to complete captions quickly, so that the Washington office could "get the stuff mounted up and ready for use."[45]

Stryker gave the photographers in his unit much freedom in editing their own work. In Post's case, he believed she leaned toward taking too many exposures of a particular scene or subject, inevitably costing the lab an exorbitant amount in development. In an attempt to eliminate the problem, Stryker suggested that Post "kill" a good number of the negatives as she edited and captioned. Post respected the director's guidance and direction, but even more she appreciated the unusual liberty he allowed her in editing and cropping her own pictures. He also consulted her about lab work and exhibit layouts, causing Post to remark that he provided an opportunity for "unprecedented creative and artistic expression." She gained experience and insight unavailable to a routine staff photographer in the 1930s and said of these opportunities, "I don't know of any magazine that would give you the freedom that Roy gave you in editing your pictures. He would listen to arguments. I mean if he wanted to keep a picture that you wanted to throw out he would certainly give you your chance to say. I suppose in

the end he had the last say but if your arguments were valid he would bow to them. . . . We never had any real struggle about this at all."[46]

Post found that Stryker's fairness extended even further, especially regarding her position with FSA regional advisors. As with all of the unit's photographers, Stryker gave Post the authority to handle the FSA representatives as she deemed most appropriate. Local and regional advisors, particularly in the South, often turned out to be stubborn and quite hesitant to allow a young woman to plot her own course on "their territory." Some attempted to shield her from the more unsuccessful aspects of the FSA projects and so limited her travel to the few places they personally wished to have photographed. Post recalled, "They didn't want us to photograph the seedy side of their area, their program; they wanted us to spend much more time, of course, on the progress that they had made." Having aired her frustrations to Stryker about this kind of treatment, she received encouraging replies that assured her that she was the boss in those situations. Stryker explained that she, like all the other FSA photographers, had been hired because she was a specialist. And as a specialist, she was entitled to the privilege of deciding what should be recorded on film. He further stressed the extent of her authority, telling her, "Don't take orders on what is to be photographed or how it is to be photographed from anyone. . . . Don't let those guys put anything over on you. You will have to lie and do all sorts of maneuvering, but it will have to be done—and you know I will always back you, so be sure that you are right, and you may always depend on my OK and support." Post realized that Stryker entrusted her with substantial responsibility and that he faithfully relied upon her judgment, leaving "the whole business" to her discretion. According to FSA scholar Beverly Brannan, his "willingness to let the photographers follow their instincts reflected not only a general confidence in their abilities but also the certainty that the discoveries they made in the field would lead to a diverse selection of photographs for the file." Stryker provided general shooting scripts for the photographers at the beginning of their assignments, but they served merely as guidelines.[47]

Stryker held the reins tightly, though, when it came to logistics and official details. More than once in the spring of 1939 he

had to track down Post. He demanded that she correspond often with the Washington office by mail or telegram, informing the staff of her whereabouts. In mid-March Post's agenda had her scheduled to leave Florida and proceed toward Montgomery, Alabama. Several days after her expected arrival date, Stryker wrote in a distressed tone, "I don't think you realize yet the importance of keeping us informed at frequent intervals about where we can reach you. Here it is Thursday and we don't know if you got to Montgomery or not." The second major rule Post had to learn to follow involved satisfying a bureaucratic system. If she wanted a U.S. Government paycheck, her paperwork had to be completed accurately and submitted on time. The Finance Office required FSA photographers to present the following materials on a regular basis: travel logs showing miles covered, equipment sheets listing film rolls and flashbulbs used, and account forms recording all expenses incurred. At different times Post and each of her colleagues neglected the red tape, provoking Stryker's threat to "raise hell with all of you people if you don't attempt to do this." His "volatility" was what she remembered most about Stryker years later, as she observed, "I think he felt possessive of all of us. He could be so supportive, and he also could be so damn tyrannical."[48]

Stryker was forthcoming if he thought his field workers had failed to meet the agency's expectations. He expressed disappointment at their visual surveys of a well-known resettlement project in Coffee County, Alabama. Before the FSA moved in, the area had been devastated by a major flood that destroyed soil that had long been exhausted by intensive farming. Coffee County's farmers had relied solely on the cotton crop until the 1930s, when they were forced to diversify their crop production in order to survive. Some began planting peanuts and beans, while others turned to poultry farming. U.S. Government officials remained curious about the Coffee County project's successes in the wake of diversification and were anxious for Stryker's photographers to provide some visual evidence. FSA photographers Dorothea Lange and Arthur Rothstein on respective assignments had attempted to photograph the "new" Coffee County, but neither could produce the desired effects for Stryker. Like her predecessors, Post could not supply enough material to prove that conditions in this rural Alabama county had changed. After informing his friends and superiors in

Washington that Coffee County remained unphotogenic, Stryker flatly told Post, "*Three* photographers can't be wrong."[49]

Although Stryker felt Post's results left much to be desired, her Coffee County photographs *did* in fact carry the message of success that the FSA wanted to disseminate. In one image a woman stands in her smokehouse, backed by shelves full of canned vegetables and fruits and framed by substantial portions of cured meat. In another photograph Post captured a family's collaborative efforts: a mother and a father and their two sons shell peanuts in preparation for the planting season ahead. Armed with big bowls and busy hands, the four are portrayed as diligent and content to be working together in close proximity. Beyond her attempt to prove that Coffee Countians had embraced alternative crops, Post arranged the image to promote her own agenda—that collective work not only paid off in strict economic terms but also provided necessary human contact, enriching the group effort and in turn producing benefits for the entire community. In another Coffee County image, Post worked from that same theme and revealed yet another issue that she would pursue in many places over the next two years—abundance. From her angle slightly above the Peacock family dinner table, Post places the food at the center of her photograph (fig. 27). Framed on all sides by the members of the family, full bowls, plates, and glasses measure the bounty. No one has paused for the photographer; nutritious eating continues uninterrupted. In the foreground, the central act of *sharing* the food marks the image, as two individuals are connected by the representation of plenty. Light streams in on the scene, transforming the occasion from a mundane daily occurrence to an extraordinarily fulfilling, almost divine process. In her photo caption Post pointed out that FSA supervisors had helped improve the diet and health of project families; in other notes she listed the menu as having included "sausage, cabbage, carrots, rice, tomatoes, cornbread, canned figs, and bread pudding."[50] Stryker's dismissal of the series notwithstanding, Post marked her work in Coffee County and the rest of Alabama with the signs of liberal politics and communal effort—family members helping each other with housework and farmwork, home economists and vocational agriculture teachers instructing rural rehabilitation clients, and neighbors working together in a house-raising project.

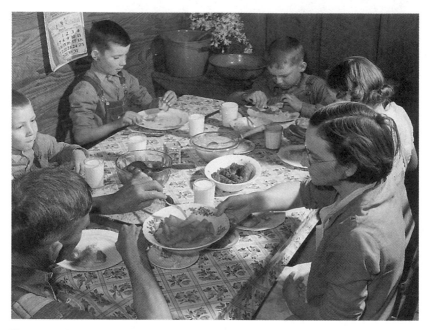

Fig. 27. Marion Post Wolcott. *Family Dinner. Coffee County, Alabama, 1939.* U.S. Farm Security Administration Collection, Prints and Photographs Division, Library of Congress.

To prepare for her assignments in Alabama and Georgia, Post scanned the reading material Stryker had sent weeks earlier. One of the works she reviewed was sociologist Arthur Raper's *Preface to Peasantry* (1936), a critical study of farm tenancy in Greene County, Georgia. Raper blasted the earlier plantation system for fostering an unnatural dependency among rural laborers. Well-respected for his comprehensive research, especially his effective interviewing techniques, Raper received thoughtful recognition from FSA staffers. He was genuinely interested in the field photographers' work and never failed to offer his assistance when they came to the Atlanta area. Stryker noted that Raper possessed a keen eye for selecting key sites and angles for the FSA cameras, even though Raper himself was not a photographer. Post was scheduled to spend April and May traveling throughout the state, adhering closely to Raper's suggestions but attending to other matters as well. Post's activities during her two months in the state accurately reflect the varied responsibilities an FSA photographer faced, from documenting segregated farm projects to attending small-town celebrations to locating a decent place to get a camera fixed. Using the Henry Grady Hotel in Atlanta as a base, Post initially directed her energy toward one of the more mundane tasks—shooting a "progress report" on the Area Warehouse in Atlanta. Her principal subjects were broken-down tractors, some photographed before repair, others after repair. Besides focusing on farm equipment, Post got some inside shots of the workrooms and office space. Her comprehensive treatment of the site resulted in Stryker's glowing acknowledgments a few weeks later.[51]

In a three-week period, Post journeyed from Greensboro to Irwinville to Montezuma to Orangeburg and then back to Atlanta. A crowded schedule, horrid weather, and temperamental equipment posed numerous problems for her. Although it meant losing some time, Post decided not to drive at night since everything closed early, including the gas stations. She discovered that "the only ones who stay out are bums who are pretty drunk or tough or both." Realizing that people would not understand why she remained out alone after dark, she cautiously avoided the likelihood of confrontation. Rain kept Post from traveling too far on a couple of occasions. Unable to maneuver her car on the slippery red clay, she decided not to drive it. Stranded in a small town, she was left

to endure two May Day programs, both ruined by messy weather and boring speeches. A few days later, with rain continuing, Post took her Plymouth out on the road again and got stuck twice in the thick clay of the Flint River Valley. While her car was being repaired, mechanics found a faulty rear axle, one that obviously had been broken and welded. Post then realized she had driven some twenty thousand miles across the South in a defective car that she had presumed was new, in fact right off the assembly line. She understood why it was a "lemon" after realizing that she had purchased it in the wake of the auto workers' strikes a few years before, when the demand for automobiles was high. With one breakdown repaired, yet another occurred, this time with her camera equipment. The rangefinder, which the Eastman Kodak Company in Atlanta attempted to adjust on three different occasions, had given Post constant trouble. The company seemingly bungled the job each time, leaving Post no alternative but to pack it up and ship it to Washington. Stryker's immediate response included a reprimand about her harsh handling of FSA equipment, but his admonition was accompanied by the good news that her photographs had just been published in *Collier's*.[52]

Stryker gave Post an exceedingly high overall evaluation on the pictures from her Georgia assignments, particularly the recreational scenes. His favorite shots included those taken of schoolhouse activities, of sandlot baseball games, and of sharecroppers standing in front of log cabins. Post, too, was overwhelmed by the pictures, so much so that she found editing even more difficult than usual—"It's practically impossible for me to throw any of them away because the people and their faces are so often different even tho the place or situation is similar." Additional praise came from Raper, who traveled to Washington to view the finished prints and requested that Post be assigned to the region again. Raper eventually used several of Post's photographs in his 1941 publication *Sharecroppers All,* a look at changes in sharecroppers' lives and how U.S. Government programs had affected them.[53]

After enduring sweltering heat and voracious mosquitoes in New Orleans, where she had been "lent out" to the U.S. Public Health Service, Post neared the end of her seven-month journey through the American South. Despite all the pleasure she derived from her assorted encounters with southerners and their ways of

living, Post welcomed the opportunity to return to Washington. She wrote to Stryker just before heading north:

> I'll also be glad of a rest from the daily & eternal questions whether I'm Emily Post, or Margaret Bourke-White, followed by disappointed looks—or what that "thing" around my neck is, & how I ever learned to be a photographer, if I'm all alone, not frightened & if my mother doesn't worry about me, & how I find my way. In general I'm most tired of the strain of continually adjusting to new people, making conversation, getting acquainted, being polite & diplomatic when necessary.
>
> In particular I'm sick of people telling me that the cabin or room costs the same for one as it does for *two,* of listening to people, or the "call" girl make love in the adjoining room. Or of hearing everyone's bathroom habits, hangovers, & fights thru the ventilator. And even the sight of hotel bedroom furniture, the feel of clean sheets, the nuisance of digging into the bottom of a suitcase, of choosing a restaurant & food to eat.[54]

The long-awaited retreat from the field brought Post back close to the FSA headquarters for three months. For the first time she was able to see the total accumulation of her work—thousands of negatives and prints with her name in the top right corner.

A few months earlier art critic Elizabeth McCausland had written in *Photo Notes,* "Today we do not want emotion from art; we want a solid and substantial food on which to bite, something strong and hearty to get our teeth into. . . . We want the truth, not rationalization, not idealizations, not romanticizations." She believed that FSA work provided "the strongest precedent for documentary" in the 1930s. And she foreshadowed analyses of FSA imagery that situated it inside a thriving social science community in the 1930s. In his 1940 publication *Since Yesterday,* Frederick Lewis Allen discussed contemporary documentary images and described the thirties photographer as "one with the eye of an artist who was simultaneously a reporter or a sociologist." Post claimed

that Stryker urged his field staff to record and document America from "the historian's, the sociologist's, and the architect's point of view." Respected art photographer Ansel Adams once told Stryker, "What you've got are not photographers. They're a bunch of sociologists with cameras." By the late 1930s they could also be considered preservationists, since they were compiling what historian David Peeler has called "a visual catalog of thirties America."[55]

Despite the various descriptive labels they were given, FSA photographers did frequently operate as practitioners of social science. Few FSA field workers were as rapidly immersed in the discipline as Post. In October 1939 she headed for Chapel Hill, North Carolina, to see firsthand how some of the nation's finest social scientists carried out their research. Her assignment there required her to work closely with a cadre of University of North Carolina sociologists at the Institute for Research in Social Science. The institute, whose projects examined farm tenancy, race issues, and southern culture, had put the university's Sociology Department on the map. Directed by Howard Odum, the institute had fostered the work of Arthur Raper, Rupert Vance, Harriet Herring, and Margaret Jarman Hagood. Hagood, having earned her Ph.D. in the department two years earlier with a study of fertility patterns of southern white women, assisted Post while she was in North Carolina. Excited about the prospect of a comprehensive photographic survey of the area, Howard Odum cordially arranged extra help for Post. Several graduate students accompanied her in the field, taking notes while she snapped pictures. Odum seemed extremely anxious to secure as much of Post's time as possible and held out as a return favor the promise of garnering support for the FSA in its attempts to produce a solid publication within the next year. Stryker took notice and was generous with Post's time in North Carolina since photo publication kept the agency and its attempts at social welfare alive.[56]

Perhaps the photographer's lengthy stint at UNC was designed not only with the Sociology Department in mind but also with an eye on the university press. If Chapel Hill could claim the boldest social scientists in the region, it could also boast the most daring and innovative southern publishing organization, the UNC Press. Chief editor W.T. Couch had drawn national attention by accept-

ing works on controversial topics that addressed race, lynching, and labor strikes. Couch's other position, regional director of the Federal Writers' Project (FWP), kept him closely in touch with southern voices. In 1939 thirty-five of the nearly four hundred "life histories" collected by FWP writers were published under the title *These Are Our Lives*. The volume received critical acclaim, including praise from historian Charles Beard, who said, "Some of these pages are as literature more powerful than anything I have read in fiction, not excluding Zola's most vehement passages." Historians Tom Terrill and Jerrold Hirsch, who edited a volume of previously unpublished "life histories," wrote that "[Couch] wanted to give Southerners at all levels of society a chance to speak for themselves. In his opinion collecting life histories was one way of doing this. He thought project workers could be used in an effort to provide a more accurate picture of Southern life than had either [Erskine] Caldwell or the Agrarians." Couch was the kind of ally Stryker needed, especially since continued publication of FSA photos kept the public's mind on domestic problems rather than on the gradually encroaching foreign policy concerns.[57]

Post immediately recognized the possibilities the region could offer a photographer. In fact, she initially expressed a concern that the sociologists at Chapel Hill seemed unaware of the ways in which visual images could enhance their scholarly efforts. But her diplomatic skills and affability helped her build the necessary bridges to make successful collaboration possible. The FSA written records reveal that the institute's personnel found Post much easier to work with than Dorothea Lange; Harriet Herring appended a thorough outline entitled "Notes and Suggestions for Photographic Study," with the comment, "Miss Lange does not consider this a very good outline. Too much emphasis on the economic set-up, not enough on the people at the center of it." In her nota bene, Herring pointed out that Lange had suggested the institute use movies rather than still pictures to complete their visual study of the thirteen-county Piedmont area in the state. By this time Lange was working only sporadically for the FSA, but the North Carolina survey ended her tenure with the New Deal agency. A few weeks after Herring typed her warning note about Lange's opinions, Stryker permanently released the photographer, claiming she was the "least cooperative" of his employees. Post's work on a similar assign-

ment shows, by contrast, her willingness to cooperate with the UNC professors; she adhered closely to a shooting schedule prepared by the institute's Margaret Hagood. Post documented an array of agricultural pursuits, including wheat plowing, hay baling, and soybean thrashing.[58]

The variety of crops grown in the region sparked Post's curiosity, but she devoted her most concentrated effort to tobacco—its preparation and marketing. Her 1939 series on the tobacco industry closely follows the suggestions on Hagood's outline. Although Professor Odum often looked over her shoulder as she photographed and edited, Post nonetheless cast her North Carolina images in her own mold, focusing on the spirit of cooperation and group effort. Intent on revealing the fruits produced when family members worked together, Post highlighted the prosperity enjoyed by black tobacco farmers in Orange County (fig. 28). In this image an impeccably dressed, carefully groomed husband and wife strip and grade tobacco. They not only sit close to each another; they even face each other while working. The positions of their bodies suggest their participation in a collaborative venture, pursued toward a single goal that will help them maintain their present level of comfort. The tobacco, surrounding them on all sides, serves as symbol of their prosperity; they are engulfed by it. Post also revealed in her tobacco series the demands imposed by segregation during the tobacco auctions. She photographed the warehouse "camp rooms" where farmers congregated, conversed, and slept while awaiting the chance to sell their tobacco. Post made her way into one of the "Negro camp rooms" and documented the crowded conditions—men sleeping on low benches, their bodies tightly cramped, twisted and touching each other at odd angles. The tobacco auctions attracted hundreds of people to the larger towns, such as Durham, where Post was able to capture the atmosphere of bustling activity and constant money-changing. Auction time put dollars into people's hands; knowing this, product hawkers circulated throughout the auction area selling everything from patent medicines and socks to hound dogs and farm equipment. An itinerant preacher, anxious to market his own product to the crowds, figures prominently in several pictures. An African American "corn parer" works diligently on a white man's foot, displaying the results of his other successful operations (various corns)

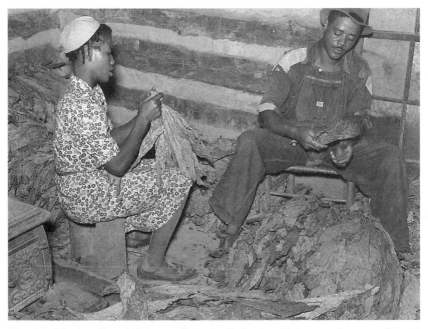

Fig. 28. Marion Post Wolcott. *Couple Stripping Tobacco. Orange County, North Carolina, 1939.* U.S. Farm Security Administration Collection, Prints and Photographs Division, Library of Congress.

on a towel nearby. Post recorded some faces cautiously deliberating what to buy and others simply enjoying the frenzied environment with enthusiasm. Her images reveal the relationships between tobacco buyers and sellers, marked by the looks they exchanged; some sellers wince at the prices being offered, whereas others exude their confidence in securing profitable deals. In nearly every photograph, Post aimed to portray the connections between individuals or groups of people—their looks, their touches, or their words to one other.[59]

One agricultural field trip particularly suited to Post's vision of the collective ideal was a "corn shucking" she and Hagood attended near Stem, North Carolina. The harvesttime event, described by Hagood as "the most widespread occasion for gatherings of a semisocial nature," produced paradigmatic situations for Post's camera work. As the "form of cooperative endeavor most commonly reported" in the area, the ritual brought together male family members, neighbors, and laborers to shuck the corn, while their wives prepared the obligatory meal for them. Hagood reported that one family's corn return was so large that the event required them to serve both "dinner and supper" to their shuckers. Post illuminated the enormity of the day's task at the Wilkins family farm in a shot of corn piled high in the yard; in another frame, she pictured two men sitting and one standing in a sea of corn yet to be shucked.[60]

But the photographer's most penetrating depiction of the cooperative spirit may be found in her images of the mealtime activities. Six women, including five white sisters-in-law and one black woman, toiled together to prepare food for twenty men. Post's series shows the step-by-step process from biscuit-cutting to cooking to serving to extensive dishwashing. She highlights gender-specific responsibilities as well as race-determined roles. The meal progressed through three stages: a seating for all of the white men, a similar seating for the white women and children, and finally a meal for the black male tenants. One image in the series shows where several of these constituencies situated themselves during the first stage (fig. 29). Here in the midst of the clan gathering, the photographer peers in to capture the Wilkins wives standing fairly stationary in their places, children at their sides, while their husbands enjoy a meal at its hottest and freshest. The

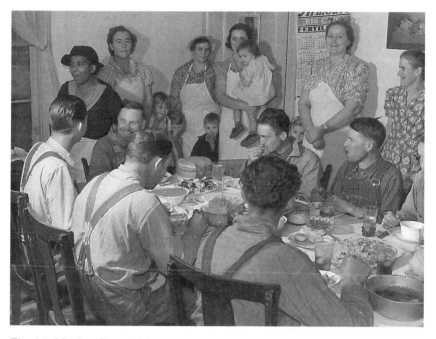

Fig. 29. Marion Post Wolcott. *Dinner on Corn Shucking Day. Stem, North Carolina, 1939.* U.S. Farm Security Administration Collection, Prints and Photographs Division, Library of Congress.

camaraderie between these male family members and neighbors is marked by their hearty laughter and ease, despite the presence of a U.S. Government photographer. Aside from the smiles and limited arm motions of the eaters, the most concentrated energy is detected in the upper left quadrant of the frame, where a black woman is caught walking. Where is she going? Is she the principal server headed off to retrieve an item the diners have demanded? Or does she wish to step out of the photographer's view, feeling misplaced in a candid family picture? During each stage of the prolonged meal, she stands to serve those who eat, but nowhere is her own dinner recorded. The nature of her portrayal in this series reflects the limitations of 1930s social science, even that which challenged the comfortable confines of acceptable scholarship on race. The issues facing African Americans were defined almost solely in terms of what black men needed, so that well-intentioned efforts often blurred the gender lines.[61] Even Post, whose keen social-political consciousness attuned her to problems inherent in a racially segregated society, made precious few statements on film about segregation's peculiar effects on black women. The frames she shot at the Wilkins cornshucking event in Stem, North Carolina, are among the few.[62]

If Post's personal feelings about the segregated South had previously been revealed in subtle ways, Mississippi changed her mind about her approach. In no other assignment is her commentary on the bifurcated social system more pointed than in her study of the Delta region. Taken within a few weeks of the intense North Carolina job, Post's images expose her yearning to illuminate both the complexities and the cruelties of Jim Crow. Among her staging grounds were the cotton market, a plantation store, a movie theater, a juke joint, and several other public venues. In observing a common and rather benign activity of cotton pickers getting paid, Post realized that social "separation" actually translated into something much greater. She attempted to communicate its reality in an image highlighting the distance and the physical barriers between blacks and whites. In one image, behind a pay window stands a laborer known only by the straw hat she wears, since her face is obstructed by the heavily supported window design. Her clearest identifiable feature is her right hand, reaching through a tiny opening to receive her wages. The cash transfer is indirect,

not from a white hand to a black hand, but placed at a safe distance between the two parties, so they need not come into contact with each other. The white cashier's sacred space, completely partitioned from the outside world save for the small window at the edge of his desk, protects him from potential unpleasantness. How apt that Post made this laborer's hand the focal point, the center icon, of her frame; it was a cotton picker's principal asset in the plantation economy. So valuable to white landowners, yet at the same time untouchable. Initially Post watched the scene from the African American side of the partition but was frustrated by the angle's ineffectiveness at portraying the unfolding drama. She then managed to attain a better position and viewpoint (inside the sacred space, from the "white" side of the window), by being "sweet" to the cashiers, a couple of men who failed to realize that her presence "might be to their disadvantage." Existing in a well-entrenched patriarchal system that considered blacks inferior and women politically innocuous, the cashiers were not culturally prepared to accept the possibility that a polite and appealing young woman with a camera could house a radical, accusatory voice.[63]

Post's role as an FSA commentator on race can be measured by the place she commanded in Nicholas Natanson's study *The Black Image in the New Deal: The Politics of FSA Photography* (1992). The first picture he introduces to the reader is from Post's Mississippi assignment, *Negro Man Entering a Movie Theatre by "Colored" Entrance* (see fig. 23). As Natanson observes, the figure stands as a symbol in "the psychology of Jim Crow" because "the man's blackness, and not the man, is what counts." That he is unidentifiable makes the image even more powerful, because he is everyman in the southern black world. In addition to the illuminatory postures Post captured at the cotton picker's pay station and outside the Belzoni movie theater, she detected a highly charged moment between two black farmers and a prospective buyer at a Clarksdale cotton market (fig. 30). She must have reveled in the unshielded temerity displayed by the farmer at a price that displeased him. With his hand propped on his hip and his right leg comfortably crossed over his left leg, his apparent ease in challenging the meager offer sets him in noticeable contrast to the well-suited buyer, who has backed away in a defensive posture. The buyer signals with his body his surprise and confusion at the

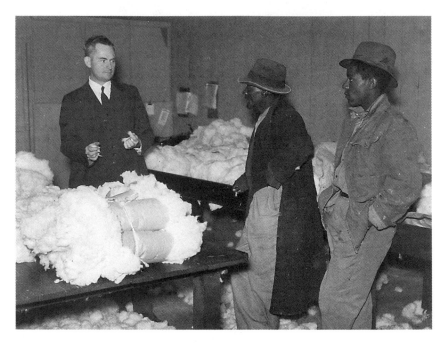

Fig. 30. Marion Post Wolcott. *Unsatisfied Farmers with Cotton Buyer. Clarksdale, Mississippi, 1939.* U.S. Farm Security Administration Collection, Prints and Photographs Division, Library of Congress.

dispute—holding the cotton samples in nearly fisted palms, as a boxer would position himself to protect his upper body. The image stands almost alone in the FSA file as a depiction of African American challenge to the powerful white elite in the South.

Since the social realm was the milieu where Post felt most comfortable, she sought out places that would help her characterize people's lives beyond their work responsibilities. Shortly after she took the FSA photography position, she intimated her general preference to observe and record "the hanging around, the 'messing around,' the gambling." Her attempts to capture scenes of leisure activity helped strike a balance in a photography collection filled overwhelmingly with work-related scenes, especially those of the rural hoe culture taken by earlier FSA photographers such as Lange. In the Delta Post had a hard time convincing white authorities that she needed to enter the "off hours" world of black living. She begged, insisted, and eventually bribed a white male escort (a plantation owner's son who wanted to take her out) to accompany her into a "juke joint." In the Delta juke joints, from Clarksdale to Memphis, Post continued to document the intensity of human relationships in group settings. In one image made in a Memphis juke joint (fig. 31), Post frames a couple's attempts to dance the jitterbug. The young woman's cautiousness is checked by the young man's confidence. Looking down, she measures carefully with feet barely apart, while her partner reassures her with his eyes, challenging her to balance his risky swings and steps by pulling her toward him. Post's own dance studies inspired her extended observations of various dance styles and steps that she encountered while on the road. Driven by energy expressed in two dimensions, Post's dance pictures became some of the most frequently published photographs in her FSA oeuvre.[64]

Exhibits of FSA photography attracted widespread attention in the late 1930s, particularly after a successful showing at New York's Grand Central Terminal in 1938. The agency sponsored its own exhibits in public spaces, and it lent and sold photographs to other organizations that had embraced the visual image as a powerful vehicle for delivering their messages. Una Roberts Lawrence, of the Southern Baptist Convention's Home Mission Board in Atlanta, made plans with Stryker to set up exhibits at the 1940 Southern Baptist Convention in Baltimore and at the Baptist Stu-

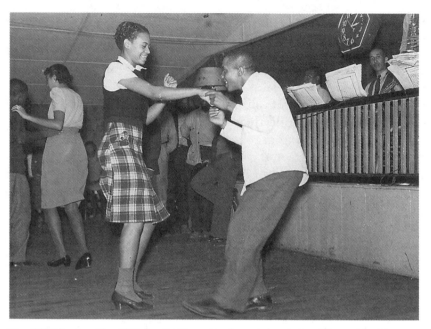

Fig. 31. Marion Post Wolcott. *Dancing in a Juke Joint. Memphis, Tennessee, 1939.* U.S. Farm Security Administration Collection, Prints and Photographs Division, Library of Congress.

dent Union Conference in Ridgecrest, North Carolina. She made a specific request for "a complete exhibit of Negro life" so as to "strike more surely at the intelligence and conscience of our folks" by showing "conditions as they are." She also explained the importance of FSA pictures in instructing writers of Southern Baptist church literature, who she said displayed "an appalling lack of contact with farm life and especially with these problems and the solutions that are being worked out." Art photographer Ansel Adams asked for thirty-five prints to display at San Francisco's Golden Gate International Exposition, in hopes of demonstrating the "use of the camera as a tool of social research for communication and information." But the gap between art photography and documentary photography remained open, as was proved when the New York World's Fair officials abandoned the idea of an FSA exhibit. In focusing on the future, new technology, and the urban world almost exclusively, the fair found little place for agrarian traditions or regional emphases, and its organizers chose commercial photographers to do their bidding. Another group not so willing to embrace what pictures could offer were professional historians, Stryker reported. He admitted making little progress at the 1939 American Historical Association meeting, where he attempted "to convince the historians that the camera and the photograph" could be "important tools for them to use." In the meantime, he directed Post to continue producing the kinds of photographs he wanted, scenes of the good life in America.[65]

Pictures of families and community gatherings and flourishing small towns, the places where collective strength and cooperative efforts were frequently displayed—Stryker sought these for his file. Although he was a friend of sociologists Robert and Helen Lynd, Stryker disagreed with their less-than-flattering assessment of community life in their studies *Middletown* (1929) and *Middletown in Transition* (1937). With FSA photography he attempted to provide a contrasting image, one that would prove that the small town in America was alive and well and that its inhabitants remained committed to home, family, church, and community. Stryker wanted his photographers to capture the uplifting spirit of unity that bound people together in close-knit communities—he believed such a spiritual climate characterized most small towns in America. Historian James Curtis has argued that Stryker

mounted a serious campaign "to counter Lynd's portrait of declining family solidarity with fresh visual evidence. . . . [He] needed a counterweight to assure his contemporaries that home life still mattered, that it was a basic determinant of American values."[66] Fortunately, the FSA director had Post on board at the height of his campaign. No one on his photography staff was better equipped ideologically to handle these themes. Her personal vision, molded by her experience with cooperative efforts and group identity both at home and abroad, helped guide the FSA into the next decade.

For Post, 1940 proved to be her best year in producing extended photo essays on community and its requisite human relationships. Four extended assignments illuminated her attachment to the value of cooperative spirit—one in New England, a second in Louisiana, another in Eastern Kentucky, and a fourth in Caswell County, North Carolina. The New England assignment took Post to a region blanketed in fresh snow. Exactly one year earlier, she was trying every way imaginable to protect her equipment and film from blistering Florida heat; now she faced the freezing cold of a Vermont winter, "Everything stuck & just refused to operate at *least* half the time. Shutters, diaphragms, range finders, tracks; film & magazine slides become so brittle they just snap in two." With temperatures below zero every morning, Post devised creative ways to keep her camera parts warm. She wrapped them in sweaters with a hot water bottle, and when driving she tried to place them as close to the car heater as possible. She pleaded with Stryker to understand her struggle to prevent equipment breakdown in the event her negatives turned out "underexposed, overexposed, out of focus, jittered, in any other way technically not too hot."[67]

The New England assignment was a significant one since FSA photographers had spent very limited time in that region. The office files included only a few prints of the northeastern United States, so Stryker wanted Post to fill the gap with a large number of assorted scenes and activities. His specific request was for broad, snowy landscapes. In spite of hazardous driving conditions on icy roads, Post made her way from western Massachusetts through Vermont and New Hampshire and on up into Maine. In one wealthy section where an exclusive mountain lodge was located, she photographed skiers gliding down the slopes. But she was much more

interested in the permanent residents of the area; she focused in particular on their seemingly smooth adaptations to fierce weather. Scenes of rugged activity—men and women clearing snow, cutting wood, logging, and making early morning milk deliveries—are matched with those of carefree playfulness, most notably delighted children headed downhill on sleds. Cabin villages, private farms, and a local general store served as stages for Post's artistry. After spending several weeks in New England, she received word from Stryker that novelist Sherwood Anderson wanted her to emphasize particular themes. Anderson's detailed list suggested that Post find and photograph a small-town jail, a birth scene, an abandoned roadhouse, and a country lawyers' gathering.[68]

Taking advantage of the free agency Stryker allowed, Post accommodated Anderson to an extent but ignored many of his requests. Her own fascination with the wide spectrum of personalities she encountered kept her continuously occupied, encouraging her years later to name the New England trip as one of her favorite assignments. She heard one farmer explain the extensive sugaring process and how the season's excessive snow prohibited him and many others from reaching their maple groves. "Sugaring" served as a social event, bringing people of all ages together to assist in the gathering and boiling of maple tree sap. Enamored of the old mill village Berlin, New Hampshire, Post discovered that most of its townspeople came from French, Norwegian, Swedish, or Italian backgrounds. In North Conway, New Hampshire, she was asked by "a couple of cranks who weren't too pleased" not to snap many pictures of the town meeting.[69]

The rejection in New Hampshire mattered little because Post soon gained entry into a town meeting in Woodstock, Vermont, allowing her a comprehensive look at the theme of community action. Woodstock residents had received "warning" to attend the annual business meeting, where several vital issues would be discussed—among them whether the town would allow baseball or concerts to be played or movies to be shown on Sundays and whether to permit the Prosper Home Makers Club to build an addition onto the local schoolhouse. The subject that seemed to attract the most attention, though, was the selling of "malt and vinous beverages" and "spirituous liquors" in Woodstock. In one image Post recorded the interplay among three older participants,

one a selectman casting his secret ballot on the liquor issue. As a woman reaches to give the voter his ballot, the lighthearted banter shared among the three is evident in their smiles and laughing eyes. Post captured the exchange not only visually, but also in a caption reading, "If you vote yes for liquor you'd better put your ballot in a box in a different town. We won't let you stay around here long." The woman's comment, jokingly uttered, reveals one of the gendered avenues toward political influence. Although her voice and presence may be minuscule in the collective gathering (proved by the absence of women voters in Post's photographs of the meeting), her personal and nonthreatening contact with a voter on this local prohibition initiative carries her message effectively.[70]

The importance and intensity of the discussion on liquor sales in Woodstock may be observed in the crowd scenes that Post captured from various angles inside the town hall (figs. 32 and 33). Although it was scheduled on a Tuesday morning, the meeting obviously attracted a substantial crowd. She indicates the size of the group with back views and overhead views of the meeting room. Each wooden chair holds an interested discussant. In the crowd were men from different classes, the more modestly dressed wearing field jackets and no neckties. Post's direct view from an aisle reveals these participants crammed closely into tight space, their looks and actions ponderous and deliberate. One man cradling his chin in forefinger and thumb listens intently, while another, with pencil in hand, takes notes on his ballot. Prominently displayed by the two men in the foreground are copies of the seventy-five-page "Annual Town Meeting Agenda and Report," distributed to all meeting attendees. Beyond their direct and active engagement with the issues, the men Post included in *Town Meeting* (fig. 32) serve to articulate her commentary on class in small-town America. They may share in this democratic experiment, but they occupy seats at the back of the room. None of these men, whose clothes and untidy long hair set them apart from voters at the front of the meeting hall, appear at the counting table (fig. 33). Those in charge of the ballots hail from a different class. They have fresh haircuts; starched, collared shirts; vested suits; and neckties. That so many wear eyeglasses implies a certain literacy level, perhaps that they work with words or numbers in jobs that require specialized, skilled training. These men represent the

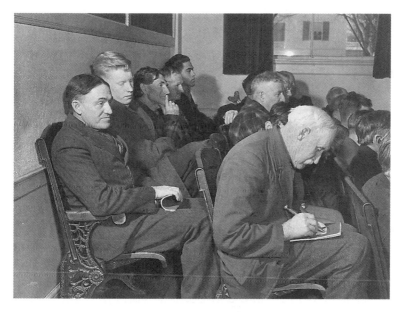

Fig. 32 (above). Marion Post Wolcott. *Town Meeting. Woodstock, Vermont, 1940.* U.S. Farm Security Administration Collection, Prints and Photographs Division, Library of Congress.

Fig. 33 (below). Marion Post Wolcott. *Counting Ballots after a Town Meeting. Woodstock, Vermont, 1940.* U.S. Farm Security Administration Collection, Prints and Photographs Division, Library of Congress.

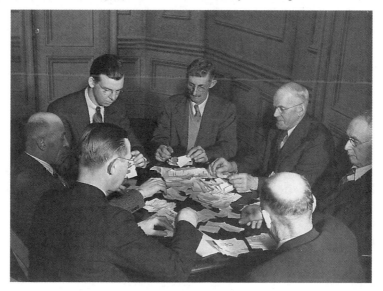

town's power elite; their willingness to work together, as Post demonstrates, ensures their ability to maintain their honored position. Apart from each other, the two images bespeak the varied contributions of Woodstock's male citizens to the civic enterprise; together they illuminate the subtle disparities existent in an otherwise bucolic setting.[71]

Some of Post's most widely circulated prints were those she generated in her six-week venture in New England. Sherwood Anderson, in collaboration with Edwin Rosskam, printed twenty-five of Post's photographs in his 1940 publication *Home Town*. Anderson admitted developing a sense of appreciation for collective endeavor during the 1930s, all the while shaping his views on community efforts and small-town values. The week *Home Town* appeared, an editor at *PM's Weekly* penned a glowing review, suggesting, "Now is a good time for intelligent persons to start learning about small towns. City planners insist that the big city has outlived its usefulness and that there will be a migration back to the small town." Praised for "its timeliness" in some quarters, *Home Town* later suffered criticism with regard to its use of FSA photographs. William Stott believes the images, although "badly presented," greatly transcend Anderson's text. Former agency photographer Walker Evans put it more bluntly in proclaiming Anderson's words "cheap use" of FSA imagery. Evans described an example in which a Post photo was accompanied by an adjoining caption that "degrade[d] the picture." Post's photographs of New England and its inhabitants proved to her contemporaries and to later critics that they were hearty enough to stand with few or no words.[72]

Late in the spring of 1940, Post crisscrossed the South covering routine government assignments, some repeat affairs for Public Health and for Surplus Commodities as well as the FSA project areas. Her Louisiana assignments on the Terrebonne Project, the Transylvania Project, the LaDelta Project, the Allen Plantation Project, and the Bayou Borbeaux Plantation Project were designed to show off the FSA's tremendous success in the state. The images Post created elicit conceptions of model environments where comfort, cleanliness, abundance, prosperity, and cooperation characterize all life and experience. She focused particular attention on an unusual FSA venture she must have appreciated—the racially

integrated Allen Plantation Project in Natchitoches. Post's frames show men and women, black and white, working alongside each other in the cotton fields there. But to reveal her personal opinions about the project's limitations, she also photographed the cooperative's all-male, all-white board of directors.[73]

The FSA's strides in home management supervision at the Louisiana projects provided Post with ideal subject matter. In one image (fig. 34) a young boy stands in his home's orderly, well-stocked pantry. Post's angle emphasizes the depth of this project family's abundance, as she shows the long sweep of canned vegetables from the left edge of the frame to just past the center line. The photograph shouts "Plenty." That the rows are reflected in the window gives the illusion of unending nourishment achieved through expert planning. The boy, wearing a spotless shirt and trousers, is literally weighted down by the bounty his family has stored up for their future. But as Post's larger photo essay describes, the scene is the result of more than good harvests. The FSA's provisions for this kind of client security were made through hands-on instructional methods, which Post recorded in the same series. The most vivid image shows a home management supervisor demonstrating the use of a pressure cooker to an enthusiastic student. As one Terrebonne Project client, a former tenant farmer, said, "I think *we* are going to put it over. I think *everybody will get together and work hard and put it across.* . . . I've never been able to get anywhere. Now I'm on the project and I'm going to make a better living. I'm working now and getting paid for it, and when *we* make a crop I'll get part of the profits." Individual success depends upon the willingness of everyone in the community to contribute to the collective strength; when "we" cooperate, "I" will reap the rewards, the farmer realizes.[74]

The third of Post's profitable long-term community studies in 1940 was set in Kentucky. She was shocked by what she encountered: "I was quite amazed at the backwardness of the Kentucky mountain country when I saw that for the first time. . . . I hadn't realized that it was still this way in this country, in the U.S." As the FSA photographer responsible for the majority of Kentucky scenes, Post took more than seven thousand photographs in the state during the late summer and early fall of 1940. Aside from conducting a brief session with Public Health officials in Louis-

Fig. 34. Marion Post Wolcott. *Child of an FSA Client. LaDelta Project, Thomastown, Louisiana, 1940.* U.S. Farm Security Administration Collection, Prints and Photographs Division, Library of Congress.

ville, she spent most of her time either on major highways connecting the larger central Kentucky towns or in the Appalachian region. The pictorial record that Post produced illuminated the social, cultural, and economic lives of Kentuckians, particularly those who were tucked away in the mountains and kept few written records. Post received a limited amount of preparatory material before entering the world of Kentucky mountain natives. She had read only the recently published WPA *Guidebook to Kentucky* and Malcolm Ross's *Machine Age in the Hills* (1933), but fortunately the *Louisville Courier-Journal* staff was helpful in lending suggestions and showing her the best travel routes. Post left the newspaper office impressed by the "superior" job they did running a paper, but more than that she was elated that one employee had repaired the shutter on her Speed Graphic.[75]

While in central and eastern Kentucky, Post used her time scrupulously and never failed to carry her camera everywhere she went. She attended county fairs and horse shows, church suppers and farm auctions, an American Legion fish fry and a Primitive Baptist Church baptismal ceremony. In September she begged Stryker to allow her to stay longer than her designated time so that she could record the sorghum molasses "stir-offs," community apple peelings, and bean stringings. Included in her vast collection are scenes of children walking to school, families mourning their deceased kin, and women carrying heavy loads of weekly supplies up creek beds. Away from telephones and Western Union offices, Post unleashed her creative spirit. She traveled several days through a remote area of the region guided by Marie Turner, the Breathitt County school superintendent. Turner's assistance proved exceptionally useful; because of it Post gained entrée into places that she would not have known existed otherwise. Having a willing guide gave Post the kind of support Doris Ulmann had enjoyed with her Kentucky escort, John Jacob Niles. But the experiences of Ulmann and of Post in eastern Kentucky were quite different upon comparison. Post and Turner faced travel difficulties that Ulmann and Niles tended to avoid by staying on main thoroughfares. On their first day out in Breathitt County, Post and Turner got their borrowed car stuck in a mountain streambed and had to be pulled out by a mule. A bit farther up in the mountains they were stopped with a flat tire. Post told Stryker of their

successful attempt at repairing it: "Tore down a fence post & while our driver (a young kid who is the son of the school janitor) tried to prop the car up I was down on my belly in the creek bed piling rocks under it. But we finally got it fixed. . . . We did amazingly well over the worst & most dangerous roads & creek beds I've ever seen."[76] On another trip, the two women traveled by mule on a narrow mountain trail, finding great relief when their mode of transportation was upgraded to horses. Post spoke excitedly of the tour.

> It is wonderful country & the people are so simple & direct & kind if they know you, or if you're with a friend of theirs. I got some excellent school pictures I think, & some other things as we went along. It takes a great deal of time just to *get* anywhere & make friends. . . .
>
> Got arrested the other day in a town in the next county, even after all kinds of precautions & after having gone to the F.S.A. office & walked all over town with the F.S.A. people too. But there's a feud there between F.S.A. & Triple A, & that's where it all started. They just took me before this county judge who asked questions & looked at identificaton, etc.—it was just funny because the whole town was full of people (Labor Day) & got all stirred up over it & followed me in a big procession to the court house—all crowding around the judge afterwards to see my papers & getting into arguments about spies.[77]

The case ended quickly. The judge charged Post with being a suspicious person but dismissed the case and concluded that she was probably "as good an American as anybody."[78] Her connection to the U.S. Government sparked her accusers' doubts. Ulmann had avoided such confrontation, probably because of her relationship with the Russell Sage Foundation, a private humanitarian organization.

Stryker realized that Post's work in Kentucky was invaluable, her official contacts important, and her scenes priceless. He told her that the stories she could tell of her experience in the Kentucky mountains would fill an entire chapter of the book he

wanted the FSA staff to write someday, adding that "with your contacts down in them thar hills, we should be able to bring out good gold." Beyond the contacts she made, Post stepped into traditional gender roles in order to gain her subjects' trust. In her casual attire, she helped women in their kitchens by peeling potatoes, dressed small children in the family, and drove to town to pick up household necessities for them. She engaged herself in the scenes she arranged, just as the Workers' Photography Movement had instructed its adherents in the mid-1930s. Her own cooperation within the family, the neighborhood, and the community allowed her a comfortable reciprocity from the people she photographed. They returned to Post uninhibited poses, natural images for her camera.[79]

In a series on the annual memorial service held in Breathitt County, Post surveyed the day-long ritual that brought together nearly three hundred people who were unable to hold formal funeral services immediately following a death in the family. As Post reported in "General Caption No. 1" on the assignment, travel was much easier during the summer and early fall, allowing family members and friends from remote areas to reach mountain cemeteries. The collective mourning for those who had died during the year took place at an outdoor feast where people gathered to "tell about the events of the past year." The group also listened to "a battery of preachers" for several hours and often witnessed immersion baptisms in nearby creeks.[80] In one image (fig. 35), five men share the arduous task of carrying a coffin along a river fork. Post captured on film the moment of greatest difficulty, at the place where the stream is widest. The man in the foreground stands awkwardly on an exposed rock, while another on the far left steps carefully from dry ground into the water. The communication among the five is essential if they are to safely complete the job. Another photograph in the annual memorial service series (fig. 36) exhibits the sense of camaraderie that Post sought out in all her shooting locations. Here small clusters of friends and family members, of all ages, share stories and news. The seriousness of the occasion is marked by the prominent gravestone, but Post's rendering of the scene draws more attention to the lively storyteller profiled in the center. The participants carry on despite the camera's presence, with only one person in the crowd gazing at

Fig. 35 (above). Marion Post Wolcott. *Men Carrying a Coffin. Breathitt County, Kentucky, 1940.* U.S. Farm Security Administration Collection, Prints and Photographs Division, Library of Congress.

Fig. 36 (below). Marion Post Wolcott. *Visiting After a Memorial Service. Breathitt County, Kentucky, 1940.* U.S. Farm Security Administration Collection, Prints and Photographs Division, Library of Congress.

the photographer (at the far right of the frame). Holding a baby, the woman stands out as the only individual in the scene who is not engaged in a small group conversation. Post's message has little to do with the principal reason for gathering, the funeral; it is instead a comment on communication—people laughing, listening, and touching.

Even though they traversed the same area within just seven years of each other, Marion Post and Doris Ulmann produced extremely different portraits of southern Appalachia. Both in content and in style, Post's work stands apart from Ulmann's collection. Based on disparate generational and cultural backgrounds, the two photographers created what they wanted viewers to see. Ulmann's vision reflected Progressive Era reform ideology combined with the influences of the 1920s agrarian appreciation movement. Post's views were informed by thirties radical politics, which emphasized the strength of the masses, the group, the collective ideal. As a result Post highlighted social lives and connections, whereas Ulmann defined individuals by their work, especially what they made with their own hands. Post placed value on activities that filled leisure time; Ulmann searched for personal industry. Among the events that Post examined was a "pie supper," where eager teenage men bid on pies baked by young women with whom they wished to share their desserts. Energy permeates these scenes, as well as many others, such as the Fugate School playground, the Woodford County courthouse square, and the site of a neighborhood house raising. In Post's Kentucky photographs people weep, laugh, and flirt. They rarely stare off into the distance pondering their individual lives or their fates; with an occasional exception, they connect with each other by word or touch or glance. As Sally Stein has pointed out, Post "was especially attentive to informal group interactions for the way they expressed some of the bonds and boundaries within a community. . . . Hers are rather cool observations which document not only the character of people's gestures but also the general environment and specific objects that gave rise to these forms of non-verbal communication." An excellent source for comparative analysis on this issue is *A Kentucky Album,* for which editors Brannan and Horvath selected a representative sampling of FSA photography by each field staff member who visited Kentucky during the agency's eight-

year life. Here Post's images stand out because they survey the wide spectrum of human relationships, dissecting the ways people interact with each other.[81]

With the Kentucky assignment finished in midfall, Post assumed a more structured shooting schedule to cover several FSA projects in North Carolina. She traveled to Chapel Hill, where she got caught in the swarming activity of a university town. Since students had taken most of the rooms in Chapel Hill and Durham, Post had trouble finding a place to live. But the enlivened atmosphere, especially on home football weekends, gave her rich subject matter for visual studies. She recorded college student frivolities, fraternity parties, and practical jokes. Her more essential camera work took her to Caswell County on the North Carolina–Virginia border. Assigned to record the success of project activity, Post thoroughly surveyed FSA borrowers' homes, farms, and work in progress.[82]

In Caswell County Post completed the fourth of the community studies that defined her FSA vision. Two images (figs. 37 and 38) based on the same theme, land use, appear similarly derived. Each shows a small group, a community land use planning committee, examining a map of the county. Both groups sit at tables, are focused on their purpose, and appear earnest in making thoughtful decisions. Their hands on the maps symbolize their direct participation in creating change in Caswell County. Below the surface of the seemingly similar messages, though, lies Post's subtle commentary on race, class, and gender. That one county requires two land use committees intimates the limits of the ability—and perhaps of the willingness—of the U.S. Government to challenge regional social standards on race. Beyond the obvious bow to Jim Crow laws are the local community-driven expectations. The all-white committee includes women; the all-black committee includes males only. The white women planners serve not merely as onlookers but as participants, with fingers and pens pointed to specific locales. Their contributions may be checked by the two men who have assumed authority by standing over the table, but their power relations are little different from those that exist between the seated men and the standing men. By comparison, the African American committee shows one individual who has taken charge, so much so that he has bored the person seated to his right. Those

Fig. 37 (above). Marion Post Wolcott. *Land Use Planning Committee. Locust Hill, North Carolina, 1940.* U.S. Farm Security Administration Collection, Prints and Photographs Division, Library of Congress.

Fig. 38 (below). Marion Post Wolcott. *Land Use Planning Committee. Yanceyville, North Carolina, 1940.* U.S. Farm Security Administration Collection, Prints and Photographs Division, Library of Congress.

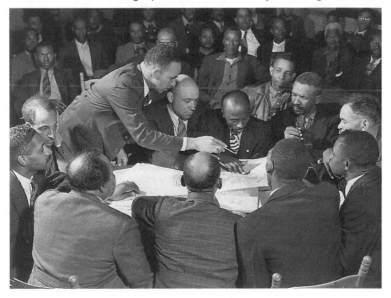

at the table wear suits and ties, while several men sitting outside
the realm of decision-making wear open-collared shirts and ca-
sual jackets or overalls. These men appear physically and socially
removed from the center of power, which poses itself as solidly
middle-class. A wider view of this same scene reveals clearly that
a white observer is seated at the table. His responsibility as an
advisor to the group allows him closer contact with the men than
the only remaining "other" in the room—a woman charged with
taking notes of the meeting. Post's photographic survey yielded
pictures used in a USDA pamphlet entitled *We Take You Now to
Caswell County.* Advertising the positive effects of federal gov-
ernment programs such as the Civilian Conservation Corps, the
Agricultural Adjustment Act, the Soil Conservation Service, and
the FSA, the tract announced, "They're putting some real stuffing
into democracy in this North Carolina county where farmers and
representatives of Government services are meshing their resources
and energies through the Land Use Planning Program." Accom-
panying the uplifting rhetoric were Post's mirrors reflecting the
limits of democracy in a community where a web of sexism, rac-
ism, and classism exists.[83]

Despite her valued contributions toward putting across the FSA
message in 1940, Post had grown weary of her job, with its tight
schedules, haughty social workers, and disrespectful clients. She
had waited on several occasions and for many hours for a Caswell
County doctor who was supposed to be a subject of her survey
there. He finally refused to oblige her. In general, Post felt she had
gotten a "temporary 'belly full' of the dear old South." Further-
more, news of the European war bothered her. Recollections of
her days in Europe seemed to promote a concern Post found dif-
ficult to dispel. Several times she mentioned her uneasiness as the
international scene grew darker. In May, she wrote to Stryker, "War
news, international and national happenings, always seem to be
even worse & more terrifying to me when I'm away & don't have
anyone I know to talk to about it." Nightmares about the war
and the "human" race, as she put it, kept Post from fully enjoying
the travel. Her job was made even more difficult because people
gradually became more hysterical about the war and grew suspi-
cious of who she was and what she was doing. In the summer of

1940, while working on the Terrebonne Project in Louisiana, Post frightened a couple of Cajun children who ran away screaming to their father that they had seen a German spy with a machine gun (her camera). On several occasions state officials and policemen stopped her to check her identification. Unable to ease authorities' suspicions, Post found herself in a number of county sheriffs' offices. She hated to waste time on the long, drawn-out security procedures, but she concluded that the officers probably had nothing else to keep them busy.[84]

At midyear Post "complained that she felt pigeon-holed as 'the project-photographer-in-chief.'" Her claim was not unfounded: She was saddled with a large number of routine assignments and was often sent to regional FSA offices where a public relations visit from an "attractive and enthusiastic" member of the Washington team meant more than any photograph she might take while there. By the fall she expressed her accumulated frustrations in an outburst, "Now tomorrow I'd like to wake up in the morning & say—today I can go where I damn please, I don't *have* to let F.S.A. & Stryker know where I am, I don't *have* to go to Western Union or the post office or the railway express, or feel guilty because I haven't done my travel report & can't find the notebook that has the mileages of the first half of the month in it." This letter more than any other that Post wrote in her tenure at the FSA highlights the double standard to which she felt Stryker held her. The overwhelming paperwork load she bore alone, unlike most FSA photographers who had enjoyed the aid of traveling companions. Yet Stryker would not have permitted her to have a "secretary" as her colleague Russell Lee did while on the road. Post had to keep herself above suspicion in the realm of intimate relations. She later told historian Jack Hurley, "I had to be so *careful* not to meet anybody or see anybody. It was so unfair. . . . I'd never have gotten away with it because everyone was so curious about a woman traveling alone in those days and any gossip they could figure out they used."[85]

Post even had to lobby for time off, reminding Stryker in late 1940 that she had not had a real vacation in three years, a fact that illuminated the close eye he kept on her and the continuous demands he made on her. She would not be allowed one for a few more months, in the interim having her frustrations heightened

by rainy Florida weather, a slow New Orleans job, an entire set of blank negatives, and more frequent assignments devoted to defense efforts in the United States. Post's growing discontent with the defense assignments is seen in an extensive typewritten report found accompanying her January 1941 assignment in Louisiana. The first paragraph reads, "If you want a taste of all-out National Defense, go to Alexandria, Louisiana. See men, women, and children living in shacks, tents, trailers, and chickencoops. Try to rent a house or apartment. Stand in line to see a movie. Pay New York City prices—and more—for your dinner in a restaurant." Later in the report she complained, "Soldiers are everywhere."[86] Her enthusiasm for the FSA waned as the agency shifted its focus.

A long-awaited vacation, spent on ski slopes in Vermont, allowed her to return to Washington refreshed, not only ready for new field assignments but also prepared to begin the most challenging and long-term adventure of her life. On 6 June 1941 Marion Post married Lee Wolcott, an assistant to the secretary of agriculture in Washington. She had met him six weeks earlier at a friend's house in Virginia and years later claimed that the two "really didn't know each other" when they got married. After the wedding they spent a few weeks near Washington; then Marion Post Wolcott resumed her full-time duty with the FSA. This time Stryker chose not to arrange a schedule filled with excessive travel connections and tight deadlines. Perhaps more importantly, he decided not to send her back to the South. Earlier she had expressed a strong desire to journey out to the wide open spaces of the Great Plains, longing to see an environment unlike any she had ever experienced. She even told Stryker that she often heard a voice shouting in her ear, "Go west, young man." A trip to the West would in some ways round out her FSA career, bring her full circle, since she had worked in nearly every other region of the United States. It would be her last field assignment for the FSA.[87]

Before she departed for the West, Post Wolcott received a preparatory reading list from Stryker. The two-page bibliography included Walter Prescott Webb's *Great Plains,* Everett Dick's *Sod-House Frontier,* Mari Sandoz's *Old Jules,* O.E. Rölvaag's *Giants in the Earth,* Hamlin Garland's *Son of the Middle Border,* and books by Willa Cather, Clyde Davis, Paul DeKruif, and John G. Neihardt. Once on the trip, Post Wolcott found the variations in

terrain fascinating. Overwhelmed by miles and miles of wheat in the flatlands, she wrote to Stryker, "I never imagined such expanses." While driving through the region, she followed Stryker's shooting script closely, attempting to capture the feeling of "space and distance and solitude." She noted that the trains stretching across the Plains looked like tiny toys, and she wondered aloud if the inhabitants ever got tired of such flat, boundless distances. During the time she resided at Brewster-Arnold Ranch in Birney, Montana, Post Wolcott concentrated on the elements that composed life on a dude ranch. Careful not to duplicate Rothstein's photographs of cattle ranches, she lent her own unique style to the horse and cattle photo stories she compiled. In Wyola, Wyoming, she documented an outdoor barbeque event, with community members talking, laughing, eating, and serving each other. She remained awed by the vastness of the land on which the animals roamed, and her photographs revealed her reverence. She also experimented with color photography, studying various phases of sunsets and red dawns over the mountains in Glacier National Park. An especially memorable part of the trip were the few days she spent on the road with her new husband.[88]

Making her own discoveries about the region, Post Wolcott finally satisfied her desire for a frontier adventure. The Western trek changed her. She experienced tremendous loneliness and realized through the course of the assignment that her loyalties were divided. Her correspondence to Stryker fell off considerably. She resorted to sending most of her messages by brief telegram, a surprising departure from the humorous, detailed letters she had always written. She found herself unable to concentrate as intensely on FSA duties as she had in the past. Among other things, the international situation frightened her, and she wished to be back within the safe confines of a home shared with her husband and two stepchildren. She wrote in August 1941, "[I] keep reading in the paper that we may be getting closer, very rapidly, to the kind of world system that may drastically, & perhaps tragically & seriously, change our whole lives. There seems so little time left to even try to really live, relatively normally." In addition, Post Wolcott had grown anxious about the shift in objectives at the FSA office. In 1941 she and other FSA photographers were assigned more jobs dealing with American war efforts, and they experienced the tighter

restrictions placed on the agency. Subjects dealing with defense, including war preparations, aircraft assembly, and defense housing, demanded priority but were particularly unappealing to Post Wolcott. In the fall of 1941, she depicted with irony a public weapons display in Washington, D.C., revealing the wide-eyed excitement and curiosity of young Boy Scouts examining various weapons of destruction.[89]

By the year's end Post Wolcott had decided to end her service with the FSA. Two months pregnant, she realized that she could no longer maintain the pace, the long hours, the rapid travel connections, and the risks that accompanied every FSA photographer's job. Post Wolcott's scrupulous timing took her out of the FSA just months before the agency fell under control of the newly created Office of War Information. Her last letter to Stryker differed from all the others written in her three and a half years with the FSA. The familiar handwriting replaced by typescript, the casual conversation turned formal, it read:

> Dear Mr. Stryker,
> I hereby tender my resignation as Principal
> Photographer in the Historical Section, Division of
> Information, Farm Security Administration, effective
> at the close of the business day, February 21.
>
> Sincerely yours,
> Marion Post Wolcott

The cool tone no doubt reflected her increasing alienation from Stryker in the previous months, a rift aggravated by Lee Wolcott's insistence that every FSA photograph ever taken by his wife have her new married name recorded on the print. As a USDA administrator further up the bureaucratic ladder than Stryker, Wolcott got his way through an official memorandum reminding all regional directors that "when a female employee in government service marries, her legal surname *must* be used by her instead of her maiden name."[90]

Marion Post Wolcott's three-year tenure with the FSA had taken her from the Maine coast to Miami Beach, from the South Caro-

lina lowlands to the Louisiana swamplands, from the Appalachians to the Rockies, and practically everyplace in between. She had stood in fields of wheat and cotton and corn, between rows of tobacco and tomatoes and peas, and under orange trees, maple trees, and palm trees. Inside these venues she had created thousands of images of Americans working together, playing together, and simply enjoying each other's company, in spite of economic devastation. Her emphasis on the rituals of corn shucking, sugaring, bean stringing, gambling, and card-playing, among other activities, points to her steadfast belief in visually defining America according to a communal ideal rather than by individual achievement. Post's pictures stunningly portray the essence of an era guided by the simple precept uttered by her contemporary Malcolm Cowley, "Not I but we; not mine or theirs but ours." Having transcended the prevailing themes of individual independence and success through mobility depicted in Lange's work and the inspiration of the past in traditional rural environments portrayed in Ulmann's work, Post came to stand with a cadre of new photographers who measured cultural standards by other criteria. Her view of group power and human relationships augmented the visions of women who were guiding documentary expression along a different set of markers. Among the most notable of these featured the vital role of modern technological power and its connection to the human element.[91]

Of Machines and People

MARGARET BOURKE-WHITE'S ISOLATION OF PRIMARY COMPONENTS

> When I was discovering the beauty of industrial
> shapes, people were only incidental to me. . .
> I had not much feeling for them.
> —Margaret Bourke-White, *Portrait of Myself*

AT A 1934 CONFERENCE IN NEW YORK entitled "Choosing a Career," an advertising executive told the following story: "If [our company] had let us say a brand of peanuts that weren't selling very well at ten cents a bag because people didn't think they were worth ten cents, thought they were only five cent peanuts, usually the inevitable conference would be called, and after a half hour or so of collaboration, the conclusion of the conference would always be the same, the best thing to do would be to hire Miss Margaret Bourke-White to take a picture of the peanuts and then people would think they were worth twenty-five cents a bag." Margaret Bourke-White could claim, at age twenty-nine, one of the most recognizable names in advertising photography. She had built her career in just over five years by assuming any challenge offered her and, in some cases, by creating her own challenges, even drawing attention to herself with outrageous antics and

colorful clothes. She exhibited the "bluster and self-confidence" of the quintessential American "advertising man" whose role required spreading the word about exciting new products to a mass audience. Bourke-White reveled in the freedom and power her position afforded her, intimating early in her career to an old school chum, "I have the most thrilling job in America, I believe. I can go anywhere I want to go and meet anybody I want to meet." Part of the job entailed molding a remarkable image of herself, as the daring yet glamorous woman charting new and occasionally dangerous territory. Those efforts to cultivate a public persona would have meant little if Bourke-White's photographic images had been marginal. Instead, her pictures generously fed the modern imagination, seducing viewers with extreme angles, close focus, and emotional vitality. The manipulative powers Bourke-White wielded and applied in her camera work made her one of America's most penetrating modernist *seers* and one of its most controversial documentarians.[1]

A fascinated observer of industrial and technological changes, Bourke-White genuinely loved science. Like millions of other Americans in the 1920s and 1930s, she harbored a steadfast faith in technology, finding beauty in the "excitement" and "power" of the machine. She maintained her modernist sensibilities even after turning her camera in the mid-1930s toward people and their environments, particularly those who inspired a nationwide documentary impulse in writers, artists, and photographers. Her perpetual obsession with the material world was difficult for her to set aside as she ventured into the realm of neglected people and places. She continued to view progress in terms of what machines, rather than people, could achieve. Technical processes and their products were to be studied and admired; people were to be courted and persuaded. The relationship Bourke-White fostered between these two entities, the mechanical and the human, revealed illuminating results, with people dwarfed by forces they had little or no control over. While on assignment in 1930, she wired the following message to her boss: "INDUSTRIAL SUBJECTS CLOSE TO HEART OF LIFE TODAY—STOP. PHOTOGRAPHY SUITABLE PORTRAY INDUSTRY BECAUSE AN HONEST KIND OF MEDIUM—STOP. BEAUTY OF INDUSTRY LIES IN ITS TRUTH AND SIMPLICITY." Bourke-White's pursuit of what she viewed as the most essential truth and simplicity made her an apt spokesperson

for the machine age. Her unabashed enthusiasm for it warranted her inclusion in a group dubbed the "apostles of modernity" by cultural historian Roland Marchand.[2]

As a child, Margaret developed a love for mechanical things under the watchful eye of her father, Joseph White, a machinery buff and devoted inventor. In addition to his work as a factory superintendent, White spent his life perfecting the printing press. He worked on color press variations, made small presses for mapmaking during the First World War, and invented the first Braille press. White, who sought out any mechanical challenge, also recognized the tremendous experimental possibilities the automobile offered. He bought one as much to try out his technical abilities as to offer exciting Sunday afternoon entertainment to his family. The vehicle provided numerous avenues for White's testing. Margaret, an astute observer of her father's interests, learned to enjoy them with him. Bourke-White biographer Vicki Goldberg relates a pivotal experience White provided for his eight-year-old daughter inside a foundry for press manufacture: "She already had a taste for adventure and the sense that everything she did with her father was adventurous, but factories came first, for he loved them best of all. . . . He steered her quietly up a metal stairway, nodding absently at the workmen. . . . he had brought her into a secret world that other girls had never seen."[3]

Recognizing the limits imposed on females, Margaret watched her mother operate under the rules that confined middle-class women in the early twentieth century. Margaret, born in 1904, would not see measurable improvements until sixteen years later, when women finally won the right to vote and middle-class society began to embrace some degree of social flexibility for women.[4] Before then, it seemed to Margaret that her mother simply marked time in the home, exerting her energies to carry out the smallest tasks to utmost perfection. Minnie Bourke White nevertheless offered indirect encouragement to her daughter by providing an example of determination and courage amid grim domestic circumstances. She chose not to erect barriers around her daughter's world. As Goldberg points out, Margaret "realized at an early age that her mother's energies were misplaced and that women were generally fated to live within what looked like narrow bound-

aries. While still a child, she dreamed of enlarging the territory, and no one said a word to discourage her dreams."[5] The contributions Minnie provided to Margaret's development equaled those of her husband. Later, as a young photographer, Margaret would honor both parents and their respective families by taking on the hyphenated surname Bourke-White.

The interests Margaret cultivated early had a significant impact on the subjects she later chose to photograph. She preferred science over history, geography over penmanship. In an effort to better her daughter's handwriting, Minnie White prompted Margaret to practice it during her summer vacation and even promised her a reward if it improved. Though Margaret thought little about how legible her script was, she did pay attention to instruction in other subjects. When she was thirteen, she took home an encouraging report from her teacher, who informed Joseph White that his daughter had done "excellent work in General Science." With the world of science ever changing, boasting new discoveries and various technological improvements, Margaret invested her time and her talents wisely. Knowledge in the scientific arena helped make any future appear brighter. But the sheer gathering of information would mean little if one pictured a personal destiny lived within the confines of the domestic sphere. Margaret had no such plans; she hoped to combine her knowledge with her quest for adventure. Her deepest desire was to become a biologist and "go to the jungles to do all the things women never did before, hoping . . . to be sent on an expedition."[6]

A thorough character analysis performed on Margaret in 1919 revealed facets of her personality and prospects for her future that amazingly prefigured her actual life experience. In several places the study suggested that Margaret use her adventuresome spirit toward productive ends. Phrenologist Jessie Allen Fowler recommended that Margaret teach geography since she harbored a "desire to travel, explore and see new localities." Fowler even made a prophecy based on the teenager's character, noting, "This temperament enables you to observe the details of everything you see in nature, and when you visit a new city you come away with a clear idea of what you have seen. Therefore it would pay you to travel and see the world, for you will be able to retain ideas of where you have been and what you have done. You should always take

photographs of places you have visited." The personality described was well suited to the active life, because Fowler had determined that her patient was "always ready to go to any place that is suggested." But the analyst also addressed Margaret's weaknesses, about which she issued the clear warning, "Cultivate a little more reserve, tact, and diplomacy. . . . Try to moderate your approbativeness or sensitiveness of mind, your desire to excel, and your love of popularity." Even at age fifteen, Margaret White realized that others saw the enormity of her potential and the amount of energy she would need to fulfill it. She set her goals accordingly, keeping in mind her father's creativity and her mother's determination as examples to emulate.[7]

In Margaret's freshman year at Columbia University, her father suffered a massive stroke and died. His financial mismanagement forced Margaret to find another source for her college tuition. Fortunately, her uncle Lazar assumed that responsibility and allowed his niece to resume her studies, including those with Clarence H. White, whom she later described as "a great teacher and one of the most outstanding of our earlier photographers." But after Margaret's freshman year, her uncle could no longer finance her education at Columbia University. As the White family's money matters grew worse, it appeared that Margaret would not be able to continue her education. A philanthropic neighbor who knew about the family hardships offered to send Margaret to college, asking only that she do the same someday for a needy student. When Margaret expressed her interest in herpetology, she was told to enroll at the University of Michigan, where Professor Alexander Ruthven taught. She left her New York home for Ann Arbor at age eighteen, entertaining two passions, one for reptiles, the other for photographs. After one semester, Margaret's talent for taking pictures surpassed her abilities in the zoology classroom. Professor Ruthven urged his would-be protégé to move away from a career in herpetology and toward one in photography. He found employment for Margaret in the university museum, where she could combine her interests in science and photography by making negative prints of exhibit material. In her sophomore year at Michigan, Margaret began to consider herself a photographer. She took pictures for the yearbook, assisted other photographers, and even cultivated a romance with a fellow photographer, Everett

Chapman. "Chappie," as his classmates called him, reminded Margaret so much of her father that she was immediately attracted to him. Bourke-White biographer Vicki Goldberg has said that Margaret adored Chappie because he was "modeled on her dreams and her upbringing." Through his death, Joseph White had etched the outline of his daughter's future. She had gone to Michigan, where she reclaimed him in the person of Everett Chapman.[8]

Their common interest in taking and developing pictures led Margaret and Chappie into an intimate relationship, one that would revolve around photography and ultimately be dissolved by it. Although each took on various jobs, Margaret was more determined than Chappie to make something of her talent with the camera. Her boyfriend had his eyes set on a graduate degree in engineering, and he nonchalantly assumed Margaret would follow him to his chosen destination. As they became more seriously involved, their highly charged emotional lives crossed and caused each a great deal of suffering. Both confused energy, jealousy, and uneasiness for love. Believing that simultaneous elation and misery could be cured only one way, they got married. To celebrate their unconventionality, they scheduled a brief ceremony on Friday, 13 June 1924. Since none of the White family members attended, Margaret wrote to tell her mother about the less-than-spectacular event, which she described as "a miserable affair," made so by an Episcopalian minister who insisted they rehearse in order to make the ceremony "as dignified as possible."[9]

Both the bride and the groom were exhausted, having worked in the darkroom until two o'clock that morning. Immediately following the wedding ceremony, they went back to making prints, while Margaret's new mother-in-law "went home and cried two days afterward, and said that she'd never feel right about [the marriage]." Margaret's troubles with her mother-in-law began early, foretelling a conflict that would grow increasingly tense as the marriage wore on. Once when the newlyweds managed to get away to a quiet lakeside cottage, Mrs. Chapman unexpectedly showed up for a vacation of her own. In her frequent pouting she required that her son display more devotion for her than for his wife. That he frequently switched his loyalties from one woman to the other complicated an already stormy marriage. To ease the domestic tension, Margaret delved further into her work, nurturing her

ambition to succeed. She continued with her photography jobs even after her husband took a secure position at Purdue University. Torn between her desire to have a child and her fear of sacrificing her individuality for a satisfying domestic life, Margaret agonized over the choice between home and career.[10]

The couple's move from Michigan to Indiana and then to Ohio left Margaret with various college credits but no degree. The single constant in her life was her photography. She always managed to find jobs, either on campus or around town. Margaret's camera work generated excitement in her life while her temperamental husband offered only silence. In 1926 Margaret finally worked up enough courage to leave Chappie and pursue her education again. She returned to New York, enrolled at Cornell, where she resumed her studies in herpetology, and continued to take pictures. Recognizing the advantages a single woman could enjoy in the 1920s, Margaret never mentioned her marriage. She wanted desperately to succeed on her own. On a trip to New York City, she spent most of her time "running around trying to make connections . . . in the photographic world." An observant aunt of Margaret's described her as "a Janus faced person," possessing inside "a little girl who won't stay down, who peeps out constantly, and comes out boldly when the adult person gets tired and retires for recuperation." Aunt Gussie, whose expectations reflected her nineteenth-century upbringing, good-naturedly offered a few helpful hints to her niece, such as "Don't wear yourself out. . . . I think your photography will be just the kind of a thing you can combine with being a housekeeper, as you will be able to a large extent to select your time for your work." The last thing Margaret wanted to do was "select" time for her photography. It came first. Although she considered a reconciliation with Chappie, she finally decided not to forfeit her passion or ambition in order to keep an unhappy marriage intact. A job offer in Cleveland persuaded Margaret to give her full attention to photography. It also prompted her to tie up loose ends.[11]

New circumstances and old problems combined to ensure Margaret a fresh start, one offering a path toward professional success and away from domestic strife. For two years Margaret had listened to Chappie's mother express hurt that her son had "deserted her," choosing "a wife instead of coming back to her."

When the Chapmans finally decided to dissolve their union, Margaret looked back on her trials with her mother-in-law as good experience that toughened her. She wrote, "I owe a peculiar debt to my mother-in-law [who] left me strong, knowing I could deal with a difficult experience, learning from it, and leaving it behind without bitterness, in a neat closed room. . . . I am grateful to her because, all unknowing, she opened the door to a more spacious life than I could ever have dreamed." With the divorce Margaret dropped her husband's name and reclaimed "White," determined to erase from memory her fiery, short-lived romance. At age twenty-three, she started over again, recreating both her identity and her image. Margaret cut her hair, bought brightly colored dresses and gloves to match her camera cloths, and set out to record the world in pictures. She began her trek in Cleveland.[12]

A thriving midwestern city, Cleveland boasted various industrial plants and plenty of river traffic. Margaret was intrigued. She walked the streets studying the architectural design of houses and buildings, always carrying along her portfolio and her camera. In a public square she took what became her first commercial photograph, a shot of a black man with his arms raised to the sky, preaching his gospel to an audience of pigeons. The backdrop for his public sermon is an imposing two-towered neo-Romanesque structure. The Cleveland Chamber of Commerce paid Bourke-White ten dollars for the scene. She worked on a commission basis for several months, taking pictures for architectural firms and a number of wealthy patrons. Her bosses quickly recognized their employee's eye for artistry and design, as she provided them with slick, high-quality images emphasizing the geometrical exterior lines of office buildings and private estates. She embraced this work in order to support herself, even though she wanted to devote time to more stimulating subjects. She decided that the massive Terminal Tower, a structure still under construction, was a perfect place for visual experimentation and personal adventure. The pictures she took there got her professional reputation off to a brilliant start, because the tower's controlling interests, the Van Sweringens, named her "official photographer" for the project. She had free reign to photograph the inside, the outside, even the top of the tower, if she wished. The Van Sweringens paid her "to feed her own excitement."[13]

The daring young photographer loved standing high above the city on steel scaffolding. Within months she had rented a studio on the twelfth floor of the new skyscraper and was able to enjoy the breathtaking heights anytime she pleased. At the front end of her career, Bourke-White wedded herself to a truly American design form, the modern skyscraper, whose towering presence dwarfed turn-of-the-century structures. The view allowed her to look down below at people, who seemed like tiny ants making their way through the streets. At eye level she could see factories sprawled out over the city. A glance up into the sky showed her industry's trademark of success, gray smoke billowing from automobile plants, paper mills, and steel mills. These signs reminded Bourke-White that industry dominated America, that it promised the best hope for the nation's economic future, and that it brought great financial success to those who took it seriously. Beyond its practical attributes were industry's strictly visceral appeals, which had been heightened by visual artists who portrayed what James Guimond has called "a kind of sooty romanticism." As early as the turn of the century, photographers such as Alfred Stieglitz, Edward Steichen, and Alvin Langdon Coburn had depicted industrial landscapes, dramatizing in particular the smoke and dust produced by locomotives and factories. The pictorialist vision cast industrial by-products in a soft haze, giving them an ephemeral, even mystical, quality. Remnants of this characteristically romantic view of industry still existed in the late 1920s, when Bourke-White began her professional career. But she would contribute to the transformation of the mechanized world into something not merely romantic, but positively seductive. What she saw in machines and their possibilities thrilled her, just as a new automobile had excited her father, providing him endless opportunities for experimentation. Of all the available manufacturing industries, steelmaking impressed Margaret most. She exclaimed, "There is something dynamic about the rush of flowing metal, the dying sparks, the clouds of smoke, the heat, the traveling cranes clanging back and forth." Steel marked the age, an age of progress and prosperity. That industry would help launch Margaret Bourke-White's career in photography.[14]

In 1928 she accepted two offers that elevated her professional status. One, from the president of the Otis Steel Mill in Cleve-

land, paid her one hundred dollars a photograph; the other, from Columbia University economics instructor Roy Stryker, provided public exposure but no considerable income. Bourke-White accepted both, seeing the complementary nature of the opportunities. She began exercising the clever business sense that would sell her pictures even after economic depression swept the United States. Her timing could not have been better; she was fortunate to have begun her career in advertising photography at a fortuitous time. Photographs "won increasing favor, partly because they were cheaper than drawings or paintings." Bourke-White quickly shed her cloak of inexperience and revealed a sharp eye for self-promotion. When Stryker requested a few of her photographs to use as illustrations in a revised edition of the department's economics textbook, Bourke-White immediately sent to him a full portfolio free of charge. She believed that students needed to recognize the beauty of industry as much as corporate stockholders did. She also understood that having her photographs in a book written by the highly esteemed economics faculty at Columbia University would mean wide circulation of her name and her pictures. The department's professors were so impressed with the photographs Bourke-White delivered to them that many requested prints to hang in their offices. "They are without doubt the finest set of industrial pictures I have ever seen and we all wish to commend you upon your ability to capture the artistic in the factory," Stryker wrote. He further noted that one of his students had been so inspired by the pictures that the young man wanted "to get out and work again." Bourke-White helped bring to life the ideologies promoted by Stryker and his mentor-colleague, Professor Rexford Tugwell. In a 1924 edition of their textbook, *American Economic Life and the Means of Its Improvement,* the authors had expressed a desire to provide for readers "the understanding, the control, and the improvement of the uses of industrial forces." Illustration, particularly photography, enhanced their presentation. One of the most telling images in the text showed the dominance of industry's components over the individual. In a penciled sketch, a huge crane dips molten steel as the accompanying manual laborers, who are dwarfed by the mechanism, tentatively look on. In the Otis Steel Mill, Bourke-White captured a similar scene on film, a first-prize winner at the Cleveland Museum of Art show that year.[15]

The early images Bourke-White created fed the notion that industry could simultaneously wear two mantles: it could be both an icon of power and a symbol of beauty. In affirming the processes of technological modernization, Bourke-White pointed to the attributes she believed most indicative of beauty: truth and simplicity. That her pictures of machines graced the pages of art and culture magazines showed how deeply the industrial age aesthetic had penetrated the nation's expressive soul by the end of the 1920s. When *Theatre Guild Magazine* ran a full-page print (the magazine's first such image) of Bourke-White's favorite "dynamo" shot, the caption read, "In her camera study of the dynamo, Margaret Bourke-White has evidently caught some of the power and beauty of the machine which suggested to Eugene O'Neill his Dramatic theme. But the repose in Miss Bourke-White's interpretation is quite unlike the demoniac godliness of Mr. O'Neill's." The reference to O'Neill's new play, *Dynamo* (1929), highlights the centrality of electrical power in Americans' lives by the late 1920s. The "Electrical God" figures prominently in *Dynamo,* as does one skeptical character who must be convinced by this development in modern living. Ramsey Fife grumbles early on about "Hydro-Electric Engineering" as "stuff that gives those stuck-up engineers their diplomas." By the end of the play, though, people are on their knees before the dynamo. The suggestion by *Theatre Guild Magazine*'s caption writer that peace and tranquillity could be found in industrial shapes indicates the level of innovation wrought by industrial designers and their followers. Bourke-White saw "perfect simplicity" in the dynamo, arguing that it was "as beautiful as a vase. . . . There is no decoration and not a line wasted."[16]

The fear of industry promoted largely by early-twentieth-century radicals and reformers, especially labor advocates arguing for protective legislation, had been replaced by excitement about the changes within corporate structure designed to enhance work life and its benefits. In addition, as more sophisticated machines required more skilled technicians and fewer unskilled laborers, the equipment itself demanded a new look. Facing the machines of a more complex industrial system than had existed just ten years earlier, Bourke-White stood in awe. Through the lens she recognized her own reverence, capturing it on film for others to con-

template. Because her vehicle was photography, itself a mechanical medium, Bourke-White stood as a true beneficiary of the machine-age perception that photography recorded reality. Displaying the widespread faith in photography as an honest medium, even industrial critic Lewis Mumford conceded that photographers made "right use of the machine."[17]

While Bourke-White's photographs stood as artistic renderings of elements in the nation's economic structure, they also served a more functional and perhaps immediate purpose. The images were meant to persuade. Twelve Bourke-White photographs graced the pages of a booklet entitled *The Story of Steel,* the Otis Steel Company's brochure for stockholders and clients. The Otis job took Bourke-White six months to complete, as she filled "waste basket after waste basket . . . with discarded films."[18] She sought artistic perfection, realizing that her task involved changing minds and molding opinions. The dozen printed pictures proved to be such a huge success that other corporations wanted to commission the young woman who turned assembly lines, ore piles, and smoke stacks into works of art. Republic Steel, Lincoln Electric, and the Chrysler Corporation hired her to photograph their mills and projects, allowing Bourke-White one adventure after another inside the male-defined world she longed to explore.

The photographer's actions cast her as an intermediary of sorts—on the one hand she contributed to the "feminization" of American consumer culture by continuing to portray the mechanical and technological realm as a sphere closed off to and largely misunderstood by the culture's primary consumers, women; at the same time, she exploited certain aspects of her own femininity and thrived on being the ultimate female consumer.[19] On her various expeditions, she charmed laborers, floor managers, and corporate presidents, leaving each with indelible impressions of her style, wit, and daring. Men rushed to assist her with her heavy cameras, tripods, and lights. Bourke-White manipulated her advantageous position among them and once categorized her supporters as either "high hats" or "low hats."

> My high hat friends are my advertisers, and as long as
> I have the publicity counselor and the advertising man-
> ager of the Union Trust Co., the secretary of the Cham-

ber of Commerce and the Treasurer of the East Ohio Gas company, the publicity manager of the new Union Terminal and the president of the Otis Steel, talking about me at luncheon, I shall never need to buy any advertising in Cleveland.

. . . [M]y low hat friends do all my hack work. The amount I have had done for me is marvelous, and I could scarcely buy for money all the little fussy jobs that have gone into making my little apartment the BOURKE-WHITE STUDIO.[20]

The charms and conceits Bourke-White displayed would eventually have worn thin in the business world had her work not been superb. But her pictures commanded as much attention as Bourke-White herself did. If her personality turned some heads, her photographs went a step further—they received long, thoughtful stares. Bourke-White's careful cultivation of the art of persuasion began to pay dividends.

The Otis Steel Company pictures, which showed up in several newspapers' rotogravure sections, also landed on Henry Luce's desk in New York City. Luce, the publisher of *Time* magazine, found the pictures fascinating. The Otis job had required Bourke-White to experiment with various film types, exposures, and lighting methods because of "the intense heat, splashing metal, and the extremes of brilliant lights and heavy shades." Luce, impressed with the photographer's eye, her range, and her unusual interpretative abilities, wasted no time in summoning Bourke-White to his office. He wired, "HAROLD WENGLER HAS SHOWN ME YOUR PHOTO-GRAPHS STOP WOULD LIKE TO SEE YOU STOP COULD YOU COME TO NEW YORK WITHIN A WEEK AT OUR EXPENSE STOP PLEASE TELEGRAPH WHEN." Seeing a great opportunity before her, the rising star decided to take "a free ride" on the corporation's budget; according to one *Time* employee, after Bourke-White arrived in New York she "went about her own business for two or three days before she bothered to look up Mr. Luce." When Bourke-White finally met the magazine owner, the two discussed his idea for a new publication devoted entirely to business and industry. Luce intended for the magazine, tentatively titled *Fortune*, to survey the diversity and excitement inside the industrial world. He planned to reach a wide

audience by covering *Fortune*'s pages with striking visual images. And he wanted Bourke-White to help him succeed.[21]

Luce offered Bourke-White a full-time position with the magazine, which was to print its first issue in January 1930. Although the opportunities and benefits appealed to her, she declined the job. Unwilling to sacrifice her freelance work for a prestigious staff position, Bourke-White explained to her mother, "I would rather develop as an industrial photographer than an executive." The meeting between publisher and photographer ended in compromise, though, as Bourke-White allowed him to borrow her steel mill pictures in order to sell advertisers on the *Fortune* idea. Luce, in turn, considered Bourke-White's offer to work part-time on the magazine while continuing to take commissioned assignments. Since the editor wanted to launch "a purely business magazine with the best procurable in industrial art," he could hardly afford to be inflexible. He needed a photographer like Bourke-White, one who had taken the steel industry by storm, had impressed architects throughout the Midwest, and was gradually making her way through the ranks of advertising from Cleveland to Madison Avenue. Within a few weeks, *Fortune*'s managing editor, Parker Lloyd-Smith, wrote to Bourke-White: "This is to inform you officially of what you might conceivably have suspected. That we are glad to accept your proposition of giving us half your time from July 1. The cash consideration being $1000 a month." In the summer of 1929, Bourke-White began her affiliation with the Luce publications. The relationship would enhance her professional reputation as well as feed her adventuresome spirit.[22]

Fortune's only photographer went to work immediately. Within a week her travel agenda had been expanded to include Europe. Bourke-White excitedly dashed off a wire to her mother, exclaiming, "I cant believe it. . . . Just came from their offices this morning where they discussed sending me to photograph the Chmpaign [*sic*] Caves of France and the marble quarries of Italy along with some possible ship building in Germany." *Fortune*'s developers had grandiose objectives in mind and planned to implement them using the talents of its ambitious new photographer. Before the magazine sent its cameras abroad, though, it would establish a reputation in North America. Since the United States had been the most

prosperous industrial nation throughout the 1920s, it seemed a logical place to begin the survey.[23]

In July Bourke-White began crisscrossing the continent, completing assignments from the East Coast to Chicago to Texas to Canada and in each place fashioning views that would help shape a rapidly developing machine-age aesthetic. On the trek she photographed watchmaking, glassblowing, meatpacking, salt mining, and plow blade manufacturing. In a photograph for the Oliver Chilled Plow Company (fig. 39), Bourke-White offered an artistic rendering of speed through a repeated image, a technique commonly used by industrial designers in the 1930s. Here the repeatability of the plow blades suggests not only the function but also the beauty of mass production. In this case Bourke-White employed repetition of a simple subject to create in her viewers an attraction to the product's potential movement. The image reveals some of the basic forms of the machine age aesthetic, most notably pure, clean, curved lines. Assuming a natural quality rather than a manmade one, the pieces of steel are stunningly suggestive of the human female body in profile. Unadorned, the smooth roundness of the successive figures connotes female fecundity, a quality defined by productive capabilities. Bourke-White's image is similar to Marcel Duchamp's modernist icon, *Nude Descending a Staircase, No. 2* (1912), where the figure's action effects a sweep of motion across the canvas. Although Duchamp claims to have removed any "naturalistic appearance" from the human image in the painting, his preliminary studies for the work were focused upon experimental research done in the field of photography twenty-five years earlier. Whereas Duchamp had created a human figure based upon its abstract mechanical qualities, Bourke-White had given machinery natural characteristics—in both, motion and beauty were inextricably bound.[24]

Though she often claimed to have invented the probing focus on industry's various components, she received a good deal of assistance in solidifying her style. Bourke-White had developed her visual sensibilities in a Clarence White class, years after Doris Ulmann and Dorothea Lange had studied with him. The experiences Bourke-White had with the photography master contrasted with those his pre–World War I students could remember. Since pictorialism declined after the war, visual emphases shifted from

Fig. 39. Margaret Bourke-White. *Plow Blades, 1929.* Estate of Margaret Bourke-White.

shadowy scenes to more sharply defined objects. Bourke-White stepped in just as one trend in photography edged out another. Though she was on the membership rolls of the Pictorial Photographers of America for years, her work rarely, if ever, exemplified their artistic standards. The most memorable event Bourke-White recalled about the White School was an occasion when she posed nude for her classmates. One of those classmates, Ralph Steiner, reappeared in Bourke-White's life seven years later, not long after the Otis Steel job and her first taste of fame. Steiner, a skyscraper photographer, quickly became Bourke-White's most scrutinizing critic. He not only advised her on technical matters but also helped keep her ego in check. Bourke-White confided to her mother that Steiner never praised her work. The unrelenting critic remembered the night that he finally penetrated the photographer's cool, hard demeanor. He laughed at Bourke-White, who burst into tears and cried, "You're the only person in America who doesn't think I'm a great, great photographer." Steiner believed that was exactly the reason she kept returning for his advice. He taught her about different types of lenses and filters and focusing mounts, all the while improving her views and stimulating her creativity.[25]

Steiner's criticism helped Bourke-White successfully continue her mission to show industry in a new light and from different angles. His relationship to Bourke-White and her work is very different from the links he established with photographer Marion Post a few years later. Post found Steiner extremely supportive, open-minded about different styles, and hardly a tough critic. Although his steadily growing reputation in the intervening years may have mellowed Steiner, more likely the contrasts seen in his work with Bourke-White and with Post are due to the former's unwillingness to listen to anything but praise for her photography. And she seemed to hear it everywhere else she turned. Dwight Macdonald, a young editor with *Fortune* who collaborated with Bourke-White on one of the magazine's first stories, a survey of the Corning Glass factory in New York, wrote to her of the series, "It's very fine—even better than I anticipated. You certainly got a great deal out of your material; I especially liked the ones on the sand pile, the potter, and the blower. . . . Your pictures fit in well with the story. . . . It will be a great combination of pictures and text." Another *Fortune* writer, Archibald MacLeish,

recognized Bourke-White's skill with the camera and begged her for prints of the glassmaking series. When she obliged him, MacLeish not only thanked her but also offered a glowing evaluation of her method, saying, "All your best things convince me that if photography is ever to become an art in the serious & rigorous & harsh sense of the term (not in the terms of the fashion magazines)—that is, if it is ever to become an art comparable to the art of painting—it will have to develop along the road you have set out upon! It will have to create its objects by isolating them in the real world, not by arranging them in a fake world." Although she never took part in the popular debate over whether photography itself was an art, Bourke-White illuminated her approach in a message to a dissatisfied client, telling him that she would rather destroy less-than-perfect prints than have them accepted with reluctance. She claimed to have followed a policy that allowed only satisfactory photographs to leave her studio; she told the patron, "I want my name signed only to pictures that I think are as artistically perfect as I can make them." In so doing, Bourke-White established herself as an art photographer as much as anyone else working in the field. Her sentiments mirror those of Doris Ulmann, who spent hours in her darkroom manipulating images to produce the desired effects after having spent hours with each subject to render the truest personality that could be captured on a glass plate.[26]

In Bourke-White's attempts to isolate objects and make them aesthetically pleasing, as MacLeish had pointed out, she often overlooked the people and the larger issues around her. With such deliberate intent, she unknowingly clouded her peripheral vision. One of the most crucial situations Bourke-White failed to recognize took place in a Boston bank the last week of October 1929. Assigned to take photographs of the bank's interior design, Bourke-White chose to work at night when the institution was closed and its customers were out. On her last night there, she became frustrated with the bank's vice presidents, who had stayed late and were frantically running about, too often in front of her camera lens. Amid Bourke-White's complaints, one official finally said, "I guess you don't know, the bottom dropped out of everything. . . . The stock market! Haven't you read the papers?" In one of Bourke-White's images in the series (fig. 40), the lines of the bank

Fig. 40. Margaret Bourke-White. *Bank Vault, 1929.* Estate of Margaret Bourke-White.

vault do not in any way intimate that disaster has just befallen the financial world, or that it ever could. Instead, the shine of the backlit steel evokes a sense of stability and security. The circular opening that protects the safe has bold concentric circles marking reinforcement, thus the solid protection of investments. The illumination coming from the vault itself makes yet another statement about the worship of material wealth in the 1920s. It would appear that heaven (or in this case, prosperity) stands just on the other side of the golden (steel) gates. In her autobiography, *Portrait of Myself,* Bourke-White spoke of the ill-fated night and admitted, "History was pushing her face into the camera, and here was I, turning my lens the other way."[27]

By the time Henry Luce published the first issue of *Fortune* in February 1930, the American business and financial realm had changed dramatically. Following the stock market crash came bank failures and factory closings. Unemployment began to rise steadily. The prosperity that had characterized the 1920s virtually disappeared. *Fortune* carried on, despite the irony of its existence. Although financial failure seemed a real possibility in any corner of the United States, Luce continued to assign projects surveying various industries and businesses. He sent Bourke-White to Hollywood to inspect moviemaking and on to Seattle to photograph the logging industry. She still gave the magazine only half her time but realized that her soaring reputation could be attributed to *Fortune*'s popularity; in turn, the magazine's success depended upon her roles as both extraordinary photographer and captivating woman. One Time Corporation executive argued that Bourke-White contributed a great deal to the early success of *Fortune,* which depended heavily on visual imagery. He wrote, "There is no denying that Bourke-White's work did most to making them [illustrations] outstanding—also, the intense little girl who took pictures for the big magazine of business added its fillip." Ralph Steiner reminded Bourke-White of the mutually beneficial relationship, pointing out, "'Fortune' is certainly skyrocketing your fame." While continuing to accept private commissions, Bourke-White also worked through the Cleveland advertising agency, Meldrum and Fewsmith. Through the firm, she got jobs that paid well; her boss, Joe Fewsmith, best remembered that his finest commercial photographer was willing to do anything, "from

photographing a box of tacks to climbing up on the scaffolding on the top of a skyscraper." Bourke-White kept herself so busy that the specter of nationwide economic disaster seemed very distant. In the summer of 1930, she would forget about it entirely.[28]

On 27 June she received a bon voyage wire from her older sister that read: "SS BREMEN SAILING SATURDAY MORNING NEW YORK NY = PLEASURE ROMANCE THRILLS SUCCESS I KNOW THEY ARE ALL AWAITING YOU HERE AND ON THE OTHER SIDE." Luce had finally arranged his photographer's long-awaited trip to Europe. In the spring Bourke-White had written to a friend, "Imagine, getting paid to go to Europe! It seems too good to be true." Her itinerary included a long stay in Germany, with photography jobs scheduled at the Krupp Steel Works, the Allgemeine Elektrizitäts Gesellschaft, and the I.G. Farben chemical corporation. Upon arrival at the Farben trust, Bourke-White discovered that women were not allowed inside the plant. Bearing the double burden of being an outsider and a woman, the photographer claimed that Farben debated "six months" about whether to let her in or not. Officials eventually welcomed her, but she never knew what changed their minds. As a result of her position with a highly regarded business magazine, she managed to gain entrance into several other factories; but the business she had most looked forward to examining, the Krupp Works, was closed off to curious onlookers. The images Bourke-White took at German industrial sites show only a modest focus on the machinery, primarily because of the restrictions limiting what she could shoot. The workers themselves became her principal subjects, striking poses and expressions that made her comment that all German workers "look exactly alike." She considered her arrest at a factory near Cologne the "most exciting experience" she had while in Germany. She told her mother, "I was surrounded by police who thought I was a French spy." *Fortune* could take credit for feeding Bourke-White's daring spirit in her quest for adventure. When she finished the German assignments, she was directed to head east to the Soviet Union, a place that she discovered would teach her "a lesson in patience."[29]

Bourke-White entered the country at a particularly crucial time. The twelve-year-old Soviet experiment in government had expanded to include the huge task of mechanizing a vast, largely rural nation. Soviet leader Josef Stalin envisioned a plan that would

reorganize the country within five years. A substantial part of the plan involved introducing industry to a population largely unfamiliar with its processes, rapidly mechanizing existing industries to accelerate progress, and building camaraderie among the people who participated in its execution. The stunning achievements included, for example, exponential growth in the number of heavy coal cutters and coal drills put in place; the replacement of manual labor with conveyor belts; and the creation of sophisticated machine production shops within existing factories.[30] Bourke-White knew only a little more about the Five Year Plan than she did about the political situation. Since the United States had elected not to extend official recognition to the Soviet government, Bourke-White was one of just a few Americans (and the only photographer) who had been allowed to travel inside the new Russia. Americans who had earlier garnered invitations from the Soviet bureaucracy usually came from the ranks of business and engineering; they crossed international lines much more easily than did their countrymen who were in politics. Perhaps Bourke-White's disinterest in diplomatic relations made her presence more palatable to Soviet officials. She later admitted, "No one could have known less about Russia politically than I knew—or cared less. To me, politics was colorless beside the drama of the machine." The portfolio pictures she toted everywhere grew worn as Russian bureaucrats and workers alike passed them around and marveled at the beautiful images of American industry. Bourke-White's photographs so impressed the right officials that she was presented traveling papers that stipulated few restrictions. She could move freely without fear of being searched at every turn. One Russian bureaucrat told Bourke-White she could "go to the moon" with the government papers she held. Relishing her independence, Bourke-White took full advantage of the few weeks she had in the Soviet Union to photograph its industrial progress.[31]

To her, the most appealing aspect of the Five Year Plan was its expedience. The Soviet bureaucracy was attempting to accomplish in five years what had taken one hundred years in the United States. Bourke-White realized what a rare opportunity it would be to record step by step the entire industrialization process, what she called this "great scenic drama being unrolled before the eyes of the world." Since nineteenth-century artists had shown little

interest in the American Industrial Revolution, the tremendous changes that had accompanied it had gone undocumented. Bourke-White was in a position to capture similar scenes and show much more of the process because it had been greatly accelerated in the Soviet Union. Perhaps for the first time in her career, she realized that her photographs could serve a purpose beyond their immediate utility as advertising shots. A hint of the documentary impulse is evident in a vitae statement she made several months after her return: "Things are happening in Russia, and happening with staggering speed. . . . I wanted to make the pictures of this astonishing development, because, whatever the outcome, whether success or failure, the plan is so gigantic, so unprecedented in all history that I felt that these photographic records might have some historical value." While in the Soviet Union, Bourke-White had felt the contagious excitement of workers fascinated by new machines and various gadgets. Their favorite phrase, *Amerikanskoe tempo,* referred to the ultimate model in industry—the American way—one dependent upon assembly-line production. American engineers helped direct the implementation of Five Year Plan objectives, from assembly-line management to dam construction. Bourke-White remembered the Stalingrad factory workers' animated discussions about the wonders of the conveyor belt. Noticing that everywhere she traveled in Russia, people worshiped machines, Bourke-White later reflected, "They looked on the coming of the machine as their Saviour; it was the instrument of their deliverance." Given her own reverence for industrial design and machine functionalism, Bourke-White found the atmosphere in Soviet Russia congenial to her prejudices and tastes.[32]

American curiosity about the mysteries of Russian progress worked in Bourke-White's favor. She returned home to find numerous offers for her pictures of Soviet industry. Seeking advice, she informed publisher Max Schuster that she had been "bombarded with requests" from newspapers and magazines for the photographs. Although *Fortune* had first rights to the pictures, Schuster suggested that Bourke-White limit their circulation in order "to arouse anticipatory interest" in a prospective book. *Fortune* published nine of Bourke-White's numerous photographs in its February 1931 issue. A brief two-sentence introduction under the heading "Soviet Panorama" opened the photo essay. The image

story included two traditional landscapes, one marked by horses in a field, the other by farm machinery. The captions for these less-than-remarkable agrarian scenes informed the American reader that 75 percent of Soviet farms were still privately owned, but that collective farms or "voluntary organizations of peasants who combine their farms" had been so successful that the Five Year Plan included a goal of 100 percent collectivization by 1933. In addition to depicting changes in rural life, the pictures focus on the "most ambitious" Soviet industrial project, the Dneiper Dam; the expanding tractor industry; and in a rather unusual undertaking for Bourke-White, a textile mill. In one image, highly lit threads coming off endless spools appear like sparks in a steel mill, sprinkling three-quarters of the frame. A stooped woman attends the machine but takes a place on the periphery as the process of manufacturing assumes center stage. Bourke-White's eye for geometric design dictates the very stylized image with its crossed, hair-thin lines connecting to their respective circular homes.[33]

Having whetted the American public's appetite for images of Soviet industrial success (while the United States floundered in the seeming demise of its own industrial economy), Bourke-White decided to accept an offer made by the Simon and Schuster publishing house. Max Schuster wanted to publish the Russia pictures, but he also wanted words to complement them. He asked Bourke-White if she would provide a few stories about her trip to the Soviet Union. She promised to lock herself away in her studio and ignore the telephone while she attempted to chronicle her experiences. Assured that Bourke-White would finish the task, Schuster drew up a contract in April that allowed the author a $250 advance and guaranteed to her "all property rights to the original photographs." Bourke-White found that showing her pictures to the American public was easy. Writing, however, was a different matter; she would have to exercise strict prudence in describing the new Soviet Union.[34]

The magnificence of Soviet industrialization had not blinded Bourke-White to the country's problems. Despite the help offered by American engineers and businessmen, industrializing the rural society proved to be a difficult task. Even with Henry Ford's assembly lines, Albert Kahn's factory designs, and Col. Hugh Cooper's personal direction of the Dnieper Dam construction, domestic

problems persisted. In a letter to her mother, Bourke-White described the severity of the food situation: the peasants hoarded what little they raised, and the government exported the rest "to pay for machinery." Upon her return to the United States, Bourke-White summed up the Soviet situation to Walter Winchell in ten words: "Little food, no shoes, terrible inefficiency, steady progress, great hope." But she rarely elaborated upon the story of human suffering in public; she limited her opinions on any contentious matter to the circle of her family. Likewise, while writing *Eyes on Russia* for Simon and Schuster, she chose her words carefully. She was most afraid her critics would claim that the Soviet government had allowed her to see only what it wanted her to see. Since the government had made Bourke-White its guest and had given her "a fat roll of ruble notes," her motives could appear suspicious to the American public. She alleviated any potential controversy by concentrating on the tedious details of cement-making, steelmaking, and dam-building. She complemented her descriptive stories with charming anecdotes, scoring points with her editors. The balance she struck helped make *Eyes on Russia* a success. In her mother's opinion, Bourke-White had mastered the art of diplomacy. After seeing the book, Minnie White wired her daughter: "WISE GIRL TO STEER CLEAR OF SCYLLA OF POLITICS CHARYBDIS OF PROPHECY."[35]

Bourke-White wanted to write nothing that would compromise her skyrocketing career. At twenty-seven she had made a name for herself in the photography world, and she envisioned making even grander contributions to it. In order to be closer to the *Fortune* offices, she moved to New York City. Perhaps her most stunning embrace of the machine age was her insistence on living in one of its newest monuments. When the Chrysler Building opened in 1931, Bourke-White had to apply for a janitorial position there in order to be allowed off-hours occupancy in a city office building. But she wanted the best view in New York. She later wrote of her experience in the Chrysler Building, "I loved the view so much that I often crawled out on the gargoyles, which projected over the street 800 feet below, to take pictures of the changing moods of the city." In one image, the elements of early 1930s industrial design dominate (fig. 41). The aerodynamic shape of

the eagle's head, with its curved beak, are augmented by the concave sweep of the figure's supports, which Bourke-White highlighted with her camera angle. The gargoyle bears several characteristics of popular machine-age design created to connote speed and power. The use of steel on the structure's exterior, on a decorative feature, no less, reveals the transcendence of the modern, industrial way over the older, traditional monuments, marked by brick, stone, and wood. Steel's smooth surface suggests its lightness, which in turn allows for speed. The structure's aerodynamic quality supplants the rough-surfaced heaviness of earlier external structures. Bourke-White enhanced this compelling figure by carefully timing her photographic process; she scheduled the shooting early one Sunday morning when the air was "much clearer" than on weekdays, then attempted to "catch the view at just the moment when the sun [struck] the bright shell work of the gargoyle with the dark city as a background." Power resides in the steel figure, whose watchful eye stares out over the city; that the protective eye belonged to a company that made automobiles, the single most influential mass-produced item in the previous decade, marked its unwavering status in American culture. The gargoyle image netted Bourke-White four hundred dollars from Meldrum and Fewsmith Advertising Agency.[36]

Among the photographs in the gargoyle series were several stunning images of Bourke-White poised atop the eagle's head looking through the viewfinder of her camera. Her fearlessness turned heads in the photography world; it also landed her an assignment to shoot the Chrysler Building's recent rival. Joe Fewsmith, Republic Steel's advertising representative, tapped Bourke-White to photograph the company's stainless steel trim on New York City's newest skyscraper, the Empire State Building. His specific instructions directed her to "climb out on some of the ledges" in order to get "a very unusual view" for a full-page ad in the *Saturday Evening Post*. Fewsmith did not hesitate to ask Bourke-White to take the physical risks necessary to get the best shots. His treatment of a young female employee contrasts sharply with Roy Stryker's handling of the women on his FSA photography staff, particularly Marion Post. From the beginning Stryker attempted to protect Post from potential problems she might encounter and encouraged her not to take risks or conduct herself

Fig. 41. Margaret Bourke-White. *Chrysler Building, 1930*. Estate of Margaret Bourke-White. Courtesy of George Arents Research Library, Syracuse University.

in a way that might arouse suspicion. Bourke-White's deliberate construction of her public persona and her demands for individuality (with requisite guidelines for various employers) allowed her the freedom of movement that Post could not enjoy. To ensure that her reputation remained intact, Bourke-White had many portraits of herself as a photographer taken for promotional purposes. But maintaining the Margaret Bourke-White image proved to be costly.[37]

More than willing to attach her name to another eye-catching project, Bourke-White devoted her Christmas holidays to photographing America's tallest building. She hoped to enhance her reputation with the Empire State job; she also needed the money to pay her rent. Speaking engagements, advertising assignments, and movie jobs provided Bourke-White with some money, but she still struggled with her finances. She refused to give up a fashionable address and a stylish wardrobe, since she believed that these impressed her clients and drew the public's attention, making her reputation her "greatest selling factor." The appearance of success brought further success, she opined. And women, especially, had to be tireless in their pursuit of success. In a May 1933 speech, Bourke-White advised the career woman to "bring her name before the eyes of the public *in general* so as to build up a reputation, to keep her work constantly before advertising executives and industrials—who are her buyers—and to constantly keep on tip-toe turning out something new." She showed signs of harboring a feminist consciousness in her practical advice to professional women. Her own goals had kept her on site in the manmade world of machines, while she played on the new woman stereotype, telling interviewers that she had little time for a domestic life since professional demands kept her occupied; living expensively on credit; enjoying intimate relationships with several men; costuming herself in the latest fashions; and proving that she understood mechanization processes, something the advertising community had strongly suggested that women knew very little about. Constructing herself was one of Bourke-White's most stellar achievements.[38]

The Bourke-White reputation kept her employed, but it failed to satisfy her anxious creditors. She had outstanding debts throughout the city, from camera shops to Fifth Avenue department stores, where she continued to indulge her desires. Family members had

even allowed her to draw on their insurance policies in order to keep her studio open during the leanest Depression years, but by 1933 she had, according to her mother, "milked the insurance cow dry." She owed hundreds of dollars to Eastman Kodak in 1934 but put off settling her account until she had equipped her new studio, a Fifth Avenue penthouse. She had been forced to find a cheaper place after the Chrysler Corporation evicted her from the skyscraper studio. Bourke-White considered her financial situation a minor inconvenience in her busy and exciting life. She was content to search endlessly in pursuit of the best scenes the industrial world had to offer. She believed that her public reputation as a professional artist would more than compensate for her mismanagement of private business affairs.[39]

LaSalle Automobile executives agreed, since they hired her to promote their new models in 1933. In her series of automobile advertisements, Bourke-White further showed herself a devotee and promoter of the machine age aesthetic. In a close-up of a LaSalle (fig. 42), Bourke-White isolated one of the more important attributes of the machine—precision. The streamlined design, with the egg-shaped headlight and the rounded front wheel cover, provides the requisite aerodynamic quality. The front panel's decorative details are simple but modern, their modernity denoted by the round decorative features. As she had done on numerous other jobs, Bourke-White isolated the circular and curved forms on the automobile. The uniformity of the design elements, all of which bear the streamlined curve, suggests that this is a carefully planned, well-functioning machine. The light color is yet another mark of the machine-age aesthetic, where the appearance of cleanness in a product became a vital sign that its operation was as flawless as its appearance. Bourke-White employed dramatic shadows to enhance the machine's true color and its brightness. With this series, her photographic work bears out historian Miles Orvell's assessment of the camera's contribution in developing industrial capitalism. He said it was not only "an instrument for analysis and record" but also "an instrument for promoting an *image* of the product that would stamp it in the public mind."[40]

In helping to foster and define this new role for the advertising camera, Bourke-White had not always met willing supporters for the modern style. Two years earlier, H.S. Bishop, an advertis-

Fig. 42. Margaret Bourke-White. *LaSalle Automobile, 1933.* Estate of Margaret Bourke-White.

ing executive at the Pierce-Arrow Motor Car Company, complained to Bourke-White about hearing "What beautiful photography!" He wanted people to comment on the cars in the pictures rather than the pictures themselves. Having worked little with the automobile industry when offered the Pierce-Arrow job in 1931, Bourke-White had enthusiastically accepted it. She loved taking pictures in the whirlwind of city traffic and saw great "possibilities" in automobile photography, but Bishop did not share her point of view. He thought that Bourke-White's work was too abstract and dramatic to be functional and that she should show automobiles from a more "familiar angle of vision." He concluded that the photographs were "much too fine a thing for advertising. . . . These have your favored industrial flavor, but they are not pictures that we believe would help sell Pierce-Arrows to the proletariat." Within months the auto industry was moving away from such criticism, with executives growing more willing to support abstract design in advertising. Their attitudes shifted, as did automobile design, away from the black, box-shaped vehicles the industry had offered consumers in the 1920s. And Bourke-White's pictures were playing a role in the rapid transformation.[41]

By 1933, as a result of Bourke-White's experience with isolating components of the machine age, from shiny automobile hubcaps to sleek stainless steel cocktail shakers, she embraced an augmented visual form that enhanced the modernist's use of extreme angles and bright lights—photomurals. The large-scale works implied that the bigger the picture, the more influential its message, but Bourke-White saw the new form a bit differently. A ten-foot-tall picture was no better than one ten inches high, she noted, until "a large company gives over its expensive wall space to photographers. . . . that, I think, is something." Bourke-White's first photomural job took her to the RCA Building at Rockefeller Plaza, headquarters of the National Broadcasting Company. She saw the mural project as an opportunity to use photography on a much grander scale. An added benefit would be the excellent publicity the prestigious location would lend to her work. Identifying the photomural as "a new American art form," Bourke-White encouraged businesses to take advantage of these huge pictures by decorating their office buildings with them. She suggested in a speech to the *New York Times* Advertising Club that companies

choose wall coverings showing the kinds of work carried out in the offices. She explained, "Art is too often divorced from life and, it seems such a sound idea to me to have the subject of a mural intimately tied up with the activities that go on in the company, so that it will have real flesh and blood."[42]

Bourke-White believed her photomural for NBC/Radio City exemplified the new directions and standards being developed in the arena of public art. Since her theme was industry, the photographs brought people closer to processes they might not otherwise understand. The NBC photomural showed pictures of microphones, switchboards, generators, towers, and transmission tubes. Broadcasting operations could be seen in photographs covering a rotunda 160 feet around and 10 feet high. One image (fig. 43) revealed a sea of radio loudspeakers, all uniformly arranged in closely aligned rows. Using the technique of patterned repetition that she had employed before, Bourke-White enhanced the elements of power and beauty in sound design. Simplicity is borne out by two unadorned features, the ringed indentations on each speaker and the limited number of nuts and bolts holding the speaker frames together. Whether or not her pictures helped unfold radio's mysteries, they stood as arguments for smooth functioning and the optimal form through which it was achieved. But images like these also served to exacerbate the national phenomenon known in the 1930s as "cultural lag," the gap between rapid technological growth and the culture it had outrun. During that decade the intensive artistic search based on American sources, regional histories, and local color could be attributed, in part, to the attempts to close the gap by creating what Warren Susman called "patterns of a way of life worth understanding." Bourke-White's highly modern, stylized views of powerful technological components emphasized their aesthetic qualities much more than their practical applications, so that the resulting images inspired awe in onlookers, thus limiting their ability to close the gap between industrial determinism and society's capacity to adapt to it. Bourke-White continued to push the limits of technological progress even further when she chose to study and photograph an experimental medium called "television" inside NBC's "secret laboratories" at the Empire State Building. Perhaps her reverence for the machine age and its components was best seen in her photo-

Fig. 43. Margaret Bourke-White. *Radio Loudspeakers, 1934.* Estate of Margaret Bourke-White.

murals, as pictures enlarged over one hundred times revealed her truest perceptions of what she considered the guiding forces within American society, namely the "bigness and power about this industrial age."[43]

Bourke-White used the NBC job as a springboard for other photomural assignments. In her appeals to Fred Black of the Ford Motor Company, she said that a Ford mural "would cause a great deal of interest among industrialists as well as art critics." She pointed out how overwhelming the response had been at Radio City, hinting at the free publicity Ford would enjoy if it undertook a similar project. She told Black, "If the amount of newspaper space devoted to the NBC mural is any indication of the interest in this new art, I think that a mural using the wealth of spectacular material in the Ford Motor Co. would attract even more attention." Bourke-White talked her way into a contract with Ford, then moved on to deliver the same pitch to General Motors. She recommended that photomurals be used in dealer displays, since the enlarged pictures would show "how adequate your factory is and with what precision General Motors operations are carried out." Impressed with Bourke-White's earlier murals, executives at the Aluminum Company of America sent the photographer to the Midwest to take pictures for their exhibit at the Chicago "Century of Progress" Exposition. They, too, were pleased with Bourke-White's execution of the project and the attention drawn to their products as a result of her murals.[44]

While devoted clients depended upon Bourke-White's expertise, a few critics attacked her artistic approach; others thought her perception of industry's dominant role in America was overrated. Bourke-White's evaluation of the American viewing public was challenged by moviemaker David O. Selznick, who discouraged her plans to shoot industrial films. He seemed unimpressed with Bourke-White's *Fortune* contacts and told her that big industrial names were "absolutely valueless" in the filmmaking business. He informed Bourke-White that industry as a subject had no entertainment value and concluded, "Work is not the most interesting idea in America. . . . The movie goer still goes for escape. Vogue of realism is no exception; people like some other kind of realism, not their own." Bourke-White even received criticism from nonprofessional ranks. Members of a Boston women's club com-

plained that the photographer had provided too much illustration and not enough talk at a luncheon speech. After hearing the comments, Bourke-White's booking agent cautioned her not to rely too heavily on her photographs, warning, "There is nothing better than a fine pictorial presentation to catch the eye and bring to mind what the realities actually are. But that is the end of the function of the pictures." Bourke-White adamantly disagreed with her critics. She believed photography, of all media, could best illuminate what she considered to be the overriding feature of American life—industrial capitalism.[45]

Despite the nationwide economic depression, business picked up for Bourke-White in 1934. Several of the numerous solicitations she had made the preceding year paid off. In addition to the photomurals, she completed assignments for popular magazines such as the *Saturday Evening Post* and *Vanity Fair*. The VanBeuren Corporation, a subsidiary of RKO, bought the experimental film she had taken in 1932 on her third trip to Russia. Bourke-White had hoped a bigger studio would be interested in her film's timely connection to President Roosevelt's official recognition of the Soviet Union. To entice Norman Moray of Warner Brothers, she wrote, "The news in the papers continues to be intensely interesting. . . . There is every reason to believe that when the event comes it will not be a mere trade pact but full recognition and will cause the news to be extended over a much longer period than might have been true. . . . I believe the people in the U.S. are going to want to know what the people of this new country are like." But the popular movie moguls disagreed with her prediction, remaining unconvinced that a story about Russian life and work would attract the general public to the box office. So Bourke-White accepted the only feasible offer for her film. Her campaign to sell the Russia story encouraged her increasing acknowledgment of current political news. More than ever before, she was showing an interest in matters outside the machine-age consumer culture.[46]

As she shifted her eyes to examine political issues, numerous groups solicited her support. They recognized the advantages of having Bourke-White's celebrity attached to their causes. In January 1934 she donated thirteen prints to a San Francisco exhibit and auction sponsored by the National Committee for the Defense of Political Prisoners. The committee's appeal to artists,

writers, and musicians described their current effort to raise money and consciousness in order to counter "prejudice and hate" over the Scottsboro Boys case, where slight evidence had been enough to convict nine black youths of raping two white girls on a train in northern Alabama. Bourke-White also gave photographs to the New School for Social Research and lectured at the New Workers School. Eventually she joined Dorothy Day, Josephine Herbst, Mary R. Beard, and others in the League of Women Shoppers, a group that supported organized labor protests and other activities to abolish "sweat shop conditions" in factories and stores. Along with Ralph Steiner, Berenice Abbott, Reginald Marsh, and Lee Strasberg, she served as a major sponsor for the Film and Photo League, an artists' collective seeking to educate the public about the interests and concerns of the working class.[47]

But the group Bourke-White felt most strongly about was the American Artists' Congress, a coalition designed to protect cultural freedom by supporting artists in their political convictions. She wrote to several other photographers, asking for their participation in the congress and alerting them that "such reactionary tendencies as have appeared in the form of censorship and destruction of works of art, and in the suppression of civil liberties, are symptomatic of more serious conditions to come. *It can happen here.*" By directing her energies into social causes, Bourke-White developed a side of herself previously neglected. As her biographer has pointed out, "In the twenties, Margaret lost her innocence; in the thirties, her indifference." The noticeable shift in Bourke-White's attentions placed her, at least sentimentally, alongside some of the decade's great documentarians, optimists who celebrated ordinary people's lives and trials. But however deeply Bourke-White may have felt about the victims of political oppression or economic displacement or natural disaster, her photographic records lack an expression of genuine compassion.[48]

In her autobiography Bourke-White admitted, "When I was discovering the beauty of industrial shapes, people were only incidental to me . . . I had not much feeling for them." She first attempted to make the transition from photographing industrial shapes to photographing people after learning about the Roosevelt administration's New Deal programs, which supported everything from bridge building to landscape painting. Bourke-White's edi-

tor Max Schuster suggested that she look into photographing the New Deal for the Treasury Department, which was "literally teaming [*sic*] with paintings and sketches by hundreds of CWA [Civil Works Administration] artists." Bourke-White, however, thought that the Tennessee Valley Authority projects offered greater opportunities for her photographic style. Since the TVA plans included dam building, Bourke-White felt particularly qualified to document the construction. She told TVA official Arthur Morgan of her experience photographing similar works in the Soviet Union and added, "I have always thought that industrial photographs could perform a very important service in informing the public about the vital things that are happening in their country." But Bourke-White planned to go beyond merely documenting the building process; she wanted to show how a massive government project would affect its workers' families. She called the social aspects of the project an "important American development" that would "catch the public imagination." TVA executives appeared sold on hiring her until Bourke-White mentioned her rate of five hundred dollars per ten pictures. As much as they wanted Bourke-White's expertise in documenting the project, they could not commit government money to such an expense and so wired, "Regret that Photos you mention are quite beyond our means."[49]

Despite her aborted attempt with TVA, Bourke-White got an opportunity to focus more closely on humanity when *Fortune* sent her to the drought-stricken Plains in the summer of 1934. Claiming to have experienced a change of heart after witnessing the Dust Bowl firsthand, Bourke-White recalled its impact: "I had never seen people caught helpless like this in total tragedy. They had no defense. They had no plan. They were numbed like their own dumb animals, and many of these animals were choking and dying in drifting soil." The pictures Bourke-White took of the survivors revealed hard, shell-like faces, reminiscent of wax figures in a museum. In one sidewalk shot (fig. 44), Bourke-White peered through her lens downward on two young men who stare glumly ahead in the distance. They are diminished physically by the photographer's angle. Their eyes obscured, one pair by aviator glasses, the other by dark shades, the men project a certain vacuity. With their lips tightly closed, they appear resigned to the fate nature has dealt them. The visual image projects the message that

nothing they might say could change their present condition. In photographing these subjects, Bourke-White neglected to pursue the single most vital facial feature in measuring human emotion: eyes. The only hint of an eye is seen through the reflected lens of the aviator specs, and even then, the eye seems out of place, set askew without its mate. Bourke-White makes the tiny circle the central focus of her image, the most highly-lit object in the frame. It stands alone, not unlike the mechanical television eye she had isolated and photographed at Radio City a couple of years earlier. In the Dust Bowl series, Bourke-White failed to capture the residual strength of individuals ravaged by environmental disaster. Whereas Dorothea Lange had illuminated what was left of human dignity amid horrible circumstances, Bourke-White focused on what had been stripped away. In Lange's photographs, the spirit survived; in Bourke-White's, it had disintegrated, much like the eroded soil (see, e.g., fig. 16). Historian David Peeler explains that Bourke-White failed to articulate the human toll taken by dust storms because she turned her cameras overwhelmingly toward buildings rather than people. In the end her "habits subverted her intentions," Peeler concludes.[50]

Although she would spend the next few years attempting to depict people and their lives, Bourke-White rarely managed to accept what they offered to the camera. The tactics of persuasion she had honed as an advertising photographer remained deeply ingrained; exaggerated angles and isolated elements yielded a picture of fragmented humanity. Even her contemporaries recognized Bourke-White's limitations when it came to portraying people. Eleanor Tracy, of *Fortune,* passed along general criticism of the images Bourke-White had made in a "family" assignment for the magazine, noting that they appeared "too stiff and posed-looking" and that they lacked "spontaneity." Tracy offered blunt advice to Bourke-White in an attempt to ensure that the photographer's next "family job" would produce better results: "After all, the only reason for candid photography is the ability to catch people unawares and to get natural expressions and actions which cannot be caught in any other way. . . . you ought to concentrate on taking lots of pictures without the subjects' knowledge if possible."[51] Tracy's suggested method was the complete antithesis to Bourke-White's carefully calculated, highly stylized work. The photogra-

Fig. 44. Margaret Bourke-White. *Dust Bowl Faces, 1935.* Estate of Margaret Bourke-White.

pher had forged a stellar career out of her ability to arrange and control scenes. Just as she had dramatized sunlit steel on the Chrysler Building gargoyles, she captured faces blinded by harsh, artificial light. She stood or crouched at extreme angles in order to record the human condition from a different, and sometimes disturbing, perspective. The resulting images often showed people at their basest level, similar to the farm animals to which she had compared the Dust Bowl survivors. The photographer's shift from machines to humans proved an arduous task.

While struggling to redefine her place in American photography in the mid-1930s, Bourke-White wrote an essay in which she explained (perhaps to herself as much as to the reading public) the significance of a photographer's "point of view." She claimed that this aspect was paramount, transcending "the illumination, modelling, choice of boundaries, focal length of lenses" and other necessary elements in the image-making process. The principal questions Bourke-White posed in the essay reveal a litmus test of sorts in judging a photographer's point of view—"How alive is he? Does he know what is happening in the world? How sensitive has he become during the course of his own photographic development to the world-shaking changes in the social scene about him?" Here the model photographer proves his or her worthiness in the profession by having developed a social consciousness along the way; the extent to which he or she may be taken seriously as a professional rides on a level of sensitivity to social issues. But how could such sensitivity be measured?[52]

If Bourke-White came to documentary through a desire to bring her work closer to the "realities of life," as she wrote in 1936, she probably recognized the advantages that words could offer her images. At the same time that Bourke-White's pictures of people needed supportive text, southern novelist Erskine Caldwell's words about people needed pictures. In 1936 Caldwell found himself in search of "the best photographer available." He intended to make a thorough evaluation of the American South in order to prove that the scenes portrayed in the long-running Broadway play based on his best-selling novel *Tobacco Road* (1932) were authentic. Critics and censors had railed against Caldwell's fiction, stories that depicted the South in terms of its most chill-

ing trademarks—illiteracy, racism, and poverty. Caldwell hoped to change their minds with a new piece of nonfiction that would be filled with telling photographs. His show of faith in the camera as a recorder of truth and photography as an objective medium placed Caldwell squarely within a mainstream intellectual milieu whose wholehearted embrace of technically produced visual images gave them credibility as powerful articles of truth.[53]

Early in 1936 the novelist contacted Bourke-White, asking her to meet him in Georgia six months later. She accepted his offer with enthusiasm, exclaiming, "I am happier about this than I can say! If I had a chance to choose from every living writer in America I would choose you first as the person I would like to do such a book with. . . . Just when I have decided that I want to take pictures that are close to life—seems almost too good to be true." From spring until summer Bourke-White stayed quite busy with advertising jobs, including a stint in South America for the American Can Company. Business affairs kept her in New York just long enough to delay her arrival in Augusta, Georgia, by a few days. When Caldwell threatened to find someone else for the project, Bourke-White calmed him with a letter explaining her need "to carry the overhead while doing a really creative and socially important job like the book with you." Caldwell softened, and the two started their journey together the next day. On the trek the photographer would get many opportunities to prove the expanse of her sensitivity to the "world-shaking changes in the social scene."[54]

The duo traveled through Louisiana, Arkansas, Alabama, Mississippi, Georgia, Tennessee, and South Carolina to find substance for their enterprise. In two trips, one in the summer of 1936, the other in March of 1937, Bourke-White and Caldwell gathered enough evidence to publish a shocking and sensational book entitled *You Have Seen Their Faces* (1937). Revealing human despair at its worst, the work received immediate attention. In delivering the southern portrait they thought Americans needed to see, Caldwell and Bourke-White helped to create what Alan Trachtenberg has identified as "a new cultural mode, the choreographed rapport of word and text." The viewing public had seen recent photographs of poverty-stricken farmers, displaced sharecroppers, and Dust Bowl survivors, but none of the pictures pro-

duced by the federal government or published in popular photo magazines and newspaper rotogravure sections carried the punch of Bourke-White's images. The advertising veteran used her camera to manipulate and highlight certain features of her subjects, just as she had done with LaSalle headlights, Chesterfield cigarettes, and Goodyear tires. The human features she found most appealing were oddities: a goiter distorting the face of an elderly Arkansas woman, the blind eye of a young Georgia mother (who also, from Bourke-White's angle, appears to have only one leg), and the shriveled limbs of a disabled Florida child, the kinds of choices that led historian David Peeler to comment that the photographer "willingly rendered her subjects as a set of grotesques riddled with poverty and disease."[55]

In a rare image where Bourke-White recorded a smile, a young boy stands face-to-face with the camera (fig. 45). Since a straw hat guards his head from the daytime sun, more than half of his face is cast in shadow. With his eyes and nose darkened by the shade, the most conspicuous feature he offers the lens is a profoundly maligned set of teeth. Played upon by the white-hot southern sun, these four teeth occupy the center square of the frame, prominently transcending all other elements in the composition. A fictionalized caption by Bourke-White and Caldwell attached to the boy's portrait reads, "School is out for spring plowing, and Pa said I could go fishing." Seemingly innocent, the combined word-image message points up a weak educational system subject to agrarian demands, while also hinting at the stereotype of the lazy southerner who chooses leisure activity over field work. The child's awkward mouth suggests genetic frailty, thus reinforcing early-twentieth-century literature that emphasized the natural weaknesses inherent in certain groups. One recent critic of Bourke-White and Caldwell's collaborative effort argues that they chose "only the material that sustained certain images of the South, and set the rest aside."[56]

Indeed Caldwell had taken his place among a few southern writers in the early 1930s who challenged the previous generation's construction of a magnolia-laden, peaceful region. Caldwell's writing reflected a charge made to southern writers in 1924 by playwright Paul Green. Green challenged his contemporaries to embrace the "crude, unshaped material" of lower-class southern

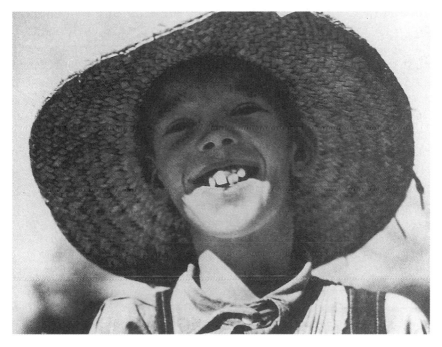

Fig. 45. Margaret Bourke-White. *Ozark, Alabama, 1936. You Have Seen Their Faces* (1937). Estate of Margaret Bourke-White.

life in order to find "'dynamism of emotion terrible enough in its intensity for the greatest art.'" In his reporting Caldwell depicted the tenant farming situation as a horrid, sorrow-filled existence that survived "only by feeding upon itself, like an animal in a trap eating its own flesh and bone." His prose described an exhausted South, filled with tyrannical landlords, lazy white farmers, and hopeless blacks. According to one of Caldwell's contemporary critics, Vanderbilt "fugitive" and Agrarian leader Donald Davidson, the novelist had overemphasized the negative aspects of southern life and ignored the rest, much as H.L. Mencken and other New South critics had done a few years earlier.[57]

Likewise, Bourke-White produced such an unflattering portrayal of her southern subjects that James Agee and Walker Evans reprinted a Bourke-White newspaper interview in their own documentary treatment of southern sharecropping, *Let Us Now Praise Famous Men,* which appeared in 1941. Agee and Evans clearly presented the piece for its ironic effect. In the interview Bourke-White's condescending comments about the ways she and Caldwell had to bribe and cajole their subjects in order to get from them what they wanted are juxtaposed with a concluding statement in which she argues that any *group* of photographs on a given subject offers "truth." In defense she offers, "Whatever facts a person writes have to be colored by his prejudice and bias. With a camera, the shutter opens and it closes and the only rays that come in to be registered come directly from the object in front of you."[58] After cultivating the art of persuasion for nearly a decade, Bourke-White proved she could sustain the public interest in herself and her work regardless of the subject matter. Even though she had turned her cameras away from machines and toward people for a large-scale project, she did not shed her modernist eye or sensibilities, and they in turn made her a very different kind of documentarian than her thirties contemporaries Doris Ulmann, Dorothea Lange, and Marion Post. Because of her modernist tastes and prejudices, she was an amazingly appropriate candidate to document "life" in the expanding new field of photojournalism.

While still working with Caldwell on the southern sharecropping project, Bourke-White joined the staff of Henry Luce's newest magazine venture, *Life.* In her contract she agreed to "work exclusively for TIME Inc." on the condition that she receive two

months' leave of absence each year to pursue independent projects. *Life* offered Bourke-White an excitement different from that of advertising; it was a weekly publication that kept its photographers on the road, looking for the next newsbreaking story. For Bourke-White, the thrilling pace equaled her earlier adventures atop city skyscrapers. Her photo essay on the New Deal work relief project at Fort Peck, Montana, helped launch the magazine in November 1936. Curious readers purchased all newsstand copies of the inaugural issue in one day; twelve weeks later *Life* could boast a weekly circulation of one million. Bourke-White's Fort Peck Dam image (fig. 46) introduced Americans to *Life*. The icon and the photographer's reputation were merged on the magazine's cover. As a symbol of the persistence of American technological ingenuity in the midst of the Depression, the massive dam brought Bourke-White back to her first love—industrial power. To augment the grandiose structure and highlight its scale, the photographer included in her frame two tiny human figures. They stand nearly insignificant in the huge presence of the federal government on one hand and the western environment on the other. The wide open spaces of the American West allow such a structure to exist; it could not have been erected in an urban area, nor would it have been an appropriate fixture in the Midwest.[59]

But there is a cultural thread in the Fort Peck Dam photo essay suggesting that westerners could embrace the bigness of the idea and certainly could manage the construction. If, in Bourke-White's eyes, southerners had appeared pathetic, their western counterparts were tough. Her photographs and the accompanying text in the Fort Peck piece play up the popular nineteenth-century "frontier" stereotype, according to which rough men and raucous women built towns with grit and determination and washed their lives in plenty of alcohol. In one scene Bourke-White pictures relief workers dancing cheek-to-cheek in a saloon. On top of a table, one woman sits on a man's lap while he and a younger man embrace her. From her abdomen to her neck she is covered with construction laborers' hands. The women in the picture, known as "taxi-dancers," require each partner (or "fare") to buy them a five-cent beer for a dime. The caption explains the system: "She drinks the beer and the management refunds the nickel. If she can hold sixty beers she makes three dollars—and she frequently

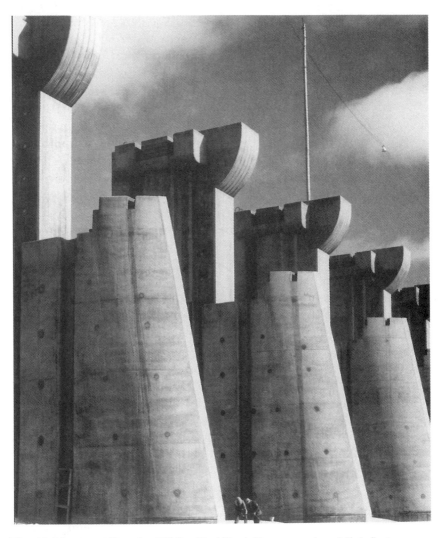

Fig. 46. Margaret Bourke-White. Fort Peck Dam, used on *Life's* first cover. Reproduced by special permission from *Life*, Nov. 23, 1936, © TIME, Inc.

does." The last phrase casts these entrepreneurs in the stereotypical role of the "comfort" women who had populated the western frontier for nearly a century. In Bourke-White's photo essay, nearly all of the women pictured provide some kind of comfort, either as laundresses, waitresses, bar owners, or taxi-dancers. In one photograph juxtaposed with a large two-page heading that reads "THE COW TOWNS THAT GET THEIR MILK FROM KEGS," a smartly-dressed young woman turns up a full shot glass underneath a sign warning, "No Beer Sold to Indians" and another hailing President Franklin Roosevelt as "A Gallant Leader." The ways in which Bourke-White pictured women in her Fort Peck photo essay support the arguments put forth by cultural historian Wendy Kozol, who has shown that *Life* attempted to reinforce certain ideas about representative families in the United States. She notes that in the pre–World War II years the magazine "typically used the camera as a class tool enabling middle-class audiences to gaze at the family in crisis." The Bourke-White images that most clearly reflect Kozol's argument feature a young waitress forced to bring her child to work since there is no one at home to care for the little girl. The wide-eyed child, who may be three or four years old, sits atop the bar while the men around her swill beer, smoke, and flirt with the women there.[60]

Life's composite portrait of the Fort Peck Dam milieu does, however, reinforce traditional notions about the western frontier as a truly American environment, considered so because it offered a wide range of economic opportunities to both men and women and because it promoted rugged individualism. The living conditions around the Fort Peck shanty towns left much to be desired, with limited sanitation and frequent fires, and the towns offered little encouragement for traditional family life, but such drawbacks seemed less important than the larger issue—that the federal government's sponsorship of projects like these maintained the strength of American workers rather than softening them with government checks. Thus *Life* could label the venture "Mr. Roosevelt's New Wild West," connoting the ambivalence of excitement and adventure mixed and weighed against risk.[61]

Varied assignments, full itineraries, and cross-country travel kept Bourke-White busy in the late 1930s. She wrote to a friend, "I'm hardly back in New York before a new assignment takes me

away again." She had to turn down numerous speaking engagements because she remained on call for the magazine. *Life*'s popularity brought attention to her photographs, just as the pictures brought buyers to the newsstands. Contemporary critic Halla Beloff has argued that *Life* made its photographer a "recording angel," one who showed America what it wanted to see of itself. In Beloff's opinion Bourke-White, as a "visual politician," reinforced the dominant culture by emphasizing "the themes of opportunity, equality, the protestant ethic, and amelioration." *Life* did attempt to show the public what ordinary Americans were doing on a day-to-day basis, but its stories and pictures covered a wide variety of subjects, from papermaking to slum clearance to Mrs. Theodore Roosevelt's needlework. The magazine, which rarely covered controversial topics, received its most heated criticism for a pictorial essay on human birth. A friend wrote to Bourke-White, "You know by now that *LIFE* was banned from half a dozen cities and states for telling the world where babies came from." Otherwise, *Life* and its star photographer heard praise.[62]

From the East Coast high art establishment to the Hollywood movie studios, critics and clients and interested onlookers applauded Bourke-White's work. In one intraoffice exchange, Bourke-White's photos were described as "breath-taking" with the added punch, "Boy, this will show the studios how pictures should be taken. . . . Let her take anything she sees which she thinks good, regardless of the stories we may outline for her." Such reviews allowed her to enlarge further the scope of her artistic freedom. Beaumont Newhall, of the Museum of Modern Art, congratulated the photographer for her "superb series" of "Middletown," identifying it as "the finest piece of documentary photography" he had seen.[63] One of the most arresting images in Bourke-White's series, which had been prompted by Robert and Helen Lynd's follow-up study of Muncie, Indiana, showed three members of the town's Conversation Club (fig. 47). The women appear rather solemn at a club meeting lecture on astronomy, their behavior displaying a posture antithetical to what one might expect from a "conversation" group. Bourke-White's framing of the image situates the women on the periphery, as figures who seemingly hold up the world in the center, a comfortable middle-class existence marked by its requisite accoutrements—books for intellectual stimulation, a Victorian-style

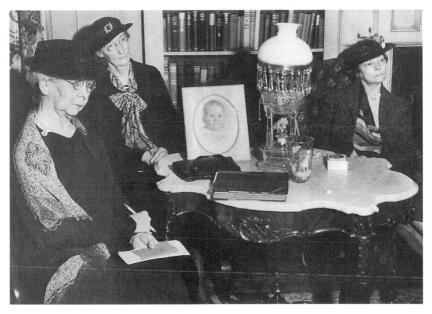

Fig. 47. Margaret Bourke-White. *Conversation Club, 1937*. Reproduced by special permission from *Life,* May 10, 1937, © TIME, Inc.

table and lamp to show the homeowners' traditional tastes, and a baby's portrait to prove the central place of family in the household. But the world these women have created and continue to support seems only to have promoted boredom. Not one of the three seems particularly excited about the way she has chosen to spend her leisure time. Bourke-White's exaggeration of the constituents' staidness, their corpse-like existence, in part reflects the photographer's own fear of succumbing to a similar middle-class life. She hoped that *Life* would keep her from it.

In spite of continued accolades for her work at the magazine, not everyone close to Bourke-White thought it was beneficial. Her long-time friend Ralph Steiner considered the magazine assignments too soft, warning, "Maybe, in time those LIFE boys (not LIFEBUOYS) will find out how to use you so that you function and so that this job is not only a financial haven but also a place where you can grow. . . . If they are going to keep you on the sort of thing they have had you do rather than on the kind of thing you have made your reputation on then something must be done—I should think and soon." Nor did Erskine Caldwell share Bourke-White's enthusiasm for *Life*. He had fallen in love with the photographer on their southern journey and was disappointed that the magazine assignments demanded so much of her time. Bourke-White later recalled that he "had a very difficult attitude toward my magazine, a kind of jealousy." When Caldwell realized that his competition with *Life* for his lover's attention was growing more intense, he pressured her to marry him. After many months, she relented, challenging the advice of a friend who said, "I have serious doubts regarding the alleged worth of monogamy to those who lead nomadic lives."[64]

Marriage failed to diminish Caldwell's insecurities; they continued to mount as Bourke-White built her reputation as a photojournalist. When *Life* sent Bourke-White to Europe to take pictures of citizens coping with war, Caldwell remained at home. Although he had accompanied her on assignment to Czechoslovakia in 1938, he stayed behind in the fall of 1939. War had changed everything. Although she was well behind the front lines, Caldwell's wife was considered a valuable asset, one who was "counted on to cut much red tape." Because of the nature of her work, she had to be prepared to move on a moment's notice, which

meant traveling alone; Caldwell's presence might pose problems or cause delays. During her six months overseas, Bourke-White received numerous letters from her husband begging her to return to the states. He appealed for the sake of his reputation, her reputation, even the prospect of a future child. In December 1939 Caldwell sent Bourke-White a newspaper clipping about Marion Post, a U.S. Government photographer making her way through the South. He warned, "The young lady in the enclosed clipping is kicking up a lot of dust around the country, and I dislike seeing her getting so much glory. . . . I can't help reading the handwriting on the wall! To wit—to your everlasting glory you should make haste to get back here & do those books." Caldwell regretted Bourke-White's insatiable appetite for grabbing the latest story because he wanted her fame to rest on something more permanent. Assuming the tone of a patronizing man of letters, he instructed her, "Books, like objects of art, are not thrown away like the morning paper."[65]

But the opportunities granted a foreign news photographer were too alluring for Bourke-White to pass up. If industry had offered the greatest excitement in the late twenties, war offered the same in the late thirties. *Life* sparked Bourke-White's development as a photojournalist, and she was determined not only to participate but to help shape the new field. In assuming the mantle of photojournalist, Bourke-White took steps to shed the social conscience that had made her a documentarian. She chose not to support any political causes or group efforts; she requested that her name be taken off committee letterheads; and she sought complete independence from creeds and slogans. Her biographer, Vicki Goldberg, argues that the process helped solidify Bourke-White's position as a photojournalist, with "impartiality" being "part of her equipment." "Photography came before her causes. Photography, in fact, *was* her cause."[66] The reality of Bourke-White's transformation from documentarian to photojournalist may be best measured by the failure of her last documentary effort with Caldwell.

To placate her husband, Bourke-White worked with him on another book about the United States. *Say, Is This the U.S.A.* (1941) proved an artistic failure in that it revealed stilted communication rather than true collaboration between the writer and the pho-

tographer. The lack of public interest in the book showed the diminished place of domestic concerns in the American imagination. The documentary impulse as informed by social realities and realism inside the nation's borders had given way to photojournalism, with its smaller cameras, faster films, and wire services, whose effects were to bring the world to the United States. Making international news available quickly was the newest game in photography. In 1941 Bourke-White crossed the Atlantic as a war correspondent for the U.S. Air Force; Caldwell stayed behind. Unwilling to carry on a long-distance relationship, he asked for a divorce. Bourke-White wrote to her lawyer that she was relieved: "I have felt for so long that such a disproportionate amount of my attention went into worrying about whether someone was in a good mood or not, whether he would be courteous or forbidding to others, whether day to day life would be livable at all on normal terms, that I am delighted to drop all such problems for the more productive one of photography. . . . In a world like this I simply cannot bear being away from things that happen. I think it would be a mistake for me not to be recording the march of events with my camera." Bourke-White stayed in Europe to photograph the war. Of her decision to maintain an international focus, Bourke-White biographer Goldberg wrote, "Work was the only safeguard of her independence and integrity." A look back at her career proves that this had always been the case.[67]

Life magazine photographer Alfred Eisenstaedt once said that Bourke-White was "married to her cameras. No assignment was too small for her. If she had been asked to photograph a bread crumb at five-thirty in the morning, she would have arrived for the session at five."[68] Besides this commentary on his colleague's work ethic, Eisenstaedt isolates the material out of which Bourke-White shaped her reputation in the 1930s. She took ordinary objects and with her camera eye made them into extraordinary images that not only turned viewers' heads but often made them stare and wonder just what they were looking at. By showing up early Bourke-White assured herself the comfort of time in order to arrange her lights, pose her models, and manipulate the background so as to create dramatic effects. And having taken an otherwise absurd assignment so seriously, she then could make *herself* (as

much as the exquisitely arranged bread crumb) the center of the story. Bourke-White's perceptions of the forces shaping the contemporary world, including the camera itself, made her the quintessential advertising photographer in the early 1930s. Her path from advertising to documentary photography set her apart from her female contemporaries such as Doris Ulmann, Dorothea Lange, and Marion Post, who harbored in varying degrees a sense of social reform. Although Bourke-White did recognize the desperate conditions of some Americans during the Depression, she never possessed a strong desire to lift up a specific American subculture or portray individual human dignity or expose class-based and race-based inequities. Using the camera as a tool of social reform seemed foreign to her. Yet her contribution toward shaping the age of documentary is indisputable, particularly since she collaborated on one of the first and most significant documentary books to appear in the 1930s. Her decision to leave behind the popular genre of the age seemed a natural step in her professional development, certainly in keeping with her desire to stand at forefront of new trends in photography; the advent of photojournalism provided Bourke-White a decidedly fresh challenge. As a modernist who embraced the subjects and issues of the documentary genre for a brief time, Bourke-White secured her place among visionaries who realized what sophisticated technology could mean in a complex, machine-driven environment. By isolating the elements of modernity—a radio cable, a steel plow blade, a shiny hubcap, a gargantuan dam—she cultivated an aesthetic that made mechanical parts come alive. Bourke-White's vision helped to break new ground in the photography world, and as a modernist, she was eclipsed only by a woman who addressed the cultural "lag" by arranging elements of change in their cultural and environmental contexts. The decade saw the most thorough and comfortable integration of the documentary impulse and modernist sensibility in the work of Berenice Abbott, who managed to narrow the gap between contemporary symbols of power and the existing American culture.

5

Modernism Ascendant

BERENICE ABBOTT'S PERCEPTION OF THE EVOLVING CITYSCAPE

> If I had never left America, I would never have
> wanted to photograph New York. But when I saw it
> with fresh eyes, I knew it was *my* country, something
> I had to set down in photographs.
> —Berenice Abbott

WHEN A NEW DEAL PROJECT OFFICIAL first saw Berenice Abbott's Bowery pictures, he warned her that nice girls should stay out of certain New York City neighborhoods. Abbott retorted, "I'm not a nice girl. I'm a photographer." That such a warning could be given, even in jest, revealed the widely accepted limitations still placed on female photographers, especially those who stepped outside the confines of a studio to ply their trade in the 1930s urban world. Abbott's succinct reply clearly reflected her no-non-sense view of herself, including a valued ordering of professional responsibility over certain gendered restrictions. Since Abbott had consciously chosen to put on film as much of the preeminent American city as she possibly could, she planned not to focus only on its orderly neighborhoods, beautiful facades, or attractive residents. Weather-beaten tenements and crowded markets had roles

to play in Abbott's project, which was grand in scope, an attempt to capture the city in all its energy and fluidity. Early in her tenure as a Works Progress Administration photographer, she told a reporter, "This is not a 'pretty picture' project at all—it is to get the real character of New York."[1]

Abbott hoped to comb Manhattan from Harlem to the Brooklyn Bridge, and she wanted her pictures of the city to stand apart from some of those her popular predecessors in the American photography world had created. Her methods and her independence kept her from joining the Alfred Stieglitz followers, a group she evaluated as a "powerful cult" guided by one man's "stupendous ego." She avoided the soft-focus style of pictorialists like Doris Ulmann, because she thought they made "pleasant, pretty, artificial pictures in the superficial spirit of certain minor painters." Since Abbott made no pretenses about the documentary tone of her images, New York's art photography circles chose not to include her. She succeeded in spite of them, pointing to her dependence upon "a relentless fidelity to fact [and] a deep love of the subject for its own sake." Neither trait, however, illuminates her modernist sensibilities. Claiming "fidelity to fact" put her in the same camp as other 1930s documentarians, who worked in a cultural context dependent upon the public's belief in the ability of the camera to record truth and to show circumstances as they actually existed. Choosing the city itself for a large-scale documentary project placed Abbott in a distinguished line of observers who had for nearly one hundred years pondered the city's possibilities and then created and disseminated visual messages to audiences hungry for definitions of the urban landscape and its inhabitants. But, as Peter Hales has shown, these purveyors of an ideal metropolitan environment had been transplanted by the 1920s as other forms of mass culture, notably motion pictures and radio, better explained the urban experience. Unwilling to "order" the city through her lens, as other cityscape photographers had done, Abbott showed instead a world in flux; by so doing she inadvertently denied that anything could be "captured" on film. Her attempts to frame only particular moments in the evolutionary processes she viewed marked her photography as modern in the truest sense of the word.[2]

Abbott first experienced New York as a nineteen-year-old journalism student. Like many other midwesterners in the first decades of the twentieth century, she left her Ohio home in search of the opportunities the urban life offered. She intended to cast aside memories of an unhappy childhood, a disintegrated family, and a dull freshman routine at Ohio State University. Her parents had divorced soon after her birth in July 1898, and Abbott grew up having little contact with her three older siblings or her father. Feeling somewhat alienated from her family members, she assumed enough personal independence to leave them behind and seek a different life for herself. In the winter of 1918, she borrowed twenty dollars to buy a train ticket to New York. The friend who lent Abbott the money also gave her a place to sleep in a spacious Greenwich Village apartment. While living in the Village, Abbott found herself surrounded by artists, actors, and playwrights, many of whom started their workdays at dusk. Their late nights often ended in raucous neighborhood parties, where Abbott's shyness left her in the minority. But after convincing herself that the life of an artist offered greater satisfaction than the career in journalism to which she had aspired, Abbott dropped out of Columbia University, a place she later described as "a hell of a sausage factory" despite her sporadic class attendance. Admitting that she would have made "a very poor journalist," Abbott attributed her choice of the field to youth's uneasiness, the inescapable grappling for personal identity.[3]

To support herself, Abbott took a variety of jobs, from secretary to waitress to yarn dyer. She dabbled in acting and landed parts with the famed Provincetown Players, including a small role in Eugene O'Neill's drama *The Moon of the Caribbees*. Struggling to find her niche in the art world, Abbott decided to cultivate her interest in sculpture. She moved away from her acquaintances and the night life in Greenwich Village in order to live alone as an artist. Though making little money at her craft, she noticed that other artists in the city focused on how much profit their works would bring. Abbott pondered the kinds of inspiration that commissions provided, believing that such patronage might restrict her artistic freedom. Not until several years later would she be able to reconcile the need to take commissioned work in order to but-

tress her more experimental projects. By 1921 Abbott craved an
atmosphere more conducive to creativity, and with encouragement
from her friend the baroness Elsa von Freytag-Loringhoven, she
decided to study in Paris. She explained her dissatisfaction with
both the immediate community and the larger nation that sur-
rounded her: "I was scared of New York, scared of America. . . .
I wasn't commercial. I never dreamed about how much money I
could make—it never even occurred to me. And America was so
commercial, that's why I left it." As a young, carefree, self-styled
sculptor, Abbott had little to lose by starting over in another place.
Of the move to Paris, she remembered thinking, "I may as well be
poor there as poor here."⁴ Although she failed to realize it at the
time, the environments Abbott chose to work in throughout her
career would become either allies or enemies, inspirational havens
or desolate grounds. Her surroundings were vital in stimulating
her imagination.

Veritably unambitious, Abbott bought a one-way ticket to
Paris. She recalled, "In March 1921 I set sail on the great big sea,
like Ulysses, and I said to myself, 'Whatever happens, happens.'"
For two years, as Abbott struggled to develop her sculpting tal-
ents, she held down a variety of jobs to support herself. She often
posed for other sculptors and painters in order to make money.
Even if her artwork failed to furnish the income she had hoped
for, Paris offered the working atmosphere she had craved. Abbott
explained that "Paris had a quality in those days that you can't
have in an overcrowded place. People were more *people*. No one
was rushed. . . . We had the illusion that we could go ahead and
do our work, and that nothing would ever come along to stop us.
We were completely liberated." Abbott's friends belonged to the
American and British expatriate circles who huddled on Paris's
Left Bank. Most were writers or painters or patrons of the arts.
Leslie George Katz described them as a "community of congenial
individuals" who discovered their most meaningful expression
through the vehicle of the arts. He explained that "in the practice
of the arts a person acting as an individual, a loner exploring a
commitment to a craft, could hope to express thereby the vernacular
total of human experience." Unfortunately, Abbott failed to reach
a satisfying level of expression with her sculpture. Although she
had escaped the commercialism of the United States, she was dis-

contented with the European art world. Her lack of commitment combined with her personal dissatisfaction led Abbott to abandon sculpture. After nearly three years of study and practice, she willingly gave up her dream and went to work full-time as an assistant to the experimental visual image creator, artist and photographer Man Ray.[5]

When Man Ray discovered that Abbott knew nothing about photography, he immediately hired her to print his negatives. He wanted to train a novice to develop negatives using *his* vision. Man Ray realized that he could mold the inexperienced young sculptor and pay her very little while she learned the trade. Abbott surprised herself and her employer by readily mastering darkroom techniques. She employed her artistic skills in order to sculpt the faces in Man Ray's portraits. Abbott's keen ability to see "white, gray, and black" tones helped her to print sharply defined likenesses of the portrait sitters. Abbott biographer Hank O'Neal has pointed out that Abbott produced a stunning "three-dimensional effect" on paper, a pleasant consequence that attracted even more patrons to Man Ray's already-popular portrait studio. For three years Abbott worked closely with Man Ray's negatives, but she rarely observed his methods with sitters. All she witnessed emerged on film emulsion in the darkroom. Perhaps the long hours she spent alone developing, printing, and critically studying Man Ray's work encouraged Abbott to try her own hand with a camera. He showed her how to operate the machine, and soon afterward she began taking photographs of her friends during her lunch break. As Abbott took more and more photographs, her satisfied customers helped to build her reputation by word of mouth. When one of Man Ray's appointments asked for Abbott to take her portrait, the tension in the studio mounted. Abbott decided to resign rather than exist in an inhospitable working environment. Although Man Ray had been the only photographer Abbott had known and the two had worked together closely, their respective portraiture styles displayed relatively few similarities. Producing photographic work that best fit within the surrealist tradition, Man Ray was once described as "the wittiest juggler the camera has ever known." Abbott experimented with light, angle, and shadow but produced images of individuals that bore more marks of traditional portraiture than did Man Ray's. In 1926 Abbott got the opportunity to

develop her ideas about portrait-making even further when two loyal patrons, Peggy Guggenheim and Robert McAlmon, loaned her enough money to set up her own studio.[6]

Out of the studio came pictures of countless faces, young and old, suspicious and carefree, affected and quite natural. Abbott took her time with her sitters and allowed them to "be themselves." She considered each subject so important that she took only one person a day. Ample time for interaction between the photographer and the sitter was vital because, in Abbott's opinion, only a comfortable session would reveal true character. Abbott explained, "I wasn't trying to make a still life of them . . . but a person. It's a kind of exchange between people—it has to be—and I enjoyed it." One critic has said of Abbott's Paris portraits, "The sitters are her peers, her accomplices, her friends, her heroes. They sit for her as her equals, one to one." And they participated. Most of the time, Abbott elected not to pose her subjects; instead, she allowed them to strike their own poses. She consciously tried not to flatter them. Some of them dressed up, whereas others appeared in casual clothes. Bookseller Sylvia Beach donned a full-length dark rain slicker and a white neck scarf for her portrait. The striking contrasts, from Beach's shiny coat to her smooth, pale-skinned profile, reveal the ways in which Abbott experimented with various textures in order to create multidimensional figures that appealed to the senses. Some of her sitters looked at the camera, some away from it; some had joyous smiles, and a few had introspective gazes. Abbott treated each sitter differently and claimed to have started every session as if she "had never taken a photograph before." She once told a group of students to avoid the "photographed expression" when making pictures of people, implying that such a conscious effort would yield more honest results in the darkroom. A rapport between photographer and subject is evident in Abbott's portraits.[7]

The relationships Abbott forged with her sitters resulted in some of the most lively, most poignant, and most haunting photographs to come out of 1920s Paris. In her series of James Joyce, a contemplative, troubled face dominates each frame. His bodily shifts from scene to scene suggest a restlessness as he looks away from the camera eye, leaning back comfortably on a sofa in one scene, then in another scene leaning forward toward the photog-

rapher, and in yet another having turned away again. Joyce's movements, which may have been orchestrated by Abbott, reveal the portraitist's attempts to record the depth of her subject's discontent. Seemingly captured in anguish, Joyce has his head propped on his hand and his chin set with lips pursed; his mood is accentuated by his furrowed brow (fig. 48). Despite the energy emanating from an Asian-inspired sofa pattern, Joyce's striped shirt, and his dotted bow tie, all potential sources of competition, the subject's emotional state is laid bare in the image, thus dominating the peripheral elements. Much in contrast to the writers' portraits by Doris Ulmann, where studio props such as ink wells and paper connected the sitters to their craft, Abbott's creation of Joyce's image shows the tormented expatriate soul, worried and disillusioned. Through the faces and bodies of her sitters, Abbott communicated the mood of European modernism, all movement, fragmentation, and fluidity. One critic commented about the Paris portraits, "There is no irony or facile cleverness in them. They are friendly and admiring, yet they never strike a false note."[8]

Among the expressive faces are the all-knowing and unshakable Princess Eugene Murat, who stares directly at the camera; the dramatic yet pensive Solita Solano, who rests her chin on her shoulder; and the straight-backed, serious editor Jane Heap, posed as the classic androgyne. Coco Chanel, Leo Stein, André Gide, Janet Flanner, and many others offered Abbott their faces and their souls for a day. They admired her work and helped make her a successful artist in a city that had not wholeheartedly brought photographers up to the level of respect that painters, sculptors, and writers enjoyed. One of her sitters and biggest promoters, Jean Cocteau, even attempted to shape Abbott's image by altering the spelling of her first name for her first one-woman exhibition in Paris in 1926. He changed her name to Bérénice, a reference to a virgin who would not marry a king, suggesting that Abbott refused to depend upon a male companion for financial support. Abbott later explained that she did not like her given name, "*Burrnees*," so welcomed the addition of another letter in order to make it "sound better."[9] Cocteau's influence on Abbott cannot be underestimated, especially given his love of America and its indigenous sources and original products, such as jazz. Abbott had escaped what she considered stifling mainstream values in the

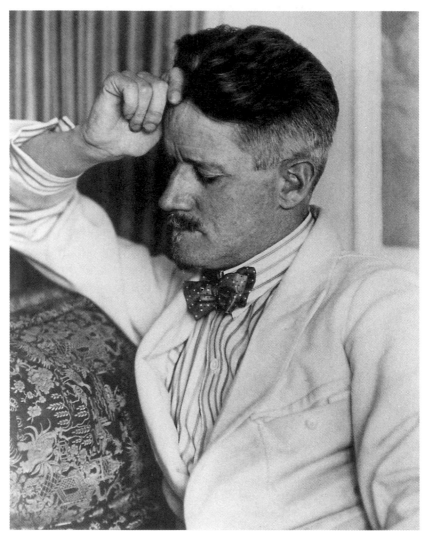

Fig. 48. Berenice Abbott. *Portrait of James Joyce.* Commerce Graphics Ltd, Inc.

United States, but she heard a refreshing point of view about her own country from Cocteau. The seeds he planted about the young nation's offerings were no doubt present when Abbott returned to New York City later in the 1920s.

For Abbott, Paris was defined by its people more than its landmarks, its palaces, or its history. Her profitable business was supported by clients who admired her depictions of them and reveled in her appreciation of their various artistic, literary, and social endeavors. She found comfortable, wealthy women particularly fascinating and once said, "People can be great in themselves, and not for what they do. There were women in the 1920's who knew how to live doing nothing, just pouring tea or going to the store." Of all the Parisians and exiled Americans and other individuals who inhabited the city, perhaps none interested Abbott more than the photographer Eugène Atget. Having seen a few of Atget's pictures in Man Ray's studio, Abbott sought out the photographer who provided artists with source material for their canvases. Abbott happily discovered that Atget lived just up the street from Man Ray's studio in Montparnasse. She recalled her first encounter with him as shocking, finding behind Atget's apartment door a "tired, sad, remote" man, yet one who was also oddly appealing. She befriended him, studied his photographic techniques, and bought as many of his prints as she could afford. Her curiosity about a different kind of photography marked her first step in moving away from portraiture. Several months after Atget's death in August 1927, Abbott managed to convince his closest friend, André Calmettes, to sell Atget's photograph collection to her. The fifteen hundred glass plates and thousands of prints revealed to Abbott the extent of Atget's dedication to his City of Paris project, which was later identified as "more comprehensive than anything previously attempted in European photography."[10]

For nearly thirty years, from 1898 to 1927, Atget carried his 18 × 24 cm view camera, tripod, glass plates, and covers into every corner of the city and its environs. A substantial portion of his pre–World War I photography focused on the artifices and ornamental details of Old Paris, including storefronts, balcony designs, home interiors, sculpted facades, and architectural designs. He advertised his wares as "Documents pour Artistes," peddling them to the likes of Braque, Utrillo, and Picasso, as well as other

artists who might find ornate door decorations or busy storefronts interesting subjects to paint. Set designers also found Atget's images appealing for their sheer quantity of collected interior and exterior details. The cumulative body of the photographer's work impressed Abbott as a kind of "poetic epic," one that amassed numerous minuscule components in storefronts, churches, signs, fountains, and parks, among other things. Regarding his vision, she wrote, "He was obsessed by the materials of existence, the substances in which life is given form. The cobblestones of streets, the moulting limestone of houses, the bark and leaves of trees, the luster of berries, the gloss of rose petals, crumbling earth in plowed fields, marble fountains in landscaped esplanades—all these qualities and a million more controlled his imagination." With a particular focus on transitory elements, Atget was able to document a city moving out of the nineteenth century into the twentieth. The Paris he had known as a young man was fading; the fin de siècle trends crept in to modernize the city and its people. The romantic air of Delacroix's Paris and the stately manners of Manet's Parisians gradually disappeared as the sounds and sights provided by Picasso, Stravinsky, and Diaghilev demanded more of the public's attention. Atget hoped to preserve the remnants of the old world before they vanished completely. He was particularly proud of his photographic series showing neighborhoods in transition, with buildings in various stages of demolition. His theme, according to Abbott, was "society, its facades and bourgeois interiors, its incredible contrasts and paradoxes. . . . the vast scope of this world, the changing 19th century world."[11]

In 1928 Abbott began the task of promoting Atget's name and what she interpreted as his vision. She exaggerated the Parisians' neglect of Atget, who had in some quarters been thought to be a spy during the war. They considered him mysterious, this strange character toting around a huge old camera and a dark cloth. The man who focused on street signs and shopkeepers' windows seemed an oddity in 1920s Paris. Although Atget once told Abbott that the only people who appreciated his work were "young foreigners," his client records reveal that his photography interested several hundred buyers. In addition he sold more than two thousand negative plates in his "Old Paris" collection to the Monuments Historiques in 1920, a decision that allowed him, both

financially and artistically, to embrace new subjects. As a close observer of Atget's development, Maria Morris Hambourg has argued that the sale marked a point of transition for the photographer, in that it allowed his 1920s imagery to become freer, more "overtly subjective, idiosyncratic, lyrical, and suggestive. . . . less concerned with facts than with life."[12]

Inspired by Atget's pictures, Abbott unknowingly began laying the groundwork for a similar project of her own, one that would take her away from Paris indefinitely. She continued to make portraits in the late 1920s, but she also took some of her first outdoor photographs during those years. If Atget's work had measured anything, it was the importance of the present, the singular moments and scenes that vanished quickly in a modern environment. In a typical scene he photographed on the Rue de la Montagne-Sainte-Geneviève, Atget peers down a narrow passageway that divides the frame. Characteristic of hundreds of his street scenes, the darkened and unseen path has a hint of mystery about it. The surrounding neighborhood seems innocuous enough, with inviting shop windows on the left side of the frame and private residences on the right half of the frame. Yet the brightness of a contemporary cheese shop window, with its baskets and milk cans neatly stacked on the sidewalk, provides a stark contrast to a darker, wrought-iron-fenced residence across the street. The shop's openness and close proximity to the street are markedly different from the home's prison-like walled closure and distance from the public space. Even the vehicles Atget used to mark the separate spheres highlight the differences; a produce wagon's wheels and a metal-fendered automobile tire stand on opposite sides of the frame yet show two worlds coexisting. One bespeaks a rural past, the other a mechanized urban future. Although Abbott had focused solely on human personalities in her studio portraiture, she came to appreciate Atget's point of view, his focus on the external world, what she called "realism unadorned." Just a few months after she bought his photograph collection, Abbott made a trip back to New York, the place she had rebelled against a decade earlier. She immediately fell in love with the city, and later she said, "I knew that I couldn't go back to Paris. Here I was, in the most complicated city in the most complicated country on earth, and I knew that that was where I had to stay." A yearning to rediscover her

roots had led Abbott back to the United States, yet she never
expected to feel so overwhelmed upon her return.[13]

The vitality of New York City attracted her. Her newfound ap-
preciation for artistic realism made her aware of what tremen-
dous possibilities the city offered as a subject. Atget's urban project
may have planted the seed, but New York itself brought Abbott
back. She returned to Paris just long enough to trade her furni-
ture and pack up the Atget collection for shipping. She left behind
in Paris the dadaists, the constructivists, the surrealists (whom she
referred to as "microbes"), and all those who she believed focused
too heavily on manipulating or distorting the human experience
in their art. In her rejection of the avant-garde, Abbott carried
out Atget's forbearance against highbrow innovators. He had
distanced himself from them throughout his career, shunning their
aesthetic tastes by drawing a line between his work and theirs.
What best illustrates Atget's view of how far apart his images stood
from experimental art is an anecdote describing a brief encounter
between him and Man Ray. In 1926 the surrealists wanted to use
on their magazine cover a 1912 Atget picture of Parisians watch-
ing an eclipse. Atget sold them the photograph but told Man Ray,
"'Don't put my name on it. . . . These are simply documents I
make.'" Atget circulated in a European world where documen-
tary photographs were supposed to serve a myriad of purposes,
having been defined as such at the Fifth International Congress of
Photography in Brussels in 1910. It was there that images were
cast as vehicles for other, more important work, such as "scien-
tific investigation." Atget scholar Molly Nesbit has pointed out
that this perception of documentary photography made a visual
image simply "a study sheet. . . . beauty *was* secondary; use *did*
come first." This was documentary as Atget understood it, and it
is the principal reason he felt compelled to take thousands of
photographs. In the end, quantity counted most.[14]

As a result of thinking and writing about Atget for years,
Abbott cast him as one of the world's greatest photographers, in
a way rescuing him from being remembered as *merely* a docu-
mentarian. By creating an image of Atget that would satisfy her
American audience, she bolstered her own reputation as a docu-
mentarian of a large metropolitan area in the United States. Abbott

helped transform Atget from a yeoman camera operator into an extraordinary *seer,* describing his work as "purely and entirely photographic." Molly Nesbit has argued that Abbott's recreation of Atget in aesthetic terms, despite his aversion to being defined in such a way while he was living, made him the kind of photographer that an American culture could accept, whereas in France he remained essentially a working-class artisan. In Abbott's interpretations of Atget, he was a wholly objective viewer, a photographic eye whose vision could be trusted. Convincing others to share her convictions and recognize Atget became one of Abbott's principal goals after returning to the United States in 1929. The other was to frame as many moments in the evolution of an urban area as she could, in the form if not the spirit of a dead French photographer whose reputation she would later shape.[15]

Abbott moved back to New York to find an array of obstacles facing her. Within months of her return, the stock market crashed, and soon thereafter a nationwide economic depression set in. The reputation Abbott had enjoyed in Europe had not accompanied her across the Atlantic, so she was forced to support herself by seeking out business rather than waiting for it to come to her. She quickly learned how to survive in New York; she took on commercial work and "anything that came up." Abbott's pictures appeared in popular magazines such as *Vanity Fair* and the *Saturday Evening Post.* She was hired by *Fortune* to make portraits of several business tycoons. While Margaret Bourke-White pictured the inner workings and tiniest elements of industrialism, Abbott photographed the men behind it all, those in charge of the machine age. Although the *Fortune* assignments kept her working with portraiture, Abbott found her new sitters much more difficult to deal with than her Parisian friends. She recalled, "I couldn't bear it. Those chairmen of the board were so different from Europeans, so unrelaxed, so uncooperative, so 'just do your stuff and get out of here.'" Yet Abbott chose not to measure New York by those men. To her, the city was defined more by its places than its people, unlike Paris. She understood and even liked the difference, the "new urgency" in her immediate environment that she found so characteristically American. "There was poetry in our crazy gadgets, our tools, our architecture," she said. Abbott

planned to picture those facets that composed Americans' external world and helped them chart their progress.[16]

In between magazine assignments and other commercial jobs, Abbott reserved one day a week for roaming about New York. She spent her Wednesdays alone with the city. She felt uneasy on her first trip out, intimidated by the curious and often unfriendly stares from passersby, but she knew she would have to overcome the barriers or abandon her project altogether. Beginning at the waterfront, Abbott worked her way up Manhattan, "using a small camera as a sketch pad, noting interesting locations, storefronts, facades, and views." When she ventured out with her larger 8 × 10 Century Universal and its requisite tripod, crowds gathered. Bowery residents scoffed at the young woman hiding under the black cloth, and more than a few others played practical jokes on her. She recalled, "Men used to make fun of me all the time. They couldn't understand what I was doing. The worst time I ever had was when I wanted to photograph the George Washington Bridge, which was just going up. I wanted to shoot it from up in the crane. The construction workers put me in the pan and, once I was high in the air, they swung the crane back and forth so I couldn't take any pictures. I was *terrified*." Abbott's experiences with the men she encountered while taking pictures revealed some of the prejudices against working women that circulated during the Great Depression. Prevailing opinion viewed active, employed women as threats to men who needed work.[17]

Even though Abbott's sporadic employment could hardly characterize her as a woman who had taken a job away from a well-deserving male breadwinner, she nonetheless suffered from the public's opinion on the subject. In addition, Abbott did not enjoy the advantages some of her female contemporaries in photography could boast. Shy and unassuming, unlike the flamboyant, confident, and egocentric Margaret Bourke-White, Abbott had to force herself to contend with New Yorkers in her efforts to document their city. In the early 1930s, Abbott worked on New York's streets alone, without the benefits of a personal entourage like the one Doris Ulmann enjoyed during those years. And not until several years into her documentary project on the city did Abbott carry the credential "U.S. Government photographer," a position that garnered for Dorothea Lange and Marion Post a

considerable amount of respect and clout in the locales where they carried out their agency fieldwork. Nevertheless, Abbott resolved to continue the project that had become a personal obsession, even though no institution offered to support her work in the early 1930s.

In 1931 Abbott applied for a Guggenheim Foundation fellowship but was rejected because her project failed to meet "international" character requirements. Her examination of an American city generated little interest among the referees. Several months later she appealed to the Museum of the City of New York, which also turned down the pictorial survey. The next year Abbott crystallized her objectives in a proposal sent to the New York Historical Society. She stressed the importance of preserving the city's "unique personality" in a collection of documentary photographs. Her eloquent statement included an argument supporting photography's role in historical preservation: "The camera alone can catch the swift surfaces of the cities today and speaks a language intelligible to all." She felt particularly qualified to document the American city since she had spent nearly a decade in Europe and had gained some sense of perspective about the United States from a distance during those years. Convinced she had developed an unusual appreciation for her native country, Abbott wanted the privilege to interpret what she saw before other, perhaps less objective, photographers assumed the same task. She continued taking pictures of New York, though all of her appeals for institutional support were rejected. One private museum patron sent Abbott the only contribution she received—fifty dollars.[18]

As the national economic depression worsened in the 1930s, Abbott received even fewer opportunities for commercial business. She eventually resorted to other means of income, claiming in particular to have sharpened her barbering skills. She would say to portrait sitters, "the pictures will be all wrong because of your hair," as she pulled out her scissors in order to make a little extra money. When architectural historian Henry-Russell Hitchcock asked Abbott to collaborate with him on two photo projects, she accepted his offer. They gathered enough material to mount an exhibit at Wesleyan University entitled "The Urban Vernacular of the 1830s, 40s, and 50s: American Cities before the Civil War." At the Museum of Modern Art, they exhibited pictures of build-

ings designed by Boston architect H.H. Richardson. The time
Abbott spent working on Hitchcock's jobs prompted her to re-
sume her New York documentation with a vengeance. Travels to
several eastern seaboard cities had convinced her that America's
premier city boasted an incomparable energy that could not be
ignored. In Abbott's opinion, to abandon the project because it
aroused no support would have meant not only artistic failure but
social irresponsibility on her part. She plunged forward in spite of
personal poverty.[19]

New York City offered Abbott a study in contrasts. Through
close observation she saw "the past jostling the present."[20] She
recognized that new skyscrapers were beginning to overshadow
old brownstones and that modern technology was edging out any
semblance of nature. In a 1932 series she completed on the con-
struction of Rockefeller Center, Abbott seized on the scale of new,
modern architecture. In one image (fig. 49), taken from the base
of the structure looking up, Abbott used the appearance of natu-
ral elements in the foundation to highlight their place in relation
to manmade structures. Although gargantuan in size, the ice for-
mations on the limestone foundation have been surpassed by the
steel framework of the building itself. To provide a sense of mag-
nitude, Abbott included a man's head in the lower right corner of
the frame. He, along with nature, is dwarfed by the architectural
wonder. In another image Abbott made in the Rockefeller Center
series (fig. 50), a cutaway view of the framework reveals a high
level of activity and movement on the site. The workers, who stand,
crouch, lift, bend, and walk, seem in command of their respective
rectangular cubicles; they are important in a relatively small space,
but set in the larger project they are tiny, insignificant components
whose lives are overwhelmed by the structure itself. That the image,
this collection of adjoining rectangles, extends beyond all sides of
the photographic frame reveals Abbott's developing modernist
sense. The picture represents a fragment of a moment, but even
more so, a fragment of a place. There is no clear beginning or
ending to the image, and there is no single definable icon on which
a viewer can or should focus. What exists, instead, is a visual
smorgasbord, allowing initial and subsequent fixations on any point
at any place in the field.[21] A viewer's perspective in this particular
Rockefeller Center image is determined by the human element;

Fig. 49. Berenice Abbott. *Rockefeller Center, 1932*. Commerce Graphics Ltd, Inc.

Fig. 50. Berenice Abbott. *Rockefeller Center, 1932.* Commerce Graphics Ltd, Inc.

no other reference points in it so clearly define scale as the persons, who appear like worker bees in a colony.

Since the face of the city changed on a daily basis, Abbott wanted to preserve the pieces of New York's past that were slowly disappearing. "I wanted to record it before it changed completely . . . before the old buildings and historic spots were destroyed," she remembered. But she also hoped to capture on film the fleeting moments known as the present. She believed that one of her primary responsibilities as a photographer was to capture as many elements of the present moment as could be comprehended. As she explained to Meryle Secrest, "[t]he present is the least understood thing about life. It's harder to gauge, to know fact from fiction, to know what's going on behind and in front of the scene. You can't tell from people as much as you can from things. You can see our villages and towns and they are really expressive of our real people." A city in flux, New York provided a spectacular continuum for Abbott's work. She saw her pictures as connectors, bridges that linked her subjects simultaneously to the past and to the future. In a 1934 series on Trinity Church, Abbott juxtaposed the neo-Gothic structure with the Wall Street buildings that had come to not only surround but also minimize the religious edifice (fig. 51). Built in the 1840s, Trinity Church embodied in stone the medieval-age principles of gallant chivalry and Christian Church domination. But here Abbott shows the mid–nineteenth century romantic revival structure taking a lesser place than the turn-of-the-century bastions of commerce and finance. The modernist observer has framed an icon of the past jostling the omnipotent symbols of the present. Realizing that the tiny pieces of the present she recorded became part of the past as soon as the shutter clicked, she maintained that a photographer's duty was to recognize "the now."[22]

A few years after she began photographing New York, she told a reporter that she considered cities important social indicators because they had "a personality. Not the people in them, but the buildings, the little odd corners. . . . And New York, especially. It's so changing. It's in the making. We're making it. There's so much movement. It gets into your blood. You feel what the past left to you and you see what you are going to leave to the future."[23] The thrill of the city's possibilities led Abbott to explore

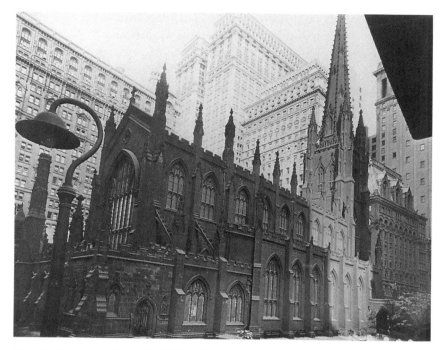

Fig. 51. Berenice Abbott. *Trinity Church, 1934.* Commerce Graphics Ltd, Inc.

its streets, observe its statues, and study its structures. Her vision
was distinct from those of earlier observers of New York as an
urban space. Best known for his penetrating views of slum life
and high crime areas was Jacob Riis, a Dutch immigrant whose
police reporting yielded him sufficient ammunition to produce a
groundbreaking publication entitled *How the Other Half Lives:
Studies among the Tenements of New York*. Appearing in 1890,
the book's critical acclaim was due primarily to its use of photo-
graphs "of a sort that had been seen by very few."[24] The cityscapes
showed crowded, dirty streets and even more crowded sleeping
rooms that doubled as living and working spaces for large fami-
lies. The environment that bred violence and disease was laid bare
in Riis's work. Abbott viewed similarly poverty-stricken areas, but
she did so with a much larger scope; instead of going into an alley
where vagrants loitered, she set a working-class tenement house
against the backdrop of New York's fresh twentieth-century sky-
line. Or she provided a sense of overcrowding not by picturing
people but by showing instead their endless lines of laundry strung
crisscrossed from window to window. Abbott's vision of New York
also varied from that of her contemporaries Lewis Hine and
Margaret Bourke-White, both of whom made photographic stud-
ies of the Empire State Building and other skyscrapers. Bourke-
White's aesthetic demands were for material textures, articulated
through the isolation of polished steel components or machine-
age design elements. Her highly stylized arrangement of such objects
provided a sense of compositional stability, in that the eye could
find one or two central points in an image on which to fix a gaze,
with the realization that those points were not themselves mov-
able (see, e.g., fig. 41). Abbott's studies of skyscraper development
do not offer such clearly defined points of reference, nor do her
subjects emit a sense of comfortable solidity.

 Because of the surface similarities between Abbott's New York
and Atget's Paris, some of her contemporaries argued that she was
merely copying her mentor's work and possessed no creative im-
pulses of her own. She shared his values and his vision, and as
photographer Minor White pointed out, "a store front full of shoes,
or a store window filled to the edges with hardware had a fasci-
nation that neither could resist." But Abbott saw what different
and exciting possibilities the modern age offered a young nation,

whereas Atget had viewed remnants of the past in an aged culture. Unlike Atget, who had stood in the present looking back to the past, Abbott stood in the present looking forward to the future. Many of Atget's prewar Paris scenes were marked by the soft haze and the indefinite backgrounds that the American pictorialists had employed; by contrast, the New York of Abbott's pictures is alive and bustling and sharply defined on photographic paper. Art critic Elizabeth McCausland, comparing the two photographers, found "two worlds and two ages portrayed—his the romantic last glow of nineteenth century nostalgia, hers the modern technological triumph of man over nature." Photographer Lisette Model agreed, arguing that Abbott's pictures revealed some sense of the daily struggle people carried on to control the external, their immediate surroundings.[25]

Even though they showed two very different worlds from opposing perspectives, Atget and Abbott did share a few basic artistic principles. Perhaps of most importance to Abbott was her recognition of the power a cumulative body of images could wield over a select few, perfect pictures. Her New York colleagues, the highbrow art photographers, created singular points of reference in their symbolic images, perpetuating what Abbott later called "the stale vogue of drowning in technique and ignoring content." Abbott took numerous shots in the same places on various occasions; often she returned to sites in order to capture subtle changes. In 1936 she told a reporter, "Once, way up at the end of Broadway, I saw a little church next to a row of new apartment houses. I went back the next week to take it, and the church was gone." This was the kind of surface alteration she believed constantly reshaped the spirit of the city. Abbott could not accept the idea that a few striking photographs could represent New York in all its complexity. For that reason she continued her quest to document the whole city over the course of days, months, and years, just as Atget had done in Paris. The step-by-step building of Rockefeller Center, the erection of the George Washington Bridge, the nighttime city glowing with electric lights—all of these and more went into Abbott's amorphous portrait of a thriving New York City. Eventually, the composite received notice. The power of Abbott's cumulative corpus of images caught someone's eye.[26]

Curators at the Museum of the City of New York decided to

exhibit forty-one of Abbott's city pictures in the fall of 1934. The show "proved of such great interest to the public" that the museum kept it on the walls for several months. Elizabeth McCausland published a glowing review of the exhibit in a Springfield, Massachusetts, newspaper and repeated her praises in the next issue of *Trend* magazine. The list of Abbott supporters continued to grow. The New School for Social Research offered her an instructorship in photography for the fall semester of 1935. Marchal Landgren, an official on the state's Municipal Art Committee, suggested that Abbott seek public funding for her "Changing New York" project. He had already made appeals to private citizens in Abbott's behalf but thought that one of the federal government New Deal programs might be willing to sponsor her work.[27]

Abbott prepared a new proposal describing the thrust of her documentary survey and submitted it to Audrey McMahon, the director in New York City for the Works Progress Administration's Federal Art Project (FAP). In the proposal she described the multifarious elements that made up "New York City in 1935," and in summary she asserted, "It is important that they should be photographed today, not tomorrow; for tomorrow may see many of these exciting and important mementos of eighteenth- and nineteenth-century New York swept away to make room for new colossi. . . . The tempo of the metropolis is not of eternity, or even time, but of the vanishing instant." Abbott laid out her objectives specifically, making it clear that she alone intended to guide the project, rather than have government officials direct her hand or her camera. Even if she did need financial support, she did not intend to forfeit her artistic integrity at the hands of bureaucrats— "I presented them with a complete plan of what I wanted to do. I also had five years' work to show them," she remembered. In September, after she had begun teaching at the New School, Abbott learned that Federal Art Project officials had accepted her proposal. They gave her a new title, "Superintendent of the Photographic Division—FAP/New York City" and allowed her to continue building on the collection she had started six years earlier. Each new picture she took would be part of WPA/FAP project number 265-6900-826, more familiarly known as "Changing New York." The independent-minded photographer, who became employee number 233905, welcomed the federal government as a

benefactor. Abbott and many others like her would discover that public patronage of art and artists greatly enhanced facets of American culture that had been previously neglected.[28]

The Federal Art Project supported scores of struggling artists in the middle to late 1930s. At the inception of the project, the *New York Times* announced, "U.S. to Find Work for 3500 Artists."[29] The FAP, along with the Federal Theatre Project, the Federal Music Project, and the Federal Writers' Project, comprised the Four Arts program known as Federal One. Sponsored by and supported with funds from the Works Progress Administration, the arts projects sought to provide steady, weekly work for unemployed, creative talents, some of whom were well established before economic depression swept the United States. The WPA, established under President Franklin Roosevelt's Executive Order 7034, removed Americans from relief rolls and placed them on employment payrolls of public or private work projects. The president's endeavors caused resumption of active, productive lives for hundreds of thousands of Americans. They picked up hammers, hoes, scripts, songbooks, pens, paintbrushes, chisels, and cameras. They built highways and swimming pools, erected bridges and courthouses, cleaned streets, cleared lands, and painted post offices. Their efforts changed the face of America. What they could not clean or restore or erect fresh, they counted or recorded for the sake of historical preservation. Alan Lomax trekked through the deepest South to record Delta Blues lyrics and tunes that were inspired by conditions in the cotton fields; southern writers interviewed former African American slaves about their experiences in bondage; and throughout the states, FWP employees on the State Guide projects collected folklore, ghost stories, tall tales, and other distinctly regional narratives that revealed local color and character. The mixture of indigenous influences and ethnic variety in the United States provided a wealth of material for researchers on federal arts projects, among them Berenice Abbott.

Illuminating her own pursuit of such evidence and her passion to incorporate it into a usable visual narrative, Abbott told a *New York Herald Tribune* reporter in 1936, "For instance, Front and Pearl Streets are very Dutch, and Cherry Street is pure English. . . . And from all this melange comes something that is uniquely New York."[30] Abbott invested substantial time and en-

ergy in the streets on the Lower East Side. Along with the garment sellers who hung their wares on the sidewalks and the peddlers who pushed carts through the streets were the food merchants. Abbott's direct frontal view of a kosher chicken market (fig. 52) provides a sense of vitality. Although the brightly sunlit birds have their legs tied together, the fanned wings suggest flight, their feathery lightness implying potential movement despite the fact that the animals are no longer alive. That half the display rack is nearly empty suggests the merchant's success; for Abbott's purposes, the market window was a perfect example of the fleeting nature of the present. Throughout a typical day, this window would regularly change in appearance, depending upon the availability of fowl, the demand for chicken in the neighborhood, and each purchaser's selection of specific birds from the rack. The curious produce seller may have gazed out his window at another point during the workday, seeing nothing because his vision was obscured by a full cadre of fowl, or he might have stared out, as he does in this image, and clearly observed those gazing at him.

As a WPA photographer, Abbott captured on film merely a small portion of the country—its largest city—yet her work reflected and, at the same time, contributed to the growing national search for American identity. As well as accomplishing important physical and structural changes, the WPA encouraged an internal, and more introspective, examination of national character. One FAP artist noted, "It has nourished my enthusiasm to know that I was contributing to the social order, that I was part of it." Federal One artists felt motivated to carry out the tasks of isolating and scrutinizing regional characteristics that, when taken as a whole, would add to the understanding of the collective cultural pulse of the United States. One music critic noted that the Federal Music Project (FMP) orchestras showed "the promise of a new growth of art feeling in America—'local and vital.'" According to the same critic, FAP painters, muralists, sculptors, and photographers elicited similar responses after taking "living art into schools, hospitals and public buildings." The sole guideline for their FAP work was to choose American subject matter, whether "naturalistic, symbolic, legendary or historical." By exploring what was essentially American and bringing it before the public in the form of art, FAP employees participated in a reciprocal agreement with

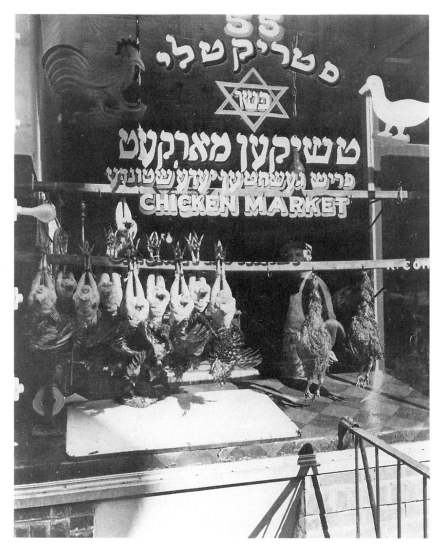

Fig. 52. Berenice Abbott. *Chicken Market.* Commerce Graphics Ltd, Inc.

the government. They could see their artistic visions realized, and even expect audiences to see their work, if they spoke merely from their own experiences as Americans. Project administrators would meet artists halfway by setting up exhibits in tax-supported public institutions that normally could not afford to obtain works of art, including "colleges, high schools, normal schools, trade schools, libraries, hospitals, museums, sanitoriums, prisons, and other Federal, State, and Municipal institutions and buildings." The government sought not only to raise the level of appreciation for art in general, but also to celebrate American artists and American subjects.[31]

WPA officials sometimes needed to defend the work of Federal One employees to the more cautious elements within the American public. Some skeptics believed that those on the public payroll should carry only shovels or rakes. Aubrey Williams, a WPA administrator, said, "We don't think a good musician should be asked to turn second-rate laborer in order that a sewer may be laid for relative permanency rather than a concert given for the momentary pleasure of our people." The WPA encouraged workers to continue using their own skills by giving them jobs in their chosen fields. For painters and sculptors the Federal Art Project resumed on a larger scale what the aborted Public Works of Art Project (PWAP) had abandoned in 1934 and what the Federal Emergency Relief Administration (FERA) could no longer afford. The differences in the new program resulted in more funding, better administration, and employment of all kinds of artists, photographers included. A *New York Times* article about the FAP stated in its subheading, "Nation-Wide Enterprise Is to include Photographers as Well as Painters," and it emphasized the vital roles of these men and women hired to "record the progress of the various activities and compile a record of WPA projects." A large number of FAP photographers, particularly those categorized in "Part 11, Publicity and Research," countered the cries of "boondoggling" by providing pictures of artists and other WPA employees at work.[32]

Well over half of the New York City photographic staff devoted its time to recording citywide WPA activities. In one of her first items of correspondence to FAP national director Holger Cahill, Audrey McMahon explained that the New York photography

project was "primarily a service project and only secondarily a creative one." Photographers charged to record work in progress made their medium a purely documentary one, in that their pictures served the larger purpose of fulfilling agency goals. As the vehicle through which WPA officials and the American public were informed about the agency's projects, the photographers' visual records helped to solidify the role of photography as a significant contributor to the documentary impulse working in the culture. Thus the federal government, in promoting nearly unlimited visual recordings with cameras, enforced the notion that photographs could themselves stand as clear renderings of actual conditions and real processes. In the first few months, FAP photographers snapped so many pictures of various WPA projects that Cahill was forced to limit the excessive documentation. He asked McMahon to scrutinize all photography assignments and make sure that her photographers did not step outside the FAP's jurisdiction. Although he wanted sufficient evidence to prove the value of the project, Cahill also recognized the importance of fostering artistic excellence in visual expression. In the long run, quality work would convince the American public of Federal One's worth.[33]

Cahill operated under the influence of John Dewey's aesthetic philosophy, which considered a person's (particularly an artist's) experience with the immediate environment to be important. Cahill emphasized this relationship as a measure of the national cultural awareness in a speech he gave: "The finest way of knowing our own country is to consult its works of art. . . . In these works we participate fully in the rich spiritual life of our country. In our own day it is the works of artists in all fields which concentrates [sic] and reveals [sic] contemporary American experience in its fullness. It is works of art which reveal us to ourselves. For these reasons I consider the Government art projects of the greatest importance." In the FAP reference material on procedure, suggestions were made to photographers "to work on research projects and on other projects of value to the community." No other artist than Berenice Abbott was more appropriate to be selected to create a documentary record of New York City. Even if she had been unaware of the FAP's stipulations about "American" subject matter, her pictures would have met federal government requirements. For she was not attempting to paint a glowing picture of the metropolis

nor to provide a nostalgic walk down memory lane. Rather, she was trying to capture all the elements that composed a burgeoning city characterized most distinctly by its heterogeneity. Within the larger context of FAP objectives, her work fit in, since it was largely dictated by her own fascination with the city and guided by her experiences there. Abbott's photographs celebrated what one observer has called "the aleatoric quality of American culture." It was exactly what the FAP hoped to reveal.[34]

"Changing New York," as one of the FAP Photography Division's "creative" projects, stood apart from the service assignments. Since Abbott served as its director, photographer, consultant, and printer, she enjoyed a great deal of freedom on the job. When listed in reports along with other creative projects, Abbott's work was usually treated separately, as a unique undertaking.[35] Photography division supervisor Noel Vincentini made the distinction soon after Abbott's arrival at FAP. In his November 1935 report, Vincentini briefly described the activities of the general photography project:

> The work of Photography, Part 6, consists of the taking of photographs requested for their records and official work by the various W.P.A. projects in the metropolitan area. . . .
> In addition to this work, the Photography section is carrying out a creative project called, "Changing New York." On this project, photographs are being taken of buildings, locales and street scenes, which are meant to serve as a permanent graphic record of the transformations of the city and the changes in the habits of its life.[36]

The FAP allocated money for Abbott to have a driver, two technical assistants, and two researchers on the "Changing New York" project, but she personally assumed most of the responsibilities; she chose her own subjects, fussed over her negatives, and preferred to make her own prints. Government sponsorship neither diluted her fierce independence as a photographer nor redirected her professional goals on her urban project. Here Abbott's motivations and artistic sensibilities mirror those of Dorothea Lange, who during the same period found herself struggling with

Photography Unit director Roy Stryker over control of the negatives she was producing for her own employer, the Farm Security Administration.

Abbott's pictures gained immediate recognition. Within six months of her initiation with the FAP, she had photographs on exhibit at the WPA Gallery on East Thirty-Ninth Street. The *New York Herald Tribune* interviewed her, providing her a forum in which to tell the city's residents why she felt the "Changing New York" project should be important to them. Abbott's explanation echoed the numerous appeals for support she had made in the early 1930s, including her appreciation for its variety: "New York is a spectacular city full of contrasts. The city is changing all the time." Requests for Abbott's pictures and negatives and prints poured into administrators' offices. As cosponsor of the FAP's "Changing New York" project, the Museum of the City of New York wanted to retain Abbott's negatives. Hardinge Scholle, the director of the museum, went over local heads directly to the FAP's Washington headquarters in an effort to obtain the project negatives for future print requests. FAP director Holger Cahill explained to Scholle, "Artists like Miss Berenice Abbott are very reluctant to have anyone else do their printing," but he reassured Scholle that the museum would eventually receive all of the negatives to keep permanently. The Grand Central Palace displayed several of Abbott's photographs in a May 1936 show entitled "Women's Exhibition of Arts and Industries." The following month, twenty "Changing New York" project pictures were selected for inclusion in a traveling exhibit known as the "Washington Circuit." For the circuit, called Project Number 8, the national offices chose outstanding examples of project art and sent them to federal galleries throughout the country. Nearly all were mixed-media exhibits that included paintings, prints, pictures, designs, and sculpture, but two traveling shows were devoted exclusively to photography—one to pictures taken for the Federal Writers' Project Washington, D.C., *City Guide Book* and the other to Abbott's "Changing New York" images.[37]

Because of the increasing demand for her photographs in 1936, Abbott spent an extremely busy year taking new pictures and making prints. She completed extensive studies of the Brooklyn Bridge, the Manhattan Bridge, Union Square, and Pennsylvania

Station. She focused on construction projects all over the city, but those that continued to hold special interest for her were the magnificent skyscrapers that dwarfed older, adjacent buildings. This theme would persist throughout her remaining years on the "Changing New York" project, thus proving poignantly true her intimation to a *New York World-Telegram* reporter about the inspiration for her study, "I'm sort of sensitive to cities. . . . They mean something to me."[38] Abbott's attempts to juxtapose landmarks from several generations may be seen in a 1938 view she took of Fortieth Street (fig. 53). Working from the Salmon Tower on West Forty-Second Street, Abbott depicted nearly one hundred years of New York history. The image exudes a sense of vitality because the frame is almost entirely filled with interconnected plane levels offering a variety of horizontal and vertical touch points in addition to layers of depth. The mid–nineteenth century structures occupying the lower right segment appear almost lost amid the towering modern structures, but the text stands out. The charge to "Save Regularly" at the Union Dime Savings Bank dates these old buildings, which continue to exist in the midst of a contemporary consumer culture that prizes buying over saving. The late-nineteenth century skyscrapers that initially dwarfed their counterparts of the 1800s bear the marks of a young urban landscape, complete with neoclassical and neo-Romanesque flourishes. In the lower left quadrant stands the Bryant Park Studio Building, with its revival window frames and small balconies. On the right edge of the image, the World Tower Building is distinguished by its uniformity all along the exterior, suggesting an upward sweep, until one reaches the top, where the European decorative details dominate the tower. In great contrast stand the modern skyscrapers filling up the center and top portion of the frame. Starkly simple and functional by design, the only variation in structure is the terracing at certain levels. The terraces provide layers of depth for the image, but more importantly, they send the eye up or down ladder-like steps. The climb higher to the top, whether inspired by ambition or greed or some other driving force, leads to security by contemporary standards but takes one further away from the monuments and ideas of the past. That such fluidity in movement is even possible in this relatively small area makes the feat all the more incredible.

Fig. 53. Berenice Abbott. *View of 40th Street.* Commerce Graphics Ltd, Inc.

Abbott's desire to depict the generational layers and their corresponding messages remained steeped in her belief that change occurred so rapidly that previous scenes could become unrecognizable to an eye that once knew them. In a 1938 study of an East Forty-Eighth Street block (fig. 54), Abbott framed two dwellings that had been identical to each other just five years earlier. The brownstone on the left, erected around 1860 and designed with classical-style window frames and decorative motifs, represents old New York. The newer and more prominent brick facade on the extreme left stands out just enough to obscure the brownstone's door front, but the more obvious juxtaposition is that of the brownstone's former twin, which occupies the right half of Abbott's frame. The contemporary dwelling shows no sign of its former life; the brown stone has been covered with glass brick and lightened with tones of a modern age, including concrete steps and a smooth, molded first-floor facade. What once was a stoop with open railings has been narrowed and closed off on one side, and the doorway's significant distance from the sidewalk allows the house a much more private, exclusive entrance. Wrought-iron rails with decorative grillwork have been replaced by the clean, curved lines of stainless steel, a mark of 1930s design known as streamlining. Abbott's steadfast determination to absorb as many signals as possible and then to show the fragmentary signs of deliberate and fast-paced change made her reputation as a documentarian who casts modernist eyes on the external world.

The popularity Abbott enjoyed as a WPA photographer was accompanied by controversy. When the Museum of Modern Art (MOMA) decided to put an FAP show on its walls, the museum's public relations director insisted on handling all publicity for the exhibit. Within a few weeks the *New York Times,* seemingly unaware of the upcoming MOMA exhibit, offered to present an Abbott photograph layout in its Sunday rotogravure section. Officials at MOMA threatened to cancel the exhibit, and national FAP administrators threatened to dismiss any employees who released information regarding the forthcoming show. Abbott, although one of the more prominent artists on MOMA's agenda, let FAP administrators handle the whole unpleasant affair. Her principal interest remained the same—to take pictures of New York, rather than to get mixed up in its highly volatile art community.

Fig. 54. Berenice Abbott. *East 48th Street, 1938.* Commerce Graphics Ltd, Inc.

In early 1937 the Museum of the City of New York expressed an interest in showing off the project it had cosponsored. The museum directors wanted to present a comprehensive exhibit composed entirely of Abbott's "Changing New York" pictures. When the show opened in October, 110 of Abbott's 260 project photographs revealed the multifaceted exterior of New York City to its residents. Public response was overwhelming; the museum reported increased general attendance, especially during the Christmas holidays when college students "flocked to the exhibition." Museum officials were forced to put off the exhibit's closing date in order to accommodate all of the curious patrons. Without doubt, "Changing New York" had accomplished several of the FAP's major goals, not the least of which involved generating Americans' interest in visual images created by their own, rather than European, artists.[39]

Abbott broke new ground with her "Changing New York" exhibits. Photography-only shows were rare because the value of the medium had not yet gained full recognition from other visual artists. Photography critic Beaumont Newhall, who served as an administrator on the Massachusetts FERA art project, pointed out that holding a photography exhibit in 1937, particularly at a New York museum, was a risky and controversial business practice. He explained that some critics abhorred the idea of such pictures being shown on the same walls that had previously held great paintings.[40] If any photographer could expect to be accepted among artists or even art photographers, it certainly was not Abbott, who told a newspaper reporter, "Next to golf and bridge, I loathe people who try to make photographs look like paintings or engravings."[41] Having stayed away from art photographers, Abbott aligned herself with very few others in her field. Perhaps she found more in common with her audience than with colleagues, since the former looked at her pictures with enthusiasm similar to that she felt when photographing the scenes. But what is even more likely is that Abbott had shown herself to be a modernist in tone and style, even though she had accomplished her feats with a camera rather than a paintbrush. So despite keeping her distance from other modernist photographers, such as Alfred Stieglitz and Edward Weston, she had defined herself as an innovative *seer* who embraced the principles, if not the practitioners, of modernism.

The reputation Abbott built from the popularity of "Changing New York" helped to open up other avenues for her photographic pursuits. The FAP administrators in Washington looked on with scrutinizing eyes, while Abbott received countless compliments, inviting offers, and numerous requests for pictures. Although they appreciated the tremendous attention given to an FAP project, government officials seemed uneasy with Abbott's personal success. They flexed their bureaucratic muscles in order to keep her independence in check. Working through the channels of bureaucracy grew tiresome to Abbott as the Washington FAP office insisted more emphatically on approving material released for publication. The policy, which had been in place since the inception of the WPA, hampered the New York City office because it handled such a large volume of book, magazine, and newspaper requests. The New York City division of the FAP appeared to federal administrators a bit cavalier in its approach toward publishable material. Constant reminders about necessary federal "clearance and approval" landed on Audrey McMahon's desk. Thomas Parker, Holger Cahill's assistant, addressed the subject on numerous occasions. He usually reiterated the FAP's responsibility to its public, in one instance writing, "I think it would be well for the information service to remember in the preparation of such articles that they are the employees of the Federal Government, and that the public who read the articles are the taxpayers who are providing the money for their employment." Ellen Woodward, another assistant in the Washington office, supported Parker's criticism of the New York City project and suggested that "material which goes to a nation-wide audience must be approved from the standpoint of the national program."[42]

The success of the New York City FAP, and particularly Abbott's contribution to it, no doubt prompted the national office of FAP to pay closer attention. One official from the Information Section made a special trip to New York to meet with Abbott about several photographs that might have publication potential. In the summer of 1938, Parker caused an uproar by asking Abbott to send her negatives to the Washington office. Without hesitation, McMahon replied, "Miss Abbott does not wish her negatives to be sent out and it is not procedural with us to act against the wishes of the artist." Although she was on the govern-

ment payroll, Abbott enjoyed a great deal more freedom than other FAP artists and other government photographers. While Abbott was winning battles with Washington bureaucrats, Dorothea Lange was fighting to maintain some sense of artistic independence in her job at the FSA. While Abbott got to develop her own negatives and toss out the ones she disliked, Lange and her FSA colleagues had to send their undeveloped rolls of film to Washington to be printed. But Abbott's freedom was short-lived. In 1938, when E.P. Dutton offered to publish selected "Changing New York" images in a book, FAP officials assumed a great deal of control over the project, refusing Abbott permission to select all of the photographs or to make suggestions regarding the book's design. Several months later, when the FAP discontinued the "Changing New York" project, Abbott left the agency with hopes of photographing the 1939 World's Fair in New York. Under WPA guidelines, an agency employee could not be gainfully employed elsewhere and receive a paycheck from the federal government. Abbott's release was timely in that Federal One soon came under close scrutiny from many sides.[43]

Throughout the year, general criticism of Roosevelt's New Deal programs had grown more severe. The changing attitudes reflected congressional sentiments in the aftermath of the president's infamous "court-packing" attempt in 1937. His plans to change the structure of the U.S. Supreme Court appalled Washington politicians and the American public alike, thus diluting the overwhelming mandate he had fashioned from his landslide victory in the 1936 election. Roosevelt lost further party support after launching an offensive before the 1938 congressional elections to reward his loyal court-plan supporters and to eliminate the disloyal elements. In addition, the economic downturn in 1937-38, labeled "Roosevelt's Depression," had caused many skeptics to withdraw their support for the administration's bold recovery plans. In a political sense, New Dealers suffered "a discouraging year" in 1938. One of the programs most closely examined was the WPA, particularly its Federal One branch. Fear that radicals might infiltrate the Four Arts projects led Congress to cut WPA funding. All project workers who had been on the payroll for eighteen months or longer were released. New relief workers were forced to take a "loyalty oath," and the FAP, the FWP, and the FMP could con-

tinue only under the direction of local sponsors who closely supervised each project. The Federal Theatre Project, which had been perceived as the most radical of the Four Arts programs, was abolished. Fortunately, Abbott had come in as a government employee when the New Deal programs, Federal One in particular, enjoyed widespread support, before they were transformed by politicos. To have carried on her work under heavy editorial eyes would have gone against Abbott's spirit as a modernist who happened also to be a documentarian. Federal patronage had been good for her but only up to a point—when it began to dictate individual interpretation, the most talented artists, Abbott among them, chose to leave rather than to compromise.[44]

Beaumont Newhall called the "Changing New York" project "the greatest example of photography in the WPA." Considered as a whole body, a cumulative set not to be divided, "Changing New York" achieved what Abbott hoped it would achieve. Later in her career, she wrote, "Photography does not stand by itself in a vacuum; it is linked on the one side to manufacturers of materials and on the other side to the distributors of the product, that is, to publishers, editors, business leaders, museum directors, and to the public." "Changing New York" was not only an appropriate product of the 1930s but an extraordinary example of the substance necessary to address the nation's "cultural lag." The project celebrated what was American, yet what was regional; what was contemporary, yet what was historical; where urban dwellers had been, and at the same time where they were headed. The photographs commanded viewers to place themselves in the scenes, to examine the buildings, the doorways, the architecture, and the statuary; the picture urged them to imagine that they were standing in the scene, personally judging the interplay between past and present and past again. Abbott's pictures asked onlookers to gauge the weight of history in relation to the fleeting present, the "vanishing instant." Abbott knew that at the moment her shutter clicked, a piece of the present became the past, yet she continued to study those fragments of time and place, hoping that others could participate in a specific moment just as she had. By recognizing the power that external forces wielded over internal lives, Abbott led viewers to evaluate their own places within their shifting environ-

ments. She argued that photography should be "connected with the world we live in," and she challenged photographers to guide their senses, contending, "The eye is no better than the philosophy behind it. The photographer creates, evolves a better, more selective, more acute seeing eye by looking ever more sharply at what is going on in the world." By surveying New York with a documentary spirit, Abbott experienced firsthand the transitory nature of an American city. By photographing it, she fit a few brief moments of time and place into the larger scheme of the past, the present, and the future—the whole gamut of human experience through the eyes of an American modernist.[45]

Conclusion

It is the spirit of his approach which determines the
value of the photographer's endeavor.
—Elizabeth McCausland

BERENICE ABBOTT'S CONFIDANTE, the art critic Elizabeth
McCausland, wrote in 1939 that documentary photography's rapid
growth indicated "strong organic forces at work, strong creative
impulses seeking an outlet suitable to the serious and tense spirit
of our age." Arguing that documentary stood worlds apart from
earlier, more introspective and short-lived experimental fads in pho-
tography, McCausland characterized documentary's purpose as "the
profound and sober chronicling of the external world." That same
year, FSA Photography Section director Roy Stryker sat on a panel
addressing "Some Neglected Sources of Social History" at the
American Historical Association's annual meeting. In his presen-
tation Stryker challenged historians to embrace photographs as
evidence when constructing social history; he noted that visual
images were "the raw material from which to compound new
histories and make old ones more vivid." Stryker's entreaty re-
veals his hope that the American past could be seen and not merely
read. Having observed the nationwide yearning for pictures dur-
ing the Depression, Stryker tried to convince this rather skeptical
group of scholars to join other social scientists who had already
effectively used photographs to propel their arguments or secure
their conclusions. The motivations pushing McCausland and
Stryker to engage in discourses about documentary resemble those
of many documentarians in the 1930s, including Doris Ulmann,
Dorothea Lange, Marion Post, Margaret Bourke-White, and
Berenice Abbott. At the foundation of each woman's camera work

lay her desire to have her photographs contribute to a usable past or a practicable present that would help Americans shape a more promising future. All five women wanted their pictures to serve a purpose that would bring about social reform or cultural health or, at the very least, awareness if not implementation of these goals. And in varying degrees, each expressed visually the "serious and tense spirit" of the age in which she lived. Assuming the mantle of documentarian gave credibility to the wide-ranging interests of each photographer; in addition it assured each one that her pictures would be bought or circulated or filed temporarily, until some opportune moment for publication.[1]

The early-twentieth-century appeal of identifying "vanishing races" on the American landscape set the stage for Doris Ulmann's work. Her focus on marginal cultures in the United States, particularly in southern Appalachia, reflected the expectations of some Americans that isolated groups of rural inhabitants had been untouched by modernizing forces such as industrial development and urban growth. Like her counterparts who sought out cultural peculiarities in groups and ethnic enclaves that had experienced contact with modern America, Ulmann attempted to recreate their disappearing or already-dead worlds. She promoted the romanticization of people living in Appalachia, in religious communities, and in protected rural environments by situating them in the soft glow of pictorialism, a photographic style fashioned after nineteenth-century pastoral landscape painting. With noble intentions, Ulmann hoped to foster greater appreciation in the United States for traditional craftwork and the rural inhabitants who carried it out. Her willingness to pour a substantial amount of her own money into the Southern Highlands Handicrafts survey in order to promote the sale of handmade goods instead of mass-produced items is a testament to her ideological inclinations. Despite her old-fashioned camera equipment and a predictable style that had sitters pose for portraits, she exhibited the spirit of documentary by wanting her records to be used productively for educational purposes. Her generous donations to Berea College and to the John C. Campbell Folk School, in both photographs and money, secured her legacy as a documentarian and a supporter of innovative experiments in cultural education. Several years before the

Farm Security Administration photographers heightened American regionalism by showing southerners to New Englanders and Dust Bowl refugees to other Americans, Ulmann manipulated regional and racial stereotypes by celebrating differences among distinctive groups of people. That rural inhabitants captured so much of her attention shows her active participation in the popular debates that pitted modern urban life against an imagined bucolic agrarian existence.

Dorothea Lange built her reputation portraying the perseverance of human dignity in debilitating circumstances. She developed this posture early in her life when her own challenging environment toughened her reserve; as a result she fashioned and applied a fail-safe formula for enhancing her subjects' lives by casting them as American heroes. Her camera angles on individuals ennobled them, fostering an illusion of optimism and steadfastness. Combined with the enduring American theme that equated freedom to move with potential success, Lange's negatives emit a widespread sense of hope despite the grim realities of the Great Depression. The subjects in her photographs stand as pioneers and adventurers, often worn down but certainly not worn out. Her visual messages read like nineteenth-century diary pages full of struggle and persistence in the fight against nature's forces. Like Ulmann, Lange undertook photographic assignments in remote areas, often under primitive conditions. But in the starkest cabins and the driest fields, the two photographers created invisible portrait studios where the focus remained centered on the uniqueness of an individual. Lange, who was devoted to the contemporary trend of matching images with word texts, underpinned her visual messages with verbatim accounts of conversations and responses offered by her subjects while they were being photographed. Building upon the work of her husband, economist Paul Taylor, her pictures stood as mutual supports for the statistical tables, graphs, and other weighty evidence that he offered in their collaborative efforts.

Marion Post, born a generation after Ulmann and Lange, prepared fresh, revisionist messages through her efforts to reveal the potential of group power—that inspired by the family, the community, and the masses. Having picked up her first camera in the midst of National Socialist hysteria in Austria, she shaped her

vision through the lens beside workers and students who demonstrated in the streets against encroaching fascist forces. Further experiences in leftist movements in the United States helped mark her documentary efforts with subtle reminders of social inequities that pervaded the nation. Her attempts to rebalance the scales meant that her employer, the U.S. Government, kept many of her more suggestive photographs in a file drawer, safe from the public eye. Her countless scenes of cooperative spirit in the midst of economic depression clearly indicate a departure from both Ulmann's and Lange's deliberations on individual attempts to recoil from hardship. Post's messages focus much more on human relationships than on the lone individual. Stylistically, her images evoke a sense of busyness; the smallest elements of everyday living, from spoons and clocks to tattered hats and shiny shoes to casual conversations, fill her frames to the edges. The historical record according to Post was full of the mundane details that made up daily existence. Through her use of the mundane, the spillage of minutiae over the four edges of a photograph, Post's images hint at a modernist aesthetic. In many of her photographs, she suggests that she has captured or created only a fraction of a part of a scene. From the time she joined the FSA in 1938, a period of transition for the agency, she was able to experiment stylistically. Roy Stryker was so desperate at that point to have his photographers survey as many areas of the country as possible that Post enjoyed almost unlimited freedom to shoot. The sheer quantity of negatives marked with her name bears this out. Post made an initial attempt to imitate Lange's fieldwork approach but abandoned it after completing her first assignment. Pictures in succeeding assignments show that she favored a more participatory role for herself than Lange had claimed. This manifests itself most clearly in scenes where Post engages her subjects in conversation, and they speak to her in the camera images. As in her earliest experiences using photography in Austria, Post developed scenes where she herself became part of the group under examination, as a player in a political or social drama. Just as her counterpart Berenice Abbott required viewers to place themselves in scenes, where they examined construction processes or building facades, Post created an atmosphere where viewers entered the sites of her images, sometimes as voyeurs but more often as full participants.

Margaret Bourke-White attracted a large viewership with her innovative looks at industry and mechanization. Having considered herself a scientist from an early age, she reveled in visually deconstructing engines, electrical processes, and automated systems down to their tiniest components. She embraced the latest technologies, contributing her talents to the business world and the realm of profit, while the country struggled to survive economic devastation. Enamored with machine-age design elements, such as streamlined curves and light, clean, unfettered surfaces, Bourke-White arranged and isolated industrial components that exuded characteristic clarity and precision, the apparent fruits of assembly-line production. Inanimate objects so forcefully dominated her early work that people, if they had a place in her photographs at all, were peripheral, used most often to gauge the power and scale of industry. When Bourke-White chose to focus upon people in the South in her collaborative efforts with Erskine Caldwell, the results revealed a quality of brutishness pervasive and inescapable in poor Americans' lives. Bourke-White's application of her modernist sensibilities to human beings yielded disturbing depictions of magnified and distorted elements in their daily existence. Such realism, combined with the photographer's popular byline, guaranteed her images wide exposure in the 1930s. The success of her book *You Have Seen Their Faces* prompted other writer-photographer teams to pursue similar projects. In some cases these endeavors were undertaken to correct Bourke-White's sensationalism as much as anything else. That she provoked such action further enhances her reputation as a shaper of documentary expression in the 1930s.

Fascinated by shifting urban landscapes, Berenice Abbott roamed the streets of New York City in the 1930s, where she sought out evidence of the fleeting moments she called "the now." The myriad facets of a vibrant external world were her primary material. After determining that the clearest signals of cultural change could be found in juxtapositions of the historic with the contemporary, she focused on the processes of skyscraper construction and building demolition, in addition to the constant transformations inside storefront windows and along busy streets and sidewalks. Picturing the fragmentary and peripheral signs of human experience, such as clothesline laundry and daily advertisements,

Abbott created a visual framework that was indisputably modern. Virtually free of the overt distortions that characterized European modernists' views of humanity, Abbott brought her own way of seeing in line with the popular documentary impulse in the United States. In so doing, she managed to produce a comfortable marriage of modernism and documentary that addressed contemporary concern over "cultural lag" in the United States. Her images helped close the gap between fast-paced technological advances and the existing social fabric. Abbott's scenes of a Lower East Side chicken seller in his daily routine or of tenement laundry lines set against new high-rise apartment buildings sent reassuring messages about American cultural identity, especially when compared with Bourke-White's pictures of diseased sharecroppers and shackled black men, which promoted general uneasiness about what constituted Americanness in the 1930s.

Although they stood at opposite ends of the documentary spectrum in terms of aesthetic philosophy and stylistic production—and as a result are situated at opposite ends of this study—Ulmann and Abbott shared a desire to capture distinctive entities before they disappeared from the American scene. Their respective attempts to preserve specific faces and particular moments were exercises in historical preservation, as much as were the endeavors of the WPA workers who interviewed ex-slaves or gathered folktales. Ulmann achieved her goals by arresting time; consciously removing any elements within the scope of her lens that would date her images, she cast her characters in personal dramas that transcended specific dates. Abbott's continuous efforts to capture passing moments meant that she produced a piece of the past as soon as her shutter clicked. The resulting documentary images themselves became pieces of history, elements in the passage of time. Compared to Abbott's views, Ulmann's scenes appear decades older, even though both photographers' projects were conducted within a twelve-year period. The varieties and levels of experimentation displayed in their work as well as in that of Lange, Post, and Bourke-White, attest to the rich complexity of the documentary genre in the 1920s and 1930s.

All five photographers created powerful representations of pervasive, penetrating ideologies circulating in the two decades between the world wars. In the last twenty years, scholarship on

photography has been heavily informed by postmodern theories that posit images as representations, entities dependent entirely upon their contexts.[2] The photographers in this study recognized the role of context and realized that the uses of their pictures would far outweigh the pictures themselves. Perhaps this is why their work and their ideas about photography seem so fresh over half a century later. Certainly another reason is that the photographers' lives and experiences figure as important texts as well. Their stories as women command attention. At a 1995 conference session, Gerda Lerner urged historians of women to strike a balance between theory and narrative. She reminded her listeners that the past is full of real women whose stories require telling and retelling. This study seeks to strike such a balance by integrating ideas about visual representation with the experiences of several women who were largely responsible for shaping the field of documentary photography. Ideally their stories will become as familiar as traditional historical narratives, so deeply internalized that we naturally see "a vision of U.S. history as women's history as much as it is men's history."

Notes

The names of manuscript and photograph collections are abbreviated as shown in the bibliography.

Introduction

1. Bourke-White, typescript draft for "Popular Photography," Sept. 1939, MBW.

2. In 1922 Walter Lippmann had stated emphatically, "Photographs have the kind of authority over imagination to-day which the printed word had yesterday, and the spoken word before that. They seem utterly real" (quoted in Orvell, *The Real Thing*, 151). In the 1930s, when the camera was thought to be able to "support" and "prove" various contentions, a "picture hunger" swept the United States, argues David P. Peeler in *Hope among Us Yet*, 75–76.

3. Remarks by Houk in Edwynn Houk Gallery, "Vintage Photographs by Women," n.p. The glaring omissions in particular works are discussed by Naomi Rosenblum in the introduction to her *History of Women Photographers*, 7–9. The scholarship gap on women photographers has begun to close; the most notable new work in the field is Davidov, *Women's Camera Work*. Kerber, Kessler-Harris, and Sklar, *U.S. History as Women's History*, 14.

4. Most helpful for their exposition of the diverse ways in which the role of gender may be examined are the essays in Alpern et al., *The Challenge of Feminist Biography*. Myra Albert Wiggins, quoted in Davie, "Women in Photography," 138. Beloff, *Camera Culture*, 61. Glazer and Slater, *Unequal Sisters*; Anne Noggle's introductory remarks in Mann and Noggle, *Women of Photography*, n.p.; Gover, *The Positive Image*; and Mary Abrams, "Women Photographers," *Graduate Woman* 25 (Sept.–Oct. 1981), 22, 24.

5. Paul Katz, introduction to Edwynn Houk Gallery, "Vintage Photographs by Women," n.p.

6. A note on use of names: recognizing that a woman's choice of name and/or title (e.g., Mrs., Miss, etc.) reflects her sense of identity, I have given these careful consideration in the text. I have noted where and when these professional photographers chose to change or alter their names. For example, Marion Post did not marry Lee Wolcott until near the end of her stint as a documentary photographer for the U.S. Government, so throughout most of the text, she is referred to as Marion Post;

at the point where she legally assumes the name Marion Post Wolcott,
I begin referring to her that way.

7. Orvell, *The Real Thing*, in which he comments, "In some ways
the modernist sensibility . . . with its commitment to photography as an
art form, albeit a uniquely modern one, was at odds with the documen-
tary mode" (228).

8. Borchert, "Historical Photo-Analysis," 36. Schlereth, "Mirrors of
the Past: Historical Photography and American History," in Schlereth,
Artifacts and the American Past, 46. Peeler, *Hope among Us Yet,* 7.

9. Singal, *The War Within,* xiii; Sekula, "Invention of Photographic
Meaning," 37. Beloff, *Camera Culture, 75.*

1. Doris Ulmann's Vision of an Ideal America

1. Doris Ulmann to Allen Eaton, 9 July 1934, JJN.

2. Crunden, *Ministers of Reform,* 3–38.

3. Seixas, "Lewis Hine," 381–82; Hine, "Charity on a Business Ba-
sis"; Hine,"What Bad Housing Means to Pittsburgh"; Hine, "Toilers of
the Tenements." This represents a fraction of Hine's work in those years.
A substantial Hine bibliography may be found in Rosenblum and
Rosenblum, *America and Lewis Hine.*

4. Heilpern, "Vita"; Seigfried, "Invisible Women"; Cook, "Female
Support Networks"; and Whisnant, *All That Is Native and Fine,* esp.
chaps. 1 and 2.

5. Warren, "Photographer-in-Waiting," 142; on White's influence upon
his women students, see Davidov, *Women's Camera Work,* 90-94.

6. Ulmann, *Darkness and the Light,* 8–9; Warren, "Photographer-
in-Waiting," 142; I owe a great debt to Ulmann biographer Philip W.
Jacobs for describing to me Ulmann's various illnesses and physical prob-
lems.

7. A fine discussion on the relationship between pictorialism and
Photo-Secession may be found in Rosenblum, *History of Women Pho-
tographers,* 95–99; Jussim, "'Tyranny of the Pictorial,'" in which Jussim
notes, "Muckraking journalism was firmly established in the very year—
1902—that Alfred Stieglitz . . . was planning the first issue of *Camera
Work.*" (54) See also Trachtenberg, *Reading American Photographs,* where
he notes that Stieglitz was "more attached to aesthetic, individualistic
alternatives than to social or political solutions" (167).

8. Seixas, "Lewis Hine," 386–89.

9. Boxes 1, 2, DU-NY.

10. Box 2, DU-NY; Sarah Greenough, "How Stieglitz Came to Pho-
tograph Clouds," 151–65. Stieglitz altered his style as the popularity of
tonalism faded, abandoning the characteristic blurred image for sharper,
more geometrical features. See Trachtenberg, *Reading American Photo-
graphs,* 180–84; and Orvell, *The Real Thing,* 198–220.

11. Lovejoy, "Photography of Doris Ulmann"; David Featherstone

declares Ulmann an "ethnographer" in *Doris Ulmann*, 31–35; Ulmann to Warren, in Warren, "Photographer-in-Waiting," 144.

12. Signed, dated prints of Ulmann's early work may be found in DU-NY, DU-OR, and DU-UK. Since Ulmann preferred to sign her prints in pencil rather than ink, the alteration process was rather simple. It is apparent that she re-signed earlier photographs after her final break with Jaeger.

13. Henry Necarsulmer to William J. Hutchins, 10 July 1935, DU-BC, emphasis mine. The discrepancy is revealed in two features on Ulmann's photography that appeared in *Theatre Arts Monthly*, one in 1930, the other in 1934; the former referred to her as "Miss Ulmann," the latter as "Mrs. Ulmann." For her family's reactions to her traveling companion, the Kentucky folk singer-actor John Jacob Niles, see the heated correspondence in DU-BC; see also "Notes by Doris Ulmann concerning Her Will," an odd dictation to Niles in the days immediately preceding her death, where Ulmann asks that her reputation and her sister's peace of mind not be dragged "into an unfortunate & undignified position" after she dies (box 51, JJN).

14. Books 61, 62, DU-OR.

15. Photographer Laura Gilpin remembered "a quiet Doris Ulmann who sat in on a [Clarence White] class she herself was attending" (quoted in Ulmann, *Darkness and the Light*, 8–9); see also Allen H. Eaton's description of Ulmann in Eaton, "Doris Ulmann Photograph Collection," 10. The quotations in the text are from Warren, "Photographer-in-Waiting," 142, 144.

16. For her breadth in studying writers, see books 21, 61, 64, 70b, 71b, 73, 74, 75, 78, 79, DU-OR; Ulmann quoted in Warren, "Photographer-in-Waiting," 139; Jargon Society, *Appalachian Photographs of Doris Ulmann*, n.p.; Stein quoted in Hoffmann, *The Twenties*, 220.

17. Warren, "Photographer-in-Waiting," 131.

18. Philip W. Jacobs, "Doris Ulmann's Search for Meaning," Ulmann Symposium, Gibbes Museum of Art, Charleston, S.C., 8 Nov. 1997; Warren, "Photographer-in-Waiting," 136.

19. Anderson's disillusionment with an industrialized society is best evident in his novels *Winesburg, Ohio* (1919) and *Perhaps Women* (1931); *Call Number* 19 (spring 1958). The quotation is in Warren, "Photographer-in-Waiting," 142.

20. Ulmann to John Bennett, 12 Oct. [?], JB.

21. Campbell, "Doris Ulmann," 11; selected prints in DU-OR, DU-UK, and DU-UKA.

22. The complications of Ulmann's private life are revealed in Williams, *Devil and a Good Woman*, 232-36.

23. Ulmann, preface to *Portrait Gallery of American Editors*, v.

24. Warren, "Photographer-in-Waiting," 131; Ulmann, preface to *Portrait Gallery of American Editors*, v.

25. DU-OR, DU-UK, and DU-BCP.

26. John Jacob Niles in Jargon Society, *Appalachian Photographs of Doris Ulmann*, n.p. The size of the Ulmann entourage is described in Bill Murphy to H.E. Taylor, 11 April 1934, DU-BC. Murphy, of Boone Tavern, Berea, Kentucky, expresses fear that the large group will tie up too many rooms at the local hotel during "commencement time" at Berea College.

27. Niles to W.J. Hutchins, 14 Sept. 1934, DU-BC; Campbell quoted in Whisnant, *All That Is Native and Fine,* 137.

28. A perfect example of Ulmann's place could be seen in the National Portrait Gallery's 1994 exhibit entitled "Art and the Camera, 1900–1940," where her work was more widely represented than that of any other photographer. Alongside her seven images were photographs by Clarence White, Alfred Stieglitz, Edward Curtis, Edward Weston, Julia Margaret Cameron, and other famous camera artists.

29. A compelling discussion of these early-twentieth-century reformers or "culture workers" may be found in Whisnant, *All That Is Native and Fine;* a fine set of primary source materials is Stoddart, *The Quare Women's Journals;* Ulmann to Allen Eaton, 25 Aug. 1933, JJN; Niles to William J. Hutchins, 16 Aug. 1933, DU-BC; the quotation is in Eaton, "Doris Ulmann Photograph Collection," 10.

30. See Lewis Hine, "Social Photography," reprinted in Trachtenberg, *Classic Essays on Photography;* Peeler, *Hope among Us Yet;* Stott, *Documentary Expression;* Fleischhauer and Brannan, *Documenting America.* For opinions from Farm Security Administration photographers on what their intentions were, see the interviews in Amarillo Art Center, *American Images.*

31. Featherstone, *Doris Ulmann,* 19; Warren, "Photographer-in-Waiting," 142; Williams quoted in Jargon Society, *Appalachian Photographs of Doris Ulmann,* n.p.; Stott, "What Documentary Treats," in Stott, *Documentary Expression,* 62 (page references are to the 1986 edition); Guimond, *American Photography,* 4.

32. Shipman, introduction to Ulmann, *Portrait Gallery of American Editors,* 1. Shipman referred to Ulmann's "gallant survivors" in a publishing world that had shifted to cover the "right shade of lip-stick . . . the merits of a cigarette or the cut of a dinner-jacket" (1); Among the scores of contemporary critiques commenting on the effects of mass culture on the nation's distinct regions was an essay entitled "A Mirror for Artists," in Twelve Southerners, *I'll Take My Stand.*

33. One of the best photographs of Ulmann standing next to her camera accompanied Olive D. Campbell's recollections of the photographer in "Doris Ulmann"; Allen Eaton interview, conducted July 1959, partial transcript, DU-BC; Jargon Society, *Appalachian Photographs of Doris Ulmann,* n.p.; Niles, "Doris Ulmann," 7.

34. Because Ulmann treated time in such a fashion, she produced hundreds of photographs that scholars have been unable to date definitively. A range of dates may be placed on particular subject matter be-

cause we know the months and years she took certain trips to specific places. However, a substantial number of the Appalachian elders remain anonymous, mere examples of a "type" that Ulmann was seeking to capture. Many of the subjects Ulmann photographed before 1931 remain unidentified and were marked accordingly in the proof books (DU-OR) after Ulmann's death. But unless Ulmann herself signed and dated her prints, doubt remains. Niles's field notebooks are somewhat helpful, as are Ulmann's occasional references to particular subjects in her letters (JJN; JJN-BC). She and Niles kept more thorough written records on the journeys they took together a few years later, especially in the summers of 1933 and 1934.

35. Niles, "Doris Ulmann," 7; Enos Hardin study (book 45), Paul Robeson study (book 72), Thornton Wilder study (book 78), DU-OR. Of the portrait session with Wilder, Ulmann recalled he was so enthusiastic that he canceled all his morning appointments and then said to her, "We might go on all the afternoon if you have nothing else to do" (quoted in Warren, "Photographer-in-Waiting," 132, 142).

36. Book 12, DU-OR. Throughout the chapter the word *series* refers to photographs made of the same subject or person in a single sitting.

37. Warren, "Photographer-in-Waiting," 139; Jonathan Williams, in Jargon Society, *Appalachian Photographs of Doris Ulmann*, n.p.

38. Conkin, *The Southern Agrarians*, 86–87; Singal, *The War Within*, 198. On the characterizations of Tennesseans and southerners in general, see Hobson, *Serpent in Eden*, 11–32, 147, 184 (page references are to the 1978 edition). The critic is quoted in Ulmann, "The Stuff of American Drama," 132.

39. Many Ulmann critics and interpreters have referred to the "types" she photographed. Although Ulmann initially sought out particular groups, she focused almost entirely on individuals. See Featherstone, *Doris Ulmann*; Niles, "Doris Ulmann," 5.

40. "The Mountain Breed," *New York Times*, 2 June 1928, 16, col. 6; Ulmann, "The Stuff of American Drama," 141.

41. Eaton interview, July 1959, DU-BC; Loyal Jones, interviews with Ulmann subjects, discussed in Banes, "Ulmann and Her Mountain Folk," 41–42; William J. Hutchins to John Jacob Niles, 1 Sept. 1934, DU-BC; Campbell, "Doris Ulmann," 11. Sarah Blanding, dean of women at the University of Kentucky, said after Ulmann's death, "The remembrance of her is like a Past bright ray of autumn sunshine—warm and glorious and meaning more than all the other myriad of rays of the preceding months" (undated letter, Sarah Gibson Blanding to John Jacob Niles, box 51, JJN).

42. Niles once wrote, "We would pull up in front of someone's house right beside a very nicely paved road, take out the camera, set it up, and I would say, 'Folks, we have come to take your picture,' and they would line up in a row and that was all there was to it" ("Doris Ulmann," 7). Niles's flippant recollection disregards all of the groundwork laid for

their arrival at certain locations; in addition, it deflates Ulmann's deliberations as an artist, ignoring the overwhelming character of her Appalachian portraiture.

43. Books 7, 15, DU-OR.

44. Ulmann quoted in Warren, "Photographer-in-Waiting," 139; books 9, 14, DU-OR; DU-BCP; Niles, "Doris Ulmann," 5.

45. Niles, "Doris Ulmann," 4–5; DU-BCP; Ulmann, "The Stuff of American Drama," 132; Fass, *The Damned and the Beautiful*; Hoffman, *The Twenties*, 110.

46. Books 12, 52, DU-OR; DU-BCP.

47. Singal, *The War Within*, 202–7.

48. Davidson, "Julia Peterkin"; Peterkin quoted in "Calhoun Times," 1927, untitled typescript of a newspaper article, JP; Davidson, "Peterkin"; at her death the *Charleston News and Courier* ran an obituary featuring a portrait of Peterkin that bore the caption "Understood Negro" (12 Aug. 1961).

49. Ulmann to Averell Broughton, 4 Oct. 1929, quoted in Featherstone, *Doris Ulmann*, 43; "Current Exhibition News in Brief," *New York Times*, 3 Nov. 1929, sec. 9, p. 12. Evidence of the burgeoning interest in rural African American communities may be gleaned from the popular dramas written in the 1920s and early 1930s by Paul Green, Eugene O'Neill, and DuBose Heyward. On Ulmann's connection to this kind of theater, see Brown and Sundell, "Stylizing the Folk," 335–46.

50. Henry Necarsulmer, Ulmann's brother-in-law and one of her three living relatives, wrote of the friendship to Roger Howson, 17 Oct. 1936, DU-BC. The intensity of the Ulmann-Peterkin relationship is wonderfully described by Williams in *Devil and a Good Woman*, 153–54, 232–34.

51. Ulmann, *Roll, Jordan, Roll*. The hand-pulling process is described in Greenough et al., *The Art of Fixing a Shadow*, 504; White quoted by Coles, in Ulmann, *Darkness and the Light*, 82; DU-NY; DU-SC.

52. On the failure, see "The Movement" in Conkin, *The Southern Agrarians*, 89–126.

53. Clift, in Ulmann, *Darkness and the Light*, 10; The Melungeon woman's portrait was first published in a 1929 issue of *Pictorial Photographers in America*. Interest in this group may be seen in Kennedy, *The Melungeons*. Both the "Turk" and the "Cracker" were featured in Ulmann, "The Stuff of American Drama," 135, 139. Ulmann did not label the photograph "Turk" (DU-UK).

54. Peterkin, *Bright Skin*, 22–23, 31, 94, emphasis mine. Two of the best builders on the earlier theme of belonging were Nella Larsen, *Quicksand* (1928) and *Passing* (1929) and Anzia Yezierska, *Breadgivers* (1925). Into the 1930s, those employed in the public arts projects made regional ties and sense of place a key element in their artistic productions.

55. Megraw, "'The Grandest Picture.'"

56. Ulmann had photographed African Americans since her earliest years as a photographer (e.g., her study of New York City laborers in 1917). In 1924 she submitted a portrait of a black man for the Kodak Park Camera Club's Fourth Annual Exhibition. Ulmann's Deep South tours allowed her to build on her already-substantial collection of African American portraits.

57. Books 43, 50, 67, 72, DU-OR; Ulmann's promise to complete future work in Louisiana was made in "The Stuff of American Drama," 141.

58. Eaton, *Handicrafts*, (1973 ed.) v; Eaton, "Doris Ulmann Photograph Collection," 10; Stieglitz, "Pictorial Photography," 117; Ulmann quoted in Eaton, "The Doris Ulmann Photographs," in Eaton, *Handicrafts*, 17; Rayna Green, introduction to the 1973 edition of Eaton, *Handicrafts*, xiv; see also Tanno, "Urban Eye on Appalachia," 30; and Featherstone, *Doris Ulmann*, 50–52.

59. Orvell, *The Real Thing*, 181; Eaton, *Handicrafts*, 249; Knoxville Museum of Art, "Patchwork Souvenirs of the 1933 Chicago World's Fair" Exhibition, curated by Merikay Waldvogel and Barbara Brackman, Traveling Exhibition, 1994–96. The process of "traditionalizing" mountain handicrafts was necessary in order to increase their marketability, argues Jane Becker in *Selling Tradition*.

60. Featherstone, *Doris Ulmann*, 55; Observation by Niles, "Doris Ulmann," 5; Ulmann to Eaton, 25 Aug. 1933, JJN, where Ulmann goes on to speculate about the kind of work Hardin could accomplish "if his wife were a different woman."

61. DU-BCP; Ulmann to Eaton, 25 Aug. 1933, JJN.

62. DU-OR.

63. Davidov discusses White's theories in *Women's Camera Work*, 91-92.

64. Thornton, "New Look at Pictorialism." Thornton says that Ulmann "persisted in her fondness for outmoded Pictorial effects."

65. Niles, "Doris Ulmann," 7; Thornton, "New Look at Pictorialism"; see also Featherstone, *Doris Ulmann*, 17, 58–60.

66. Eaton, *Handicrafts*, 74, 258; Niles to Eaton, 5 June 1934, JJN, in which he notes that the granddaughters were wearing "Aunt Sallies cloths [*sic*]"; David Whisnant, lecture at National Endowment for the Humanities Institute, "The Thirties in Interdisciplinary Perspective," University of North Carolina, Chapel Hill, July 1995, in which he used the Wilma Creech portrait as an example of Ulmann's manipulations in the field, since Creech was a university student. On Creech's role in creating an idealized ancestral past, see Becker, *Selling Tradition*.

67. Articles of incorporation quoted in Whisnant, *All That Is Native and Fine*, 139; Jan Davidson, "The People of Doris Ulmann's North Carolina Photographs," Ulmann Symposium, Gibbes Museum of Art, Charleston, S.C., 8 Nov. 1997; Davidson pointed out that there were 147 pledges made by Brasstown residents to support the project; Ulmann

to Eaton, 24 July 1933, 26 June 1934, JJN; typescript of Niles's field notebook page, 31 July 1934, JJN.

68. Berea College, *Bulletin*, 11–12; Ulmann to Hutchins, April 1930, DU-BC; Hutchins to Ulmann, 28 March 1930, DU-BC; Eaton to Hutchins, 21 July 1930, DU-BC; Niles to Hutchins, 16 Aug. 1933, 20 Sept. 1933, Oct. 1933, DU-BC. The ellipsis points are Niles's; he creatively used his own punctuation system.

69. Ulmann to President and Mrs. Hutchins, 3 Nov. 1933, DU-BC; Ulmann to Hutchins, 4 Jan. [1934], DU-BC; Ulmann to Mrs. A.N. Gould [Berea College Art Department], 20 Nov. 1933, DU-BC.

70. Ulmann to President and Mrs. Hutchins, 3 Nov. 1933, DU-BC; Hutchins to Niles, 30 Oct. 1933, DU-BC in which Hutchins speaks of the kind gesture (the returned check); Ulmann to Mrs. A.N. Gould, 20 Nov. 1933, DU-BC; Ulmann to President and Mrs. Hutchins, 3 Nov. 1933, DU-BC.

71. Niles to Hutchins, 20 Sept. 1933, DU-BC, in which he noted the results of their summer's work: "She has about 1100 plates and I have three note books full of various sentimentalia." In Jargon Society, *Appalachian Photographs of Doris Ulmann,* Niles recalls accompanying Ulmann to numerous events, including "the best of the current New York plays"; Niles, "Doris Ulmann," 4.

72. Niles to Hutchins, 16 Aug. 1933, DU-BC, in which he notes that the dictionary will explain "the origins of our strange woods"; DU-BCP; DU-OR, where an entire series features Niles with various types of dulcimers; Eaton, *Handicrafts,* 138; When the Ulmann print collection was mounted into scrapbooks (DU-OR), Niles labeled many of the photographs, identifying numerous people from the trips to Kentucky, Tennessee, and North Carolina. Cross-references may be found in his own *Ballad Book*.

73. DU-G; DU-OR; DU-UK.

74. Niles to Hutchins, 11 March 1934, DU-BC; Leicester B. Holland to Niles, 11 April 1934, JJN; Ulmann to Eaton, 8 May 1934, 24 May 1934, 6 May 1934, JJN.

75. Ulmann to Eaton, 24 April 1934, 1 July 1934 (emphasis mine), 6 May 1934, 26 June 1934, JJN.

76. Hutchins to Ulmann, 2 May 1934, DU-BC; since Ulmann had already arrived in Berea, Hutchins directed his request to Boone Tavern, where the photographer was lodging; Niles to Eaton, 5 June 1934, JJN, in which he notes that Ulmann's work in the kitchen operations, including the candy kitchen, was shot on 18 May 1934; photographic series, DU-OR.

77. Photographs by FAP photographers, New York City Photography Unit, Still Picture Branch, National Archives, Washington, D.C.; Daniel et al., *Official Images;* Davidov, *Women's Camera Work,* 157-61, 165-67; Guimond, *American Photography,* 37; Berea College series, DU-OR, DU-BCP.

78. Ulmann to Eaton, 9 July 1934, JJN; Stryker correspondence, RESP, FSAWR.

79. Ulmann to Eaton, 24 April 1934, 1 July 1934 (in which Ulmann mentions those centers Campbell suggested she omit, including Hot Springs, Crossmore, Higgins, Penland, and Tallulah Falls), 26 June 1934, 22 July 1934, 9 July 1934 (where Ulmann claimed to value Campbell's judgment "more than anybody's, as she does not allow any prejudice to influence her decisions"), JJN.

80. Ulmann to Eaton, 22 July 1934, JJN

81. The last portraits Ulmann composed were of the Hipps family, who lived just south of Asheville; Niles's notebook, JJN-BC; here he points out that "these pictures represent the last work in Doris Ulmann's life." He made photograph notations that correspond to prints in DU-BCP. Niles's *Ballad Book* mentions dates of various visits, revealing that their 1934 summer travel schedule was extremely rigorous.

82. Deed of trust, will and bequest of Doris Ulmann, ser. 2, DU-BC; Clift notes that "her intent was to show the wealth of individual character belonging to her subjects and how they had come to possess it" (in Ulmann, *Darkness and the Light*, 9).

83. Susman, "The Culture of the Thirties," in Susman, *Culture as History*, 150–83; Deed of trust, will and bequest of Doris Ulmann, DU-BC. Correspondence from August 1936 reveals that President Hutchins was quite helpful in locating people and having prints made for the subjects and their relatives, DU-BC; Ulmann quoted in Warren, "Photographer-in-Waiting," 142.

84. Eaton interview, DU-BC; Jones quoted in Warren, *A Right Good People*, 12, 9; Hawthorne, *Photographs by Paul Buchanan*. Hawthorne states that Ulmann made her Appalachian subjects "icons," romanticized subjects from an earlier era.

85. Twenty-five years after her death, the body of Ulmann's work was transferred from Columbia University to the University of Oregon for preservation. Allen Eaton, who directed the move, sought to eliminate the tremendous cost of transporting thousands of glass plates across the country. He assumed the responsibility of choosing representative photographs, perused each portrait series and broke the "unnecessary" plates, leaving only one or two poses of each individual. The complex studies Ulmann composed of Berea College's bakery operations, of the Mount Lebanon Shaker settlement, of Virginia Howard and John Jacob Niles, and thousands of other subjects, were suddenly altered by the destruction of original plates. The surviving plates of various individuals limit their reproduction to a one-dimensional sight on Ulmann's part, far removed from the actual artistic philosophy she developed and exercised; Hutchins to Niles, 1 Sept. 1934, DU-BC; Ulmann to Eaton, 8 June 1934, JJN; Ulmann, "Stuff of American Drama," 132.

2. Dorothea Lange's Depiction
of American Individualism

1. Dorothea Lange, interviews conducted for the soundtrack of the National Education Television film on Dorothea Lange, undated, unedited transcripts, transcribed by Meg Partridge, OM-ART; Dorothea Lange, "Dorothea Lange: The Making of a Documentary Photographer," interviews by Suzanne Riess, Oct. 1960–Aug. 1961, transcript, p. 1, UC-OHC.

2. NET soundtrack interviews, 136; Lange quotations from Lange-Riess interviews, 11, 5–6.

3. NET soundtrack interviews, 137; For examples of different avenues in which women exerted their independence, see Cook, "Female Support Networks"; Cott, *The Grounding of Modern Feminism;* Jones, *Heretics and Hellraisers,* esp. chap. 1, entitled "Women Are People," 1–27; and Sklar, *Florence Kelley.*

4. Meltzer, *Dorothea Lange,* 8; Stein, "Peculiar Grace," 58–59; Lange quotations from Lange-Riess interviews, 13.

5. Paul Schuster Taylor, interview by Suzanne Riess, 1970, transcript, UC-OHC; see also Van Dyke, "Lange—A Critical Analysis"; Banta, *Imaging American Women.* Among the influential promoters of ideal womanhood was artist Howard Chandler Christy, whose *Liberty Belles* (1912) featured active, nubile American beauties. In addition, the female nude as a ripe and fertile being was becoming more popular in photography, as can be seen in the work of Clarence White, Alfred Stieglitz, and their students. Lange-Riess interviews, 16.

6. Ohrn, *Lange and the Documentary Tradition,* 3; Lange-Riess interviews, 26; Lange, *Dorothea Lange,* 105; on her work with Genthe, see Lange-Riess interviews, 27–31.

7. Herz, "Lange in Perspective," 10; Lange-Riess interviews, 60–61; Stein, "Peculiar Grace," 63.

8. Ohrn, *Lange and the Documentary Tradition,* 4–6.

9 Lange-Riess interviews, 39; quoted in Herz, "Lange in Perspective," 10.

10. Lange-Riess interviews, 42; quoted in Herz, "Lange in Perspective," 11; Dorothea Lange, interview by Richard K. Doud, 22 May 1964, transcript, AAA; Conway, "Convention versus Self-Revelation"; Heilbrun, *Writing a Woman's Life,* 24–25.

11. Minick's remarks in Heyman, *Celebrating a Collection,* 9; Lange-Riess interviews, 89.

12. Roger Sturtevant, interview by Therese Heyman, Feb. 1977, transcript, DL, 7; Lange-Riess interviews, 89–90; Sturtevant interview, DL, 5, in which he claimed that the group "didn't have any ism's," unlike the avant-garde photographers living on the East coast. He said that the tension between Lange and Ansel Adams was largely due to the fact that Adams clung to a rigid political agenda. Lange believed this distracted one from creating honest pictures.

13. Lange-Riess interviews, 118–19; list entitled "Family Photographs, 1920s & 1930s," in contact sheets, vol. 1, DL. The typewritten list includes eight pages of family names who were Lange subjects during her studio years. Among those she served for a number of years were the Clayburgh family, the Shainwald family, and the Katten family.

14. Conrat quoted in Heyman, *Celebrating a Collection,* 53.

15. Lange kept well-organized records of her portrait jobs. One cost that she frequently figured in was "transportation to the site," which suggests a good deal of work outside the studio. See contact sheets, vols. 1–18 (1920–34), vol. 11: "Studio," DL; Dixon, "Dorothea Lange," 75.

16. Willard Van Dyke, interview by Therese Heyman, May 1977, transcript, DL; Van Dyke, remembering Lange's seriousness, mentioned that she constantly centered her conversation around grand themes and visions, so much that it often became "irritating" in social situations; Lange-Reiss interviews, 97.

17. Peeler, *Hope among Us Yet,* 61; Cowan, "Two Washes in the Morning," where Cowan argues that the "problem that has no name," identified by Betty Friedan in the 1950s, had its roots in the 1920s; NET soundtrack interviews, 252–53; Lange-Riess interviews, passim.

18. Weber series, vol. 3: "Studio," DL; Lange-Doud interview, 4.

19. Lange-Riess interviews, 92; Dixon, "Dorothea Lange," 71–72, in which Lange noted that she later felt that she was mistaken to have attempted a timeless quality and that photographs need to be "dated."

20. NET soundtrack interviews, 87.

21. Lange-Riess interviews, 59; Negative catalogues, vol. 2, DL; Lange quoted in Goldsmith, "Harvest of Truth," 30; Lange and Dixon, "Photographing the Familiar," 71.

22. Negative catalogues, vol. 2, DL; Van Dyke, "Lange—A Critical Analysis," 464.

23. Dixon, "Dorothea Lange," 73; on Lange's advertising, see Ohrn, *Lange and the Documentary Tradition,* 22; also Heyman, *Celebrating a Collection,* 16; Lorentz published his observation in the 1941 *U.S. Camera Annual,* here quoted in Bennett, "Dorothea Lange," 56.

24. Quoted in Herz, "Lange in Perspective," 9; Sturtevant interview, DL, 11, 24.

25. Stott, *Documentary Expression,* 28; Tucker, "Photographic Facts and Thirties America," 41–42.

26. NET soundtrack interviews, 255; Stott, *Documentary Expression,* 66; also cf. Curtis, *Mind's Eye, Mind's Truth,* preface.

27. Lange-Riess interviews, 145–47.

28. Lange-Doud interview, 5; see also Christopher Cox, introductory essay, in *Dorothea Lange,* 8.

29. For a different reading of this photograph, see Peeler, *Hope among Us Yet,* 63.

30. Herz, "Lange in Perspective," 9.

31. Sturtevant interview, DL, 11, 24; Herz, "Lange in Perspective,"

10; Lange-Riess interviews, 152.

32. Tucker, *The Woman's Eye*, 5.

33. Clark Kerr, "Paul and Dorothea," in Partridge, *A Visual Life*, 42; Peeler, *Hope among Us Yet*, 7; Stott, *Documentary Expression*, 57.

34. Lange-Riess interviews, 152; NET soundtrack interviews, 42; Van Dyke interview, DL, 14; Heyman, *Celebrating a Collection*, 52; see also Heyman interview, 12 July 1989.

35. Van Dyke, "Lange—A Critical Analysis," 467; Clark Kerr, quoted in Taylor, *On the Ground in the Thirties*, viii; see also Kerr, "Paul and Dorothea," in Partridge, *A Visual Life*, 36–43. Kerr pointed out that although Taylor was listed as an "economist," he had also studied sociology at the University of Wisconsin and had additional interests in law and public policy.

36. Van Dyke interview, DL, 11; Lange quoted in Heyman, *Celebrating a Collection*, 16.

37. NET soundtrack interviews, 75.

38. A thoughtful discussion of the words as supplementary material to photographs is Levine, "The Historian and the Icon"; Lange-Riess interviews, 204–5; Puckett, *Five Photo-Textual Documentaries*, 91; Lange-Riess interviews, 155; Van Dyke interview, DL, 3; James Curtis discusses Lange's need for public recognition as a documentarian in *Mind's Eye, Mind's Truth*, 48.

39. The nature and variety of protests from the left are discussed in Brinkley, *Voices of Protest;* Karl, *The Uneasy State*, 104–7, 146–51; and Williams, *Huey Long*. A measure of the tone of ordinary Americans may be seen in McElvaine, ed., *Down and Out in the Great Depression*.

40. Baldwin, *Poverty and Politics*, 117. For the specific purposes of the RA's Information Division, see Curtis, *Mind's Eye, Mind's Truth*, 5–20; Hurley, *Portrait of a Decade*, 36–37; cf. Stange, "Symbols of Ideal Life," 105–7.

41. The best description of Stryker's development as an educator may be found in Hurley, *Portrait of a Decade*. On the impact of Stryker's training at Columbia University in the 1920s, see Stange, "The Management of Vision," 6; see also Stange, *"Symbols of Ideal Life,"* 90–93.

42. Anderson, *Roy Stryker*, 4; Curtis, *Mind's Eye, Mind's Truth*, preface, 5–20; see also Kozol, "Madonnas of the Fields," 1.

43. Stryker, "The FSA Collection of Photographs," in Stryker and Wood, *In This Proud Land*, 7–8.

44. Stange, "The Management of Vision," 6; Lange-Riess interviews, 181; Stott, *Documentary Expression*, 57; in Doherty, "USA-FSA," 10; Heyman, *Celebrating a Collection*, 80; see also Heyman, interview by author; see Sekula, "Invention of Photographic Meaning," 45.

45. David Lange, interview by Therese Heyman, 15 Feb. 1978, transcript, DL.

46. Curtis, *Mind's Eye, Mind's Truth*, viii–ix.

47. Puckett, *Five Photo-Textual Documentaries*, 105; Elliott, "Pho-

tographs and Photographers," 97; Curtis, *Mind's Eye, Mind's Truth*, 52, 65; on "Migrant Mother," see also Davidov, *Women's Camera Work*, 3-6, 235-37.

48. NET soundtrack interviews, 40.

49. Ohrn, *Lange and the Documentary Tradition*, 75; Taylor-Riess interview, 132.

50. In *Five Photo-Textual Documentaries*, Puckett describes MacLeish's work as "a flabby poem . . . its language unequal to the photographs it accompanies" (48); Wright and Rosskam, *Twelve Million Black Voices*; Ohrn, *Lange and the Documentary Tradition*, 75; Mann, "Dorothea Lange," 101.

51. Stange, *"Symbols of Ideal Life,"* 108–9; Stryker-Lange correspondence, RESP; the letters written in 1937 are especially heated.

52. Fleischhauer and Brannan, *Documenting America*, 10; Even Stryker's complete frustration with Walker Evans for his lack of contact and his scant production while on the road did not match the continual bickering that Stryker carried on with Lange. For comparison, see Stryker-Evans correspondence, RESP.

53. Lange and Taylor, *An American Exodus*, 107; Jordy, "Four Approaches to Regionalism," 37.

54. Tocqueville, *Democracy in America*; Foner, *Free Soil, Free Labor, Free Men*; Oakes, *The Ruling Race*, 76–77; see also Cashin, *A Family Venture*; Higham, *History*, 174–79.

55. Negative catalogues, vol. 2, DL; contact Sheets, "Southwest 1920s & 1930s," DL; Lange and Taylor, *An American Exodus*, 60.

56. Lee and Post, the FSA's most productive photographers from 1938 to 1941, spent weeks at a time studying single communities and their activities. The most famous of these are Lee's "Pie Town, New Mexico" series and Post's town studies, e.g. lots 1641, 1459, 1599, FSAPP; Lange-Riess interviews, 215.

57. For a completely gendered reading of Lange's replacement by Post, see Fisher, *Let Us Now Praise Famous Women*. Fisher summarizes, "Where Lange had allegedly been the Mother, documentary attempted to cast Post Wolcott as its 'girl'" (144); Stryker to Jonathan Garst, 30 Nov. 1939, RESP.

3. Marion Post's Portrayal of Collective Strength

1. Wolcott, keynote address, presented at "Women in Photography" conference. I would like to thank Amy Doherty, conference director and George Arents Research Library archivist, for her personal copy of Wolcott's speech notes. A note on names: since Marion Post did not marry Lee Wolcott until near the end of her tenure as a documentary photographer in the 1930s, I refer to her in the text as Marion Post until the point where she legally takes on the name Marion Post Wolcott.

2. Known as the Historical Section of the Resettlement Administra-

tion when it was formed in 1935, the Photography Unit came under the newly named Farm Security Administration in 1937 and made its final move to the Office of War Information in 1942.

3. "Special Memorandum on Photography, John Fischer to All FSA Regional Information Advisers," 4 May 1938, Office Files—Field Correspondence, FSAWR, in which Fischer notes the federal agencies enlisting support of FSA photographers"; Stryker quoted in Anderson, *Roy Stryker,* 4; Trachtenberg, "From Image to Story," 58.

4. Wolcott, "Women in Photography" speech.

5. Wolcott, "Women in Photography" speech; see also Brannan, "American Women Documentary Photographers"; Hurley, *Wolcott: A Photographic Journey,* 3–7. The most thorough treatment of Nan Post's eccentricities and the Post divorce is in Hendrickson, *Looking for the Light,* 13–30.

6. Kennedy, *Birth Control in America,* 19–23; Boddy, "Photographing Women," 155; Wolcott, "Women in Photography" speech.

7. Hurley, *Wolcott: A Photographic Journey,* 7; Marion Post Wolcott File, RESC; the quotation is from Mazo, *Prime Movers,* 61; Brannan, telephone conversation with author, 19 March 1990, in which Brannan emphasized Post's leftist leanings in connection with her study at the New School and her interest in John Dewey's ideas; Boddy, "Photographing Women," 156. Post had decided just months before to pursue an education degree at NYU. For a discussion of the influence St. Denis and Humphrey had on American dance, see Shelton, *Divine Dancer.*

8. Mazo, *Prime Movers,* 118. Mazo entitled his chapter on Doris Humphrey "The Eloquence of Balance," 117–52.

9. Boddy, "Photographing Women," 156–57; Brannan, "American Women Documentary Photographers"; Hendrickson, *Looking for the Light,* 31.

10. Post Wolcott File, RESC; Wolcott, "Women in Photography" speech.

11. Hardt and Ohrn, "The Eyes of the Proletariat," 54, 53. Cf. Osman and Phillips, "European Visions," 74–103.

12. Marion Post Wolcott, interview conducted by Richard Doud, 18 Jan. 1965, Mill Valley, Calif., AAA; Boddy, "Photographing Women," 158; Wolcott, "Women in Photography" speech, where Wolcott recalled that Fleischmann had told her she had "an exceptionally good eye."

13. Lois Scharf, "Even Spinsters Need Not Apply," in Scharf, *To Work and To Wed,* 85; Post Wolcott–Doud interview.

14. Post Wolcott File, RESC; Pauly, *An American Odyssey,* 5–34; Peeler, *Hope among Us Yet,* 5, where he notes that *Waiting for Lefty* was tagged at the time "the birth cry of the thirties."

15. Boddy, "Photographing Women," 160; Post Wolcott–Doud interview; Steiner, *A Point of View,* 8, 31.

16. Steiner quoted in O'Neal, *A Vision Shared,* 174; Murray, "Marion Post Wolcott," 86; Glen, *Highlander;* and Horton, *The Highlander Folk School.* Film text quoted in Pauly, *An American Odyssey,* 43; Post's

comments about Frontier's influence on her in Wolcott, "Women in Photography" speech.

17. "Consumer Cooperatives."

18. O'Neal, *A Vision Shared*, 174; Dixon, *Photographers of the Farm Security Administration*, 161; Post Wolcott File, RESC; Story told in Wolcott, "Women in Photography" speech; Post Wolcott–Doud interview.

19. Post Wolcott–Doud interview; Post Wolcott File, RESC; Strand to Stryker, 20 June 1938, RESP; Post to Stryker, 26 June 1938, July 1938, RESP.

20. Correspondence between Stryker and Lange, Mydans, and Evans, respectively, reveals detailed information not only on Resettlement Administration objectives and work, but also on outside employment each of the three sought at one time or another (RESP). Mydans left the Historical Section in the summer of 1936; Lange tended to venture in and out, doing special assignments and projects, then returning to Stryker's team to complete her FSA shooting scripts. In a 28 Feb. 1938 letter to Stryker, Evans described the painful process of getting "the book" published, dealing with governmental bureaucracy and publishers' rejections. Evans's assignment with Agee, originally produced for *Fortune* magazine, which decided not to publish it, later appeared under the title *Let Us Now Praise Famous Men* (Houghton Mifflin, 1941); Post Wolcott File, RESC.

21. Stryker to Post, 14 July 1938, RESP.

22. Post Wolcott–Doud interview; Amarillo Art Center, *American Images*. The program, which later aired on PBS, was taped at an FSA reunion-symposium that brought together after fifty years Wolcott, Rothstein, Lee, Jack Delano, John Collier, Jr., and Ed Rosskam.

23. Post quoted in Murray, "Marion Post Wolcott," 86; Stryker's reading assignments, RESP and FSAWR; O'Neal, *A Vision Shared*, 175.

24. Post to Clara Dean Wakeham, Sept. 1940 [?], RESP. The letter is apparently misdated (Post had failed to date it herself) because Post's tone marks her as a relatively new employee, still a bit insecure; she speaks of Roy Stryker very formally: "The last thing Mr. Stryker said to me was *that I should take my time*." By 1940 Post addressed Stryker as "Roy" or "Papa" or any number of other humorous titles. A second clue is that in September 1940 Post was immersed in a project in Eastern Kentucky, then had to move hurriedly to Chapel Hill, North Carolina, to confer with Professor Howard Odum on his decision to use FSA pictures in an upcoming publication. A final point to be made is that Post was assigned to the coal mining areas of West Virginia only once, in fall 1938. I believe the letter in question, from which the quote was taken, was written the last week in September 1938. Marion Post Wolcott to Paul Hendrickson, quoted in Hendrickson, *Looking for the Light*, 261; lot 1730, FSAPP; Lifson, "Not a Vintage Show," 70.

25. Stott, *Documentary Expression*, 58; Post Wolcott–Doud interview.

26. Post admitted trying to reproduce the style of earlier FSA photographers on her first FSA assignment, but she abandoned it midway through the trip (Post Wolcott–Doud interview); see also Snyder, "Marion Post Wolcott," 301.

27. Snyder, "Post and the Farm Security Administration," 459; lots 1723, 1724, 1727, FSAPP, where Post wrote in a caption, "These 'foreigners' are generally thrifty and their houses are cleaner than most"; Dixon, *Photographers of the Farm Security Administration*, 162.

28. Baldwin, *Poverty and Politics*, 279; Leuchtenburg, *Franklin D. Roosevelt*, 141; Baldwin, *Poverty and Politics*, 158.

29. Post Wolcott–Doud interview; see also Snyder, "Post and the Farm Security Administration," 458–59; "Special Memorandum on Photography, John Fischer to All FSA Regional Information Advisers," 4 May 1938, Office Files—Field Correspondence, FSAWR. For further explanation of services offered by FSA photographers to other U.S. agencies and departments, see White, "Faces and Places," 415–29. See also Howe, "You Have Seen Their Pictures."

30. Stryker to Post, 14 July 1938, RESP; Wolcott, "Women in Photography" speech.

31. Wolcott, "Women in Photography" speech; On the suspected kidnapping, see Post to Stryker, 23 Jan. 1939, RESP; Post Wolcott–Doud interview; and Brownell, "Girl Photographer for FSA."

32. Stryker to Post, 13 Jan. 1939, RESP.

33. Post to Stryker, 13 Jan. 1939, RESP; Hurley, *Wolcott: A Photographic Journey*, 40; Robert Snyder gives important attention to gender issues in "Marion Post Wolcott" and in "Post and the Farm Security Administration."

34. Post to Stryker, 23 Dec. 1938, 12 Jan. 1939, RESP.

35. Post quotations in Post to Stryker, 12 January 1939, RESP; Post to Stryker, 5 July 1939, RESP; see also Snyder, "Post and the Farm Security Administration," 476–77.

36. Post to Stryker, 23 Dec. 1938, RESP.

37. Stryker to Arthur Rothstein, [1936], RESP, where he informs Rothstein of the conditions he could expect to face as he dealt with the migrant laborers; See esp. lot 1586 (Belle Glade) and lot 1590 (Canal Point), FSAPP, where Post seemingly goes out of her way to show the filth in which migrants live and work; lot 1591, FSAPP.

38. Post to Stryker, 13 Jan. 1939, RESP.

39. Post to Stryker, Jan. 1939, RESP; Stryker to Post, 1 Feb. 1939, 13 Feb. 1939, RESP.

40. Post to Stryker, 13 Jan. 1939, 3 Feb. 1939, Jan. 1939, RESP.

41. Stryker to Post, 28 Jan. 1939, RESP; Post to Stryker, Jan. 1939, RESP.

42. Wolcott, excerpt taken from the biographical essay she submitted to *Contemporary Photographers*, ed. Walsh, et al., 606; Raedeke, "Introduction and Interview," 14; Cohen in *Contemporary Photographers*,

ed. Walsh et al., 607; Carl Fleischhauer and Beverly Brannan chose pictures from Post's Miami series for *Documenting America,* 174–87.

43. Stein, introduction to Wolcott, *Wolcott: FSA Photographs;* Lifson, "Not a Vintage Show," 70.

44. Fleischhauer and Brannan, "Marion Post Wolcott: Beach Resort," in *Documenting America,* 174–87, shows clearly the safe distances at which the photographer kept herself; captions for lot 1602, FSAPP; Post Wolcott–Doud interview.

45. Post to Stryker, 24 Feb. 1939, RESP; Stryker to Post, 13 Feb. 1939, RESP, where he tells her, "Either the Rolleiflex is out, or you are at fault; something is sure as the devil wrong . . . I am most certain the fault isn't in the laboratory"; Stryker to Post, 21 Feb. 1939, 16 Feb. 1939, RESP.

46. Stryker to Post, 13 Feb. 1939, 1 Feb. 1939, RESP, where he suggests Post "cut pretty ruthlessly"; Stryker to Post, 21 Feb. 1939, RESP; the quantity of Post's early work may be determined by examining Stryker's correspondence: every seven to ten days he sent back to her approximately one hundred rolls of negatives; Post Wolcott File, RESC; Post Wolcott–Doud interview.

47. Post Wolcott–Doud interview; Stryker to Post, 1 April 1939, 11 May 1939, RESP, where he sympathized, "I know that regional people have been making life miserable for you. . . . As far as chasing around for all these regional people—forget it!" Fleischhauer and Brannan, *Documenting America,* 10; Post Wolcott–Doud interview.

48. Stryker to Post, 16 March 1939, 8 March 1939, 4 Feb. 1939, RESP; Post Wolcott quoted in Hendrickson, *Looking for the Light,* 58.

49. Stryker to Post, 6 April 1939, RESP.

50. Lot 1621, FSAWR. In a series of another Coffee County family, Post focused in closely on the family's table, a dinner consisting of roast beef, turnip greens, potato salad, stuffed eggs, lima beans, rice, pickled pears, biscuits, cornbread, milk, peaches, and cake.

51. An insightful essay on Raper's work and personal background is found in Singal, *The War Within,* 328–38; Stryker to Post, 1 April 1939, RESP; Post to Stryker, 7 April 1939, RESP; Stryker to Post, 27 April 1939, RESP.

52. Post to Stryker, 8 May 1939, 21 May 1939, RESP; Stryker to Post, 25 May 1939, RESP.

53. Stryker to Post, 20 May 1939, RESP; Post to Stryker, 1 June 1939, RESP; Raper and Reid, *Sharecroppers All.*

54. Post to Stryker, 5 July 1939, RESP.

55. McCausland, "Documentary Photography," 2. Cf. Stott, *Documentary Expression,* on the "documentary impulse" operating in American art and literature; and Peeler, *Hope among Us Yet,* where he describes the "soft" ideological bent of thirties documentary photographers. Allen, *Since Yesterday,* 212–13; Post Wolcott File, RESC; Ansel Adams quoted in Stryker, "The FSA Collection of Photographs," 352; Peeler, *Hope among Us Yet,* 100.

56. For an excellent description of Odum's background and his relationship with the institute's sociologists and their work, see Singal, *The War Within*, 115–52, 302–38, passim; Hagood built on her work in succeeding months and then published it under the title *Mothers of the South: Portraiture of the White Tenant Farm Woman;* Post to Stryker, 2 Oct. 1939, RESP; Stryker to Post, 17 Oct. 1939, RESP.

57. Beard quoted in Swados, *The American Writer,* 48; Terrill and Hirsch, *Such as Us,* xxi; In his earlier correspondence with Stryker, Couch mentioned the idea of combining FSA photography with Federal Writers' Project Guidebooks (Stryker to Dorothea Lange, 22 Dec. 1938, RESP; Stryker to George Mitchell, regional director in Raleigh, 3 Dec. 1938, Office Files, Field Correspondence, FSAWR, in which he urges Mitchell to have Post complete some work similar to that which has made possible book-length publications such as *Forty Acres and Steel Mules*). For a description of Couch's impact on the UNC Press, see Singal, *The War Within,* 265–301, passim.

58. Post to Stryker, 2 Oct. 1939, RESP; Harriet L. Herring, "Notes and Suggestions for Photographic Study of the 13 County Sub-regional Area," Supplementary Reference Files on lot 1503, FSAWR; Lange and Post actually worked on this project at the same time, but it was the last assignment Lange would take as an FSA photographer; Stryker to Jonathan Garst, 30 Nov. 1939, RESP.

59. Lots 1502, 1503, FSAPP; Hagood's typed notes/general captions for the photographs, Supplementary Reference Files, FSAWR.

60. Hagood, *Mothers of the South,* rev. ed., 132ff, 175, 177; photographs, lot 1518, FSAPP.

61. This was especially the case in rural areas and had been fostered by U.S. Government policies since the Progressive Era; see, for example, Hilton, "'Both in the Field,'" 114–33.

62. Post's other North Carolina work in 1939 expresses her personal statement about segregation in general, including an often-analyzed image of a sidewalk confrontation between two black men and a white woman carrying a baby. Different readings of its race and gender implications may be found in Fisher, *Let Us Now Praise Famous Women,* 153; Stein, in Wolcott, *Wolcott: FSA Photographs,* 6–8; and Natanson, *The Black Image,* 8–9; In her scenes of the segregated Granville County courtroom, Post downplays gender questions in favor of her more pressing messages about race in the South. See lots 1506, 1507, FSAPP and FSAWR.

63. Post's recollections about the scene told in Hendrickson, *Looking for the Light,* 91.

64. Post to Stryker, 3 Feb. 1939, RESP; Although the specific reference here was to migrant laborers, Post made efforts on nearly every assignment to capture leisure activities, which became a defining feature of her FSA work; lots 1641, 1479, FSAPP.

65. Lawrence to Stryker, 2 Nov. 1939, FSAWR; Ansel Adams to W.W. Alexander (FSA administrator), 23 April 1940, FSAWR; Stryker to E.W.

Cobb, 20 April 1939, FSAWR; Stryker to Margaret Hagood, 23 Jan. 1940, FSAWR. After amassing a formidable collection of visual data for the UNC Institute for Research in the Social Sciences, Post spent time in December 1939 editing her work for a UNC photo exhibition (Stryker to Katharine Jocher [assistant director at UNC IRSS], 19 Dec. 1939, FSAWR).

66. Curtis, *Mind's Eye, Mind's Truth,* 103. Cf. Hurley, *Portrait of a Decade,* 96–102, and Stange, *"Symbols of Ideal Life,"* 89–131.

67. Post to Stryker, 2 March 1940, RESP.

68. Stryker to Post, 27 Feb. 1940, RESP; Anderson to Stryker, 28 March 1940, RESP.

69. Post Wolcott–Doud interview; Post to Stryker, 14 March 1940, RESP.

70. "Annual Town Meeting Warning," Supplementary Reference Files, FSAWR; lot 1239, FSAPP.

71. "Agenda and Report" (sent by Post to the Washington office), FSAWR.

72. Anderson, "Elizabethton, Tennessee," in Anderson, *Puzzled America,* 145–53, reprinted in Swados, *The American Writer,* 40–47; [Steiner], "The Small Town," 46; Stott, *Documentary Expression,* 232–33; Perhaps the most personal account of the influence of Post's New England imagery is found in the prologue of Paul Hendrickson's *Looking for the Light.* He saw one of Post's Vermont scenes in a Library of Congress gift shop, was mesmerized by it, and then began pursuing her other work and her life with a missionary-like fervor.

73. Lots 1705, 1706, 1707, 1708, 1709, 1710, 1713, FSAPP.

74. Lot 1706, FSAPP; Terrebonne Project Report, 10 May 1940, FSAWR, emphasis mine.

75. Post Wolcott–Doud interview; "Things As They Were: FSA Photographers in Kentucky, 1935–1943," a guidebook to the photograph exhibit, 6 Sept. to 9 Nov. 1985, UL. Fifty-five of the seventy-seven photographs in the exhibit were taken by Marion Post; see also Brannan and Horvath, *A Kentucky Album;* Post to Stryker, 29 July 1940, RESP.

76. Post to Stryker, 9 Sept. 1940, RESP.

77. Brownell, "Girl Photographer for FSA."

78. Ibid.

79. Stryker to Post, 21 Sept. 1940, RESP; Wolcott, comments in Amarillo Art Center, *American Images;* see also O'Neal, *A Vision Shared,* 175.

80. Post, General Caption no. 1, Aug. 1940, Supplementary Reference Files, lot 1465, FSAWR.

81. For a fuller comparison of the two photographers, see McEuen, "Doris Ulmann and Marion Post Wolcott"; Stein, in Wolcott, *Wolcott: FSA Photographs,* 6.

82. Post, lots 1509, 1510, 1511, 1512, 1513, 1514, 1515, FSAPP.

83. Supplementary Reference Files, FSAWR. For an excellent discus-

sion of the intricate relationships between gender, race, and class, see Lerner, *Why History Matters*, 146-98.

84. Post to Stryker, 2 Oct. 1940, Nov. 1940, RESP; On Post's "distressing" experiences with southern welfare workers, see Snyder, "Marion Post Wolcott," 305–7; Post to Stryker, 15 May 1940, 29 July 1940, RESP.

85. Stein, in Wolcott, *Wolcott: FSA Photographs*, 9; see also Snyder, "Post and the Farm Security Administration," 477; Hurley contends that Stryker considered Post his best "troubleshooter" (*Wolcott: A Photographic Journey*, 42–43); Post to Stryker, 2 Oct. 1940, RESP; interview quotation in Hurley, *Wolcott: A Photographic Journey*, 57–58.

86. Post, untitled report, Jan. 1941, Supplementary Reference Files, FSAWR.

87. Post to Stryker, 14 March 1941, 8 April 1941, RESP; Wolcott quoted in Hendrickson, "Double Exposure," 18; Post to Stryker, 2 Oct. 1940, RESP.

88. Ganzel, *Dust Bowl Descent*, 8; Post Wolcott to Stryker, 22 Aug. 1941, RESP; lot 101, FSAPP.

89. Post Wolcott to Stryker, 22 Aug. 1941, RESP.

90. Post Wolcott to Stryker, 20 Feb. 1942, RESP; The "married name" struggle is recounted in Hendrickson, *Looking for the Light*, 202.

91. Malcolm Cowley, "The 1930s: Faith and Works," in Cowley, *I Worked at the Writer's Trade*, 101.

4. Margaret Bourke-White's Isolation of Primary Components

1. Story told in Silverman, *For the World to See*, 14; Orvell, *The Real Thing*, 223; Marchand, *Advertising the American Dream*, 1; Marchand uses the phrase *advertising man* inclusively despite its gender specificity, noting that it does accurately reflect the presumptions of a male-dominated profession that served a masculine realm, that of scientific and technological growth; Margaret Bourke-White to Chris A. Addison, 3 March 1930, MBW.

2. Bourke-White to Addison, 30 March 1930, MBW; Miles Orvell singles out *excitement* and *power* as the two overriding characteristics of the machine played upon by industrial designers in the 1920s and 1930s (*The Real Thing*, 182); see also Meikle, *Twentieth Century Limited*, 19–67; telegram, Bourke-White to Roberts Everett Associates, 17 Oct. 1930, MBW; Marchand, *Advertising the American Dream*, 1–13.

3. Goldberg, *Bourke-White Biography*, 13–14.

4. Evans, *Born for Liberty*, 173–76.

5. Goldberg, *Bourke-White Biography*, 7–8.

6. Minnie White to Margaret Bourke-White, 14 June 1915, MBW; Lindsey Best to Joseph White, 22 Dec. 1917, MBW; Vitae of Margaret Bourke-White, Simon and Schuster Review Department, 1931, MBW.

7. Character Analysis of Margaret White, conducted by Jessie Allen Fowler, 27 May 1919, MBW.

8. Description of Clarence White in Speech Notes, Bourke-White on "Careers for Women," May 1933, MBW; Goldberg, *Bourke-White Biography,* 22–32, 35.

9. Bourke-White to Minnie White, 22 June 1924, MBW.

10. Bourke-White to Minnie White, 24 June 1924, MBW; Goldberg, *Bourke-White Biography,* 51–56, in which she discusses Margaret's ambivalence about having a family. Though Margaret wanted a baby and hoped it would strengthen her marriage, she recognized the danger of bringing a child into such an unstable household. There is some evidence to suggest that she once became pregnant but carefully orchestrated a miscarriage.

11. Minnie White to F.A. Gilfillan, 28 Aug. 1928, MBW; Mrs. White mentions Margaret's difficulty in completing a degree because of the various moves the Chapmans had made. On the image of the single "working girl" in the 1920s, see Evans, *Born for Liberty,* 182–84; Aunt Gussie to Bourke-White, 17 May 1927, MBW.

12. Minnie White to F.A. Gilfillan, 12 Aug. 1928, MBW; Bourke-White, *Portrait of Myself,* 28–29; Margaret Chapman, Divorce Papers, 3 Jan. 1928, MBW. In the divorce agreement, Margaret's family name was restored.

13. Bourke-White, *Portrait of Myself,* 36. Margaret hyphenated her last name sometime in the late 1920s as she built her new image. She makes reference to it in a letter, noting, "[E]verybody calls me Miss Bourke-White as tho' I were a personage" (Bourke-White to Minnie White, 4 May 1929, MBW). I introduce it at this point in the text for the purpose of consistency and also because her move to Cleveland marked a new stage in her life, the beginning of her career as a professional photographer. On Bourke-White's relationship with the Van Sweringens, see Goldberg, *Bourke-White Biography,* 77.

14. For a discussion of American influence on modern architecture, and skyscraper design in particular, see Meikle, *Twentieth Century Limited,* 29–38; see also Orvell, *The Real Thing,* 174; Guimond, *American Photography,* 86–87; Bourke-White quoted in Silverman, *For the World to See,* 8.

15. Marchand, *Advertising the American Dream,* 149, where he points out that the magazine *Advertising and Selling* "reflected the changing sensibilities. Photographs appeared on fewer than 20 percent of the journal's covers in 1926, but on over 80 percent in 1928"; Roy Stryker–Margaret Bourke-White correspondence, 26 Oct. to 31 Oct. 1928, MBW; Stryker to Bourke-White, 16 Nov. 1928, MBW; Tugwell, Munro, and Stryker, *American Economic Life,* ix; Maren Stange explains the intricacies of the textbook's philosophy, including John Dewey's impact, in "The Management of Vision," 6, 8; Stange also argues that the production process overrides the individuals involved, a vital point in *American*

Economic Life, since it suggested that numerous ethnic industrial workers lost their cultural distinctiveness in the "melting pot" of U.S. factory work. Such work thoroughly "Americanized" people and thus created a more desirable working class.

16. Tearsheet, *Theatre Guild Magazine* (March 1929), MBW; Bourke-White received twenty-five dollars for the photograph; Eugene O'Neill, *Dynamo,* in O'Neill, *The Plays of Eugene O'Neill,* 429; "Mr. O'Neill" *New York Times,* 3 March 1929, 4; Bourke-White, Speech Transcript, "Creative Staff Meeting," 1 Feb. 1933, J. Walter Thompson Advertising Agency, MBW.

17. Meikle discusses this transition and transformation of industry in *Twentieth Century Limited,* 134–36, noting that the fullest negative expression of industrial exploitation was in Lewis Mumford's *Technics and Civilization* (1934); Mumford quoted in Orvell, *The Real Thing,* 202.

18. Vitae of Margaret Bourke-White, Simon and Schuster Review Department, 1931, MBW.

19. Marchand, *Advertising the American Dream,* describes the feminization of the American consumer public; Daniel Pope, comments at the Ninetieth Annual Meeting of the American Historical Association, Pacific Coast Branch, Portland, August 1997.

20. Bourke-White diary entry, Dec. 1927, quoted in Goldberg, *Bourke-White Biography,* 92.

21. Typewritten biography, dated fall 1931, MBW; Henry R. Luce to Bourke-White, 8 May 1929, MBW; undated office memorandum, Calkins to Hodgins, Time, Inc., MBW.

22. Bourke-White to Minnie White, 16 May 1929, MBW; Lloyd-Smith quoted in Silverman, *For the World to See,* 11.

23. Bourke-White to Minnie White, 24 May 1929, MBW.

24. Vitae of Margaret Bourke-White, Simon and Schuster Review Department, 1931, MBW; On the idea of repetition in mass production, see Meikle, *Twentieth Century Limited,* 24.

25. Bourke-White membership cards, Pictorial Photographers of America, Cleveland chapter and New York City chapter, MBW; Steiner to Bourke-White, 24 April [1930], MBW; Bourke-White to Minnie White, 19 May 1929, MBW, where she mentioned that Steiner did manage to slip one compliment into his stream of critical comments. He noted that her "viewpoint was becoming more direct and creative." The story of the tearful outburst told in Goldberg, *Bourke-White Biography,* 100; Steiner to Bourke-White, 2 Aug. [1929], MBW, in which he suggests that she extend the insurance on a particular lens to include European travel. Steiner goes into a detailed discussion on the DeBrie camera, an f1.5 Meyer Plasmat lens, a six-inch f4.5 Zeiss Tessar mount, and gelatine filters. He closes, "I'll get you the rest of the equipment with myself as instructor."

26. Dwight Macdonald to Bourke-White, 26 July 1929, MBW;

Archibald MacLeish to Bourke-White, undated letter [fall 1929], MBW; Bourke-White to William H. Albers, 23 Oct. 1928, MBW.

27. Bourke-White, *Portrait of Myself,* 72. Years later, a friend of Bourke-White's said to her, "You must have been the only photographer in the whole United States who was *inside* a bank that night." Unaware of the national news, Bourke-White had instead been reading a football manual in preparation for an upcoming date with a Harvard fan.

28. Undated office memorandum, Calkins to Hodgins, Time, Inc., MBW; Within three weeks after Luce had distributed Bourke-White's steel pictures to potential magazine advertisers, he "had sold enough ad pages to fill several *Fortune* issues" (Silverman, *For the World to See,* 11). Steiner to Bourke-White, 24 April [1930], MBW; Joe Fewsmith to Raymond Rubican, 15 Oct. 1930, MBW.

29. Telegram, Ruth White to Bourke-White, 27 June 1930, MBW; Bourke-White to Chris A. Addison, 3 March 1930, MBW; transcript, "Creative Staff Meeting," 1 Feb. 1933, J. Walter Thompson Advertising Agency, MBW; Bourke-White to Minnie White, 14 July 1930, MBW; Bourke-White, *Portrait of Myself,* 93. When she was forced to wait in Berlin for five and a half weeks while the Soviet embassy approved her visa, Bourke-White realized she would have to overcome numerous obstacles posed by the Soviet bureaucracy.

30. For specific achievements, see Hiroaki Kuromiya, "The Commander and the Rank and File: Managing the Soviet Coal-Mining Industry, 1928–33," and David Shearer, "Factories within Factories: Changes in the Structure of Work and Management in Soviet Machine-Building Factories, 1926–34," both in Rosenberg and Siegelbaum, *Social Dimensions of Soviet Industrialization,* 150–53, 202–4.

31. Bourke-White, *Portrait of Myself,* 91–92; Bourke-White to Minnie White, 10 Sept. 1930, MBW.

32. Vitae of Margaret Bourke-White, Simon and Schuster Review Department, 1931, MBW; see also Bourke-White, speech outline for J. Walter Thompson Advertising, 31 Jan. 1933, MBW. One of the points Bourke-White wished to emphasize in her talk was that "[i]n Russia things are happening now." Bourke-White, *Portrait of Myself,* 95.

33. Bourke-White to M. Lincoln Schuster, 22 Jan. 1931, MBW; Schuster to Bourke-White, 26 Jan. 1931, MBW; "Soviet Panorama," *Fortune* 3 (Feb. 1931): 60–68.

34. Schuster to Bourke-White, 11 March 1931, MBW; original contract agreement between Bourke-White and Simon and Schuster, 24 April 1931, MBW. With only minor changes, the final contract agreement was signed 21 Aug. 1931. Bourke-White would receive 10 percent of the retail price on the first five thousand copies of her book.

35. Bourke-White explains the extent of American business involvement in the Soviet Union in *Portrait of Myself,* 92. She notes that these men were there "strictly for business reasons" and that they made tremendous contributions to the expanding Soviet economy. Bourke-White

to Minnie White, 10 Sept. 1930, MBW; newspaper tearsheet, Bourke-White to Walter Winchell, Dec. 1930, MBW; see also Bourke-White, *Eyes on Russia,* 19. Bourke-White to Schuster, 8 Sept. 1931, MBW; Clifton Fadiman to Bourke-White, 19 Aug. 1931, MBW, where he congratulates her on "a splendid job," one requiring "very few changes"; Minnie White to Bourke-White, Dec. 1931, MBW.

36. Bourke-White, *Portrait of Myself,* 80. For a discussion of the machine-age aesthetic as implemented in modern architecture, see Meikle, *Twentieth Century Limited,* 29–38; Bourke-White, speech transcript, "Creative Staff Meeting," 1 Feb. 1933, J. Walter Thompson Advertising Agency, MBW; Joe Fewsmith to Bourke-White, 21 May 1931, MBW.

37. The photographs of Bourke-White on the gargoyle were taken by her darkroom technician, Oscar Graubner. Joe Fewsmith to Bourke-White, 26 Dec. 1930, MBW.

38. Typescript, "Careers for Women," May 1933, MBW, emphasis mine; Brown, *Setting a Course,* 29–47, in which she discusses characteristics of the new woman; Marchand, "Sizing Up the Constituency: The Feminine Masses," in Marchand, *Advertising the American Dream,* 66–69. He argues that the American public was reduced to advertisers' underestimation of female consumers, which led to the "feminization" of the American buying public.

39. Minnie White to Bourke-White, 12 Feb. 1933, MBW; see also general business correspondence, 1932–34, MBW; correspondence, Bourke-White Studio and Eastman Kodak Company, 1933–34, MBW. The family loans caused quite a rift in the White extended family. In business, Bourke-White's secretaries continually asked for extensions and loans. Peggy Sergent, who took over the studio books in 1935, recalled that Bourke-White "was in debt to *every*body" (quoted in Goldberg, *Bourke-White Biography,* 141).

40. On "cleanlining," see Meikle, *Twentieth Century Limited,* 101–9; Orvell, *The Real Thing,* 223.

41. H.S. Bishop to Bourke-White, 27 Aug. 1931, MBW; Bourke-White to Bishop, 24 Aug. 1931, MBW. In his letter, Bishop admitted having a "Babbit [*sic*] point-of-view."

42. Quotations from Bourke-White, speech text, "Color Photography in Advertising," Advertising Club of the *New York Times,* 16 Feb. 1934, MBW; Bourke-White to Minnie White, 30 Oct. 1933, MBW; Bourke-White to O.B. Hanson, 21 Nov. 1933, MBW; Bourke-White to Frank Altschul, 11 Dec. 1933, MBW; Bourke-White to Sanford Griffith, 5 Jan. 1934, MBW; Personal recognition from the NBC project did not come as easily as Bourke-White had hoped. She competed fiercely with the mural executor, Drix Duryea, whom she referred to as "an ordinary hack commercial photographer."

43. Warren Susman, "The Culture of the Thirties," in Susman, *Culture as History,* 156–57; Bourke-White, typescript, "Careers for Women," May 1933, MBW.

44. Bourke-White to Fred L. Black, 26 Feb. 1934, MBW; Bourke-White to C.P. Fiskin, 17 July 1934, MBW; Ethel Fratkin to Felicia White, 19 April 1934, MBW; Ethel Fratkin to George R. Gibbons, 11 July 1934, MBW; Safford K. Colby to Bourke-White, 9 Aug. 1934, MBW; Fratkin, Bourke-White's secretary, had assumed nearly all of the correspondence duties by 1934; she was even writing letters to the White family with Margaret's apologies that she was too busy to correspond.

45. "Selznick Notes," typewritten summary of Bourke-White–Selznick meeting, 11 July 1933, MBW, Elbert A. Wickes to Bourke-White, 29 May 1933, MBW.

46. On Bourke-White's 1934 business, see, for example, Bourke-White to Helen Resor [J. Walter Thompson Co.], 6 Feb. 1933, MBW; Bourke-White to Frank J. Reynolds, 7 July 1933, MBW; Bourke-White to David O. Selznick, 7 July 1933, MBW; Bourke-White to R.C. Treseda [Coca-Cola Co.], 15 July 1933, MBW; Fred C. Quimby [Metro-Goldwyn-Mayer], 25 Oct. 1933, MBW. Bourke-White enclosed portfolios with her letters; in some cases, she included as many as fifty photographs; Bourke-White set her print prices according to a magazine's circulation: $10 (up to 25,000), $15 (up to 50,000), $25 (up to 100,000), $35 (up to 250,000), $50 (up to 500,000), and $75 (over 1,000,000); Bourke-White Studio to J. Quigney [Colliers'], 14 Aug. 1934, MBW; Ethel Fratkin to Minnie White, 16 Feb. 1934, MBW; Fratkin to Felicia White, 19 April 1934, MBW; Bourke-White to Norman Moray, 13 Nov. 1933, MBW; Ralph Steiner to Bourke-White, 19 March 1933, MBW. Steiner asks, "How can cutting the Russian film take so long? . . . Russia changes fast you know—your film may be historical rather than contemporary soon. Hurry HURRY!"

47. Letter signed by Langston Hughes, Ella Winter, Lincoln Steffens, and Noel Sullivan to Bourke-White, 23 Dec. 1933, MBW; Bourke-White to Lincoln Steffens, 26 Jan. 1934, MBW; lists of donated photographs to the New School, April-May 1934, MBW; Ray Michael to Bourke-White, 7 May 1934, MBW; correspondence, Bourke-White and the League of Women Shoppers, 1935–39, MBW; program, "First Annual Motion Picture and Costume Ball by the Film and Photo League," 27 April 1934, MBW; Albert Carroll to Bourke-White, 10 Dec. 1934, MBW.

48. Bourke-White to Ralph Steiner, Paul Strand, Alfred Steiglitz, Anton Bruehl, Edward Steichen, 7 Nov. 1935, MBW; Bourke-White to John Dewey, 19 Sept. 1935, MBW, in which she asks him to make a public speech against fascism and war. Goldberg, *Bourke-White Biography*, 157; Peeler, *Hope among Us Yet*, 65–69.

49. Bourke-White, *Portrait of Myself*, 110; Schuster to Bourke-White, 3 April 1934, MBW; Bourke-White to Arthur R. Morgan, 8 March 1934, MBW; correspondence, Bourke-White Studio (Ethel Fratkin) and W.L. Sturdevant, 6 April to 13 April, 1934, MBW.

50. Bourke-White, *Portrait of Myself*, 110; Peeler, *Hope among Us Yet*, 67.

51. Eleanor Tracy to Bourke-White, 21 Oct. 1935, MBW.

52. Bourke-White, "Photographing This World"; typescript, "Photographing the World" by Margaret Bourke-White, 29 Jan. 1936, MBW.

53. Snyder, "Caldwell and Bourke-White: You Have Seen Their Faces," 396; Stott, *Documentary Expression,* 211–37; Orvell, *The Real Thing,* 198, 227, 239.

54. Bourke-White to Caldwell, 9 March 1936, EC; Bourke-White to Caldwell, undated letter, MBW. She discusses the incident and the letter in *Portrait of Myself,* 119–21.

55. Alan Trachtenberg, foreword to Caldwell and Bourke-White, *You Have Seen Their Faces,* 1995 ed., viii; see Stott's discussion of the "Documentary Book," in *Documentary Expression,* 211–37; Noggle, "With Pen and Camera"; Peeler, *Hope among Us Yet,* 69; Orvell, *The Real Thing,* 277–78. An interesting point about the criticism levied on Caldwell and Bourke-White is that the most frequently used term to describe their portrayal of southern life has been "grotesque[s]."

56. In *Portrait of Myself,* Bourke-White explained how she and Caldwell developed captions for the photographs in *You Have Seen Their Faces.* They did not use actual quotes from people in the pictures; instead, they composed the captions themselves. Bourke-White recalled, "Many times the final caption was a combination of the two—the thought mine and the words Erskine's, or vice versa. . . . I was proud indeed when either my thought or my way of expressing the subject stood up in the final test" (137); Snyder, "Caldwell and Bourke-White," 398; see also Guimond, *American Photography,* in which he notes that Bourke-White "photographed every cliché that was popular in the newspapers, movies, and popular fiction of the era" (117).

57. Paul Green, "A Plain Statement about Southern Literature," quoted in Singal, *The War Within,* 109; Caldwell and Bourke-White, *You Have Seen Their Faces,* 1937 ed., 75; Davidson, "Erskine Caldwell's Picture Book."

58. Agee and Evans, *Let Us Now Praise Famous Men,* appendix 3, 453.

59. Contract agreement between Bourke-White and Time, Inc., 4 Sept. 1936, MBW; circulation figures in Kozol, *LIFE's America,* 35.

60. "10,000 Montana Relief Workers Make Whoopee on Saturday Night," *Life,* 23 Nov. 1936, 9; On stereotypes, see Moynihan, Armitage, and Dichamp, *So Much to Be Done,* xi–xxii, 167–68; on Montana women in particular, see Murphy, "The Private Lives of Public Women," 193–205; and Murphy, *Mining Cultures;* Kozol, *LIFE's America,* 34.

61. For a different reading of the photo essay, see Smith, *Making the Modern,* in which Smith argues that the federal government weakened a potentially dangerous group by employing them "far from the centers of power to make-work projects where they struggle to survive" (347); "10,000 Montana Relief Workers," 11; For a general commentary on the photo essay as form, see Callahan, *Photographs of Bourke-White,* 17–19.

62. Bourke-White, quoted in Silverman, *For the World to See,* 81; Bourke-White to Louis Lozowick, 22 May 1937, MBW, where she explains, "Since I've gone into this work with *Life* I find it almost impossible to schedule discussions ahead of time." Bourke-White's office correspondence reveals that she agreed to speak or lecture only if an organization also scheduled a replacement for her. Beloff, *Camera Culture,* 40; listing of Bourke-White's *Life* assignments, Index Notebook, MBW; Paul Peters to Bourke-White, 17 April 1938, MBW.

63. Office Memo, Joe Thorndike to Alan Brown, 18 Oct. 1937, MBW; Newhall to Bourke-White, 10 May 1937, MBW.

64. Steiner to Bourke-White, 19 Jan. 1937, MBW; Bourke-White, *Portrait of Myself,* 169; Guy E. Rhoades to Bourke-White, 30 Nov. [1937], MBW.

65. Margaret Smith to Ruth White, 19 Oct. 1939, MBW; Caldwell to Bourke-White, 2 Dec. 1939, EC; see also Howard, "Dear Kit, Dear Skinny." Bourke-White and Caldwell had produced a second book together entitled *North of the Danube* (1939); the reviews were good because of the international subject matter, but Bourke-White was hesitant to work on yet another project with her emotionally distraught husband.

66. Goldberg, *Bourke-White Biography,* 159.

67. Ibid., 255, 235.

68. Eisenstaedt quoted in Silverman, *For the World to See,* 7.

5. Berenice Abbott's Perception of the Evolving Cityscape

1. Abbott, quoted in O'Neal, *Berenice Abbott,* 18; "Changing City Caught in Flight by Photographs," *New York Herald Tribune,* 19 March 1936. One headline describing Abbott's photography read "Woman with Camera Snaps Revealing History of New York Life in Its Homeliest of Garb," *New York World-Telegram,* 11 Nov. 1938.

2. Steinbach, "Berenice Abbott's Point of View" (an interview with Berenice Abbott), 78; see also Berman, "The Unflinching Eye." Abbott told Berman, "He [Stieglitz] took about five good pictures in his whole life, and that was only when he ventured out of himself" (88). On pictorialists, Abbott is quoted in Berman, "The Unflinching Eye," 88. Abbott wrote, "The greatest influence obscuring the entire field of photography has, in my opinion, been pictorialism" ("It Has to Walk Alone," 15); Abbott, "Photographer as Artist," 7; Hales, *Silver Cities,* 277–90.

3. Mitchell, *Recollections* (published in conjunction with the International Center of Photography's exhibition of the same name), 12. The exhibit surveyed only living photographers, with each woman providing her own biographical sketch for the publication. Steinbach, "Berenice Abbott's Point of View," 78.

4. Zwingle, "Life of Her Own," 57; Mitchell, *Recollections,* 12.

5. Abbott quoted in Russell, "A Still Life," 70; O'Neal, *Berenice*

Abbott, 9; Abbott, quoted in Russell, "A Still Life," 70; Katz, keynote address, presentation to Berenice Abbott of the Association of International Photography Art Dealers' Annual Award for Significant Contributions to the Field of Photography, 6 Nov. 1981; "Woman with Camera Snaps Revealing History of New York Life in Its Homeliest of Garb," *New York World-Telegram,* 11 Nov. 1938.

6. Arnold, "The Way Berenice Abbott Feels about Cities"; "From a Student's Notebook," 56, 174, in which Abbott stressed the importance of training the eye and noted that "tones must be viewed instead of colors"; O'Neal, *Berenice Abbott,* 10; Man Ray described by John Canaday, introduction to O'Neal, *Berenice Abbott,* 7; see also Penrose, *Man Ray,* 75–95.

7. Mitchell, *Recollections,* 12; Steinbach, "Berenice Abbott's Point of View," 79; see also Abbott, "The 20s and the 30s," n.p.; Katz, keynote address; Abbott, quoted in O'Neal, *Berenice Abbott,* 46; "From a Student's Notebook," 56, 174; see also Abbott, *Photographs,* 13-14 (page references are to the 1970 edition).

8. Kramer, "Vanished City Life."

9. Zwingle, "A Life of Her Own," 57, in which Abbott claims personal responsibility for changing her own name; Peter Barr, correspondence with author, on Cocteau's role in altering Abbott's name for artistic effect.

10. Abbott quoted in Russell, "A Still Life," 70; Abbott, undated typewritten transcript, "Eugène Atget," ML; Lifson, essay in *Eugène Atget,* 7.

11. Abbott, "Atget" transcript, ML; Nesbit, *Atget's Seven Albums,* 20, 42–44; Abbott, "Eugène Atget," 337; Lifson refers to Atget's work as "a reverie about a dying era" (*Eugène Atget,* 10); Abbott, "Photographer as Artist," 6.

12. Abbott, "Atget" transcript, ML; see also Abbott, "Eugène Atget," 336; Nesbit on Atget's "Repertoire" in *Atget's Seven Albums,* 20; Szarkowski and Hambourg, *The Work of Atget,* vol. 1, 30.

13. Abbott, *The World of Atget;* Abbott quoted in Russell, "A Still Life," 70; Mitchell, *Recollections,* 13.

14. Man Ray to Paul Hill and Tom Cooper, "Interview: Man Ray," *Camera* 74 (Feb. 1975), 39–40, retold in Nesbit, *Atget's Seven Albums,* 1; Nesbit, *Atget's Seven Albums,* 16.

15. Abbott, "It Has to Walk Alone," 16; Nesbit draws on the work of Pierre MacOrlan, who called Atget "a man of the street, an artisan poet" (*Atget: Photographe de Paris* [Paris : Jonquiéres, 1930], in *Atget's Seven Albums,* 6).

16. Mitchell, *Recollections,* 13; Russell, "A Still Life," 70; O'Neal, *Berenice Abbott,* 14.

17. Abbott, in *Berenice Abbott,* 6; Berman, "The Unflinching Eye," 92; see also Arnold, "The Way Berenice Abbott Feels about Cities"; Lois Scharf, "Even Spinsters Need Not Apply," in *To Work and To Wed,* 85.

18. Berenice Abbott, project proposal to New York Historical Society, excerpted in O'Neal, *Berenice Abbott,* 16–17; Mitchell, *Recollections,* 13; see also Sundell, "Berenice Abbott's Work in the 1930s," 269–70. Sundell, through his extensive archival work in the Museum of the City of New York, determined that Abbott sent a form letter to two hundred of the museum's contributors but received no favorable response. Abbott, "Changing New York," 158.

19. Abbott quoted in Tom Zito, "Glimpses of the Artiste," sec. E; Kramer, "Vanished City Life," 18; for a comprehensive discussion of the impact of the architectural projects on Abbott's artistic development, see Barr, "Becoming Documentary."

20. Abbott, "Changing New York"; and Zubryn, "Saving New York for Posterity," 12. Other references have misquoted Abbott's original plan to read "the present jostling the past." See, for example, Berman, "The Unflinching Eye," 92, and Merry A. Foresta, "Art and Document," 151.

21. Peter Barr provides a penetrating interpretation of Abbott's creation of continuous fields in "Documentary Photography as Poetry" and "Becoming Documentary."

22. Smith College Museum of Art, "Berenice Abbott," exhibition dates, 17 Jan.– 24 Feb. 1974; Secrest, "An Attic Studio," sec. H, p. 2; Abbott, *The World of Atget,* xxvi. In Mitchell, *Recollections,* Abbott concluded her essay, "Photography can only represent the present. Once photographed, the subject becomes part of the past" (13).

23. Arnold, "The Way Berenice Abbott Feels about Cities."

24. Hales, *Silver Cities,* 179.

25. Secrest, "An Attic Studio," sec. H, p. 2; see also Raeburn, "'Culture Morphology' and Cultural History," 255–92; White, "Eugene Atget," 80; McCausland, "Berenice Abbott . . . Realist," 50; see also Sundell, "Berenice Abbott's Work in the 1930s," 273; and Coleman, "Latent Image," 18–19; Model, quoted in McCausland, "Berenice Abbott . . . Realist," 47. In describing Abbott's photographs, Model said, "Everything is alive. Everything breathes. Everything is rooted in life" (47).

26. Abbott, "Photography at the Crossroads," 20; "Changing City Caught in Flight by Photographs," *New York Herald Tribune,* 19 March 1936.

27. Abbott, "Changing New York," 160; McCausland, "The Photography of Berenice Abbott," 17; Landgren to Ann Kelly, 27 June 1934, ML; Landgren tried to interest the Rockefeller family in Abbott's documentation of the Radio City construction.

28. Abbott, FAP proposal, excerpted in O'Neal, *Berenice Abbott,* 17; Berman, "The Unflinching Eye," 92; "Supervising Employees on Project Unit Payroll—FAP (65-1699)," 1 Aug. 1936, RG69, ser. 651.315, box 2115. Abbott was classified as a project supervisor and received $145 per month, as did all other project supervisors regardless of their assigned division (teaching, design, murals, etc.)

29. "U.S. to Find Work for 3500 Artists," *New York Times,* 4 Oct. 1935.

30. "Changing City Caught in Flight by Photographs," *New York Herald Tribune*, 19 March 1936.

31. "Portraits of the United States: The Art Project and the Writers Project of the Works Progress Administration," undated typewritten manuscript, no. 13283, RG69, Division of Information, Primary File, box 77. Unidentified critic quoted in "Government Aid during the Depression to Professional, Technical and Other Service Workers," WPA Publication 1936, RG69, ser. 0001, General Records, FAP; "Portraits of the United States"; WPA/FAP, "Uniform Procedure for Allocation," RG69, ser. 0001, FAP General Records.

32. Williams quoted in Meltzer, *Violins and Shovels*, 19; Thomas E. Maulsby (FAP research supervisor), "The Story of WPA in American Art," 1936, typewritten transcript, RG69, Division of Information, Primary File; Foresta, "Art and Document," 148–56, in which she briefly discusses PWAP as a precursor to the FAP, pointing out both the criticism and support directed at the two programs; "U.S. to Find Work for 3500 Artists," *New York Times*, 4 Oct. 1935; Audrey McMahon to Bruce McClure, 25 June 1935, RG69, ser. 651.315. McMahon informs McClure (of the FERA) that one hundred new employees may be added to the current payroll. She specifically mentions hiring photographers.

33. See copies of the "WPA Monthly Statistical Bulletin" from 1936 to 1940, RG69, Division of Information, Primary File, and copies of "New York City Monthly Report," 1936 to 1940, RG69, ser. 0004; the FAP photographs located in RG69-ANP and RG69-AN (Still Pictures Branch), show the documentary nature of the camera work in New York City: the overwhelming majority are images of works (buildings, murals, paintings, art classes) in progress; McMahon to Cahill, 26 Sept. 1935, RG69, ser. 0005; Cahill to McMahon, 17 Jan. 1936, RG69, ser. 211.5, box 443. Reiterating that the FAP's major concern was its "artists," Cahill explained that the high costs of producing unnecessary photographs might hinder the FAP's ability to take care of its creative talents.

34. See Foresta's discussion of Dewey's impact on Cahill in "Art and Document," 150; Holger Cahill, speech delivered at the meeting of Regional Supervisors, Women's Division—WPA, 2 July 1936, transcript, RG69, Division of Information, Primary File, box 77; Holger Cahill, FAP director, "Federal Art Project Manual," Oct. 1935, RG69, ser. 0001, FAP, General Records; Raeburn, "'Culture Morphology' and Cultural History," 258.

35. "Art Work in Non-Federal Buildings (65-21-3755) and the Federal Art Project (65-1699) of the City of New York under the United States Works Progress Administration," Supplement A (Dec. 1935) and Supplement C (Jan. 1936), RG69, ser. 651.315, box 2114. In these two reports, statistics for the photo projects have been compiled, but "Changing New York" is considered individually.

36. "Art Work in Non-Federal Buildings (65-21-3755) and The Fed-

eral Art Project (65-1699) of the City of New York under the United States Works Progress Administration: A Descriptive Guide," Nov. 1935, RG69, ser. 651.315, box 2114.

37. "Changing City Caught in Flight by Photographs," *New York Herald Tribune,* 19 March 1936; correspondence between Hardinge Scholle and Holger Cahill, Feb. 1936, RG69, ser. 0005, box 28; FAP/NYC Exhibition Department, Weekly Report, 20 May 1936, RG69, ser. 0004, box 20; FAP/NYC, Exhibition Department, Weekly Reports for months June to December 1936, RG69, ser. 0004. See esp. 27 Aug. 1936 report.

38. Arnold, "The Way Berenice Abbott Feels about Cities."

39. Sarah Newmeyer to Holger Cahill, 12 June 1936, RG69, ser. 0001; Elizabeth McCausland to T.E. Maulsby, 27 Aug. 1936, RG69, ser. 0001; Thomas Parker to Audrey McMahon, 13 Aug. 1936, 21 Aug. 1936, RG69, ser. 0005; McNulty to Audrey McMahon, 25 Aug. 1936, RG69, ser. 0005; T.E. Maulsby to Thomas Parker, [Aug. 1936], RG69, ser. 0005; Audrey McMahon to Mildred Holzhauer, 8 March 1937, RG69, ser. 651.315, box 2116; Exhibition Project, Weekly Reports, 8 March 1937 and 5 April 1937, RG69, ser. 0004; comment on the exhibit's popularity quoted in Department of Information, Special Release, 31 Dec. 1937, RG69, ser. 002-A; "WPA Federal Art Project Exhibitions in Full Swing," 15 Oct. 1937, RG69, ser. 002-A; Exhibition Project, Weekly Report, 25 Oct. 1937, RG69, ser. 0004; "Notes on the Exhibition Program," n.d., RG69, ser. 0001; and Holger Cahill to Edward Steichen, 4 April 1936, RG69, ser. 651.315, box 2114, where Cahill suggests to Steichen that many developments within the FAP "may furnish the basis for a new and more vital American art."

40. Beaumont Newhall, interview by Joseph Trovato, 23 Jan. 1965, Archives of American Art, Smithsonian Institution, Washington, D.C., transcript.

41. "Woman with Camera Snaps Revealing History of New York Life in Its Homeliest of Garb," *New York World-Telegram,* 11 Nov. 1938.

42. Parker to McMahon, 15 Sept. 1937, RG69, ser. 211.5, box 443; Woodward to Paul Edwards, 13 May 1938, RG69, ser. 651.315, box 2117.

43. Thomas Parker to Audrey McMahon, 18 April 1938, RG69, ser. 651.315, box 2117; Parker to McMahon, 12 May 1938, RG69, ser. 651.315, box 2117; McMahon to Parker, 23 Sept. 1938, RG69, ser. 211.5, box 444; For more on the heated controversy, see correspondence between McMahon and Parker, 13 Sept.–12 Oct. 1938, RG69, ser. 211.5, box 444; Abbott to Parker, 11 Oct. 1938, RG69, ser. 651.315, box 2118.

44. Leuchtenburg, *Franklin D. Roosevelt,* 266; Meltzer, *Violins and Shovels,* 140.

45. Newhall-Trovato interview, 12; Abbott, "It Has to Walk Alone," 17; Raeburn, "'Culture Morphology' and Cultural History," 261–62, in which he compares Abbott's work to Faulkner's *Light in August* (1932)

and *Absalom! Absalom!* (1936), suggesting that both the photographer and the novelist require their audience to participate rather than merely observe. Abbott, "Photography at the Crossroads," 21.

Conclusion

1. McCausland, "Documentary Photography," 1; American Historical Association, *Annual Report for 1939*; Stryker and Johnstone, "Documentary Photography."

2. An excellent essay examining the most influential postmodern theorists on photography is Geoffrey Batchen's chapter entitled "Identity" in his *Burning with Desire*.

Bibliography

Manuscript and Photograph Collections

AAA Photographer Interview Transcripts. Archives of American Art, Smithsonian Institution, Washington, D.C.

AFA American Federation of Art Papers. Archives of American Art, Smithsonian Institution, Washington, D.C.

BA Berenice Abbott Collection. Museum of the City of New York.

DL Dorothea Lange Collection. Oakland Museum, Oakland, California.

DU-BC Doris Ulmann Manuscript Collection. Southern Appalachian Archives, Hutchins Library, Berea College, Berea, Kentucky.

DU-BCP Doris Ulmann Photograph Collection. Art Department Library, Berea College, Berea, Kentucky.

DU-G Doris Ulmann Photograph Collection. J. Paul Getty Museum, Los Angeles, California.

DU-NY Doris Ulmann Photograph Collection. New York Historical Society, New York City.

DU-OR Doris Ulmann Photographs and Proof Books. Special Collections. University of Oregon, Eugene.

DU-SC Doris Ulmann Photograph Collection. South Carolina Historical Society, Charleston.

DU-UK Doris Ulmann Photograph Collections. Special Collections. Margaret I. King Library, University of Kentucky, Lexington.

DU-UKA Doris Ulmann Prints. University of Kentucky Art Museum.

EC Erskine Caldwell Selected Papers. George Arents Research Library, Syracuse University, Syracuse, New York.

FAP Federal Art Project Photography Unit. Still Pictures Branch, National Archives.

FSAPP Farm Security Administration—Office of War Information Photograph Collection. Library of Congress.

FSAWR Farm Security Administration—Office of War Information. Written Records. Overseas Picture Division, Lot 12024. Library of Congress.

JB John Bennett Papers. South Carolina Historical Society,
 Charleston.
JJN John Jacob Niles Manuscript Collection. Special
 Collections. Margaret I. King Library, University
 of Kentucky, Lexington.
JJN-BC John Jacob Niles Field Notebooks. Art Department, Berea
 College, Berea, Kentucky.
JP Julia Peterkin Manuscript Collection. South Carolina
 Historical Society, Charleston.
MBW Margaret Bourke-White Papers. George Arents Research
 Library, Syracuse University, Syracuse, New York.
MBWP Margaret Bourke-White Photographic Prints. George
 Arents Research Library, Syracuse University,
 Syracuse, New York.
ML Marchal Landgren Papers. Archives of American Art,
 Smithsonian Institution, Washington, D.C.
OM-ART Art Department Collections. Oakland Museum, Oakland,
 California.
RESC Roy Emerson Stryker Collection. University of Louisville
 Photographic Archives.
RESP Roy Emerson Stryker Papers. Microfilm Edition. Edited by
 David Horvath. University of Louisville
 Photographic Archives.
RG69 Records of the Works Progress Administration. Record
 Group 69. National Archives.
UC-OHC Oral History Collection. Bancroft Library, University of
 California, Berkeley.
UL Photographic Archives, University of Louisville.

OTHER SOURCES

Aaron, Daniel. "An Approach to the Thirties." In *The Study of American Culture: Contemporary Conflicts,* edited by Luther S. Luedtke, 1–17. Deland, Fla.: Everett/Edwards, 1977.

Abbott, Berenice. "Berenice Abbott: The 20s and the 30s." With an introduction by Barbara Shissler Nosanow. Exhibition Catalogue. Washington, D.C.: Smithsonian Institution, 1982.

———. "Changing New York." In *Art for the Millions: Essays from the 1930s by Artists and Administrators of the WPA Federal Art Project,* edited by Francis O'Connor, 158-62. Greenwich, Conn.: New York Graphic Society, 1973.

———. "Eugène Atget." In *The Encyclopedia of Photography* 2 (1963): 335-39. Originally published in *Complete Photographer* 6 (1941).

———. "It Has to Walk Alone." In Lyons, *Photographers on Photography,* 15-17. Originally published in *Infinity* 7 (1951): 6–7, 14.

———. "Photographer as Artist." *Art Front* 16 (1936): 4–7.

———. *Photographs.* With a foreword by Muriel Rukeyser and an introduction by David Vestal. New York: Horizon Press, 1970; Washington, D.C.: Smithsonian Institution Press, 1990.

———. "Photography at the Crossroads." In Lyons, *Photographers on Photography,* 17-22.

———. "What the Camera and I See." *ARTnews* 50 (Sept. 1951): 36–37, 52.

———. *The World of Atget.* New York: Horizon Press, 1964.

Abrams, Mary. "Women Photographers." *Graduate Woman* 25 (September/October 1981): 22-24.

Agee, James, and Walker Evans. *Let Us Now Praise Famous Men.* Boston: Houghton Mifflin, 1941.

Allen, Fredcrick Lewis. *The Big Change: America Transforms Itself, 1900–1950.* New York: Harper and Row, 1952.

———. *Since Yesterday: The Nineteen-Thirties in America.* New York: Harper and Brothers, 1940.

Alpern, Sara, Joyce Antler, Elisabeth Israels Perry, and Ingrid Winther Scobie, eds. *The Challenge of Feminist Biography: Writing the Lives of Modern American Women.* Urbana: Univ. of Illinois Press, 1992.

Amarillo Art Center. *American Images: Photographs and Photographers from the Farm Security Administration, 1935–1942.* Amarillo, Tex.: Amarillo Art Center, 1979. Videotape.

American Historical Association. *Annual Report of the American Historical Association for the Year 1939.* Washington, D.C.: Government Printing Office, 1941.

Anderson, James C., ed. *Roy Stryker: The Humane Propagandist.* Louisville, Ky.: University of Louisville Photographic Archives, 1977.

Anderson, Sherwood. *Home Town.* The Face of America series, edited by Edwin Rosskam. New York: Alliance Book Corporation, 1940.

———. *Puzzled America.* New York: Scribner's, 1935.

———, *Winesburg, Ohio.* New York: B.W. Huebsch, 1919; New York: Viking Press, 1958.

Arnold, Elliott. "The Way Berenice Abbott Feels about Cities and Photography, Her Exhibit Is like an Artist Painting Portraits of His Beloved." *New York World-Telegram,* 21 Oct. 1937.

Baldwin, Sidney. *Poverty and Politics: The Rise and Decline of the Farm Security Administration.* Chapel Hill: Univ. of North Carolina Press, 1968.

Banes, Ruth. "Doris Ulmann and Her Mountain Folk." *Journal of American Culture* 8 (spring 1985): 29-42.

Banta, Martha. *Imaging American Women: Idea and Ideals in Cultural History.* New York: Columbia Univ. Press, 1987.

Barr, Peter. "Becoming Documentary: Berenice Abbott's Photographs, 1925–1939." Ph.D. diss., Boston Univ., 1997.

———. "Documentary Photography as Poetry: Berenice Abbott's *Chang-*

ing New York," Paper presented at Frick Symposium, 3 April 1993.
Batchen, Geoffrey. *Burning with Desire: The Conception of Photography*. Cambridge: Massachusetts Institute of Technology Press, 1997.
Becker, Jane S. *Selling Tradition: Appalachia and the Construction of an American Folk*. Chapel Hill: Univ. of North Carolina Press, 1998.
Beloff, Halla. *Camera Culture*. New York: Basil Blackwell, 1985.
Bennett, Edna. "Dorothea Lange: A Timely Tribute." *Photographic Product News* 2 (Jan.–Feb. 1966): 54–56, 64–65.
Berea College. *Bulletin of Berea College and Allied Schools*. General Catalog, 1933–34. Berea, Ky.: Berea College Press, 1933.
Berenice Abbott. With an essay by Julia Van Haaften. Aperture Masters of Photography series, no. 9. New York: Aperture, 1988.
Berman, Avis. "The Unflinching Eye of Berenice Abbott." *ARTnews* 80 (Jan. 1981): 87–93.
Bledstein, Burton J. *The Culture of Professionalism: The Middle Class and the Development of Higher Education in America*. New York: Norton, 1978.
Boddy, Julie. "Photographing Women: The Farm Security Administration Work of Marion Post Wolcott." In *Decades of Discontent: The Women's Movement, 1920–1940*, edited by Lois Scharf and Joan M. Jensen, 153-66. Westport, Conn.: Greenwood Press, 1983.
Borchert, James. "Historical Photo-Analysis: A Research Method." *Historical Methods* 15 (spring 1982): 35–44.
Bourke-White, Margaret. *Eyes on Russia*. New York: Simon and Schuster, 1931.
———. "Photographing This World." *Nation*, 19 Feb. 1936, 217–18.
———. *Portrait of Myself*. New York: Simon and Schuster, 1963.
Brannan, Beverly W. "American Women Documentary Photographers, 19th and 20th Centuries." Keynote address delivered at conference, "Woman: A Different Voice," Western Kentucky Univ., Bowling Green, 26–28 Sept. 1990.
———. Telephone conversation with the author, 19 March 1990.
Brannan, Beverly W., and David Horvath, eds. *A Kentucky Album: Farm Security Administration Photographs, 1935–1943*. Lexington: Univ. Press of Kentucky, 1986.
Brinkley, Alan. *Voices of Protest: Huey Long, Father Coughlin, and the Great Depression*. New York: Vintage, 1982.
Brown, Dorothy M. *Setting a Course: American Women in the 1920s*. Boston: Twayne, 1987.
Brown, Lorraine, and Michael G. Sundell. "Stylizing the Folk: Hall Johnson's *Run, Little Chillun* Photographed by Doris Ulmann." *Prospects* 7 (1982): 335–46.
Browne, Turner. *Macmillan Biographical Encyclopedia of Photographic Artists and Innovators*. New York: Macmillan, 1983.
Brownell, Jean. "Girl Photographer for FSA Travels 50,000 Miles in Search for Pictures." *Washington Post*, 19 Nov. 1940.

Byers, Paul. "Cameras Don't Take Pictures." *Columbia Univ. Forum* 9 (1966): 27–31.

Caldwell, Erskine, and Margaret Bourke-White. *You Have Seen Their Faces*. 1937. Reprint, Athens: Univ. of Georgia Press, 1995.

Callahan, Sean, ed. *The Photographs of Margaret Bourke-White*. With an introduction by Theodore M. Brown. New York: New York Graphic Society, 1972.

Campbell, Olive D. "Doris Ulmann." *Mountain Life and Work* (Oct. 1934): 11.

Cashin, Joan E. *A Family Venture: Men and Women on the Southern Frontier*. Baltimore: Johns Hopkins Univ. Press, 1994.

"Changing City Caught in Flight by Photographs." *New York Herald Tribune,* 19 March 1936.

Chase, Stuart. "The Tragedy of Waste: The Wastes of Advertising." *New Republic,* 19 Aug. 1925, 342–45.

Coben, Stanley. "The Assault on Victorianism in the Twentieth Century." *American Quarterly* 23 (Dec. 1975): 604–25.

Coleman, A.D. "Latent Image: Further Thoughts on Berenice Abbott." *Village Voice,* 28 Jan. 1971: 18-19.

Conkin, Paul K. *The Southern Agrarians*. Knoxville: Univ. of Tennessee Press, 1988.

"Consumer Cooperatives." *Fortune* 15 (March 1937): 133–46.

Conway, Jill. "Convention versus Self-Revelation: Five Types of Autobiography by Women of the Progressive Era." Paper presented at conference, "Project on Women and Social Change," Smith College, Northampton, Mass., 13 June 1983.

Cook, Blanche Wiesen. "Female Support Networks and Political Activism: Lillian Wald, Crystal Eastman, Emma Goldman." *Chrysalis* 3 (1977): 43–61.

Cott, Nancy. *The Grounding of Modern Feminism*. New Haven, Conn.: Yale Univ. Press, 1987.

Cowan, Ruth Schwartz. "Two Washes in the Morning and a Bridge Party at Night: The American Housewife between the Wars." In *Decades of Discontent: The Women's Movement, 1920–1940,* edited by Lois Scharf and Joan M. Jensen, 177-96. Westport, Conn.: Greenwood Press, 1983.

Cowley, Malcolm. *—And I Worked at the Writer's Trade: Chapters of Literary History, 1918–1978*. New York: Viking Press, 1978.

Crunden, Robert M. *Ministers of Reform: The Progressives' Achievement in American Civilization, 1889–1920*. Urbana: Univ. of Illinois Press, 1982.

"Current Exhibition News in Brief," *New York Times,* 3 Nov. 1929, 12.

Curtis, James. *Mind's Eye, Mind's Truth: FSA Photography Reconsidered*. Philadelphia: Temple Univ. Press, 1989.

Daniel, Pete, Merry A. Foresta, Maren Stange, and Sally Stein. *Official*

Images: New Deal Photography. Washington, D.C.: Smithsonian Institution Press, 1987.

Davidov, Judith Fryer. *Women's Camera Work: Self/Body/Other in American Visual Culture.* Durham: Duke Univ. Press, 1998.

Davidson, Donald. "Erskine Caldwell's Picture Book." *Southern Review* 4 (1938–39): 15–25.

———. "Julia Peterkin." *Spyglass,* 3 April 1927.

Davidson, Jan. "The People of Doris Ulmann's North Carolina Photographs." Paper presented at the Ulmann Symposium, Gibbes Museum of Art, 8 November 1997.

Davie, Helen L. "Women in Photography." *Camera Craft* 5 (Aug. 1902): 130-38.

Dewey, John. *Art as Experience.* New York: Minton, Balch, 1934.

Dixon, Daniel. "Dorothea Lange." *Modern Photography* 16 (Dec. 1952): 68–77, 138–41.

Dixon, Penelope. *Photographers of the Farm Security Administration: An Annotated Bibliography, 1930–1980.* New York: Garland, 1983.

Doherty, Robert J. "USA-FSA: Farm Security Administration Photographs of the Depression Era." *Camera* 41 (Oct. 1962): 9–13.

Dorothea Lange. Aperture Masters in Photography series, no. 5. New York: Aperture, 1987.

Dos Passos, John. *U.S.A.: Nineteen Nineteen.* New York: Random House, 1930.

Dreiser, Theodore. *Sister Carrie.* New York: Harper and Brothers, 1900; New York: Random House, 1932.

Eagles, Charles W. "Urban-Rural Conflict in the 1920s: A Historiographical Assessment." *Historian* 49 (Nov. 1986): 26–48.

Eaton, Allen H. "The Doris Ulmann Photograph Collection." *Call Number* 19 (spring 1958): 10–11.

———. *Handicrafts of the Southern Highlands.* New York: Russell Sage Foundation, 1937. Reprint, New York: Dover, 1973.

Edwynn Houk Gallery. "Vintage Photographs by Women of the 20s and 30s." With an introduction by Paul Katz. Exhibition Catalog. Chicago: Edwynn Houk Gallery, 1988.

Elliott, George P. "Photographs and Photographers." In *A Piece of Lettuce,* 90-103. New York: Random House, 1964.

Eugène Atget. New York: Aperture, 1980.

Evans, Sara M. *Born for Liberty: A History of Women in America.* New York: Free Press, 1989.

Fass, Paula S. *The Damned and the Beautiful: American Youth in the 1920s.* Oxford: Oxford Univ. Press, 1977.

Featherstone, David. *Doris Ulmann: American Portraits.* Albuquerque: Univ. of New Mexico Press, 1985.

Fisher, Andrea. *Let Us Now Praise Famous Women: Women Photographers for the U.S. Government, 1935 to 1944.* London: Pandora, 1987.

Fleischhauer, Carl, and Beverly W. Brannan, eds. *Documenting America, 1935–1943*. Berkeley: Univ. of California Press, 1988.

Foner, Eric. *Free Soil, Free Labor, Free Men: The Ideology of the Republican Party before the Civil War*. London: Oxford Univ. Press, 1970.

Foresta, Merry A. "Art and Document: Photography of the Works Progress Administration's Federal Art Project." In *Official Images: New Deal Photography*, by Pete Daniel, Merry A. Foresta, Maren Stange, and Sally Stein. Washington, D.C.: Smithsonian Institution Press, 1987.

"From a Student's Notebook." *Popular Photography* 21 (1947): 53-56, 174.

Ganzel, Bill. *Dust Bowl Descent*. Lincoln: Univ. of Nebraska Press, 1984.

Ginger, Ray. *Six Days or Forever? Tennessee v. John Thomas Scopes*. New York: Oxford Univ. Press, 1958.

Glazer, Penina Migdal, and Miriam Slater. *Unequal Sisters: The Entrance of Women into the Professions, 1890–1940*. New Brunswick, N.J.: Rutgers Univ. Press, 1987.

Glen, John M. *Highlander: No Ordinary School, 1932–1962*. Lexington: Univ. Press of Kentucky, 1988.

Goldberg, Vicki. *Margaret Bourke-White: A Biography*. New York: Harper and Row, 1986.

Goldsmith, Arthur. "A Harvest of Truth: The Dorothea Lange Retrospective Exhibition." *Infinity* (March 1966): 23–30.

Gover, Jane. *The Positive Image: Women Photographers in Turn of the Century America*. Albany, N.Y.: SUNY Press, 1988.

Greenough, Sarah. "How Stieglitz Came to Photograph Clouds." In *Perspectives on Photography: Essays in Honor of Beaumont Newhall*, edited by Peter Walch and Thomas Barrow, 151–65. Albuquerque: Univ. of New Mexico Press, 1986.

Greenough, Sarah, Joel Snyder, David Travis, and Colin Westerbeck. *On the Art of Fixing a Shadow: One Hundred and Fifty Years of Photography*. Boston: Little, Brown, 1989.

Guimond, James. *American Photography and the American Dream*. Chapel Hill: Univ. of North Carolina Press, 1991.

Gutman, Herbert G. "Work, Culture, and Society in Industrializing America, 1815–1919." *American Historical Review* 78 (June 1973): 531–88.

Hagood, Margaret Jarman. *Mothers of the South: Portraiture of the White Tenant Farm Woman*. Chapel Hill: Univ. of North Carolina Press, 1939; rev. ed., Charlottesville: University of Virginia Press, 1996.

Hales, Peter. *Silver Cities: The Photography of American Urbanization, 1839–1915*. Philadelphia: Temple Univ. Press, 1984.

Hardt, Hanno, and Karin B. Ohrn. "The Eyes of the Proletariat: The Worker-Photography Movement in Weimar Germany." *Studies in Visual Communication* 7 (summer 1981): 46–57.

Haskell, Thomas L. *The Emergence of Professional Social Science: The*

American Social Science Association and the Nineteenth-Century Crisis of Authority. Urbana: Univ. of Illinois Press, 1977.

Hawthorne, Ann, ed. *The Picture Man: Photographs by Paul Buchanan.* Chapel Hill: Univ. of North Carolina Press, 1993.

Heilbrun, Carolyn. *Writing a Woman's Life.* New York: Norton, 1988.

Heilpern, Alfred. "Vita" [Doris Ulmann]. *Call Number* 19 (spring 1958): 12.

Hendrickson, Paul. "Double Exposure." *Washington Post Magazine,* 31 Jan. 1988.

―――. *Looking for the Light: The Hidden Life and Art of Marion Post Wolcott.* New York: Knopf, 1992.

Herz, Nat. "Dorothea Lange in Perspective: A Reappraisal of the FSA and an Interview." *Infinity* (April 1963): 5–12.

Heyman, Therese Thau. *Celebrating a Collection: The Work of Dorothea Lange.* Oakland, Calif.: Oakland Museum, 1978.

―――. Interview by author. Oakland, California. 12 July 1989.

Higham, John. *History: Professional Scholarship in America.* Baltimore: Johns Hopkins Univ. Press, 1983.

Hill, Paul, Angela Kelly, and John Tagg. *Three Perspectives on Photography.* London: Arts Council of Great Britain, 1979.

Hilton, Kathleen C. "'Both in the Field, Each with a Plow': Race and Gender in USDA Policy, 1907–1929." In *Hidden Histories of Women in the New South,* edited by Virginia Bernhard, Betty Brandon, Elizabeth Fox-Genovese, Theda Perdue, and Elizabeth H. Turner, 114-33. Columbia: Univ. of Missouri Press, 1994.

Hine, Lewis. "Charity on a Business Basis." *World Today* 13 (Dec. 1907): 1254–60.

―――. "Our Untrained Citizens—Photographs by Lewis W. Hine for the NCLC." *Survey* 23 (2 Oct. 1909): 21–35.

―――. "Toilers of the Tenements." *McClure's,* July 1910, 231–40.

―――. "What Bad Housing Means to Pittsburgh." *Charities and the Commons* 19 (7 March 1908): 1683-98.

Hobson, Fred C., Jr. *Serpent in Eden: H. L. Mencken and the South.* Chapel Hill: Univ. of North Carolina Press, 1974; Baton Rouge: Louisiana State Univ. Press, 1978.

Hoffmann, Frederick J. *The Twenties: American Writing in the Postwar Decade.* Rev. ed. New York: Free Press, 1962.

Horton, Aimee Isgrig. *The Highlander Folk School: A History of Its Major Programs, 1932–1961.* New York: Carlson, 1989.

Howard, William L. "Dear Kit, Dear Skinny: The Letters of Erskine Caldwell and Margaret Bourke-White." *Syracuse University Library Associates Courier* 23 (fall 1988): 23–44.

Howe, Hartley E. "You Have Seen Their Pictures." *Survey Graphic* 29 (April 1940): 236–41.

Hurley, F. Jack. *Marion Post Wolcott: A Photographic Journey.* Albuquerque: Univ. of New Mexico Press, 1989.

————. *Portrait of a Decade: Roy Stryker and the Development of Documentary Photography in the Thirties*. Baton Rouge: Louisiana State Univ. Press, 1972.

————. "Shooting for the File: The Farm Security Administration Photographers in the South, 1935–1943." Paper presented at the fiftieth annual meeting of the Southern Historical Association, Louisville, October 1985.

Jacobs, Philip W. "Doris Ulmann's Search for Meaning." Paper presented at the Ulmann Symposium, Gibbes Museum of Art, 8 November 1997.

The Jargon Society. *The Appalachian Photographs of Doris Ulmann*. With essays by John Jacob Niles and Jonathan Williams. Highlands, N.C.: Jargon Society, 1971.

Jones, Margaret. *Heretics and Hellraisers: Women Contributors to* The Masses, *1911–1917*. Austin: Univ. of Texas Press, 1993.

Jordy, William H. "Four Approaches to Regionalism in the Visual Arts in the 1930s." In *The Study of American Culture: Contemporary Conflicts*, edited by Luther S. Luedtke, 19–48. Deland, Fla.: Everett/Edwards, 1977.

Jussim, Estelle. "'The Tyranny of the Pictorial': American Photojournalism from 1880 to 1920." In *Eyes of Time: Photojournalism in America*, edited by Marianne Fulton, 36–73. Boston: Little, Brown, 1988.

Karl, Barry D. *The Uneasy State: The United States from 1915 to 1945*. Chicago: Univ. of Chicago Press, 1983.

Katz, Leslie George. Keynote address. Award Ceremony at the Annual Meeting of the Association of International Photography Art Dealers, 6 Nov. 1981. National Museum of American Art, Smithsonian Institution, Washington, D.C. Transcript.

Kazin, Alfred. *On Native Grounds: An Interpretation of Modern American Prose Literature*. New York: Harcourt, Brace, 1942; Garden City, N.Y.: Doubleday, 1956.

Kennedy, David M. *Birth Control in America: The Career of Margaret Sanger*. New Haven, Conn.: Yale Univ. Press, 1970.

————. *Over Here: The First World War and American Society*. New York: Oxford Univ. Press, 1980.

Kennedy, N. Brent. *The Melungeons: The Resurrection of a Proud People*. Macon, Ga.: Mercer Univ. Press, 1994.

Kentucky Federal Writers' Project. *Kentucky: A Guide to the Bluegrass State*. New York: Harcourt, Brace, 1939.

Kerber, Linda K., Alice Kessler–Harris, and Kathryn Kish Sklar, eds. *U.S. History as Women's History: New Feminist Essays*. Chapel Hill: Univ. of North Carolina Press, 1995.

Kerr, Clark. "Paul and Dorothea." In Partridge, *Dorothea Lange: A Visual Life*, 36-43.

Kozol, Wendy. *LIFE's America: Family and Nation in Postwar Photojournalism*. Philadelphia: Temple Univ. Press, 1994.

———. "Madonnas of the Fields: Photography, Gender, and 1930s Farm Relief." *Genders* 2 (summer 1988): 1-23.

Kramer, Hilton. "Vanished City Life by Berenice Abbott on View." *New York Times,* 27 Nov. 1981.

Lange, Dorothea. "The American Farm Woman." *Harvester World* (Nov. 1960): 2–9.

———. *Dorothea Lange.* New York: Museum of Modern Art, 1966.

Lange, Dorothea, and Daniel Dixon. "Photographing the Familiar." In Lyons, *Photographers on Photography,* 68–72. Originally published in *Aperture* 1 (1952): 4–15.

Lange, Dorothea, and Paul Schuster Taylor. *An American Exodus: A Record of Human Erosion.* New York: Reynal and Hitchcock, 1939.

Lerner, Gerda. *Why History Matters: Life and Thought.* Oxford: Oxford Univ. Press, 1998.

Leuchtenberg, William E. *Franklin D. Roosevelt and the New Deal.* New York: Harper and Row, 1963.

———. *The Perils of Prosperity, 1914–32.* Chicago: Univ. of Chicago Press, 1958.

Levine, Lawrence W. "American Culture and the Great Depression." *Yale Review* 74 (winter 1985): 196–223.

———. "The Historian and the Icon: Photography and the History of the American People in the 1930s and 1940s." In Fleischhauer and Brannan, *Documenting America,* 15-42.

Lifson, Ben. "Post Wolcott: Not a Vintage Show." *Village Voice,* 23 July 1979.

Lippmann, Walter. *Public Opinion.* 1922. Reprint, New York: Free Press, 1965.

Longstreet, Stephen. *We All Went to Paris: Americans in the City of Light, 1776–1971.* New York: Macmillan, 1972.

Louisiana Federal Writers' Project. *Louisiana: A Guide to the State.* New York: Hastings House, 1941.

Lovejoy, Barbara. "The Oil Pigment Photography of Doris Ulmann." Master's thesis, Univ. of Kentucky, 1993.

Lyons, Nathan, ed. *Photographers on Photography.* Englewood Cliffs, N.J.: Prentice-Hall, 1966.

Maddow, Ben. *Faces: A Narrative History of Portrait Photography.* Boston: New York Graphic Society, 1977.

Mann, Margery. "Dorothea Lange." *Popular Photography,* March 1970, 84-85, 99-101.

Mann, Margery, and Anne Noggle, eds. *Women of Photography: An Historical Survey.* San Francisco: San Francisco Museum of Art, 1975.

Marchand, Roland. *Advertising the American Dream: Making Way for Modernity, 1920–1940.* Berkeley: Univ. of California Press, 1985.

Mazo, Joseph H. *Prime Movers: The Makers of Modern Dance in America.* New York: William Morrow, 1977.

McCausland, Elizabeth. "Berenice Abbott . . . Realist." *Photo Arts* 2 (spring 1948): 47–50.

———. "Documentary Photography." *Photo Notes* (Jan. 1939): 1–4.

———. "The Photography of Berenice Abbott." *Trend* 3 (March–April 1935): 17.

McElvaine, Robert, ed. *Down and Out in the Great Depression: Letters from the "Forgotten Man."* Chapel Hill: Univ. of North Carolina Press, 1983.

McEuen, Melissa A. "Doris Ulmann and Marion Post Wolcott· The Appalachian South." *History of Photography* 19 (spring 1995): 4–12.

Megraw, Richard B. "'The Grandest Picture': Lyle Saxon and the Problem of Aesthetic Localism in 30s America." Paper presented at the Southern American Studies Association meeting, Little Rock, Ark., Nov. 1996.

Meikle, Jeffrey. *Twentieth Century Limited: Industrial Design in America, 1925–1939*. Philadelphia: Temple Univ. Press, 1979.

Meltzer, Milton. *Dorothea Lange: A Photographer's Life*. New York: Farrar, Straus, and Giroux, 1978.

———. *Violins and Shovels: The WPA Arts Projects*. New York: Delacorte Press, 1976.

Melville, Annette. *Farm Security Administration, Historical Section: A Guide to Textual Records in the Library of Congress*. Washington, D.C.: Library of Congress, 1985.

"Mr. O'Neill." *New York Times*, 3 March 1929, 4.

Mitchell, Margaretta K., ed. *Recollections: Ten Women of Photography*. New York: Viking Press, 1979.

"The Mountain Breed." *New York Times*, 2 June 1928, 16.

Moynihan, Ruth, Susan Armitage, and Christiane Fischer Dichamp, eds. *So Much to Be Done: Women Settlers on the Mining and Ranching Frontier*. Lincoln: Univ. of Nebraska Press, 1990.

Murphy, Mary. *Mining Cultures: Men, Women, and Leisure in Butte, 1914–41*. Urbana: Univ. of Illinois Press, 1997.

———. "The Private Lives of Public Women: Prostitution in Butte, Montana, 1878–1917." In *The Women's West*, edited by Susan Armitage and Elizabeth Jameson, 193-205. Norman: Univ. of Oklahoma Press, 1987.

Murray, Joan. "Marion Post Wolcott: A Forgotten Photographer." *American Photographer* (March 1980): 86–93.

Naef, Weston, ed. *Doris Ulmann: Photographs from the J. Paul Getty Museum*. Focus series. Malibu, Calif.: J. Paul Getty Museum, 1996.

Nash, Roderick. *The Nervous Generation: American Thought, 1917–1930*. Chicago: Rand McNally, 1970.

Natanson, Nicholas. *The Black Image in the New Deal: The Politics of FSA Photography*. Knoxville: Univ. of Tennessee Press, 1992.

Nesbit, Molly. *Atget's Seven Albums*. New Haven, Conn.: Yale Univ. Press, 1992.

Niles, John Jacob. *The Ballad Book of John Jacob Niles*. Boston: Houghton Mifflin, 1961.

———. "Doris Ulmann: Preface and Recollections." *Call Number* 19 (spring 1958): 4–9.

Noble, David F. *America by Design: Technology and the Rise of Corporate Capitalism*. New York: Oxford Univ. Press, 1979.

Noggle, Burl. "With Pen and Camera: In Quest of the American South in the 1930s." In *The South Is Another Land: Essays on the Twentieth-Century South*, edited by Bruce Clayton and John A. Salmond, 187–206. Westport, Conn.: Greenwood Press, 1987.

Oakes, James. *The Ruling Race: A History of American Slaveholders*. New York: Random House, 1982.

Ohrn, Karin Becker. *Dorothea Lange and the Documentary Tradition*. Baton Rouge: Louisiana State Univ. Press, 1980.

O'Neal, Hank. *Berenice Abbott: American Photographer*. New York: McGraw-Hill, 1982.

———. *A Vision Shared: A Classic Portrait of America and Its People, 1935–1943*. New York: St. Martin's Press, 1976.

O'Neill, Eugene. *The Plays of Eugene O'Neill*. New York: Random House, 1929.

Orvell, Miles. *The Real Thing: Imitation and Authenticity in American Culture, 1880–1940*. Chapel Hill: Univ. of North Carolina Press, 1989.

Osman, Colin, and Sandra S. Phillips. "European Visions: Magazine Photography in Europe between the Wars." In *Eyes of Time: Photojournalism in America*, edited by Marianne Fulton, 74–103. Boston: Little, Brown, 1988.

Partridge, Elizabeth, ed. *Dorothea Lange: A Visual Life*. Washington, D.C.: Smithsonian Institution Press, 1994.

Pauly, Thomas H. *An American Odyssey: Elia Kazan and American Culture*. Philadelphia: Temple Univ. Press, 1983.

Peeler, David P. *Hope among Us Yet: Social Criticism and Social Solace in Depression America*. Athens: Univ. of Georgia Press, 1987.

Penrose, Roland. *Man Ray*. Boston: New York Graphic Society, 1975.

Peterkin, Julia. *Bright Skin*. Indianapolis: Bobbs-Merrill, 1932.

Peters, Marsha, and Bernard Mergen. "'Doing the Rest': The Uses of Photographs in American Studies." *American Quarterly* 29 (1977): 280–303.

Puckett, John Rogers. *Five Photo-Textual Documentaries from the Great Depression*. Ann Arbor: UMI Research Press, 1984.

Raeburn, John. "'Culture Morphology' and Cultural History in Berenice Abbott's *Changing New York*." *Prospects* 9 (1984): 255–92.

Raedeke, Paul. "Introduction and Interview." *Photo-Metro*, Feb. 1986, 3-17.

Raper, Arthur F., and Ira De A. Reid. *Sharecroppers All*. Chapel Hill: Univ. of North Carolina Press, 1941.

Rosenberg, William G., and Lewis H. Siegelbaum, eds. *Social Dimensions of Soviet Industrialization*. Bloomington: Indiana Univ. Press, 1993.

Rosenblum, Naomi. *A History of Women Photographers*. New York: Abbeville Press, 1994.

Rosenblum, Walter, and Naomi Rosenblum. *America and Lewis Hine: Photographs 1904-1940*. With an essay by Alan Trachtenberg. Millerton, N.Y.: Aperture, 1977.

Rourke, Constance. "The Significance of Sections." *New Republic*, 20 Sept. 1933, 148-51.

Russell, John. "A Still Life in Maine." *New York Times*, 16 Nov. 1980.

Sandeen, Eric J. *Picturing an Exhibition: "The Family of Man" and 1950s America*. Albuquerque: Univ. of New Mexico Press, 1995.

Scharf, Lois. *To Work and to Wed: Female Employment, Feminism, and the Great Depression*. Westport, Conn.: Greenwood Press, 1980.

Schlereth, Thomas J. *Artifacts and the American Past*. Nashville, Tenn.: American Association for State and Local History, 1980.

Secrest, Meryle. "An Attic Studio Hides a Woman's Vision." *Washington Post*, 17 Aug. 1969.

Seigfried, Charlene Haddock. "Classical American Philosophy's Invisible Women." Paper presented at the annual meeting of the Organization of American Historians, Atlanta, April 1994.

Scixas, Peter. "Lewis Hine: From 'Social' to 'Interpretive' Photographer," *American Quarterly* 39 (fall 1987): 381-409.

Sekula, Allan. "On the Invention of Photographic Meaning." *Artforum* 13 (Jan. 1975): 36-45.

Shelton, Suzanne. *Divine Dancer: A Biography of Ruth St. Denis*. Garden City, N.Y.: Doubleday, 1981.

Shipman, Louis Evan. Introduction to *A Portrait Gallery of American Editors, Being a Group of XLIII Likenesses*, by Doris Ulmann, 1-2. New York: William Edwin Rudge, 1925.

Silverman, Jonathan. *For the World to See: The Life of Margaret Bourke-White*. New York: Viking Press, 1983.

Singal, Daniel J. "Towards a Definition of American Modernism." *American Quarterly* 39 (spring 1987): 7-26.

———. *The War Within: From Victorian to Modernist Thought in the South, 1919-1945*. Chapel Hill: Univ. of North Carolina Press, 1982.

Sklar, Katherine Kish. *Florence Kelley and the Nation's Work*. New Haven, Conn.: Yale Univ. Press, 1995.

Smith, Terry. *Making the Modern: Industry, Art, and Design in America*. Chicago: Univ. of Chicago Press, 1993.

Smith College Museum of Art. "Berenice Abbott, Helen Frankenthaler, Tatyana Grosman, Louise Nevelson." Exhibition Catalogue. Northampton, Mass.: Smith College, 1974.

Snyder, Robert E. "Erskine Caldwell and Margaret Bourke-White: You Have Seen Their Faces." *Prospects* 11 (1987): 343-405.

——. "Marion Post and the Farm Security Administration in Florida." *Florida Historical Quarterly* 65 (April 1987): 457-79.

——. "Marion Post Wolcott: Photographing FSA Cheesecake." In *Developing Dixie: Modernization in a Traditional Society,* edited by Winfred B. Moore, Jr., Joseph F. Tripp, and Lyon G. Tyler, Jr., 299-309. Westport, Conn.: Greenwood Press, 1988.

Sontag, Susan. *On Photography.* New York: Farrar, Straus, and Giroux, 1977.

Stange, Maren. "The Management of Vision: Rexford Tugwell and Roy Stryker in the 1920s." *Afterimage* 15 (March 1988): 6-10.

——. *"Symbols of Ideal Life": Social Documentary Photography in America, 1890-1950.* New York: Cambridge Univ. Press, 1989.

Stein, Gertrude. *Look at Me Now and Here I Am: Writings and Lectures, 1909-1945.* Ed. Patricia Meyerowitz. Harmondsworth: Penguin, 1971.

Stein, Sally. "Peculiar Grace: Dorothea Lange and the Testimony of the Body." In Partridge, *Dorothea Lange: A Visual Life,* 58-89.

Steinbach, Alice C. "Berenice Abbott's Point of View." *Art in America* (Nov.–Dec. 1976): 77-81.

Steinbeck, John. *The Grapes of Wrath.* New York: Viking Press, 1939.

Steiner, Ralph. *A Point of View.* With an introduction by Willard Van Dyke. Middletown, Conn.: Wesleyan Univ. Press, 1978.

[Steiner, Ralph]. "The Small Town." *PM's Weekly,* 13 Oct. 1940, 46-49.

Steiner, Wendy. "Gertrude Stein's Portrait Form." Ph.D. diss., Yale Univ., 1974.

Stieglitz, Alfred. "Pictorial Photography." In Trachtenberg, *Classic Essays on Photography,* 115-23. Originally published in *Scribner's Magazine,* Nov. 1899.

Stoddart, Jess, ed. *The Quare Women's Journals: May Stone and Katherine Pettit's Summers in the Kentucky Mountains and the Founding of the Hindman Settlement School.* Ashland, Ky.: Jesse Stuart Foundation, 1997.

Stott, William. *Documentary Expression and Thirties America.* New York: Oxford Univ. Press, 1973; reprint, Chicago: University of Chicago Press, 1986.

Stryker, Roy E. "The FSA Collection of Photographs." In *Photography in Print,* edited by Vicki Goldberg, 349-54. Albuquerque: University of New Mexico Press, 1981. Originally published in Stryker and Wood, *In This Proud Land.*

Stryker, Roy E., and Paul Johnstone. "Documentary Photography." In *The Cultural Approach to History,* edited by Caroline F. Ware, 324-30. New York: Columbia Univ. Press, 1940.

Stryker, Roy E., and Nancy Wood. *In This Proud Land.* Greenwich, Conn.: New York Graphic Society, 1973.

Sundell, Michael G. "Berenice Abbott's Work in the 1930s." *Prospects* 5 (1980): 269–92.

Susman, Warren. *Culture as History: The Transformation of American Society in the Twentieth Century.* New York: Pantheon Books, 1984.

Swados, Harvey, ed. *The American Writer and the Great Depression.* Indianapolis: Bobbs-Merrill, 1966.

Szarkowski, John. *The Photographer's Eye.* New York: Museum of Modern Art, 1966.

Szarkowski, John, and Maria Morris Hambourg. *The Work of Atget.* 4 vols. Boston: New York Graphic Society, 1982.

Tagg, John. *The Burden of Representation: Essays on Photographies and Histories.* Amherst: Univ. of Massachusetts Press, 1988.

Tanno, Jessica. "Urban Eye on Appalachia." *Americana* (July–Aug. 1982): 29-31.

Taylor, Paul. *On the Ground in the Thirties.* Salt Lake City: Gibbs M. Smith, 1983.

Terrill, Tom E., and Jerrold Hirsch, eds. *Such as Us: Southern Voices of the Thirties.* Chapel Hill: Univ. of North Carolina Press, 1978.

These Are Our Lives: As Told by the People and Written by Members of the Federal Writers' Project of the Works Progress Administration in North Carolina, Tennessee, and Georgia. Chapel Hill: Univ. of North Carolina Press, 1939.

Thornton, Gene. "Ulmann Forces a New Look at Pictorialism." *New York Times,* 12 Jan. 1975, 23.

Tocqueville, Alexis de. *Democracy in America.* 2 vols. London: Saunders and Otley, 1835, 1840. Rev. ed., New York: Harper and Row, 1985.

Trachtenberg, Alan. "From Image to Story: Reading the File." In Fleischhauer and Brannan, *Documenting America,* 43-73.

————. *The Incorporation of America: Culture and Society in the Gilded Age.* New York: Hill and Wang, 1982.

————. *Reading American Photographs: Images as History, Mathew Brady to Walker Evans.* New York: Hill and Wang, 1989.

————, ed. *Classic Essays on Photography.* New Haven, Conn.: Leete's Island, 1980.

Tucker, Anne Wilkes. "Photographic Facts and Thirties America." In *Observations: Essays on Documentary Photography,* edited by David Featherstone, 40-55. Carmel, Calif.: Friends of Photography, 1984.

————, ed. *The Woman's Eye.* New York: Alfred A. Knopf, 1973.

Tugwell, Rexford Guy, Thomas Munro, and Roy E. Stryker. *American Economic Life and the Means of its Improvement.* New York: Harcourt, Brace, 1924.

Twelve Southerners. *I'll Take My Stand: The South and the Agrarian Tradition.* New York: Harper and Brothers, 1930; reprint, Baton Rouge: Louisiana State Univ. Press, 1977.

Ulmann, Doris. *The Darkness and the Light: Photographs by Doris Ulmann.* With essays by William Clift and Robert Coles. Millerton, N.Y.: Aperture, 1974.

————. *A Portrait Gallery of American Editors, Being a Group of XLIII*

Likenesses. With an introduction by Louis Evan Shipman. New York: William Edwin Rudge, 1925.

———. *Roll, Jordan, Roll.* New York: Robert O. Ballou, 1933.

———. "The Stuff of American Drama: In Photographs by Doris Ulmann." *Theatre Arts Monthly* 14 (Feb. 1930): 132-41.

University of Louisville Photographic Archives. "Things As They Were: FSA Photographers in Kentucky, 1935-1943." Exhibition Catalogue. Exhibit, 6 Sept.–9 Nov. 1985.

"U.S. to Find Work for 3500 Artists." *New York Times,* 4 Oct. 1935.

Van Dyke, Willard. "The Photographs of Dorothea Lange—A Critical Analysis." *Camera Craft* (Oct. 1934): 464–65.

Walsh, George, Colin Naylor, and Michael Held, eds. *Contemporary Photographers.* New York: St. Martin's Press, 1982.

Warren, Dale. "Doris Ulmann: Photographer-in-Waiting." *Bookman* 72 (Oct. 1930): 129–44.

Warren, Harold F. . . . *A Right Good People.* Boone, N.C.: Appalachian Consortium Press, 1974.

Weaver, Kay, and Martha Wheelock. *Berenice Abbott: A View of the 20th Century.* Sherman Oaks, Calif.: Ishtar Films, 1992.

Wertheim, Arthur F. "Constance Rourke and the Discovery of American Culture in the 1930s." In *The Study of American Culture: Contemporary Conflicts,* edited by Luther S. Luedtke, 49–61. Deland, Fla.: Everett/Edwards, 1977.

Whisnant, David. *All That Is Native and Fine: The Politics of Culture in an American Region.* Chapel Hill: Univ. of North Carolina Press, 1983.

White, Minor. "Eugène Atget." *Journal of Photography and Motion Pictures of the George Eastman House* 5 (April 1956): 76–83.

White, Robert. "Faces and Places in the South in the 1930s: A Portfolio." *Prospects* 1 (1975): 415–29.

Wiebe, Robert. *The Search for Order: 1877–1920.* New York: Hill and Wang, 1967.

Williams, Susan Millar. *A Devil and a Good Woman, Too: The Lives of Julia Peterkin.* Athens: Univ. of Georgia Press, 1997.

Williams, T. Harry. *Huey Long.* New York: Vintage, 1969.

Wolcott, Marion Post. Keynote address. Presented at "Women in Photography" conference, Syracuse Univ., 10–12 Oct. 1986. Speech notes.

———. *Marion Post Wolcott: FSA Photographs.* Introduction by Sally Stein. Carmel, Calif.: Friends of Photography, 1983.

"Woman with Camera Snaps Revealing History of New York Life in Its Homeliest of Garb." *New York World-Telegram,* 11 Nov. 1938.

Woodward, C. Vann. *The Strange Career of Jim Crow.* 3d rev. ed. New York: Oxford Univ. Press, 1974.

Wright, Richard, and Edwin Rosskam. *Twelve Million Black Voices: A Folk History of the Negro in the United States.* New York: Viking, 1941.

Zito, Tom. "Abbott: Glimpses of the Artiste." *Washington Post*, 3 April
 1976.
Zubryn, Emil. "Saving New York for Posterity." *Photography: A Brit-
 ish Journal of Commercial, Advertising & Portrait Photography*
 (Jan. 1938): 12.
Zwingle, Erla. "A Life of Her Own." *American Photographer* (April
 1986): 54–67.

Index

Page numbers in italics refer to illustrations.